Feminism as World Literature

Literatures as World Literature

Can the literature of a specific country, author, or genre be used to approach the elusive concept of "world literature"? **Literatures as World Literature** takes a novel approach to world literature by analyzing specific constellations—according to language, nation, form, or theme—of literary texts and authors in their own world-literary dimensions.

World literature is obviously so vast that any view of it cannot help but be partial; the question then becomes how to reduce the complex task of understanding and describing world literature. Most treatments of world literature so far either have been theoretical and thus abstract, or else have made broad use of exemplary texts from a variety of languages and epochs. The majority of critical work, the filling in of what has been traced, lies ahead of us. **Literatures as World Literature** fills in the devilish details by allowing scholars to move outward from their own areas of specialization, fostering scholarly writing that approaches more closely the polyphonic, multiperspectival nature of world literature.

Series Editor:
Thomas O. Beebee

Editorial Board:
Eduardo Coutinho, Federal University of Rio de Janeiro, Brazil
Hsinya Huang, National Sun-yat Sen University, Taiwan
Meg Samuelson, University of Adelaide, Australia
Ken Seigneurie, Simon Fraser University, Canada
Galin Tihanov, Queen Mary University of London, UK
Mads Rosendahl Thomsen, Aarhus University, Denmark

Volumes in the Series
German Literature as World Literature, edited by Thomas O. Beebee
Roberto Bolaño as World Literature, edited by Nicholas Birns and Juan E. De Castro
Crime Fiction as World Literature, edited by David Damrosch, Theo D'haen, and Louise Nilsson
Danish Literature as World Literature, edited by Dan Ringgaard and Mads Rosendahl Thomsen
From Paris to Tlön: Surrealism as World Literature, by Delia Ungureanu

American Literature as World Literature, edited by Jeffrey R. Di Leo
Romanian Literature as World Literature, edited by Mircea Martin, Christian Moraru, and Andrei Terian
Brazilian Literature as World Literature, edited by Eduardo F. Coutinho
Dutch and Flemish Literature as World Literature, edited by Theo D'haen
Afropolitan Literature as World Literature, edited by James Hodapp
Francophone Literature as World Literature, edited by Christian Moraru, Nicole Simek, and Bertrand Westphal
Bulgarian Literature as World Literature, edited by Mihaela P. Harper and Dimitar Kambourov
Philosophy as World Literature, edited by Jeffrey R. Di Leo
Turkish Literature as World Literature, edited by Burcu Alkan and Çimen Günay-Erkol
Elena Ferrante as World Literature, by Stiliana Milkova
Multilingual Literature as World Literature, edited by Jane Hiddleston and Wen-chin Ouyang
Persian Literature as World Literature, edited by Mostafa Abedinifard, Omid Azadibougar, and Amirhossein Vafa
Mexican Literature as World Literature, edited by Ignacio M. Sánchez Prado
Beyond English: World Literature and India, by Bhavya Tiwari
Graphic Novels and Comics as World Literature, edited by James Hodapp
African Literatures as World Literature, edited by Alexander Fyfe and Madhu Krishnan
Feminism as World Literature, edited by Robin Truth Goodman
Polish Literature as World Literature, edited by Piotr Florczyk and K. A. Wisniewski (forthcoming)
Taiwanese Literature as World Literature, edited by Pei-yin Lin and Wen-chi Li (forthcoming)
Pacific Literatures as World Literature, edited Hsinya Huang and Chia-hua Yvonne Lin (forthcoming)
Central American Literature as World Literature, edited by Sophie Esch (forthcoming)
Kazuo Ishiguro as World Literature, by Chris Holmes (forthcoming)

Feminism as World Literature

Edited by
Robin Truth Goodman

BLOOMSBURY ACADEMIC
NEW YORK • LONDON • OXFORD • NEW DELHI • SYDNEY

BLOOMSBURY ACADEMIC
Bloomsbury Publishing Inc
1385 Broadway, New York, NY 10018, USA
50 Bedford Square, London, WC1B 3DP, UK
29 Earlsfort Terrace, Dublin 2, Ireland

BLOOMSBURY, BLOOMSBURY ACADEMIC and the Diana logo are trademarks of
Bloomsbury Publishing Plc

First published in the United States of America 2024
This Paperback edition published 2024

Volume Editor's Part of the Work © Robin Truth Goodman, 2023

Each chapter © Contributors, 2023

Chapter Eight, "Practicing Transnational Feminist Recovery Today," by Jessica Berman, was originally published as: Jessica Berman (2018), "Practicing transnational feminist recovery today," *Feminist Modernist Studies*, 1:1, 9–21; reprinted by permission of Taylor & Francis.

For legal purposes the Acknowledgments on p. x constitute an extension of this copyright page.

Cover design by Simon Levy / Levy Associates

All rights reserved. No part of this publication may be reproduced or transmitted in any form or by any means, electronic or mechanical, including photocopying, recording, or any information storage or retrieval system, without prior permission in writing from the publishers.

Bloomsbury Publishing Inc does not have any control over, or responsibility for, any third-party websites referred to or in this book. All internet addresses given in this book were correct at the time of going to press. The author and publisher regret any inconvenience caused if addresses have changed or sites have ceased to exist, but can accept no responsibility for any such changes.

Library of Congress Cataloging-in-Publication Data

Names: Goodman, Robin Truth, 1966- editor.
Title: Feminism as world literature / edited by Robin Truth Goodman.
Description: New York : Bloomsbury Academic, 2022. | Series: Literatures as world literature | Includes bibliographical references and index.
Identifiers: LCCN 2022018414 (print) | LCCN 2022018415 (ebook) | ISBN 9781501371189 (hardback) | ISBN 9781501371226 (paperback) | ISBN 9781501371196 (epub) | ISBN 9781501371202 (pdf) | ISBN 9781501371219
Subjects: LCSH: Feminism in literature. | LCGFT: Literary criticism. | Essays.
Classification: LCC PN56.F46 F44 2022 (print) | LCC PN56.F46 (ebook) |
DDC 809/.89287–dc23/eng/20220805
LC record available at https://lccn.loc.gov/2022018414
LC ebook record available at https://lccn.loc.gov/2022018415

ISBN: HB: 978-1-5013-7118-9
PB: 978-1-5013-7122-6
ePDF: 978-1-5013-7120-2
eBook: 978-1-5013-7119-6

Series: Literatures as World Literature

Typeset by Deanta Global Publishing Services, Chennai, India

To find out more about our authors and books visit www.bloomsbury.com and sign up for our newsletters.

CONTENTS

List of Figures ix
Acknowledgments x

Introduction: Is a Feminist World Literature
Possible? *Robin Truth Goodman* 1

PART I Genres 21

1 "There Are in Persia Many Subjects Not Accessible to
 Female Inquiry": Eurocentric and Cross-Cultural Feminist
 Nomadism in Lady Mary Sheil's *Glimpses of Life and
 Manners in Persia* (1856) *Marie Ostby* 23

2 Changing the World of Feminist Demodystopias
 Caren Irr 41

3 The Speculative Mode in Feminist World
 Literature *Debjani Ganguly* 56

4 Poet/Guerreras: Hip-Hop and World Literature
 Debra A. Castillo 71

5 Surface Matters: Female Allegories and the
 Gendering of Continents from Waldseemüller to
 Ortelius *Katharina N. Piechocki* 83

PART II Strategies 99

6 Bonds of Labor: Mahasweta Devi, Feminism,
 Leninism *Keya Ganguly* 101

7 The Worlds That Women Collect *Lisa Ryoko Wakamiya* 116

8 Practicing Transnational Feminist Recovery Today *Jessica Berman* 130

9 Woman as Anti-Suicide Bomb: Women Trapped between Past and Future *Mieke Bal* 147

10 Translating Hidden Economies: Toward a Decolonial-Feminist Worlding of Literature *Laura Doyle* 164

11 The Elusive Postcolonial: Women Writers in/and the African Diaspora *Hortense J. Spillers* 180

PART III Themes 193

12 Intertwining Feminisms, Environmentalisms, and World Literature in Ruth Ozeki's *A Tale for the Time Being* *Karen Thornber* 195

13 Troubling the Human, Worlding Gender in Maryse Condé's *The Wondrous and Tragic Life of Ivan and Ivana* *Nicole Simek* 209

14 Dissident Feminist Subjects and Spaces in Arundhati Roy's *The Ministry of Utmost Happiness* *Sarah Afzal* 222

15 Maghrebi Women's Literature and Film: The *"Ecritures féminines"* of *Unsubmissive* Voices *Valérie K. Orlando* 239

16 Toward a New Theory of Feminist World Literature, in Film *Robin Truth Goodman* 253

17 Passivity and Nomadism in the Literature of Luisa Valenzuela *Sofia Iaffa* 270

Notes on Contributors 285
Index 290

FIGURES

5.1 Abraham Ortelius, *Theatrum Orbis Terrarum* (frontispiece), Antwerp, 1574 93
5.2 Johannes Stradanus (Jan van der Straet): *Discovery of America: Vespucci Landing in America*, c. 1587–9 94
9.1 Emotional capitalism in practice 151
9.2 Emma dying 154
9.3 The young men mourning their dead friend 157
9.4 Don Quijote's rant against the men who scold Marcela. Marcela looks annoyed. At Whom? 157
9.5 Nalini Malani, Cassandra, 2009. Thirty panel reverse painting on acrylic sheet, overall size 225 × 390 centimeters, each panel 45 × 65 centimeters 158
9.6 Cassandra (Magdalena Žak) rehearsing her lines, with the help of Jakub Mikurda 161

ACKNOWLEDGMENTS

Many thanks go to Haaris Naqvi, Amy Martin, Thomas O. Beebee, and the folks at Bloomsbury who have supported this project. Jeffrey Di Leo and Christian Moraru were the ones who first invited me to pursue the ideas that developed into this book. Others who assisted with advice were Anne Coldiron, Tracy Denean Sharpley-Whiting, Ayesha Ramachandran, Laura U. Marks, and Negar Mottahedeh. As always, Kenneth J. Saltman is my intellectual partner who has spent countless hours developing ideas with me. Most prominently, I thank all the contributors to this volume, all its readers, and feminists at home and around the world, present, past, and future, who translate such politics and ideas into living form.

Robin Goodman
Professor of English
Florida State University
https://english.fsu.edu/faculty/robin-goodman
rgoodman@fsu.edu

Introduction

Is a Feminist World Literature Possible?

Robin Truth Goodman

The field of World Literature seems to skirt away from feminism. Much of the genealogical trajectory that is cited in the field's self-definitions passes from Goethe, Marx and Engels, and Auerbach—with an orientation toward cosmopolitanism and the world market—to Said's Orientalism; Moretti's "distance reading," formalism, and world systems; Pascale Casanova's world systems in literary circulations with Paris at the center dominating its peripheries; and Damrosch's imperative to "push against the market" (2009: 463) by expanding the market into the undergraduate classroom for the purpose of expanding enrollments. In this, the centuries-long contributions of feminism to literary studies seem barely a tickle in relation to the great literatures of the world. The category of World Literature, as Debra A. Castillo has noted, often just gestures to the "dark lady," that is, "the token woman in an otherwise all-male academic circle" (2011: 395). *Feminism as World Literature* redefines the thematic and theoretical contents of World Literature in feminist terms as well as rethinking feminist terms, analyses, frameworks, and concepts in a World Literature context. The authors recognize genres, strategies, and themes of World Literature that demonstrate feminism as integral to the world-making gestures of literary form and production. In this introduction, I argue that a feminist World Literature's practices, questions, theories, frameworks, materials, and modes of analyses are particularly urgent now at a time when democracy is possibly at risk of not surviving.

World Literature criticism may, indeed, identify World Literature in contrast not just to feminism but also to femininity, as femininity conventionally is associated with interiority, the body, particularity, contingency, stability, nature, the local, the traditional, and the sentimental rather than the global,

the conceptual, the expansive, or the transcendent. Simone de Beauvoir, for example, wrote of femininity as "imminent" in its hominess and grounded in the naturalized physicality of a woman's body, especially in her reproductive, care, love, and familial capacities. Beauvoir thought that women's relation to the home as a defense against the world reduced her to dependency and obstructed her liberty: "The home becomes the center of the world and even its only reality: . . . refuge, retreat, grotto, womb, it gives shelter from outside dangers; it is this confused outer world that becomes unreal . . ." (1980: 450). In a postcolonial context, Partha Chatterjee has agreed, claiming that "nationalism's success [is] in situating the 'women's question' in an 'inner' domain of sovereignty far removed from the arena of political contest" (1997: 241), where women invoke "tradition" and cultural feeling against the onslaught of political temporalities, abstract generalities, and imperializing modernity. Yet, in what sense can we say that the tradition of representing these "'inner' domains of sovereignty" may be focusing on the "women's question" in order to address broader political relations or even world political relations? Fredric Jameson might identify this "women's question"—albeit problematically—as part of a "national allegory," a "third-world" allegory, or even a world allegory in that the domestic context, private life, or locality projects a "political dimension": an "embattled situation of the public third-world culture and society" (1986: 69). Does the "women's question" that feminism poses give us a glimpse of literature's important stake within world political relations?

World Literature has been defined, in contrast to interiorizing, corporealizing, imminent, and domesticating femininity, as literary works that transcend local markets and generate sales as well as critical interest beyond the borders of their nations of origin, like trade agreements or NGOs. As Damrosch elaborates, "a work of world literature has an exceptional ability to transcend the boundaries of the culture that produces it" (2009: 2), meaning that it "can very readily become culturally deracinated, philologically bankrupt and ideologically complicit with the worst tendencies of global capitalism" (2011: 456). As an example, Damrosch alludes to his own experience of trying to sell a game he developed called "True Love," about dating, to Milton Bradley, whose marketers would evaluate the content in terms of its potential allure to global distributors (2011: 480). This type of World Literature is contra feminism, Damrosch infers, in that it is about stereotyping the seemingly most intimate experiences as heterosexualized norms carved into the "women-as-object"— dating—universally recognizable, crossing borders, translatable, and built to enhance circuits of global exchange.

Yet, Damrosch may not have his finger on this particular pulse. Feminism has already claimed a literary space of its own as contestatory to geopower and market expansion. On the eve of war, Virginia Woolf imagined a hypothetical woman saying, "[I]n fact, as a woman, I have no country. As a woman I want no country. As a woman my country is the whole world" (1938: 109). Though we may no longer idealize a woman-centered cosmopolitanism as promising

peace, Woolf's challenge is to ask us what does a world look like in feminist terms? This impulse was not new to feminism in Virginia Woolf's time. Mary Wollstonecraft was a translator before she wrote *Vindication*. As Laura Kirkley points out, Wollstonecraft did not consider translation as "an act of mere imitation" (2016: 14) but rather as a critical disengagement against the authority of original texts and authors, a way to play with authorized content in order to create unauthorized manipulations and commentary that would open up later contestation and political thinking. The feminist's marginalization and detachment from the authorized world allows her, according to Kirkley, to sense the world's disorientation, its non-identity with itself, and to cross borders with linguistic play. For feminism, detachment and disassociations allow for a changing perspective on the world-as-it-is, the world with its inequality, exploitation, sex slavery, terror, and war. In this volume, the authors identify such dispossession and disengagement in a variety of political and world-making spheres, from environmentalism to technology, migration, nomadism, development, decolonization, mapping, social reproduction, demographics, and collecting, while looking to literary texts as invoking difference within those contexts through genre creation, catachresis, retrieval, new media, multimedia, splitting subjectivities, translation, film technique, adaptation, allegorization, welcoming strangers, altering perspectives, deauthorizing authors, resituating agency, pinpointing alliances, altering chronologies, and creating resistance, for example.

Indeed, the construction of particularized identities, particularized disciplinary foci, and particularized language groups as a contrast to world theory has come under scrutiny. Shu-mei Shih and Françoise Lionnet, for example, have shown that, in the second decade of the twenty-first century, many scholars have declared the death of Theory (meaning, mostly, the spread of post-1968 "French Theory" into the academy globally, at the same time as area studies, ethnic studies, decolonization, and the Civil Rights movement). According to such heralds of Theory's death, for example, Theory's connection to English, its movement away from materialism provoked by Theory's "linguistic turn," its relativisms, reductions, and depoliticizations, as well as its abstraction of "the Other" in psychoanalytic, melancholic, and mournful posturing, are all symptoms of Theory's "neoliberal impulse" (2011: 5): Theory's gestures toward decentering and borderlessness are the same as capital's, even while implicating the same types of power hierarchies and dispossessions. Nevertheless, according to Shih and Lionnet, Theory has thrived within academic cultures like area studies and ethnic studies that were erroneously seen to be Theory's opposition.[1] European and US social movements in the 1960s that fed

[1] "[A]rea studies scholars are relegated to pragmatic and empirical research readily extracted for strategic purposes—this is the double movement of the imperial consciousness that

Theory's proliferation were inspired by Third World liberation, anti-Vietnam and anti-Algeria activism, and Civil Rights so that academic ethnic studies were built on a Marxist tradition of class analysis, even while Marxism itself was diminished and degraded in many areas of the West and, according to Shih and Lionnet, increasingly Theory was devoid of it. Class analysis, then, survived mostly inasmuch as it was related to studies of race, which kept it "connected to the concrete social" (2011: 13). They write: "Our academic division of labor remains such that we generally fail to account for the degree to which our politics of knowledge, disciplinary formations, and social inequalities are mutually constituted.... Objects of study that might first seem antithetical are often historically imbricated, just like creolized cultures or transnational intellectual movements" (2011: 2). The recognition of particularized cultural identities in the modern world allows us to do Theory, that is, to practice the production of thinking concepts by which we coexist with others, as Hannah Arendt might say, in the world that we share. The prevalent idea on both the left and the right that ethnic studies or even women's studies is too provincial is not an accurate description of these fields, according to Shih and Lionnet, but rather a symptom of how capitalism itself marginalizes some identities while blaming them for their own marginalizations.

I do not wholly agree with the contention that Theory has only or predominantly survived in area studies and ethnic studies, or that ethnic studies and area studies were the only academic enclaves where Marxist practices of class analysis could continue. Nevertheless, I do agree that World Literature is well positioned to consider the big-picture one-world projections of neoliberal policy in relation to the cultural particularities that it appropriates, reformulates, neglects, ignores, or dismisses in its de-democratizing tendencies. Similarly, to the Creolization of Theory as elaborated by Shih and Lionnet, Orientalism, as Aamir Mufti has explained it, gives this interaction—between expansive and universalizing thought-frames like Theory and the particularized life-worlds which it references and to which it applies—a deep historical consequence. For Mufti, World Literature is the legacy of a European Orientalist tradition that sought to construct a "'one world' reality" by "imagining the world as a *continuous and traversable space*" (2016: 5), based on the possibilities of globalized exchange but composed of nations—an "attempt to think diversity and

is also in fact a highly effective division of labor: The theorists do theory, while the area studies 'experts' do area. Wittingly or not, both groups ultimately serve the same purpose of furthering imperial agendas" (2011: 6). And again: "The perception by a younger generation of scholars that the class-based paradigm of ethnic studies was less and less able to account for new and multifarious forms of citizenship and more variable forms of culture, coupled with the increasing institutionalization of ethnic studies, led to the awareness that ethnic studies scholars, especially in the humanities, must partake of the larger trends in Theory" (2011: 10).

uniformity in the same instance" (2016: 14). In the logic of colonial rule, Orientalism, like World Literature, he goes on,

> consists of those Western knowledge practices in the modern era whose emergence made possible for the first time the notion of a single world as a space populated by distinct civilizational complexes, each in possession of its own tradition, the unique expression of its own forms of national "genius." It is the name for the vast cultural apparatus in modern Western culture for the establishment of identitarian truth-claims around the world—an *imperial* task, par excellence. (2016: 20)

In other words, Orientalism's "one world" vision is bolstered by collecting knowledge of its own multiple and particular expressions, and therefore we would not have particular identities, including feminist ones, without the expansionist sweep of abstract worldliness and its categories of concrete appearance:

> when a late eighteenth- or early nineteenth-century European writer turns to "India"—available to him or her first and foremost as a newly canonized textual corpus—for a stock of motifs and images, explicitly with the hope of overcoming the limitations or provinciality of hitherto existing European ideas about literature, culture, religion, or antiquity, he or she is still engaged in an exercise that is fundamentally European in nature, that is, *embedded* in a strong sense in the centers of the emergent world system and concerning its peripheries. (2016: 29)

As much as World Literature represents itself—first as Orientalism and now as neoliberalism—in terms of a seamless and all-encompassing unified body of works with parallel forms and themes, according to Mufti, it also creates methods and practices for studying and assimilating bounded realities of otherness that, in fact, in its outward orientations, it is thereby producing as other.

Debates about whether World Literature is coterminous with neoliberalism or, in fact, its generative opposition can, therefore, never reach resolution. On the one hand, neoliberalism promotes a contemporary unified geopolitics of austerity, aggression, militarism, and endless growth globally; on the other hand, it promotes a geopolitics of dispossession, disengagement, political stalemate, and disidentification through which peripheral identities are articulated or, sometimes, made unavailable to standards of articulation. Neoliberalism's "one world/one market" perspective that, in its imperialist (Orientalist) impetus, reduces everything to the same coexists within an inappropriable difference, a difference that is unequal to neoliberalism's schemas, representations, systems, and categories. To this situation, feminism must respond.

This book offers new genres, approaches, analyses, theories, canons, modes of image construction, and strategies of reading that exhibit the feminist when she is at odds with this given unified world-image of growth, expansion, and inclusion or when this given unified world-image is at odds with her. In these contexts, "woman" is often a term that denotes the world's precarity.[2] The word "woman" often applies to, for example, immigrant parents whose children are taken from them at border crossings,[3] or traumatized victims of sexual assault, or the underemployed, underfinanced, and underinsured: fast-food workers; domestic caregivers and service providers for the sick, the young, and the elderly; and gig-workers. Excessive to the law, these modern forms of precarity, as Judith Butler (following Hannah Arendt) explains, are found at the limits of the law, as an exception, where sovereignty exercises its coercions outside of the law's constraints, leaving "the stateless unprotected" and "those from non-recognized polities without recourse to its entitlements" (2004: 87). The term "woman" has come to stand for precarity: a sovereign absence, a lack of legal recognition or state protection, with today's dominant hegemonic order set, for the most part, unanswerable to the majority, unrelatable, and inaccessible. As symbol of precarity, "woman" is the negative of the false universal security promised in the expansion of commercial abundance and spatial inclusivity in the "one world" concept; by "negative," I mean an empty representation of

[2] Guy Standing defines the "precariat" as a class-in-formation, devoid of community or long-standing commitments to building identity through work and career development. An effect of globalization, these "denizens," as Standing calls them (in contrast to "citizens," who are connected to political bodies, promises, rights, and national geographies), evolve "a mass incapacity to think long term," a damaged "long-term memory consolidation process," (2011: 18), a short-term literacy, a loss of connection, a "failed occupationality" (2011: 21), a loss of privacy, a loss of skills, instability, and "chronic uncertainty" due to a lack of "mechanism to create alternative forms of solidarity" (2011: 22). Standing's perspective is predominantly informed by work structures leading to political detachments, with digitalization and an ever-larger share of production and preparation for production being demanded of unremunerated workers, including lifelong vocational education. The environmental crisis should also be included as a fundamental part of precariat consciousness. The pandemic has brought to the fore how environmental degradation and loss of world are increasingly shaping bodies and subjectivities. Additionally, the politicization of healthcare, especially in the United States, has demonstrated that tying medical insurance to work is a strong causal factor in making health precarious. Penelope Deutscher has highlighted how "woman" has become a privileged term in the making of biopolitical precarity, as the maternal role is sovereign in determining the life, death, and harm that reproduction inflicts on the newborn: "[O]nce optimal reproduction ensures the collective future, women also become figures of possible harm to those futures," she writes. "Women have been attributed a pseudosovereign capacity to harm embryos, children, and futures" (2017: 36). This alludes to a familiar politics where women are treated as the source of social risk.

[3] Guy Standing continues, "Women, often moving on their own, make up a greater share of international migrants than at any time in history" (2011: 92).

what we do not have that binds us together.⁴ In the rest of this introduction, I turn to Gayatri Spivak as well as to Hannah Arendt to demand a feminism that is necessary and central even as it seems tangential to theories of World Literature. I show that in the context of World Literature, while "woman" stands for a precarity that dovetails with the precarity resulting from neoliberalism's denigration of democracy (in economic as well as political, cultural, legal, and historical spheres), feminism is the defense of democracy.

Whereas for Woolf, women's outsider status gave them an advantageous point of view for demanding a reorganization of geopolitical ideals, today outsider status is a recipe for political detachments, hardships, and disasters. Grégoire Chamayou writes of the political sea change posed by drone warfare to a tradition of democratic sovereignty in which citizens who expose their lives, bodies, and vulnerabilities "*must* have some power over it" (2013: 183):⁵ military mechanization, in contrast, means that bodies are not exposed or made vulnerable in war, and that political leaders are less likely to have to ask the consent of citizens. Learning from colonial wars that not exposing citizens to dangers would allow power interests to maneuver outside of democratic regulations and critique, post-1990s war-managers developed remotely operating war technologies called drones where, with warfare "ghostly and teleguided, citizens, who no longer risked their lives, would no longer even have a say in it" (2013: 189). The disappearing citizen here can be said to be positioned as female/civilian in Virginia Woolf's terms but with a target on her back. With the disappearance of the citizen, the home front also disappears with its social relations of civilian belonging, as well as the desire for building a world more amenable to human attachments than war provides. For Chamayou, such social enclaves of attachment are superseded by a technologization of politics—where (he cites Arendt here) "decisions" are made by machines based on probabilities, algorithms, statistical regularities, and predictions of damage to property.

Feminist scholars have also noticed an uncoupling of the political world from its citizen referents. By this I mean that the state's "hailing" its subjects through providing narratives of identification is weakened by the state's self-representations as unrepresentative of citizen interests, in the form of, for example, disinvesting in the "soft arm" of the state's support functions, exacerbating already-existing inequalities, and doubling down on enforcement. As democratic societies depend on public interventions to mitigate persistent

⁴I'm riffing here off of Todd McGowan's definition of the universal: "The universal is what particulars share not having. The shared absence of the universal rather than the shared possession of it bonds particulars together. . . . Understanding the universal as an absence is the key to thinking about universality outside the context of the murderous regimes that invoked it" (2020: 23–4).
⁵"The citizen-electors' internalization of the human and fiscal costs of war triggers political leaders' internalization of the corresponding electoral costs" (2013: 186).

inequalities, Wendy Brown has demonstrated, social protections have conventionally made "efforts to bring into being a people capable of engaging in modest self-rule, efforts that address ways that social and economic inequalities compromise political equality" (2019: 27) by working to moderate the effects of "otherwise depoliticized stratifications, exclusions, abjections, and inequalities" (2019: 27) caused by markets and the legacies of colonialism. Therefore, Brown continues, "[t]hrottling democracy was fundamental, not incidental, to the broader neoliberal program" (2019: 62).[6] Growing corporatization, financialization, technologization, militarization, and administration have overrun the state with their logics of governance just as colonialism denied the state its connection to those it was supposed to represent. With growing statelessness, the mechanization of war, work, and education; the financialization of governance, decision-making, and social safety nets; the secrecy surrounding campaign donors; and corporate dominance over political parties, security protocols, and political messaging, for example, those in power do not need to address citizens with logical or persuasive argumentation about the rightness or benefits of their agendas. Rather than deliberation, debate, and decision, mechanization requires repairing broken machinery and optimizing efficiencies. As well as worker protections and social safety nets, voting rights are under attack, meaning that politicians and political parties understand their chances of winning future elections as dependent on fewer people voting rather than on appealing to them. The citizen as such alongside the worker is increasingly made obsolete as a referential "hailing" of democratic ideology.[7] With such a severing of the bond between the democratic public and its political representation in the nation-state, politics is experienced through loss, ineffectualness, and precarity.

Spivak's account of Enlightenment's "double bind" is useful to understand today's precarious subject, or the neoliberal citizen detached from democratically established conventions of identification and the institutions and languages that support them. In a "double bind" (a term she borrows from Gregory Bateson), insecurity opens up the possibility of systemic breaks: other democracies—maybe feminist ones—outside security systems. With its feminist inflections, World Literature similarly plays at the limits of national languages and their security in their supposedly universalizable categorical and canonical systems, calling out toward a difference that

[6] "The exceptionally thin version of democracy that neoliberalism tolerates is thus detached from political freedom, political equality, and power sharing by citizens, from legislation aimed at the common good, from any notion of a public interest exceeding protection of individual liberties and security, and from cultures of participation" (Brown, 2019: 62–3).

[7] Achille Mbembe observes, "There are no more workers as such. There are only laboring nomads. If yesterday's drama of the subject was exploitation by capital, the tragedy of the multitude today is that they are unable to be exploited at all. They are abandoned subjects, relegated to the role of a 'superfluous humanity.' Capital hardly needs them anymore to function" (2017: 3).

cannot be represented in those terms. The word "catachresis," for Spivak, refers to this difference: that is, language representation where meaning goes astray from intention: "The political claims over which battles are being fought are to nationhood, sovereignty, citizenship, secularism. Those claims are catachrestic claims in the sense that the so-called adequate narratives of concept-metaphors were supposedly not written in the spaces that have decolonized themselves, but rather in the spaces of the colonizers" (1993: 13). Spivak is not saying that words and concepts developed in Western European languages are devoid of content when applied outside of their original geographical zone, but rather that such language movement registers a distortion, an elision, or an omission (a politics?) that needs to be attended to. In Spivak's rendering, World Literature could become an opening for such catachrestic invention because it represents the national through its displacements. At the catachrestic margins of World Literature, feminism might also mobilize in the fractures of World Literature, standing askew of it as Woolf stood askew of a Europe at the edge of war. Feminism in some sense rides on misappropriations of language use through translations.

Famously, Spivak rejects World Literature as a research field. World Literature, for her, is steeped in an "unacknowledged complicity with the culture of imperialism" (1993: 121) in that it assumes the transparency of language, translating into English or other dominant and European languages of the colonizer as though the original meaning stays intact when the words change: it assimilates and flattens difference in order to "give" accessibility of the colonized to the dominant culture in its own terms. Within World Literature, she says (following Kant), "world is a regulative idea" (2012: 457); it takes on the task of "the securing of security . . . that . . . gave us 'Europe,' the 'United States,' 'the globe'" (2012: 459). World Literature affirms the current organization of world power organized by nation-states and their security systems, a world assuming an equal playing field between "cultures" exchangeable *for* exploitation. A novel or a poem here promises to secure a connection between a national category and its "reality" despite those residing inside the geographical boundaries of nationhood—the others within—who are denied the rights and recognition of belonging to it. For Spivak, the picture of "world" that World Literature assumes through its endless "adding on" of more of the same shares some beneficial Enlightenment and humanistic values like a robust public sphere and the capacities of knowledge to reflect on itself, but its implementation often adopts, rather, an Enlightenment tradition that "came, to colonizer and colonized alike, through colonialism, to support a destructive 'free trade'" (2012: 4).

For Spivak, what is missing from World Literature's perspective is a reaching out to the other. An ethics (but not a Kantian ethics where the individual reflects the all or the universal), such a reaching out would recognize the other's singularity—a "catachresis"—outside of the Enlightenment's representational equivalences. She advocates a philological orientation, the learning of many

languages to the point of fluency in graduate education, especially languages from outside of European, dominant, and imperializing settings. Through careful attention to the intimacies of linguistic associations and concrete usage, and the "imaginative flexibility ... in use for social survival and mobility" (2003: 12), literary study will *supplement* the World Literature presented through its anthologizing collections and survey courses,[8] where each nation, for example, might be designated a representative space (a "module"). The multidimensional, socially layered language that Spivak acknowledges as supplemental is particular to "the singular unverifiability of the literary" (2003: 34), the future without guarantees that looks at us from the eyes of the other. By "supplement," Spivak means that close reading of contextualized literary codes—what she calls aesthetic education—could serve as a "placeholder" (Damrosch/Spivak, 2011: 468) that suspends the representation of equivalence by actively caring for the invisible, contingent, un-inscribable, unequal, and untranslatable difference (what she often calls the "subaltern"). She calls this type of reading "wasteful spending" (Damrosch/Spivak, 2011: 468) because—pointing to a lie in the expected universalism of exchange—it cannot be likened to investment: it does not, for a predictable future settlement (2003: 13), accumulate knowledge by acquiring equitable examples within established institutional spaces, sequences, and "knowable, self-contained 'areas'" (2003: 3) and cannot specify beforehand how such readings will relate to the progress of degrees, departments, curricula, and disciplines.

I am not agreeing or disagreeing here with Spivak's characterization of World Literature. This is a well-trodden critical ground with compelling arguments on all sides. Rather, I want to pause for a minute over Spivak's characterization of World Literature as sharing conceptual space with a democracy and a feminism made precarious in the Enlightenment's "double bind." At the heart of democracy, like at the heart of the Enlightenment, she says, is the "universalizability of the singular" (2012: 4), each concrete individual exchangeable for all (as in Kantian ethics as well as World Literature's mandate to "include" additional national/cultural identities through texts that "represent" these identity categories). Like democracy's reduction of the citizen to abstract equality, World Literature's translations, according to Emily Apter, have a tendency to expose the fault lines in any security system's agreed-upon codes of social understanding, belonging, and relating, by deviating and erring.[9] For Apter, surveillance systems, wiretapping, and GPS tracking are examples of a securitization regime

[8] "[W]e must plumb the forgotten and mandatorily ignored bi-polarity of the social productivity and the social destructiveness of capital and capitalism by affecting the world's subalterns, in places where s/he speaks, unheard, by way of deep language learning, qualitative social sciences, philosophizing into unconditional ethics" (Spivak, 2012: 27).

[9] For example, the consideration of "the logic of grammar, the limits of reference, the outer reach of thinkability or the difference between meaningful and meaningless propositions" (Apter, 2013: 11)—in other words, linguistic contexts, metonymic transfers, localized analogies

that polices untranslatables crossing borders undetected, like undocumented immigrants, contraband, and information, just as World Literature insists on regulating and fixing the borders of translatability as a standard of entry in ways that may block differences by subsuming them in dominant languages and abstract categories that transform them. Here it is apparent that the stake in World Literature is democratic survival—that is, the possibility of accounting for, welcoming, experiencing, and even caring for unaccountable, unauthorized difference. Spivak calls this the ethicopolitical.[10] Aesthetic education will recognize and promote "catachresis," a mode of reading, studying, and imagining that "takes away the absolute of guarantees" (2012: 21) in the Enlightenment's self-identical norms by exposing their partialities. Aesthetic education pushes against the legacy of imperialism with sensory play from below ("ab-use").[11]

Feminism, for Spivak, shares with World Literature the democratic impulse in the Enlightenment's "double bind." Global feminism, as a protest against patriarchy, is institutionalized as "elite, upwardly mobile, generally academic women of the new diaspora [as well as other elites] join[ing] hands with similar women in the so-called developing world to celebrate a new global public or private 'culture' often in the name of the underclass or the rural poor as 'other'" (2012: 100). To build a relation to the other, feminism assumes itself "a 'level playing field'" (2012: 100), where metropolitan feminism can reflect itself in the lives of the underclassed other by "speaking up for diversity" (2012: 102). Such an assumption of universal exchangeability in the name of diversity obscures the precarity of the other, its unaccounted-for difference.[12] In the name of diversity (or categorical expansion), otherness, erring, and deviating are blocked from entry, made invisible. In the "double bind," the universalizing feminist "cannot—no self can—reach the quite other" (2012: 98)—a "woman" *here* (again, like the literary text that refers to "one world" or a national culture or tradition) cannot preordain a shared identity to account for the heterogeneity of "woman" because of an aporia in its pretension to world alliance, its "double bind."

Informed by Gramsci, Spivak's "ethical agenda" (2012: 106) is to care toward difference, that is, what cannot be detected in the feminist instrumentalist coding of "woman" that absorbs the other—to "be open to experience ethics

and associations, epistemological and cultural frameworks, territorial imbrications, social situations, and subjective placements that might not translate.

[10] "[P]eople of our sort make this plea because we cannot do otherwise, because our shared obsession declares that some hope of bringing about the epistemological revolution needed to turn capital around to gendered social justice must still be kept alive against all hope" (Spivak, 2012: 26).

[11] "[T]he style of the Enlightenment is generally recognized to be access to the self-identical, reasonable norm. Can this be historically our role? To make the Enlightenment open to a(n) (ab)-use that makes room for justice, because it takes away the absoluteness of guarantees?" (Spivak, 2012: 21).

[12] Feminism shares this feature with the abstract "economic citizen" (Spivak, 2012: 103).

as the impossible figure of a founding gap, of the quite-other" (2012: 11). The securitization of feminism's world is made insecure by the impossibility of what it references—its internal heterogeneity. As Jane O. Newman summarizes, "the project of world literature begins anew each and every time the 'understanding' historical tradition, period, or reader uses philology to grasp the meaning of the individual 'understood' textual document of *another* historical tradition, period or people, and, in so doing, allows the reader to discern in the text the representation of the 'world' of the 'human condition' that all humanity shares" (2021: 367). Talking about Spivak, she goes on: "'Discontinuous' from any one 'differentiated political space' and thus nonhegemonic," Spivak's World Literature "is 'mysterious' in its ability to transcend hierarchies of ranked difference" (2021: 372). The authors in this volume have found other avenues toward heterogeneity besides deep language learning, like new genres; new forms of mediation, multimedia, and intertextuality; new ways of combining texts toward different analytical possibilities; new visions of sociality; new interpretations of old texts that find meaning in different social and media contexts; interdisciplinarity; rereadings of canonical texts through noncanonical lenses; political frameworks developed in relation to new translations, and the like. World Literature is not here, then, about accessing the pure other as informant, representative, or example of universalism but rather about teasing out the politico-ethical "democratic impulse" (2012: 98) in the "double bind" without guarantees, as well as the feminist one, by combining, uncombining, and recombining to discern the non-heterogeneous inexpressibility prohibited by universality's categories and abstractions. Spivak's is one of the most well-worked-out explications of why World Literature is and must be an always-continuing feminist project constantly in search for a post-Kantian ethical relation to the other as its democratic impulse. Spivak, however, considers the formation of identity markers like "woman" as "depoliticized" (2003: 4) because without guarantees, a "future anterior" (2003: 6) where the future "to come" through reaching toward the other is still undecided.[13] In other words, politics can only be politics through representations, which is why we need ethics.

On one level, we know that this perspective is part and parcel of the deconstruction theory that Spivak adopts, but is deconstruction the whole story? Within deconstruction, representation, including democratic representation, is constituted through its internal aporia pointing to the unpredictable and unintentional, the "not yet" and the "yet to come," and this means that representation is always already open and unstable, without securities. Spivak's point is *not* that Europe's or the West's history does not

[13] "Again, I am not advocating the politization of the discipline. I am advocating a depoliticization of the politics of hostility towards a politics of friendship to come, and thinking of the role of Comparative Literature in such a responsible effort" (Spivak, 2003: 13).

offer useful social ideas, but that any type of securing of the world (as World Literature, democracy, and global feminism perform) projects a type of agency guaranteed for that type of securitization. As an example of a "careful critique of these assumptions [of World Literature] that there are nations, nations based on languages, and therefore based on literatures" (2012: 460), Spivak inserts a brief reference to Hannah Arendt's 1951 analysis of the *politics* of imperialism, *The Origins of Totalitarianism*.

Arendt's historical analysis develops from a reversal, where the exception (or minority) that proves the rule becomes the norm. As is well known, in *Origins* she traces the movement of populations between states and into statelessness due to the rise, in the early twentieth century, of European totalitarian governments which sought to prove "that the affirmations of the democracies [that inalienable human rights existed] were mere prejudice, hypocrisy, and cowardice in the face of the cruel majesty of a new world" (1973: 269). As Spivak specifies, Arendt foregrounds the surge in statelessness as a European crisis that might parallel the crisis of colonialism in Africa and therefore would underscore "the contingency of our assumptions about nations" (2012: 460) and lead us to imagine "the aporetic nature of World Literature" (2012: 460–1). Spivak references Arendt because Arendt's "statelessness" marks a crisis of politics: for Arendt, the rise of "statelessness" in Europe after the First World War ushers in a dismantling of communities that gave social action meaning. Statelessness was, then, an "aporia" or "catachresis" breaking into the organization of the world through nationalities "as the alien which in its all too obvious difference reminds us of the limitations of human activity—which are identical with the limitations of human equality" (Arendt 1973: 301) or, that is, human equality as posited in the terms of the nation-state. Our idea, since Kant's time, of the nation as organizing the totality of modern political relations as well as cultural life forces precarity onto the populations (as well as the languages and ideas) that this idea expels. "The representatives of the great nations," Arendt elaborates, "knew only too well that minorities within nation-states must sooner or later be either assimilated or liquidated" (1973: 273). But Arendt goes further. She insists that the nation-state, in its assumption of an interior homogeneity, was nothing other than a given fiction, while politics, rather, is the community made when human beings "act and change at will" (1973: 301). In citing Arendt, Spivak's aporia points to a world made insecure and precarious through difference, mobility, and the political failure of a world incorrectly represented as given and secured through nation-states and their languages.[14]

[14]The feminist reception of Arendt has been mixed. Most notably, Hanna Pitkin attacked Arendt's reliance on a public-private divide that has traditionally justified the separation of women from politics and public life and relegated the body—as "something shameful to be hidden in private

Even as Arendt's analysis locates the surge in statelessness in the early twentieth century, after the First World War and as the legacy of a fracturing colonialism, Arendt might also, therefore, give us a framework for understanding a contemporary politics (neoliberalism) of state disinvestment from the support systems, infrastructures, and institutions that have at least ideologically promised an even and homogeneous playing field and equal rights as part of the nation-state's democratic project since Arendt's time. The stateless could not be granted the supposed inalienable rights of citizens, according to Arendt, because they fell outside of the representational homogeneity as "minorities." Indeed, Arendt's philosophical project is an attempt to explain a crisis of the political—or a crisis of the lost political—that runs parallel to Spivak's account of World Literature as ethics.[15] For Arendt, the world is not found or given but made by human action; it is not made by humans all at once but is a continual making as yet-unrepresentable newness—or difference—continues to be welcomed within it. The making of the world brings politics into being, because the making of the world is always a taking into account of something surprising, a singularity, otherness, or a new combination of things that has not existed previously, was not caused by the compulsion to repeat existing social or historical organization, and could not have been expected. This we may call: democracy.

darkness" (1981: 337)—to anti-freedom. Many others, however, have interpreted Arendt's public-private divide to be the effect of convention predetermining social roles and read Arendt as thinking, instead, outside of both. Zeynep Gambetti, for example, follows Bonnie Honig in situating both private and public realms for Arendt as sedimenting social meaning in bodies, and the "body ceases to be natural, univocal, and closed to contestation" (2016: 31): "The ethical self would have to be considered as an *effect*, the outcome of a set of unpredictable responses to differential positions opening up as one acts" (2016: 46). Linda Zerilli reads the gendering of the body in Arendt as split between its instrumentalization through biology and work on the one hand and, on the other, a "radical imagination" that is "not bound to the law of causality" because it is "productive and spontaneous, not merely reproductive of what is already known" (2005: 163). Zerilli is here attaching to women's bodies Arendt's formulation of the concept "natality"—or the coming-into-being-in-the-world of something the world has not yet experienced—as the "locus of radical heterogeneity and vitality" (1995: 180) that cannot be determined by known concepts and categories, without precedent. Seyla Benhabib concurs that for Arendt, "the future is radically undetermined" (2012: 40). Mary Dietz, too, agrees that the habitual repetitions of biological function in the private sphere, like habitual repetitions of work more generally, give us an instrumentalized body where "'mere' life overrules everything else" (2002: 112). Arendt is inviting us, rather, toward "freedom from [this] static language of gender identity" by locating freedom instead "in acts of personal speech-revelation" (2002: 131) that cannot be relegated to the public/private divide. In the idea of "natality," Arendt was reading democracy—in opposition to the gendered body in the instrumentalism of its generalized gendered role—similarly to Spivak, as, rather, care for the being-never-before-conceived whose singular story, as the not-yet-told, gives rise to a political relation with the unknown other.
[15] I am disagreeing here with Margaret Canovan's reading of the relationship between *Origin* and Arendt's later work: "The call to respond to what was happening in the real world was constantly at odds with the withdrawal from the world involved in thinking" (1992: 8). I agree more with her when she says, "[W]hen we read her lectures and essays from the early 1950s we can follow her trains of thought and see the organic connection between her reflections on the human condition and her attempt to come to terms with totalitarianism" (1992: 63).

As is well known, Arendt like Spivak attributes a rift between being and politics to the breaking apart of colonialism ultimately leading to the Holocaust. Yet, she also understands this rift to be a split within being as such and within politics as such, theorized by classical philosophers like Plato. In what Arendt calls "the modern age," "reality and human reason have parted company" (1958: 300), and therefore the "relationship between man and world is no longer secure" (1958: 308), making "dwelling" insecure: the absence of a political connection or a point of identification with the social mechanisms of world-making result in "the deprivation of a place in the world which makes opinions significant and actions effective" (1951: 296). This situation becomes fully realized in the advent of technology, when nature is made to conform to numerical arrangements and causalities, and politics becomes automated, determined by the needs of technology. Arendt's philosophy, like Spivak's literary engagements, cannot be said to advocate including the other by adding on others infinitely in the already-recognizable categorical forms of exchangeable global identities, as David Damrosch envisions in the ever-expanding undergraduate classroom of World Literature.

In contrast, for Arendt as for Spivak, storytelling is the coming-together of being and politics through spectatorship, a seeing of the world from the viewpoint of an other, a gathering or sharing of the world with unpredictable others that are not of one's choosing. Arendt writes,

> The disclosure of the "who" through speech, and the setting of a new beginning through action, always falls into an existing web where their immediate consequences can be felt. Together they start a new process which eventually emerges as the unique life story of the newcomer, affecting uniquely the life stories of all those with whom he comes into contact. (1958: 184)

Here, politics is the life story of the unique "who" observed by the other, opposed to the "what" of the secured and objectified identities given in the nation-state system. Unlike for the state, Arendt continues, "[T]he political realm rises directly out of acting together, the 'sharing of words and deeds'" (1958: 198). In this view, World Literature is a democratic project: it must care for the unique unexchangeable story. What both Arendt and Spivak have in common, then, is that they both distinguish democracy as a literary relation: a relation of care for the untold, unpredictable other, unexpected, even wondrous, contrasted to the identities instrumentalized in the world as secured, through violence, in a system of nation-states, its homogenizing through languages, and its self-representation through an extension of commerce and rights, categories and representations.

Today, the categories and concepts that secure the world are similarly wrenching away any sense of belonging. We are currently experiencing yet

another crisis of the nation-state, and it could be said that the proliferation of statelessness and the political marginalization on which colonization was built and secured have now become generalized.[16] Even in rich nations, the nation-state—with its purpose of distributing protections and what Arendt called "a right to have rights" (1973: 296) to balance out the playing field— has proven inadequate in the face of corporatization and financialization that are increasingly taking over the administration of social safety nets, worker safeguards, retirement, healthcare, education, insurance, environmental management, and even military and policing functions that were formerly regulated by public controls. As Achille Mbembe puts it, this new form of sovereignty has, as its central project, "*the generalized instrumentalization of human existence and the material destruction of human bodies and populations*" (2003: 14; original emphasis).

The reason World Literature is feminist is that in it, another possible democracy is born. This democracy would require our awareness of our own vulnerability that, even as we are targeted with violence or deprivation, illness or pollutants, as Judith Butler elaborates, confronts us, as spectators, with our responsibility toward the incomplete other: "I find that my very formation implicates the other in me, that my own foreignness to myself is, paradoxically, the source of my ethical connections with others" (2004: 46). What World Literature gives feminism is an account of its relational subject. As Butler continues, the body is vulnerable and permeable, and, as such, it is a "social phenomenon" demanding a "rethinking of responsibility" (2009: 33) in that it is bound to conditions, institutions, ideas, histories, environments, political investments, and the Symbolic that maintain its livability only through its connections to others. World Literature's alliance with feminism has the potential, as Butler has said, of understanding "precariousness as a shared condition" (2009: 28–9). Democracy could be less about securing a state of the world based on violence, homogeneous rights and identities, legitimizing tactics, and the nation-state in a constant state of emergency, and, instead, about an ethicopolitical relation toward the nonidentical other, with her own aporetic language of difference, whose future, like her present, is made insecure and precarious in its essential politicalness.

* * *

The writers in this volume demonstrate that feminism is not just an "add on" to a world market of literature, another instance of more of

[16] Achille Mbembe writes: "the systematic risks experienced specifically by Black slaves during early capitalism have now become the norm for, or at least the lot of, all subaltern humanity. The emergence of new imperial practices is then tied to the tendency to universalize the Black condition" (2017: 4).

the same, or an "example" that "represents" a certain symbolic product of colonialism called a "nation." Feminism does not approach a World Literature that is already formed and is not just another identity that seeks recognition as a repetition within an already established and categorized literary sphere. Instead, feminism destabilizes World Literature from the perspective of its inherent democratic, ethical impulse. The authors tease out the feminism already inside world-literary texts in its genres (or forms of mediation), strategies, and themes. Genres are forms and shapes that make meaning through authorized conventions, sometimes revealing patterns of social engagement from unauthorized perspectives. Marie Ostby, for example, traces feminism in travelogue, Caren Irr in demodystopias (speculative fiction about population), Debjani Ganguly explores the speculative novel from a feminist eco-political perspective, Debra A. Castillo discovers feminism in Latin American hip-hop, and Katharina N. Piechocki in cartography. Strategies are modes of reading and writing that invite a reordering of accepted social orders and logics. Keya Ganguly, for example, addresses translation, Lisa Ryoko Wakamiya collecting, Jessica Berman recovery, and Mieke Bal the adaptation of male-authored texts into female-centered performances, while Laura Doyle considers intersectionality and inter-imperiality as narrative devices that underscore agency in feminist storytelling, and Hortense J. Spillers indicates how the indeterminacy in intimate family relations informs an openness in the unfolding possibilities for the postcolony. Themes are lines of political interest, content, and contestation that sediment in frameworks for public engagement. World Literature themes acquire urgency, direction, and contradiction through feminist inflections and articulations of otherness, as Karen Thornber considers in relation to environmentalism, Nicole Simek in relation to terrorism, Sarah Afzal in relation to social and cultural reproduction, Valérie K. Orlando in relation to decolonization and independence, I analyze in relation to development and progressivism, and Sofia Iaffa in relation to resistance. I have briefly outlined here each chapter's main manner of reaching out toward an other within World Literature's established or not-so-established canons, media, and institutionalized forms, though this list does not exhaust the topics, methods, and approaches each chapter contributes, nor the many interventions that chapters share with other chapters.

The volume covers a wide geographical range spanning continents and regions while bridging historical moments and thematic content. Yet, the purpose of the volume is not to demonstrate, paternalistically, that underrepresented groups can adapt themselves to the categorical specifications of World Literature. Such a framing would only serve to support a view of World Literature as an extension of the commercial world market, as Marx envisioned it, where World Literature can create sympathetic identifications across cultures and world literatures can

imagine themselves in the dominant mold with an eye to commodification elsewhere. This model would not accommodate the intimate engagements and untranslatable particularities that feminism has identified, traditionally, as the targets of its interventions. Rather, the intention here is to tease out the uncategorizable, the unspoken, and the unintentional, to play inside the unspecified borders of the known and exchangeable world in the hopes that this democratic impulse upsets the happy conformities through which the "one world" concept of imperialist power, now as neoliberalism, seizes its ground.

References

Apter, E. (2013), *Against World Literature: On the Politics of Untranslatability*, London and New York: Verso.

Arendt, H. (1958), *The Human Condition*, Chicago and London: The University of Chicago Press.

Arendt, H. (1973, 1968, 1966, 1958), *The Origins of Totalitarianism. New Edition with Added Prefaces*, San Diego: Harcourt Brace & Company.

Beauvoir, S. de (1980), The Second Sex, trans. H. M. Parshley, New York: Vintage Books.

Benhabib, S. (2012), "Arendt and Adorno: The Elusiveness of the Particular and the Benjaminian Moment," in L. Rensmann and S. Gandesah (eds.), *Arendt and Adorno: Political and Philosophical Investigations*, 31-55, Stanford: Stanford University Press.

Brown, W. (2019), In the Ruins of Neoliberalism: The Rise of Antidemocratic Politics in the West, New York: Columbia University Press.

Butler, J. (2004), *Precarious Life: The Powers of Mourning and Violence*, New York and London: Verso.

Butler, J. (2009), *Frames of War: When Is Life Grievable?* London and New York: Verso.

Canovan, M. (1992), *Hannah Arendt: A Reinterpretation of Her Political Thought*, Cambridge and New York: Cambridge University Press.

Castillo, D. A. (2011), "Gender and Sexuality in World Literature," in T. D'haen, et al., (eds.), *The Routledge Companion to World Literature*, 393-403, New York and London: Routledge.

Chamayou, G. (2013), *A Theory of the Drone*, trans. J. Lloyd, New York and London: The New Press.

Chatterjee, P. (1997), "The Nation and Its Women," in R. Guha (ed.), *The Subaltern Studies Reader 1986-1995*, 240-62, Minneapolis: University of Minnesota Press.

Damrosch, D. (2009), *How to Read World Literature*, Malden and Oxford: Blackwell Wiley.

Damrosch, D. and G. C. Spivak (2011), "Comparative Literature/World Literature: A Discussion with Gayatri Chakravorty Spivak and David Damrosch," *Comparative Literature Studies* 48 (4): 455-85.

Deutscher, P. (2017), *Foucault's Futures: A Critique of Reproductive Reason*, New York: Columbia University Press.

Dietz, M. G. (2002), *Turning Operations: Feminism, Arendt, and Politics*, New York: Routledge.

Gambetti, Z. (2016), "Risking Oneself and One's Identity: Agonism Revisited," in J. Butler, Z. Gambetti, and L. Sabsay (eds.), *Vulnerability in Resistance*, 27-51, Durham and London: Duke University Press.

Jameson, F. (1986), "Third-World Literature in the Era of Multinational Capitalism," *Social Text* 15: 65-88.

Kirkley, L. (2016), "'Original Spirit': Literary Translations and Translational Literature in the Works of Mary Wollstonecraft," in R. Truth Goodman (ed.), *Literature and the Development of Feminist Theory*, 13-26, New York and Cambridge: Cambridge University Press.

Mbembe, A. (2017), *Critique of Black Reason*, trans. L. Dubois, Durham and London: Duke University Press.

Mbembe, A. (2003), "Necropolitics," *Public Culture* 15 (1): 11-40.

McGowan, T. (2020), *Universality and Identity Politics*, New York: Columbia University Press.

Mufti, A. R. (2016), *Forget English!: Orientalisms and World Literatures*, Cambridge, MA: Harvard University Press.

Newman, J. O. (2021), "World Literature," in J. B. Lande and D. Feeney (eds.), *How Literatures Begin: A Global History*, 365-79, Princeton and Oxford: Princeton University Press.

Pitkin, H. F. (1981), "Justice: On Relating Private and Public," *Political Theory* 9 (3): 327-52.

Shih, S. and F. Lionnet (2011), "Introduction: The Creolization of Theory," in F. Lionnet and S. Shih (eds.), *The Creolization of Theory*, Durham and London: Duke University Press.

Spivak, G. C. (2012), *An Aesthetic Education in the Era of Globalization*, Cambridge, MA and London: Harvard University Press.

Spivak, G. C. (2003), *Death of a Discipline*, New York: Columbia University Press.

Spivak, G. C. (1993), *Outside in the Teaching Machine*, New York and London: Routledge.

Standing, G. (2011), *The Precariat: The New Dangerous Class*, New York and London: Bloomsbury.

Woolf, V. (1938), *Three Guineas*, San Diego: Harcourt.

Zerilli, L. M. G. (1995), "The Arendtian Body," in B. Honig (ed.), *Feminist Interpretations of Hannah Arendt*, 167-93, University Park: Pennsylvania State University Press.

Zerilli, L. M. G. (2005), "'We Feel Our Freedom': Imagination and Judgment in the Thought of Hannah Arendt," *Political Theory* 33 (2): 158-88.

PART I

Genres

1

"There Are in Persia Many Subjects Not Accessible to Female Inquiry"

Eurocentric and Cross-Cultural Feminist Nomadism in Lady Mary Sheil's *Glimpses of Life and Manners in Persia* (1856)

Marie Ostby

The deferential introduction to Lady Mary Sheil's travelogue *Glimpses of Life and Manners in Persia* (1856), in which she could not be more overtly aware of trespassing into a man's genre, reads:

> SIR JOHN MALCOLM, Sir John M'Donald, Sir Robert Porter, Mr. Morier, and Mr. Fraser, have nearly exhausted the subject of Persia. The histories, the travels, and the novels of these distinguished writers have made the world acquainted with the literature, the geography, the commerce, and the antiquities of that country. The present volume is simply an attempt to describe the manners and the tone of feeling and society at the present day.

The Notes attached to this volume are written by my husband. There are in Persia many subjects not accessible to female inquiry; yet the absence of all allusion to them, even in a trifling production like this, would render these pages more incomplete than, it may be feared, they actually are. (Sheil 1856: iii)[1]

In these first few sentences, Sheil declares that she is interested in recounting (a) modern Persia,[2] (b) ethnographic observations, (c) personal demeanor, among the Persians, as it reflects (d) political sentiment. With this four-pronged stated mission, the intention of travelogue is split into anthropology and ethnography, on the one hand, and memoir or life writing on the other. For the moment, however, it is a cohesive genre with a relentlessly linear plot. By the mid-nineteenth century, the travelogue genre, as a primary literary site of encounter between cultures, was already a key vessel for what we today categorize as "world literature." In her proto-feminist version of the travelogue, Sheil often aligns herself with the masculinist white supremacy of the British Empire, yet she also sets the stage for gendered intertextual openings that would eventually deepen the genre's capacity for cross-cultural representation.

Travelogues are both introspective and exploratory. Their messy parameters shape them as both intensely private and inevitably public; as a genre, travel writing tends to both reinforce biases and challenge stereotypes. In the case of Iran (then known to imperial Britain as Persia) and the battle to control its representation in English literary culture, this chapter explores the effects of women writers entering the travelogue genre starting with Lady Sheil's text, and asks what their entrance means for the genre's strategic deployment as an imperialist tool. Sheil's combination of reframing imperial perspectives on the one hand and reinforcing ethnic stereotypes on the other sets a precedent for a troubled, paradoxical genre that nonetheless continued to dominate cross-cultural representation into the twentieth century, eventually evolving into new forms from commercial travel guides to traveling memoirs to social media.

Sheil was the first European woman to write about Persia.[3] She traveled together with her husband, Lt. Colonel Justin Sheil, in Persia from 1850 to

[1] All subsequent citations of Lady Sheil are from this text.
[2] The use of "Persia" versus "Iran" to refer to the country in English, and "Persian" versus "Iranian" to refer to its people, language, and culture, has been and continues to be the subject of much scholarly and popular debate (see Ehsan Yarshater, "Communication," in *Iranian Studies* 22.1, 1989 and many subsequent responses). Both terms have ethnic and exclusionary etymologies and connotations. Beginning in 1935, Reza Shah Pahlavi requested that foreign diplomats refer to the country by its endonym "Iran." In the context of Sheil's travelogue, I will refer to the term that she employed, thus "Persia."
[3] See Herbert (1928) Both she and Justin were originally born in Ireland, but served as part of the British mission to Persia.

1852 (she began the trip in 1849 through Poland and Russia). She writes of the traveling party: "We were a cumbrous party, consisting, besides my husband and myself, of three Irish and one French servant, and last, though far from least, our inseparable companion and cherished friend Crab"—a Scottish terrier who died on the return voyage (2). Her travelogue reflects a moment quite distinct from the earliest British travelogues from Persia, beginning with *Travels in Persia, 1627–29* by Thomas Herbert, who inaugurated a long tradition.[4] The end of empire looms just beneath the surface of her text: "There seemed at one moment a prospect that Persia would hold, as friend or foe, a prominent position before the English public" (iii). Unlike in Herbert's day, Sheil was not alone in her realization that the empire was past its prime, and that it would never completely encompass Persia. "This anticipation," she continues, "led first to the production of these pages. Even now the altered aspect of political affairs may not perchance have deprived them of all interest" (iii). This "even now," clinging to the relevance of imperialist ethnography despite the exponential acceleration of globalization, posits the travelogue as potentially strategic and political.

The "Notes" written by Sheil's husband to which she alludes in the passage above comprise almost one-quarter of the total text of her travelogue. They are a long-winded catalog of imperialist machismo—sections include "Afghanistan," "Russian Military Influence in the East," and so on, which include elaborate charts, numbers, and lists—and assume a completely different level of authority than her own cautious, first-person text.[5] The effect is one of trespassing into a man's genre, and Sheil's text audaciously positions her own approach to politics, gender, space, and language as the central text rather than the subtext or paratext. Although Sheil maintains many imperial norms, this reconfiguration is a radical inversion of the European genre, which I will suggest has much to do with the influence of Persian voices, texts, and forms.

[4] Just a few examples include James Morier's *A Journey through Persia, Armenia, and Asia Minor* (1812) and *A Second Journey through Persia, Armenia, and Asia Minor, to Constantinople, between the Years 1810 and 1816* (1818), John Malcolm's *Sketches of Persia* (1827), and Arthur Arnold's *Through Persia by Caravan* (1877). Most of them remain quite patronizing about what they saw as an inscrutable modern kingdom at the crossroads of ancient empires.
[5] Generally speaking, Justin's notes and anecdotes are much more prejudicial than Mary's, less curious and less descriptive of setting, more plot-driven, and purport to deliver authoritative historical and sociological accounts while tying modernization deeply and directly to the British presence in Persia. In Kurdistan, for instance, approaching a group of soldiers upon entering a village, he relates the following with no self-consciousness: "I pounced at once on the artillerymen. I told them they were a low, base-born set of fellows, dogs and sons of dogs, without faith and without honour. Who, I said, half in Turkish, half in Persian—not knowing the former language well—who made you soldiers? Who taught you to fight the Russians? Who got you your pay? Who got you your rations? Was it not the English? How then dare you to treat an English officer in this way?" (319)

In what follows, I argue that Sheil's *Glimpses of Life and Manners in Persia* expands the travelogue genre, refocuses it on a woman traveler's perspective, and ultimately strengthens its potential for cross-cultural insight. She acknowledges the ephemerality of empire, and assumes a unique perspective on Iran as a woman traveler because of her secluded mode of travel, her access to the *andarun* (women's quarters), her focus on nonhuman life including animals and plants, and ultimately her antipastoral redefinition of what "freedom" means for women in terms of speech, religion, and nonreproductive modes of female sociality. She contrasts the women at Naser al-Din Shah's royal court with nomadic women in the countryside, gets emotionally invested in the tragic persecution of the poet and religious leader Tahirih Qorratol'Ayn and her religion of Babism, and hints at a growing embrace of intertextuality and multilingualism that would accelerate the modern porosity of travelogues. In brief moments of unconventional narration regarding gender, religion, and interspecies thinking, I read Sheil's travelogue through the prism of Rosi Braidotti's "feminist nomadism": "the kind of critical consciousness that resists settling into socially coded modes of thought and behavior" (Braidotti 1994: 5).

Sheil's text thus holds larger implications for the genre, which arrived at an inflection point in the hands of women in the mid- to late nineteenth century, showing that the coloniality of the genre was inevitably bound up with its masculinity. While Sheil sometimes replaced that masculine coloniality with new white feminist modes of imperial superciliousness, her travelogue also sometimes reveals glimpses of what would become a more theorized international feminism in the Euro-Iranian travelogues of Vita Sackville-West, Forugh Farrokhzād, and others in the twentieth century.[6]

Despite her massively gendered performance anxiety in the introduction, Sheil steps into the male-dominated travelogue genre because she believes her gender gives her something to add to the cultural diplomacy work of representing Persia to an English audience. The pages would be "more incomplete" without her contribution. The beginning of her first chapter reads:

> A few years ago it fell to my lot to make a journey to Persia, and to reside there nearly four years. At this moment, when public attention is so much directed to the East, I have thought my recollections of the scenes I have visited may not be without interest to a few readers. One

[6] Sackville-West wrote two travelogues from Persia: *Passenger to Teheran* (1926) and *Twelve Days in Persia* (1928). Farrokhzād's 1956 travelogue from Italy is published as "*Dar diyāri digar: khāterāt-e safar-e Orupa / 1335*" (1996), English translation by Farzaneh Milani and Bahiyyih Nakhjavani published online at https://accessingmuslimlives.org/uncategorized/another-time-another-place-memories-of-a-trip-to-europe/ (2020).

advantage I enjoyed over many preceding travellers in Persia. I have been able to see the anderoons or harams of the Shah and some of the principal personages of his Court; and to judge, to a certain extent, with my own eyes, of the condition of women in that portion of the East. (1)

As with that "even now," a sense of perpetual unrest and political uncertainty undergirds her announcement: the awareness that "at this moment, [so much public attention is] directed to the East." This is a shrewdly commercial observation—a precursor to the ever-ready audience for what Farzaneh Milani calls "neo-hostage narratives" in the form of a regular stream of Iranian women's captivity narratives and prison memoirs in the late twentieth and early twenty-first centuries (Milani 2008). Sheil knew that the unknown (particularly the Middle Eastern, Muslim unknown) meant fear, fear meant curiosity, and curiosity meant a market. The particular market gap she seeks to fill is explicitly gendered. She asserts she will take advantage of her female perspective to gain access to interior spaces, framing the whole text in terms of the white woman's voyeuristic complicity in the British imperial gaze—"to judge, to a certain extent, with my own eyes, on the condition of women." On the other hand, Sheil qualifies her project by referring only to "that portion" of "the East" and limiting her perspective "to a certain extent." Alongside her always latent and frequently manifest Orientalism, I read this as the (suppressed and brief) acknowledgment that her own judgment is partial and contingent—in other words, it is a start to opening up the genre beyond its culturally and epistemically violent roots. Her male precursors and contemporaries rarely made such admissions.

In the mid-nineteenth century, Britain and Russia were embroiled in the battle for financial, political, and cultural sway over Persia and its surrounding territories in the multifaceted machinations known as the "Great Game."[7] The anxiety about who would be the great Western superpower to exert both hard and soft power over Persia permeates the pages, especially in the early part of Sheil's travels, as they journey through Eastern Europe and enter Iran from the northwest. "Russia is more cosmopolite than England," she matter-of-factly acknowledges early on (62). She further ponders: "I doubt not that every one felt, at least every one of reflection felt, that a crisis between the two nations was impending" (73).

As the female consort of Justin Sheil, one of Britain's many representatives in this long strategic game, it stands to wonder what role Sheil thought her text might play politically. Sheil constantly contrasts her own insecurity as

[7]Elena Andreeva's *Russia and Iran in the Great Game* (2007) provides a thorough examination of Orientalist representations of Iran by British and Russian travelers, including their respective self-positioning as "European" and their depictions of each other.

an English woman in Persia with the power that comes with being married to a representative of the empire:

> For though, as a woman, I was in Persia every moment reminded by some trifling incident or other of the degraded position of my sex in the East, yet I was content with the reflection of the high estimation in which my husband's name was held; when his word was as valid as the most formal document, and when the name of Englishman was respected from Bushire to the Aras. (168–9)

Here, Justin's name is synonymous with the "name of Englishman," as his word is representative in an official capacity. By contrast, this leaves room for her to convey her observations in a more personal style, ranging from horticultural catalogs to impressionistic sketches of the people around her.

Documenting flowers and vegetation is a consistent pattern in British travelogues from the seventeenth to the twentieth centuries, and Sheil's is no exception. Her interest in species thinking and classification, however, is more disturbing when it extends to her remarks about tribes and ethnicities she encounters. Her racial observations generally fall into a few categories: a favorite trope is to make stereotypical distinctions between people of Persian versus Turkish descent. A few times, she points out Semitic features, an identification that seems deeply tied to her social class and the safety she derives from being in the company of the Qajar elite. "The Kajjars are an eminently handsome race," she writes, "at least the royal family are so—and not the less from the style of features being Israelitish" (116). Her racial purity discourse surfaces again when she describes the "beauty" of women she encounters in Mazarandan, and in the same breath hypothesizes that they must be of Jewish or Israeli descent (264–5). There are a few straightforwardly racist passages, painting with a broad brush the Qajars ("fine, sturdy, determined-looking warriors" with an "atrocious, cold, calculating ferocity" (117)), Turkomans ("marauder[s], and nothing more" with "frightful Mongolian features," especially the women (208)), and Afghans ("evil" but "free"; "only [bad Persians], more false and more venal" (258)), respectively.

In a rare lengthy description of enslaved Africans in Iran,[8] she valorizes "Nubees" and "Habashees" (people with origins in Egypt and Ethiopia, whom she calls "mild, faithful, brave, and intelligent") over "Bambassees" (people with origins in Zanzibar, whom she calls "genuine negroes . . .

[8] The study of enslaved Africans in Iran was largely overlooked until the last decade. Thanks to the work of Beeta Baghoolizadeh (2015), Behnaz Mirzai (2017), Anthony Lee (2015), and Alex Shams (2012), as well as the intersectional multimedia scholarship and activism of the Ajam Media Collective (2011-present) and the Collective for Black Iranians, it has now become a fast-growing area of research.

ferocious, treacherous, and lazy"). She defends the institution of slavery as it was practiced in nineteenth-century Persia:

> It is believed that in general, cruelty, or even harshness, is rarely practised towards slaves in Persia. Their customary treatment is similar to that of the other servants of a family, or even something better. . . . They are never employed as field labourers, their occupations being confined to the duties of the household. . . . Caprice and idleness are unsafe guardians for human beings of an inferior race, when there is no "Times" to denounce and correct the wantonness of power. On the whole, however, the lot of slaves in Persia is perhaps as favourable as that institution will admit of. (243–4)

Beyond the obvious racism of this passage, it can be said to contain some early traces of rights discourse, including the value of the free press as a whistleblowing institution exposing the worst brutality of enslavement. When Sheil writes that "the lot of slaves in Persia is perhaps as favourable as that institution will admit of," one gets the impression that she does not approve of the institution, though she is far from critiquing it.

Scholars of imperial British women travelers' accounts, including Billie Melman, Magda Yeğenoğlu, and others,[9] remind us that gender as an analytical category is always bound up with multiple other factors of positionality and sources of meaning. Yeğenoğlu argues that European women travelers with more direct access to the spaces and lives of Persian women played a crucial role in cementing the gendered and sexualized portrayals of Persia, effectively producing erotic images to please men's Orientalist desires (74). Sheil's status as a woman traveler meant lack of access to the official circuits of diplomacy, but her female perspective also brought advantages. She saw her access to the interior space of the royal *andarun*, or women's quarters, as a crucial contribution the travelogue had to make; as such, there is no question that *Glimpses of Life and Manners in Persia* directly reflects the complicity of European women with Orientalist fantasies.

Unlike some later women travelers, Sheil preferred an imperial bird's-eye view on her surroundings while traveling from city to city: "I preferred remaining in the carriage, from whence I had the advantage of gazing at the wild figures and the novel scene before me" (77). When the party arrives in Tabriz in November 1849, she highlights the limitations of her perspective

[9]To name just a few important works in this prolific subgenre of travelogue criticism: Sara Mills, *Discourses of Difference* (1991); Melman, *Women's Orients* (1995); Anne McClintock, *Imperial Leather* (1995); Yeğenoğlu, *Colonial Fantasies* (1998); Cheryl McEwan, *Gender, Geography, and Empire* (2000); and several intersectional analyses in *Gender, Genre, and Identity in Women's Travel Writing* (2004), edited by Kristi Siegel.

as woman: "I . . . belonging to the inferior and ignoble class of womankind, was excluded, though I was permitted to gaze on the scene at a distance" (86). She describes her own traveling quarters as a luxurious *andarun*, that is, in the exact same terms of sequestration as the Persian women she later begins to befriend; in this "small tent lined with gaily striped silk," she writes, "I could remain in entire seclusion" (81). In acknowledging this gendered seclusion, she echoes her own first-wave feminist perception about lack of women in the public sphere in Persia: "There was everything and everybody, but there was not a single woman" (86). Through the focus on seclusion, much anticipation builds for Sheil's nineteenth-century English audience about the privileged view she will assume once she gains access to the *andarun* and what her interactions with Persian women will reveal.

When Sheil visits the Shah's half-sister—she does not specify which one, but the girl is fifteen years old at the time—her description echoes typical imperialist language: patronizing due to cultural and age difference but pitying due to mutual social class. The girl is "literally covered with diamonds," she writes, but "quiet in her manners and seemed dejected." She describes her as "most anxious to hear about European customs" and concludes: "I felt great compassion for the poor young girl. I do not know what has become of her; but I suppose she is married to some one very inferior to herself in rank and position" (205). This passage stands in contrast to the hostility with which Sheil first approaches nomadic women in the countryside. Inside the royal quarters, her perceived safety and the comfort of being among fellow socioeconomic elites lead not to a more nuanced portrayal of Persian women per se, but a different one—kind of patronizing, not hostile and fearful. Because it is her comfort zone, she uses the latter category to generalize about "Persian women," effectively erasing the experiences of nomadic and rural women. Taking the lives of urban, elite, and sequestered women to be the norm throughout Iran is a pattern that echoes throughout European representations of Persian women for many decades to come. It later receives a challenge from Vita Sackville-West's exclusive focus on the Bakhtiari tribe in her 1928 travelogue *Twelve Days in Persia*.[10]

[10] In embracing a nomadic epistemology, Sackville-West is more specific than Gilles Deleuze and Félix Guattari's sweeping poststructuralist theorization of nomadic cultures ("no habits, no territories"): "Prefer what is positive and multiple, difference over uniformity, flows over unities, mobile arrangements over systems. Believe that what is productive is not sedentary but nomadic" (Deleuze and Guattari 1983: xv). Romanticizing nomadic peoples and cultures by turning them into critical theory is an Orientalist trope for which many major theorists, most famously Deleuze and Guattari, have been rightly critiqued. Sackville-West challenges this romanticization: "The beauty of the pastoral life is largely a literary convention. The truth is that nature is as hard a task-master as civilisation, and that realities, under such conditions, are very bare facts indeed" (Sackville-West 1928a).

Despite her tendency to generalize about the absence of women in public, by the end of her stay in Tehran, Sheil has come to see the *andarun* as a space of freedom, a sharp departure from her male predecessors who fetishized it as the ultimate enclosure. "Bondage, to a certain extent, there may be," she writes, "but seclusion has no existence. Daily experience strengthens an opinion I had formed of the extent of the freedom in which they spend their lives" (212). This attitude is gradually cemented throughout the narrative. Regarding the practice of veiling, she writes: "The complete envelopment of the face and person disguises them effectually from the nearest relatives, and destroying, when convenient, all distinction of rank, gives unrestrained freedom" (145). Sheil here acknowledges that the practice of veiling, far from curtailing speech or rendering women powerless, leads to freedom of movement. She observes matter-of-factly that she "do[es] not think a Persian woman ever feels the same affection for her husband as some Europeans do," while insisting this does not make Persian women "unhappy." This lack of emotion instead makes women able to negotiate for themselves financially, she writes, arguing, for example, that a new rival wife should be offered less allowance (144). Sheil ultimately sees the women's sphere in Persia not as a space of victimization, but as an immensely powerful one: "Power in the anderoon is nearly despotic. An immense deal of cruelty, even murder itself, can be committed in the haram, without any atonement" (147). Of course, this latter passage engages another Orientalist stereotype—that of violent despotism—but it is quite a different one than is frequently associated with institutions such as the harem, *purdah*, or veiling in mainstream Western media today.

As Sheil walks through the Shah's palace toward the women's quarters, murals of women grace the walls:

> Looking glasses covered the walls and ceiling; fresco paintings of damsels of Europe and Persia were interspersed, all scantily attired, but particularly the former, who were invariably represented as if in the fullest, or rather the scantiest, dress, as for a ball. In Persia, the painting of a lady intended to be European is easily distinguishable by her companion, a little dog, under her arm. (116)

What Sheil's gaze fixes on here is an artwork not characterized by gazing outward (occidentalism) or inward (self-Orientalism) but a transnational representation, a mix of European and Persian women, albeit both in terms of objectification and sexualization—and she makes particular note of the representation of the European female guest via nonhuman symbolism. This fresco is striking, not least because animal characters periodically intercede in human cross-cultural interactions in the travelogue.

On November 12, 1849, the party runs into a group of "Shaheesevens," one of the nomadic *elyat*, or tribes, of the Zagros Mountains. A moment of

eye contact between Sheil and a group of women in the tribe is interrupted by commentary on animals:

> According to the general custom of the eelyat women, their faces were uncovered, and they looked with a careless indifference, equal to that of Europeans, at our cavalcade. The only individuals who seemed to think that our party formed an unusual sight, were the donkeys, who invariably stopped and turned round to gaze after the strangers and their novel equipage, showing how much calumniated are their intellect and sagacity. Few, very few among the women, even the most youthful, had any claim to beauty; exposure and severe labour having wholly effaced the delicacy of features which nature intended to be comely. (107)

This strange passage hides a great deal about how the British expected to be viewed in Persia. Sheil lashes out at the "careless indifference" they are shown, linking this indifference to sweeping negative statements about the women's appearance. Disrupting this line of thought, however, is the suggestion that the donkeys are intelligent because of their awareness that the Europeans are an unusual sight. As with the fresco, this animal presence is used to accentuate European otherness. The animal kingdom thus seems to regularly deflect the gaze—both Sheil's and the reader's—and obstruct the possibility of a direct two-way connection between the English and Persian women. Or perhaps it serves to call attention to such moments of potential communication and defamiliarize the scene of the imperial gaze. The presence of the nonhuman might urge us to ask: what are the expectations Sheil places upon herself as an accessory English traveler—to blend in or to stand out, to face admiration or hostility?

Sheil's love of the terrier Crab frames the text and marks her as an European, but also as a woman. Her observations of Crab's interactions with the Persian dogs form an amusing proxy for her own failing interactions with the Persians she encounters: she is sequestered in the *andarun* with the dogs, at first sympathizing with them but eventually perceiving Crab as superior to the Persian dogs and deflecting her imperial superiority complex onto them. "It was really amusing to see the deference these dogs showed poor Crab. Greyhounds, pointers, &c., would fall flat when he sprang at them, if he thought they monopolised too much of my attention" (156-7). The canine references may seem like non sequiturs, but taken together with the focus on gardens, as well as on other animals occasionally mentioned like the donkeys above, the transference onto the nonhuman reverberates through later women's travelogues that connect Britain with Iran, including those of Gertrude Bell and Sackville-West.[11] It is perhaps worth considering

[11] See Bell, *Persian Pictures* (2017, orig. pub. 1894) and Sackville-West, *Passenger to Teheran* (1926) and *Twelve Days in Persia* (1928).

nonhuman companionship as a necessary space in which the travelogue blossoms and extends beyond its masculinist parameters. Women who traveled were expected to exist in specific spaces and consort with specific people, but the genre's multiple modes and affordances[12] seemingly give it a capacity to expand and accommodate encounters beyond those described in diplomatic records or even more conventional autobiographical genres like memoir or diary, which are expected to hew closer to the truth.

As a proto-feminist traveler-narrator, Sheil presents herself not as the feminine steward of the domestic front abroad but as an alternative kind of adventurer, flanked by a nonhuman companion rather than human dependents. At one point in the travelogue, Sheil suddenly states that she is looking for a nurse, but there has been no mention of pregnancy or children in the preceding pages. "Frances" is mentioned by name only three times in the whole travelogue, and entirely without context each time—far less than the narrative space allotted to Crab. In fact, thanks to research by Bahiyyih Nakjavani and Brendan McNamara, we know that Sheil had three children over the course of this travelogue, meaning that she was almost always pregnant or nursing during its composition. Beyond the brief mentions of Frances, the other two are not mentioned at all.[13] This seems like a radical choice for a genre that is otherwise concerned with the domestic and the limitations it placed on women. In fact, throughout the travelogue and across barriers of culture and class, the emphasis on describing women (including herself) is decidedly *not* on motherhood. It is on other forms of sociality: trust and distrust, hospitality, performativity, violence, or animal caretaking.

The last words of Sheil's travelogue are devoted to her trusty canine counterpart, symbolically marking the end of her ability to write about travel with the end of his life: "My joy at returning would have been complete but for the death of our faithful terrier, Crab. I shall not attempt to say how this event embittered everything, for it is uninteresting to all, and by some would not be understood" (300). The event of Crab's death, painfully stressed by the alliterative phrase, is beyond understanding, Sheil insists—a resistance to the claim of fully translating or understanding another that we are perhaps implicitly encouraged to apply to the whole travelogue.

Braidotti's theory of feminist nomadism also centers the importance of nonhuman presences in tracking travel-based accounts of cultural

[12]Caroline Levine (*Forms*, 2015) uses the term *affordances* to denote a literary form's "limited range of potentialities," but adds that "a specific form can be put to use in unexpected ways that expand our general sense of that form's affordances. . . . As they move," Levine continues, "forms bring their limited range of affordances with them" (6, 7, 11).

[13]From Brendan McNamara's "Lady Mary," (2011) an essay on connections between Ireland and the Bahá'í faith (then known as Babism): "Frances was born in April 1850. We now know that the other children born in Persia were Edward, in August 1851, and Mary (Milly) in November 1852." McNamara credits his research to Nakhjavani, who tracked down copies of the baptismal certificates for the three children born in Persia.

difference. "Nomadic thought," she writes, "amounts to a politically invested cartography of the present condition of mobility in a globalized world . . . stress[ing] the fundamental power differential among categories of human and nonhuman travelers or movers" (3–4). As she is a roving presence who is firmly ensconced in class privilege but decentered by her gender and the intrusion of animal life, Sheil's distinctions between urban and rural Persian women also reveal glimpses of a shift in her own Orientalist perspective. Beyond her time in Tehran, the travelogue is organized by tribes and areas, and she takes pains to recognize and emphasize the differences between them. One might call the anti-pastoral (Gifford, 2012) an important figure in Sheil's work. Despite her diplomatic privilege, her writing eventually transitions into a kind of social realism; here, she writes of the impoverished, harsh conditions of the *elyat* with some specificity:

> In England our associations with wanderers in tents are full of romance and ideality; we dream of pastoral life, flocks and herds, and amiable shepherds. . . . The reality is very different. In the mountains near Tehran I often passed close to small eelyat encampments, and I saw enough to cure me of any fancies and dreams I may have formerly cherished. Squalor and dirt were the general characteristics of the inmates of these oolooses, or camps. The women were in rags, haggard and careworn; the children emaciated from want of nourishment. (108)

In this condescending description, it is clear that Sheil's attraction to nomad culture in Persia has a racist undercurrent, aimed at denying Persian culture "civilized" status in the oldest of imperial ways. She echoes her husband's sentiments here in his generically titled note on "Tribes": "The habits engendered by a wandering life, living in communities separated from the ordinary portion of the population . . . are unfavourable to internal tranquillity" (395). There are, however, more thoughts to be found in Sheil's main text about the nomadic and its potential as a space for cross-cultural communication, especially among women.

The garden, a classical trope in Persian poetry of all periods and, in Europe, a stereotypically feminine concern, is not as frequent a focus for Sheil as it is for Sackville-West. There is, however, one rural scene in which she comments on the nexus of domesticity and wildness that the garden represents. On February 1, 1850, she visits a garden maintained by Gebr [Zoroastrian] caretakers. She calls it a "melancholy place of recreation," and a place of respite for the Gebrs, whom she acknowledges "struggle under oppression and bigotry." During their annual migration from Yazd, she explains, "the garden is recognized as their sanctuary and place of refuge, where no hand of violence molests them" (136). It is especially valuable, she writes, to "women of every rank" who "chose to make use of it" (137). This is a brief but notable acknowledgment of a space that is both domestic and transgressive of class, religious, and gender norms, both nomadic and

peaceful. This is not the sort of space described in the travelogues of male British emissaries, since it is outside the bounds of diplomatic utility and seeks a "sanctuary" and "refuge" for minority populations.

Unlike her husband, who only associates nomadism with barbarism among all sorts of tribes in his Notes, Sheil thus sometimes suggests that women find happiness together through thinking of nomadism. The following words attributed to the Shah's mother regarding her favorite fresco on the court's walls are quite explicit in their dream of the nomadic:

> I suppose it reminded her of some of the scenes of her youth: it was an encampment of eelyats in a green plain—goats and sheep were grazing; here and there women were to be seen, some cooking, some carrying water, and milking. "Ali!" said she, "there is a happy life—there is a charming picture." All the women joined with loud approbation in these sentiments. "Yes," said they, "life under a tent, with fine air and good water, and fresh lamb kebabs, is the best of all things." (203)

This pastoral yearning by the Shah's mother, whom Sheil has already portrayed as one of the most powerful women in Persia, suggests a romanticization of her own country that contrasts with Sheil's aforementioned social realism. One might read this as a patronizing implication that Sheil's perspective is superior or that Sheil is seeing Persia as England's past, or simply an indication that perspective is relative and knowledge of another group's lifestyle is always limited.

"Nomadic consciousness," Braidotti writes, "is akin to what Foucault called countermemory; it is a form of resisting assimilation or homologation into dominant ways of representing the self. Feminists—or other critical intellectuals as nomadic subject . . . their memory is activated against the stream; they enact a rebellion of subjugated knowledges" (25). Toward the end of her time in Persia, Sheil moves toward this kind of epistemological rebellion when she emphasizes two types of liberty: freedom of speech and religious freedom. She writes:

> Freedom of speech in Persia is on an equality with freedom of religion. It is the Persian substitute for liberty of the press, and the safety-valve of popular indignation. Every one may say what he likes. (200)[14]
>
> Notwithstanding that the government of Persia is a despotism, there is considerable latitude in the profession of religion in that country; for, however Jews and Christians may suffer from local oppression, neither the maxims of religion, nor of the common law, nor the wishes of the government, sanction their ill-treatment. (196)

[14] She adds, in the spirit of the Great Game: "At least until very recently he could do so; for during latter years more frequent intercourse with the Russian Mission has led to the introduction of some Russian ideas on the subject of liberty of speech" (200).

The conditional structure of Sheil's argument in both these passages—the use of "substitute" and "however"—suggests that she is making an effort to read these types of freedom outside the appearances of them to which she might have been accustomed in England. As for freedom of religion, Sheil was deeply intrigued by the future of Babism, the precursor to the Bahá'í faith, in Persia. Sheil perceived Babism as political from the start: "Under the disguise of a new revelation," she writes, "socialism and communism have made advances in Mazenderan, Yezd, Fars, and Zenjan" (176). She describes mass paranoia about the Babees, followers of this new religion, and extensive punishment including several executions after one of them attempted to assassinate the Shah in August 1852. She makes particular note of—and a feminist connection to—the Babee religious leader and poet Tahirih Qorratol'Ayn, lamenting her untimely death:

> There was still another victim. This was a young woman, the daughter of a moolla in Mazenderan, who, as well as her father, had adopted the tenets of Bāb. The Bābees venerated her as a prophetess; and she was styled the Khooret-ool-eyn, which Arabic words are said to mean, Pupil of the eye. After the Bābee insurrection had been subdued in the above province, she was brought to Tehran and imprisoned, but was well treated. When these executions took place she was strangled. This was a cruel and useless deed. (281)

As described by Milani (1992) and other scholars of Qorratol'Ayn's work, accounts of this event are usually centered on the fact that she unveiled herself during her speech, transgressing both religious and gender norms in a single speech just before she was murdered. Sheil does not mention the veil here, but focuses on the Arabic etymology of her name in order to characterize her status as a visionary in transnational terms. She also plagiarizes her poetry, suddenly inserting into her own prose (in reference to the fortitude of the Bab insurrection in Zenjan): "From street to street—from house to house—from cellar to cellar—they fought without flinching" (181).[15] In ventriloquizing (or paying tribute to?) Qorratol'Ayn without crediting her, the Iranian woman poet is recognized but not yet properly credited in English accounts.

[15] A stanza from one of Qorratol'Ayn's best-known poems reads: "To catch a glimpse of thee / I am wandering like a breeze / From house to house, door to door / Place to place, street to street" (Mehrabi 1989: 1949). This poem also inspired the slogan of the One Million Signatures women's rights campaign in twenty-first-century Iran: "Face to face, street to street" (Khorasani 2008).

The last observation it is crucial to make about Sheil's text is that, unlike the monologic tone of masculinist travelogues, it is suffused with intertextuality in the form of allusions and quotations from many genres, languages, and cultures. Morier and other previous British travelogue writers are frequent, explicitly invoked interlocutors and literal guides. But beyond her own genre, there are many snippets of poetry throughout the travelogue—in both Persian and English, from Saadi to William Cowper. Sheil is committed to showing off her mastery of the Persian language in a literary and idiomatic context, implying she acquired it not just for the purposes of communication and wayfaring. Before she even arrives in Persia, when is leaving Crimea, she recalls a verse from Saadi's *Gulistan*, the first entrance of Persian in the text:

> Fair befall its lovely bowers and radiant halls! May it be safe from the ravages of war, and the presence of the spider and the owl! As I remember having read in my Persian studies–
> "Perdehdaree mee kooned der kasr e kaïsar ankeboot,
> Nowbet mee zaned boom der goombed e Afrasiab."
> "The spider weaves his web in the halls of the Cæsars,
> The owl tolls his knell in the dome of Afrasiab." (32)

The animal kingdom reappears here, and while the insertion of poetry into travelogue is not unique to Sheil as a woman writer in the genre in this period—Arnold, for example, inserts verses by Milton and Hafez in close succession to emphasize the mystique of the road to Qazvin, both quoted in English (150–1)—the intertextuality is more transparent in Sheil. She quotes Persian alongside the English translation to render the importance of multilingualism explicit. In effect, Persian poetry provides her reader with an introduction to Iran that precedes any of her own ethnographic observations.

Sheil's intertexts also extend to the non-literary, as when she details the facts and figures of the slave trade in Circassia and Turkey with a price list for enslaved people of different genders and ages—off-handedly and matter-of-factly. Late in the travelogue, she includes a Persian astronomy chart of solar years, ironically after stating that "Time has no value in Persia" (240–1). Such a disparate, and only occasionally thoughtful, set of intertexts makes it a curious puzzle what role intertextuality writ large ultimately plays in the travelogue. It may be said to confer authority, making the narrator more erudite and, therefore, trustworthy as an intercultural translator. While Sheil's biases and judgments work against her credibility in such a role to the contemporary reader, *Glimpses* was published during the high age of Orientalism as an academic discipline. It is striking that intertextuality, partly resting on her devoted study of the Persian language, is a key device

by which she chooses to convey her adventuresome spirit and ethnographic knowledge, through both closed-minded and open-minded portions of the travelogue. Perhaps the use of other genres within the travelogue in 1849–52 portends its twentieth-century fracture into other genres: life narratives on the one hand and touristic texts on the other.

Ultimately, with this intertextuality, we come full circle to the insistence in Sheil's introduction that her entry into the genre is superfluous or supplemental because of her gender. Ironically, she has wound up expanding the genre and, one might argue, strengthening it, through her new subjects of the *andarun*, the nonhuman, nomadic women, and religious freedom. Sheil, with her frequent focus on sequestration, might even be said to foreshadow an end-stage of the genre when she (retrospectively, from Tabriz) describes her exit from Tehran three weeks earlier, on March 1, 1853, with her "mind full of anxiety and care" (286). It was a difficult journey, especially with snow still covering the mountains, and she writes: "This is one of the most disagreeable circumstances incidental to a residence in Persia. Once established in that country, it is nearly impossible to get out of it" (286). This trope of Iran as a country-wide prison shows up in full force toward the end of the twentieth century, in the form of prison memoirs and "neo-hostage narratives" such as Betty Mahmoody's bestseller *Not Without My Daughter* (1987), a memoir that might be read as a modern travelogue with famous passages that fed decades of American demonization of Iran: "For 18 months, I had been trapped in a country that, to me, had seemed populated almost totally with villains" (334).

Sheil's farewell to Persia clearly indicates that she has grown attached to the place, and her conclusions are riddled with ambivalence and the recognition of difference without dismissing it out of hand:

> Here, then, we bade farewell, a long farewell—that word of gloom—to Iran. The retrospect of my sojourn in that land is mingled with various feelings. It is agreeable now to look back, to have made the journey, and to have resided in a world so different from our own; and, notwithstanding my pleasure at the thought of once more returning to Europe, yet I felt a kind of pang as I returned the salutes of the Mehmendar and his suite, and a sense of loneliness as we pursued our bleak track through Turkish Armenia. (288)

Coupled with the death of Crab, which symbolically closes the nonhuman space of difference and presumably returns her focus to her role as a mother and sedentary British noblewoman back home, this wistfulness is what we might call a wish for feminist nomadism—a yearning for transnational identification that is made possible through stretching the boundaries of the travelogue and potentially opening it up to gendered, multi-perspectival

nuance as British women continue to tell stories about Iran. As a proto-feminist voice in the genre, she both replicates Orientalist conventions produced by the male gaze and encourages readers to look elsewhere, widening their perspective: from human to animal, from sedentary to nomadic, from English to Persian, and ultimately from stereotype to greater nuance in their perceptions of women both at home and abroad.

References

Andreeva, E. (2007), *Russia and Iran in the Great Game: Travelogues and Orientalism*, Abingdon: Routledge.
Arnold, A. (1877), *Through Persia by Caravan*, London: Harper & Brothers.
Baghoolizadeh, B. (2015). "Picturing the Other: Race and Afro-Iranians in Documentary Photography," *Ajam Media Collective*, July 20. Available online: https://ajammc.com/2015/07/20/picturing-them-vs-us-race-and-afro-iranians-in-documentary-photography/ (accessed June 9, 2020).
Bell, G. (2017), *Persian Pictures: From the Mountains to the Sea*, London and New York: Tauris Parke.
Braidotti, R. (1994), *Nomadic Subjects: Embodiment and Sexual Difference in Contemporary Feminist Theory*, New York: Columbia University Press.
Deleuze, G. and F. Guattari (1983), *Anti-Oedipus: Capitalism and Schizophrenia*, Minneapolis: University of Minnesota Press.
Farrokhzād, F. (1996), "Dar diyāri digar: khāterāt-e safar-e Orupa / 1335 [In Another Land: Memories of a Trip to Europe / 1956]," in B. Jalali (ed.), *Jāvadāneh zistan, dar oj māndan: nāmeh-hā, mosāhebeh-hā, maghālat, va khāterāt-e Forugh*, 66–115, Tehran: Morvarid Publications.
Farrokhzād, F. (2020), "Another Time, Another Place: Memories of a Trip to Europe," in F. Milani and B. Nakhjavani (trans.), *Accessing Muslim Lives*. Available online: https://accessingmuslimlives.org/uncategorized/another-time-another-place-memories-of-a-trip-to-europe/ (accessed August 31, 2020).
Gifford, T. (2012), "Pastoral, Anti-Pastoral and Post-Pastoral as Reading Strategies," in S. Slovic (ed.), *Critical Insights: Nature and the Environment*, 42–61, Ipswich: Salem Press.
Herbert, T. (1928), *Travels in Persia, 1627–1629*, ed. W. Foster, Abingdon: Routledge.
Khorasani, N. A. (2008), "The 'One Million Signature Campaign': Face- to- face, Street- to- Street," *The Feminist School*, July 23. Available online: http://www.feministschool.com/english/spip.php?page=print&id_article=205 (accessed August 12, 2020).
Lee, A. (2015), "Half the Household was African: Recovering the Histories of Two African Slaves in Iran," *UCLA Historical Journal* 26 (1): 17–38.
Levine, C. (2015), *Forms: Whole, Rhythm, Hierarchy, Network*, Princeton: Princeton University Press.
Mahmoody, B. (1987), *Not Without My Daughter: The Harrowing True Story of a Mother's Courage*, New York: St. Martin's Press.
Malcolm, J. (1827), *Sketches of Persia*, London: John Murray.

McClintock, A. (1995), *Imperial Leather: Race, Gender, and Sexuality in the Colonial Contest*, Abingdon: Routledge.
McEwan, C. (2000), *Gender, Geography, and Empire: Victorian Women Travellers in Africa*, Abingdon: Routledge.
McNamara, B. (2011), "Lady Mary," *Connections*, March 4. Available online: https://connectionsbmc.wordpress.com/2011/03/04/lady-mary/#fn24 (accessed August 19, 2020).
Mehrabi, M. (1989), *Qorratol'Ayn*, Tehran: Ruyesh.
Melman, B. (1995), *Women's Orients: English Women and the Middle East, 1718-1918*, Basingstoke and London: Palgrave Macmillan.
Milani, F. (1992), *Veils and Words: The Emerging Voices of Iranian Women Writers*, Syracuse: Syracuse University Press.
Milani, F. (2008), "On Women's Captivity in the Islamic World," *Middle East Report* 246, Spring. Available online: https://merip.org/2008/03/on-womens-captivity-in-the-islamic-world/ (accessed March 1, 2016).
Mills, S. (1981), *Discourses of Difference: An Analysis of Women's Travel Writing and Colonialism*, Abingdon: Routledge.
Mirzai, B. A. (2017), *A History of Slavery and Emancipation in Iran, 1800-1929*, Austin: University of Texas Press.
Morier, J. J. (1812), *A Journey through Persia, Armenia, and Asia Minor*, London: Longman, Hurts, Rees, Orme, and Brown.
Morier, J. J. (1818), *A Second Journey through Persia, Armenia, and Asia Minor, to Constantinople, between the years 1810 and 1816*, London: Longman, Hurts, Rees, Orme, and Brown.
Sackville-West, V. (1926), *Passenger to Teheran*, London: Hogarth Press.
Sackville-West, V. (1928a), "The Bakhtiari Road—II," *Country Life*, March 24.
Sackville-West, V. (1928b), *Twelve Days in Persia: An Account of a Journey across the Bakhtiari Mountains of South-Western Persia*, London: Hogarth Press.
Shams, A. et al. (2011–2021), "Ajam Media Collective," Available online: https://ajammc.com/ (accessed June 9, 2020).
Shams, A. (2012), "A 'Persian' Iran?: Challenging the Aryan Myth and Persian Ethnocentrism," *Ajam Media Collective*, May 18. Available online: https://ajammc.com/2012/05/18/a-persian-iran-challenging-the-aryan-myth-and-persian-ethnocentrism/ (accessed June 9, 2020).
Sheil, L. M. L. W. (1856), *Glimpses of Life and Manners in Persia*, London: John Murray.
Siegel, K., ed. (2004), *Gender, Genre, and Identity in Women's Travel Writing*, New York: Peter Lang.
Yarshater, E. (1989), "Communication," *Iranian Studies* 22 (1): 62–5.
Yeğenoğlu, M. (1998), *Colonial Fantasies: Towards a Feminist Reading of Orientalism*, Cambridge: Cambridge University Press.

2

Changing the World of Feminist Demodystopias

Caren Irr

The European dream of *Weltliteratur*, especially that focused on a single novel describing the world and expressing universal human values, has largely fallen out of favor. Franco Moretti (2000), for one, has influentially demonstrated the tight fit between the ambitions for the novel and Western cultural imperialism. Feminist critics such as Robin Truth Goodman (2004) take the argument a step farther, asserting that the individualist values of the imperial north obscure important strains of feminist engagement with the public sphere in the literature of the Global South. How authentically global can the privatized values of the First-World novel be if it excludes those who hold up half the sky, they ask. Rather than contributing to the globalization of a narrow conception of the world novel, then, we can follow Mariano Siskind (2010) and take up the question of the novelization of the global. That is, while seeking out a multinational archive, we can examine the visions of the world articulated in explicitly feminist fiction. In so doing, we can discover what prospects they envision for geopolitical futures in the context of postimperial environmental crisis.

One of the primary forms that second- and third-wave feminist writers have used to imagine the world is the demodystopia. This genre is explicitly concerned with prospects for the human species as a collectivity. More specifically, as coined by Anton Kuijsten (1999) and elaborated by Andreu Domingo (2008), the neologism demodystopia refers to works that concern themselves with the deleterious effects of demographic trends. Commonly, demodystopian fictions bemoan an apparent expansion of the species beyond the carrying capacity of the planet as a whole. They typically project

the future exhaustion of natural resources (especially food), the rise of densely crowded cities governed by authoritarian regimes, the emergence of rigid stratification within and between nations, and an alienated relation to nature. The plot usually takes a reluctant rebel as its protagonist, suggesting the influence of detective fiction on the form.

Influential early demodystopias include H. G. Wells's *When the Sleeper Wakes* (1899), Anthony Burgess's *The Wanting Seed* (1962), Harry Harrison's *Make Room! Make Room* (1966), and Kurt Vonnegut's story "Welcome to the Monkey House" (1968). Each of these narratives explores intense anxieties about an increasing human population, often with more than a tinge of race panic. This racist logic becomes a topic of reflection in important later examples of the genre, although they never overcome it entirely.

Because demographic questions turn on reproduction, demodystopias have been of great interest to feminist writers. Whether formulated in relation to rights, biopolitics, the distribution of labor, social systems, or species, questions surrounding reproduction have been central to feminist discourse, and seizing the means of reproduction has been an important goal (Murphy 2012). Perhaps surprisingly, though, feminist authors tend not to place overpopulation at the heart of their fictions. Instead, they far more frequently imagine an ecologically triggered population collapse followed by government-mandated reproduction and the authoritarian control of fertile bodies. The most influential vision of this future has certainly been Margaret Atwood's *The Handmaid's Tale* (1985). Atwood's dystopia begins with the premise a flourishing population and individual reproductive rights are antitheses. The individual woman exists in an antagonistic relation to events at the level of the planet and population.

In a recent interview with Constance Grady, Margaret Atwood makes this logic explicit (2017). "One thing I do for my characters," she reveals "is I write down the year of their birth, and then I write the months down the side and the years across the top, and that means that I know exactly how old they are when larger things happen." Events determine individual lives and temporality rules.

Notably absent from Atwood's two-factor table, however, is geography. To neutralize geographical and associated cultural differences, the Atwoodian demodystopia tends to be framed by a single bounded space, frequently a nation. The space in question is internally homogenous, suggesting some lingering traces of race panic discourse. With the rise of economic globalization and environmental problems experienced on a planetary scale since the heyday of the Atwood model during the 1990s, however, this racialized national frame exposes some of its limitations. Outlining these inherited generic features and their limits allows us to understand why some new versions of the demodystopia have started to appear.

The City and the Nomad

The form of enclosure that best defines the demodystopia is the walled city. Neomedieval in its implications (Lukes 2014), this figure establishes a strong opposition between a bounded and highly ordered urban space and a wilderness that lies beyond it. The internal consistency of the city results from authoritarian and patriarchal rule. Prescribed roles apply within the city walls, while in the wilderness beyond another more flexible and gender-creative set of norms is available.

The prototype for the walled city is well established in *The Handmaid's Tale*. Set in a near-future Massachusetts, the novel envisions a theocratic society responding to an environmental crisis. The titular Chaucer allusion directs attention both to the orality effect of the cassette tapes from which the narrative is purportedly transcribed and to the sumptuary laws of Gilead's society. Within the rigorously patrolled borders of the nation, the neighborhood, and the house, handmaids wear red, wives wear green, maids wear gray, and so on. The horror at the heart of this order is the ritualized rape of the Handmaid, an act that anchors the novel's universe in the violation of borders. The theocrats use walls to display the hooded and tortured bodies of rebels and transgressors, so that its own violations continue undisturbed inside the fortified city.

The concentric circles that radiate outward from the Handmaid's vagina to the doors of the household, walls of the city, and borders of the nation are all crosscut, however. Atwood's heroine Offred takes as a lover the chauffeur, the man in charge of mobility, and on her supervised walks to the market she makes contact with an underground insurgency that arranges for a flight to Canada. This insurgency uses guerilla tactics, raiding the city rather than laying siege. Its destination is the wilderness of Canada, figured as a free space when it comes to gender roles and reproduction. Nomadic travelers liberate woman enslaved by reproduction within the neomedieval enclosure.

This basic pattern has grounded feminist demodystopias for several decades. Atwood retains them in her 2019 sequel *The Testaments*. Alternating between Aunt Lydia, a covert insurgent operating from within Harvard's walled campus and the sheltered Canadian daughter, the novel traces the daughter's return to Gilead. The narrative toggles between inward and outward movement. From both directions, the energy of the nomad opposes stultifying stasis and spatial rigidity.

Other feminist fictions also use Atwood's model. Hillary Jordan's *When She Woke* (2011), Bina Shah's *Before She Sleeps* (2018), and Jennie Melamed's *Gather the Daughters* (2017) all recycle the walled city motif. Jordan's novel makes particularly direct allusions to *The Handmaid's Tale* while also pulling Atwood's embedded references to *The Scarlet Letter* up to the surface. Beginning with a Hawthorne epigraph and using "The

Scaffold" as the title for its first section, Jordan's novel relocates its punitive theocratic society from New England to Texas, while allowing the redness of Hawthorne's titular letter and the Handmaid's robe to cover the entire body; crimes against reproduction in the novel's world are punished by the injection of a red dye that marks the offender and restricts her social roles. The novel begins with the protagonist awaking to her new skin in prison. Her escapes involve being shuttled from one heavily guarded enclosure to another. As the protagonist heads north, she slowly embraces her newfound nomadism and seeks wilderness. "She was sick of people and the stink and noise they made, clustered in large numbers; sick of cement under her feet and the press of buildings with their rows and rows of windows staring out like blank, lidless eyes," she reflects. "She imagined the many wild places in Canada, vowing to visit them and perhaps even to settle in one of them" (2012: 311). Anti-urban flight is complemented by the waking dream of becoming a nomad in the northern wilderness.

Set in the Green City, the capital of an unnamed nation in Southwest Asia, Shah's *Before She Sleeps* also envisions a near-future society plagued by a virus that has decimated the population. Fertility is so limited that women "were precious resources to be treasured and protected, looked after and provided for, in return for their bodies given to the cause of reproduction" (2018: 23). Fertility drugs and high-risk pregnancies abound. Narrated by outsiders who live literally underground, the novel emphasizes both the containment of exhausted wives and the apparent Jezebels. Like the sex workers in Atwood's novel, the underground women in Shah's provide an officially illicit yet tolerated service to powerful men. They provide the comfort and companionship of a warm body to sleep next to, because sexual relationships outside of marriage are forbidden. The inevitable violation of this norm then initiates an escape sequence as the protagonist flees first the bed chamber, then the underground hideout, and finally a carefully monitored hospital room. Exhilarated by the open road and desert landscapes, she experiences "a towering yellow mass of boiling sand and dust, turning in on itself over and over again, heavy with its own momentum" and making "a deafening noise: the hooves of a thousand angry horses striking the ground at the same time" (2018: 241–2). After this sandstorm passes, the protagonist takes the wheel of the ambulance and bursts through the fence at the national border. Possessed by the spirits of the desert nomads, she gallops through and away from the walled city.

Nomads are even more central in Jennie Melamed's *Gather the Daughters*. Set on an unnamed island, Melamed's novel envisions an isolated fundamentalist patriarchal society. The islanders regularly send scouts (called "wanderers") to scavenge for supplies on the scourge-ridden mainland. This all-male band enjoys special privileges, most notably the privilege of collecting certain items for themselves—medicines, for example, and books. The wanderers govern the island and, like rulers in most

feminist demodystopias, selectively violate its tenets. The nomads found and undermine the settlement.

Gather the Daughters also retains the genre's focus on sexual violence. To allow for sexual release without increasing the population, the retrograde sexual logic of the community allows fathers to sleep with their daughters before they begin to menstruate; this ritualized pederasty also attracts new members to the community. Tactfully kept implicit, the central horror of the society is routinely alluded to without direct discussion; it's "something every woman knows, but doesn't usually say" (2017: 157). Control of reproduction is rooted in a sexual horror that permeates the whole.

Both authorized and spontaneous disruptions crack the walls of the island society Melamed imagines—from seasonal variations to routines of control to exceptional figures of resistance. An anorexic starves herself to stave off puberty, a pregnant teen tries to protect the fetus she carries, and children invent imaginary other islands. Their collective feminist rebellion fails to achieve total transformation of the island society, but it does finally liberate the girl who reads most avidly. The child of a wanderer, she escapes with her family, and the novel ends with her eastward journey toward the mainland.

In these three feminist demodystopias, then, the spatial organization of the fictional world consists of an internally homogenous bounded space and a largely unknown but presumably heterogeneous exterior. Reversing the imagery of fertilization of the ovum by sperm, the bounded space of the dystopian island or city is traversed by nomadic flights moving outward. To resist forced and controlled reproduction, the feminist heroines supercharge forms of dissent that are tolerated but ineffective within the bounded space. Breaking through the barriers, they seek access to a wider set of options without in any way being sure of what that might be. The utopian exterior for these demodystopias is negative; it represents an empty space of exteriority.

As the recruitment of would-be pederasts from the mainland in Melamed's novel reminds us, however, the negative utopia of the exterior contains its own dissenting elements—those that continue to feed the logic of the demodystopia. This important motif suggests not only the resistance to idealization of the exterior in this genre, but it is also a sign of the genre's difficulty with the coexistence of a considerable number of reproductive regimes in the world to which it responds. That is, feminist demodystopias in the Atwood mold consistently depict patriarchal sovereignty over reproduction as a barbaric return to a prior stage of social development. They use neomedieval motifs to associate patriarchy with atavism. In so doing, they close off the option of understanding an uneven cultural geography and foreclose investigation of the uneven combination of reproductive regimes that typify any given society. Positing a nomadic flight from authority as an essential survival act taken by highly literate individuals, they repeat some of the logic of the conquerors of women—imposing a single rationale

for right behavior rather than multiplying the meanings of reproduction. The difference is that while the historical defeat of matriarchy (as social theorists such as Silvia Federici (2004) would have it) sought to eradicate the remnants of the feudal village by imposing capitalist labor discipline, in the feminist demodystopia, the flight from the single story of the city is replaced by the single story of the literate nomad.

Fetishistic Displacements

A second motif of the feminist demodystopia is an intense fascination with figures of excess and displacement. Many of the most inventive moments in this genre arrive during the descriptions of techniques of social regimentation, especially as these apply to those inhabiting the periphery of reproductive processes. Beginning from the premise of demographic collapse rather than exponential growth, in other words, feminist demodystopias envision a flourishing of ideologies of social exclusion and the rise of compensatory fetishistic obsessions.

Maggie Gee's *The Ice People* (1999) draws a particularly direct line from excess to fetishism. Narrated from the point of view of a father in a dystopian London facing an ice age and a fertility crisis, this novel reverses several dystopian tropes. Its concern is not global warming but global cooling, not population growth but decline, not women but men. Similarly, Gee transforms white supremacist ideologies of race and migration. In the cooling climate, having some African ancestry becomes highly advantageous as it allows access to the more environmentally stable nations along the equator. The plot takes up the father's effort to flee to Ghana with his child, leaving behind the increasingly restrictive nanny state managed by his feminist ex-wife. This escape is animated by the father's anti-feminist resentment, a response to the officially excessive or irrelevant role of paternity within the reproductive relationship.

The father who feels himself as a surplus figure in the mother-child relationship experiences a kind of empathetic kinship with "Outsiders, Wanderers, the urban homeless and their rural cousins . . . a great stirring moving base of people with nothing" (1998: 149). These socially internalized nomads are configured as excess, the unstable bottom of a wobbly social pyramid. A strong affiliation between self-pitying fathers and the homeless threatens to unsettle the whole structure. To stabilize the situation, the fetish steps in.

Gee's fathers are obsessed with Doves. Mechanical yet birdlike, warm and cooing, and powered by organic waste, the Doves become love objects and child substitutes. Like "minimessiahs," they convert wasted food scraps into energy, and they fulfill "an essential need, for a small new being to enter our life" (1998: 96–7). Of course, these mechanical babies soon become

ominous—eating up too many life forms and threatening to outdo an infertile humanity by self-replicating. The fetish object menaces the fetishist when it does not simply absorb excess libido but amplifies it. In Gee's brilliant satire, both a feminist (here, Wiccan) separatist maternity and resentful masculinist responses devolve into ineffective vulnerability to the free-range fetish.

Using the demodystopia to satirize a stagnant feminism is also a premise of Ninni Holmqvist's *The Unit* (2009). Translated from Swedish, *The Unit* is set in an unnamed social democracy that prioritizes female self-sufficiency. Guarding against dependence on men is an essential task for women in this world, one where daycare for children is compulsory and gender equality mandated by the state. This independence has a limit, however; in the society Holmqvist imagines, adults without social relationships of care (relationships defined mainly, though not exclusively, by parenting) are required to report to a state-run facility at age fifty. Their reproductive potential apparently depleted, they are subject to medical and psychological testing as well as organ harvesting. The novel begins with the narrator, a writer named Dorrit, arriving at this facility and exploring its offerings. As an isolated and therefore surplus person, she donates ownership of her life to the social whole, much as she gives up the expectation of privacy to perpetual surveillance.

In Holmqvist's take on the excess person, the dominant mood is skeptical anger wrapped around the kinds of panic and despair that seek fetishistic compensation. Presented with a photograph of a family photo, Dorrit studies the demeanor of the eldest child, noting "her open smile . . . [and finding there] a kind of self-confidence, the sense that everything would be okay, the kind of spiritual strength that we only have at that time, when we are five, six, perhaps seven, or which is at its peak then at least; from then on it is destroyed, bit by bit, until it remains only in the forms of shards and fragments" (2009: 107). That is, she locates in the image of the child some of the same elements that she associates with her dog. Because he offers an unmediated and physical relationship in which they "lived side by side body to body, without promises, lies or small talk," the dog exemplifies a unified life for Dorrit (2009: 62). The novel asks why a multispecies relationship does not bear the same weight as a parental relationship in a system prioritizing well-being. After all, many of the same sacrificial elements characterize Dorrit's relationship with the dog as they do her planning for the fetus that she improbably conceives. The dog here is not a sad fetishistic substitution, like the Dove in Gee's novel; it is perhaps the other way around, with a child for a time offering adults access to the joyous confidence of animals. In both cases, though, the person made excessive by the dystopian reproductive regime turns to the fetish.

The thrill of the fetish is the theme driving Johana Sinisalo's *The Core of the Sun* (2016). Set in near-future Finland, Sinisalo's novel also envisions a social democracy gone haywire. In this case, though, a fixation on health

has led to bans on addictive substances from alcohol and tobacco to hot peppers. Bland food is prepared by the bland women also favored by the regime. In a nod to H. G. Wells, Sinisalo's future Finland has established a breeding program that favors eloi, or long-legged blond women who are giggly, superficial, and usually unintelligent. Women who deviate from this pattern are referred to as morlocks; they are worked hard and prevented from marrying and parenting. The novel is narrated by a morlock who physically resembles an eloi. She becomes involved with a cult seeking to breed the hottest pepper in the world.

This pepper fetish has both ecstatic and erotic elements, as the first lines of the novel quickly establish. Meeting a dealer at her sister's gravesite, the morlock tests her product by smearing some on a finger and inserting it into the sensitive membranes of her "lower lips." "First the burn spreads across my lower body," she reports; "my labia and vagina turning hot as glowing embers, then along the edge of my scalp, then down my neck. The blood rushes in my ears. The stuff thrums a dredging bass note, almost an infrasound, with fantastic dark brown tones in its burn" (2016: 4). Radiating symphonically throughout the body, the pepper's capsaicin also intensifies as the novel proceeds. The final flight of the nomad takes off simultaneously on the physical plane (a journey by air) and the metaphysical in a stream-of-consciousness passage adapted from reports made by Chukchi shamans.

From parodic threat to ecstatic salvation, then, the fetishistic substitution for the child made available to excess persons in the demodystopia is a constant element. The genre regularly describes a surplus population that bands together to become first an allowable, incorporated exception and then later an actively rebellious underground network of nomadic escapees. The fetish is the sign that bonds these nomads, introducing physical sensations (radiant warmth, most especially) at odds with the compartmentalizing and striating logic of the regime of reproductive control. Beneath this figure of the fetish, then, is an alternative conception of the body straining to emerge—one that prizes the inarticulate, the tactile, and the labial. Beneath and perhaps beyond the reproductive fixations of the demodystopia lies the throbbing, thrumming body of the other.

Future Readers and Writers

In addition to seeking fetishes and nomads, the protagonist of a feminist demodystopia must be hyperliterate. This nonnegotiable requirement may be satisfied by being an avid reader but preferably she is a writer as well. Here, the demodystopia follows conventions established in the slave narrative (Bernier and Newman 2005). As in its generic prototype, the feminist demodystopia establishes a direct relationship between literacy and liberation; reading ensures resistance to patriarchal control of fertility. As

discussed previously, Melamed's protagonist Vanessa gains knowledge and independence of mind in the library her wanderer father collects. Books are reserved from sufficiently masculine men in Sinisalo's Finland, but the morlock Vera/Vanna manages to smuggle them and hide them below the floorboards in her family farmhouse. Even a literate man will do in a pinch. The historian and narrator of P. D. James's *Children of Men* (1992) reflects from his Oxford home on the blindness to the fertility crisis instilled by nationalism and liberal individualism.

> We thought . . . the fall was deliberate, a result of more liberal attitudes to birth control and abortion, the postponement of pregnancy by professional women pursuing their careers, the wish of families for a higher standard of living. . . . Most of the concern was less about a falling population than about the wish of nations to maintain their own people, their own culture, their own race, to breed sufficient young to maintain their economic structures. (1992: 8)

The novel takes the form of a diary—one of many volumes that the diarist believes will be archived and sealed up for a nonexistent posterity. The skills this narrator acquires as a reader of the past and a chronicler of the present allow him to decode the messages of the secret organization conspiring to confront the centralized authority.

The device of the journal or the final record left by the unusually literate person witnessing social collapse also appears in Shah's Green City, Gee's frame narrative, and Holmqvist's unit. Dorrit wants "to finish writing this—even if it will probably be one of the manuscripts that immediately ends up in some underground passage beneath the Royal Library in Stockholm" (2009: 267). Gee's narrator writes in the firelight surrounded by wild children in the snow; he tells "the story of [his] times. Of the best of days, and the last of days. For whoever may read it. Whoever can read" (1998: 319). Shah's novel climaxes in a bonfire, a conflagration from which only a "tiny memory slip" survives; the slip contains an abused woman's diary (2018: 219). These final books stand in the same relation to a postliterate age that the last strains of youth occupy within a sterile population. Their presumed poignancy is somewhat undercut, however, by the frequency of these visions of a lost library as well as the sheer numerousness of the demodystopia as a genre. The genre sidesteps an explanation for imagining the last book during a period of intense media saturation just as it fends off the oddity of figuring a fertility collapse during a period of exponential population increase.

Perhaps the closest that writers come to exploring this dissonance at the foundation of the genre is the figure of a last book that reproduces itself. This is the case in Octavia Butler's *Parable of the Sower* (1993). Butler's protagonist not only collects a parcel of books as she leads her band of stragglers out of the hellscape of Los Angeles and into the promised land

of rural Mendocino. She also laboriously crafts her own new text, the Earthseed wisdom book. Folded into the conventional diary form, this book within a book becomes the Bible of an intentional community. In the novel's closing scene, remembering the past in the company of a lover whose "hair, beard, and serious expression [made] him look more than a little like an old picture [she] used to have of Frederick Douglass," the heroine leads a ceremony of burial and renewal (1998: 328). Rather than presenting its own text as the sole remnant of a destroyed society, Butler's novel innovates within the genre, depicting the text itself as a seed.

Similarly inventive, Louise Erdrich's foray into demodystopianism, *Future Home of the Living God* (2017), conjures up a novel explanation for a fertility crisis (a reversal of evolution that leaves only women of color able to bear children). This is accompanied by an escalation of digital surveillance by a Christian totalitarian government and the corresponding turn toward handwritten notes and face-to-face communication among rebels. The Ojibwe narrator, Cedar, is well positioned to thrive in this environment, since she is not only a reader of sacred gnostic and Catholic texts but also the editor of a church newsletter. The letter-cum-diary that she writes to the son she bears on Christmas Day resonates with quotations from Hildegard von Bingen, among others: "*I am the flame above the beauty of the fields.... I shine in the waters.... I burn in the sun, the moon, the stars*" (2017: italics in original, 264). As Cedar expires, she witnesses the warming of the earth, and the novel closes not with the disappearance of text but her question: "Where will you be, my darling, the last time it snows on earth?" (2017: 267). The whiteness of snow, not the whiteness of the page, is at risk in Erdrich's world, as Anglo-American civilization devolves. The survival value of literacy, it seems, reaches its limit as environmental themes come more fully into focus.

New Moves, New Voices

Since the late 1980s, feminist demodystopias from North America, northern Europe, and South Asia have recycled a set of several features. Their spatial imaginaries, metaphorics of substitution, and metafictional elements repeatedly mark their participation in the same far-flung conversation. These writings offer retorts to those concerned with increases in the human population—in particular to nationalists reliant on a discourse of race panic—by stressing the authoritarian tendencies underlying population growth initiatives. Feminist demodystopias make freedom of movement, child substitutes, and literacy the markers of anti-nationalist and anti-authoritarian individualism. Often unacknowledged in this genre, though, is uneven appeal of individualisms around the world and within multiracial societies.

A consideration of individualist logic is not foreclosed by the feminist demodystopia, however. Rotating the cube to reveal another face of the same problem, two recent contributions to the genre shift its premises. In *Who Fears Death* (2010) and *The New Wilderness* (2020), Nnedi Okorafor and Diane Cook write from the perspective of the nomad from the outset, rather than tracing the conversion into a nomad of the person dwelling inside the walled city. They also dive more deeply into the logic of the fetish, placing it in an animist logic of vitality rather than a psychoanalytic logic of displacement. And, finally, both authors dissolve the authority of the book, seeking instead the legibility of the physical world. Without in any way lessening the genre's abhorrence for sexual violence, these new twists on the feminist demodystopia manage a fusion of the questions of cultural survival and bodily autonomy. They do so in large part by shifting the center of the narrative toward minority populations under assault.

Inspired by a 2004 newspaper article about racially motivated rape in Sudan, *Who Fears Death* takes place in a dateless future when computers and cellphones are largely obsolete, pushed to the back of caves and left to molder. Everyday life is suffused with magic and ritual, and the eponymous heroine learns after her circumcision that she has the makings of a sorcerer. Her status as a biracial child of rape and the years she spent roaming the desert as a nomad with her mother made her unusual, but her ability to change her form and fight the light-skinned slavers seal her status as a culture-hero. As she prepares for her final confrontation with the evil sorcerer who is her father, the heroine Onyesonwu becomes more mobile—flying with a *Kponyungo*, "a giant lizard of heat and light"; they pass over the desert to "a forest, a true vast forest" populated with furry beasts and rich humid exhalations (2010: 285–6, 287). Her world regularly expands and contracts in this manner, roaming across several dimensions of the physical and metaphysical universe. She is inherently nomadic throughout and strengthened by her ability to draw knowledge from one register into another.

In Okorafor's novel, the pain inflicted on women through circumcision and rape features prominently, as does an overcoming of limits to women's education—here, education in sorcery. The feminist attitudes are clear, and the use of rape as a brutally authoritarian type of reproduction lies at the center of the story. The horror is experienced, however, from the child's point of view, not the mother's. Being rather than having the fetish is the starting point of the novel. As a being invested with magical abilities, Onwesonyu does battle with her father in the spirit world. In the process, he writes on her, poisoning her with a symbol that another sorcerer can only remove with still more magical writing. Ting "turned my palm up and began to draw near the symbol.... It quivered, coiled, and moved slowly away from her drawings. It was disgusting. But there was nowhere for it to escape. As the drawings closed in around it, it began to fade. Every surface

of my hand was covered" (2010: 302–3). One magical writing surrounds and neutralizes the other, as the body becomes the book. Onyesonwu's own body has been conceived in magic and violence, and it is the site of more of the same. She is replete with symbols and does not need to displace her longings elsewhere. She is the fetish herself and not a fetishizer requiring a child or child-substitute for completion.

Onyesonwu's symbol-rich body is also, of course, a text—one that disproves in its very being the worldview of the Great Book, the novel's composite holy book. This last remaining book supposedly legitimates the domination of dark-skinned people by their light-skinned neighbors, but it is also interpreted differently by the faithful who "pray five times a day, love the Great Book, and are pious people" (2010: 374). With the aid of such a person, in the final passages of the novel, Onyesonwu locates another magical text and drips the symbols inscribed on her hand into it. "I could feel the book sucking from me, as a child does from its mother's breast. Taking and taking, I felt something click within my womb," she observes (2010: 377). The book becomes a baby and confirms another pregnancy. The book here is means of liberation from reproduction but rather a mystical means of confirming conception. With these crucial scenes, Okorafor turns the figures of the feminist demodystopia in a new direction, exploring genocidal projects of domination as a form of writing bodies into being and also imagining writing as a way of literally conceiving a new life.

For some readers, Okorafor's generous intermingling of dystopian fiction with fantasy motifs (shape-changing, sorcery, and the supernatural) may veer a bit too far from generic conventions. No such risk arises in Diane Cook's *The New Wilderness*. Thickly descriptive and realist in mood, Cook's novel gradually reveals its concept. The action occurs in a nature reserve bounded by a sickly urban society. On the reserve, a team of volunteers, adults and children, participate in a research project under the supervision of rangers. According to the rules of the project, they must remain nomadic and leave no waste. They feed themselves from the land, hunting and foraging, and have little contact with the world beyond the reserve. "They were limited to seven days in one place as stated in the Manual," the protagonist of the first section reflects, "but they almost never followed this. It was hard to start moving once they stopped" (27). In other words, nomadic flight from a failing city is not a solution in this novel; it is the opening to another sort of dystopia, one shot through with problems circulating around the child.

Not only does Cook's novel begin with a miscarriage occurring in the wilderness; its events are also incited by the same woman's desire to protect her daughter. Plagued by respiratory illnesses, the daughter, Agnes, ultimately thrives in the wilderness, even after her mother suddenly leaves at the news of her own mother's death. When the narration shifts from mother to child, the figure of the child also ceases to be a fetish object to be protected or buried. Adolescent Agnes matures into an adult capable of

taking responsibility for a child. She flees from rangers with a youngster and "thought of her as [her] daughter" (2020: 389). The child in this scenario is not a possession who conveys social power to the parents, as in fetishistic interpretations. Instead, in this chain of mothers and daughters, the key figures are mother and child simultaneously. The "child" is a grammatical shifter, not a fixed fetish.

The grammar of reproduction need not be written. The little bits of writing are all subject to being misplaced, rendered illegible by water damage, or rerouted to distant locations. Writing is vulnerable and dangerous; even a single letter can rupture the community. Notably, when opening delayed mail, Agnes's mother experiences shock and dissociation: "her heat stopped for a moment. Her burning cheeks turned icy" (2020: 133). With vengeful words, she tears herself from her family and community, all as a result of reading.

By contrast, oral storytelling is a tool of connection. The novel ends with Agnes reciting "The Ballad of Fern" to her would-be daughter. She passes on her knowledge orally, and much of what she knows involves reading the signs of the wilderness rather than those inscribed on the page. Agnes is, after all, a tracker. She scampers, "certain of the ruts beneath her feet. She saw them the way an owl might see a mouse under a covering of leaves or a sheet of snow. . . . She knew this was a good way to go because, for all its imposing darkness, she had seen the glint from animal eyes" (2020: 151). Agnes reads the land, picking up cues and learning lessons from her observations, noting when something exceptional arises and when she can feel safe. Learning to feel this legibility of the natural world through the mechanism of a novel is an irony that magnifies the themes of the novel. Cook's world is overly civilized and alienated; the dystopia encloses the traces of a utopia, not vice versa. In this same spirit of reversal, the new wilderness of the title, we learn in the Epilogue, refers not to the reserve where most of the action has taken place as one might expect but rather to the rectilinear cement world that finally captures Agnes and Fern. The nomads flee across a border only to be captured in an even worse dystopia. In case the reader had not intuited the relevant worldview, the author's final note acknowledges "the Northern Paiute, Shoshone, Ute, Klamath, Modoc, Molala, Bannock, and Washoe tribes whose ancestral lands provided inspiration for where these characters lived and walked (2020: 397). Taking the point of view of indigenous peoples of the North American Great Basin, Cook's novel documents through writing the damage inflicted on nomadic oral cultures.

To shift the terms of the feminist demodystopia, Okorafor and Cook wed questions of population growth and collapse to settlement, invasion, race, and warfare as well as to gender authoritarianism. Presenting the threat of genocidal extinction from the point of view of a population literally under assault transforms the gratuitous panic of the white nationalist into

a different sort of demographic dystopia, one responsive to environmental crisis and open to new sites and themes. These creative new twists signal the vitality of the form and the creativity of feminisms capable of looking past individualist premises and toward a world in which multiple reproductive ideals coexist alongside multispecies relationships and varying forms of literacy. Immersing ourselves in these changing worlds as they are envisioned from several sites around the globe expands our vision of feminist futures.

References

Atwood, M. (1985), *The Handmaid's Tale*, Toronto: McClelland and Stewart.
Atwood, M. (2019), *The Testaments*, New York: Nan Talese.
Bernier, C.-M. and J. Newman (2005), "*The Bondwoman's Narrative*: Text, Paratext, Intertext and Hypertext," *Journal of American Studies* 39 (2): 147–165.
Burgess, A. (1962), *The Wanting Seed*, London: Heineman.
Butler, O. (1993), *Parable of the Sower*, New York: Seven Stories.
Cook, D. (2020), *The New Wilderness*, New York: HarperCollins.
Domingo, A. (2008), "'Demodystopias': Prospects of Demographic Hell," *Population and Development Review* 34 (4): 725–45.
Erdrich, L. (2017), *Future Home of the Living God*, New York: Harper Collins.
Federici, S. (2004), *Caliban and the Witch: Women, the Body and Primitive Accumulation*, New York: Autonomia.
Gee, M. (1998), *The Ice People*, London: Telegram.
Goodman, R. T. (2004), *World, Class, Women: World Literature, Globalization and Feminism*, New York: Routledge.
Grady, C. (2017), "Margaret Atwood on the Utopias Hiding Inside Her Dystopias and Why There is No 'The Future,'" *Vox*. Available online: https://www.vox.com/culture/2017/6/9/15758812/margaret-atwood-interview (accessed January 15, 2021).
Harrison, H. (1966), *Make Room! Make Room!* New York: Doubleday.
Holmqvist, N. (2009), *The Unit*, trans. Marlaine Delargy, New York: Other.
James, P. D. (1992), *The Children of Men*, New York: Vintage.
Jordan, H. (2011), *When She Woke*, Chapel Hill, NC: Algonquin.
Kuijsten, A. (1999), "Demografiction," in A. Kuijsten, H. de Gans, and H. de Feijter (eds.), *The Joy of Demography and Other Disciplines: Essays in Honour of Dirk van de Kaa*, 83–102, Amsterdam: Thela Thesis.
Lukes, D. (2014), "Neomedievalist Feminist Dystopias," *Postmedieval: A Journal of Medieval Cultural Studies* 5 (1): 44–56.
Melamed, J. (2017), *Gather the Daughters*, New York: Little Brown.
Moretti, F. (2000), "Conjectures on World Literature," *New Left Review* 1 (1): 54–67.
Murphy, M. (2012), *Seizing the Means of Reproduction: Entanglements of Feminism, Heaalth, and Technoscience*, Durham: Duke.
Okorafor, N. (2010), *Who Fears Death*, New York: DAW.
Shah, B. (2018), *Before She Sleeps*, Santa Monica, CA: Delphinium.

Sinisalo, J. (2016), *The Core of the Sun*, trans. L. Rogers, New York: Grove.
Siskind, M. (2010), "The Globalization of the Novel and the Novelization of the Global: A Critique of World Literature," *Comparative Literature* 62 (40): 336–360.
Vonnegut, K. (1968), "Welcome to the Monkey House," in *Welcome to the Monkey House*, New York: Delacourt.
Wells, H. G. (1899), *When the Sleeper Wakes*, New York: Harper & Bros.

3

The Speculative Mode in Feminist World Literature

Debjani Ganguly

Octavia Butler on Mars

The Perseverance Rover landed on Mars on February 18, 2021. On March 5, 2021, NASA named the Perseverance landing site inside Jezero Crater after Octavia E. Butler, the celebrated writer of science fiction and also the first African American woman novelist to win both the Hugo and Nebula awards for science fiction. In her commendation address, Katie Stack Morgan, Perseverance project scientist at NASA's Jet Propulsion Laboratory in Pasadena, notes: "Butler's pioneering work explores themes of race, gender equality in humanity, centering on the experiences of Black women at a time when such voices were largely absent from science fiction." Butler's protagonists, Morgan continues, "embod[y] determination and inventiveness, making her a perfect fit for the Perseverance rover mission and its theme of overcoming challenges" (Howell 2021: n.p).

While Butler's fiction is not exactly in tune with NASA's quasi-military mission to push planetary frontiers, the fictional encounters with planetary aliens that her novels stage offer an opening to reflect on the relationship between World Literature, feminist speculative fiction, and speculative modes of writing in feminist science studies and philosophy. This is the task my chapter undertakes. Broadly encompassing genres of fantasy, science fiction, horror, and alternative history, speculative fiction stages thought-experiments by creating counter-factual worlds that encompass magic, space or time travel, and alter-historical realities. In the past three decades, there has been a proliferation of speculative fictional works from Africa, Latin America, South Asia, and the Asia Pacific that figure

alternative futures for peoples oppressed by centuries-long colonialisms. The rapid proliferation of digital technology and the accelerating effects of anthropogenic climate change have given a new edge to this body of fiction. One can broadly conceive of speculative fiction as a literary form and a mode of world-making that captures cataclysmic shifts in human and nonhuman worlds that can no longer be comprehended by social, political, and moral frameworks of our recent past and present. Historically, World Literature has not had much traction with speculative fiction. The latter typically falls under the category of genre fiction in most market-driven understandings of the field and scarcely feature in scholarly debates about World Literature. This is beginning to change as the World Literature confronts the planetary turn in the humanities (Heise 2016; Wenzel 2020; Ganguly 2020).

Toward the end of the twentieth century, scholars positioned World Literature as a mode of literary engagement uniquely suited to our global, vastly mixed, culturally interactive, and digitally connected age. The idea of *world*, however, has long been part of the literary consciousness of many cultures. It has been variously understood as cosmos, as an ecumenical horizon that universalizes the human condition, as an orientation to imaginaries beyond one's immediate space and time, and even as a will to power that seeks to globally disseminate values originating in a particular tradition. In its periodic invocations through history, the value of World Literature has variously been perceived as a measure of enhanced cultural diversity, as a mode of cultural exchange, as a timeless repository of classic works, as an antidote to nationalist chauvinism, as an aspiration to a cosmopolitan public sphere, as a civilizational alibi for colonial expansion, as a civilizational force against colonialism, as a symptom of cultural anxiety, and even occasionally, a necessary philological enterprise in the face of impending political and cultural catastrophe.

Throughout modern history, the idea of World Literature has emerged alongside geopolitical crises, wars, and revolutionary social movements. The Napoleonic Wars for Goethe, the 1848 European revolutionary upheavals for Marx, the colonial partition of Bengal for Tagore, the Spanish Civil War for Neruda and WH Auden, Nazi-era Europe for Auerbach, and the Israel-Palestine conflict for Said are well-known instances. The turbulent geopolitics after 1989 is no less responsible for the contemporary revival of World Literature. This revival has as its geopolitical backdrop the end of the Cold War, the proliferation of global conflicts and civil wars, the end of apartheid in South Africa, genocides in Bosnia and Rwanda, the spectacular catastrophe of 9/11, the ongoing wars in Afghanistan and Iraq, and the violent ravaging of the Middle East by the conjoined interests of the global power elites and fundamentalisms of various hues. Geopolitical upheavals have frequently given rise to discourses on cosmopolitanism and universal belonging, and the power of literature has been harnessed for progressive

movements throughout the twentieth century. Scholars in recent years have tracked the rise of literary networks in the era of what they call Bandung Internationalism, a postwar and postcolonial period of active Afro-Asian solidarity that pushed against the Cold War polarization of the world. No less significant is the field of literature and human rights that confronts the plight of millions of displaced people around the world and that addresses the impact of war and genocide in our time.

The single most significant world-making and globally transformative phenomenon in our time is the impending climate catastrophe. This has brought into the remit of the humanities deep insights from the life sciences and earth systems science (ESS) that help us grasp the impact of human history on the natural world and our planetary system. This century has seen books previously relegated to the realm of science fiction or speculative literature gain mainstream attention as we contemplate the world in terms of planetary webs of life. Eugene Thacker's philosophical tract *In the Dust of This Planet* (2011) is pertinent here for it explores the power of supernatural horror in grasping the cascading climatological and geological disasters of our era. Thacker identifies three forms of world-making that impinge on each other today: world-for-us (the humanist realm), world-in-itself (the earth with its myriad lifeforms), and world-without-us (the planet). He conceives this last, in both speculative and spectral terms, as something that haunts us as even as it inhabits a zone of speculative fabulation. The world-without-us, notes Thacker, lies "in a nebulous zone that is at once impersonal and horrific . . . [it is] a dark intelligible abyss that is paradoxically manifest as the World and the Earth" (Thacker 2011: 6, 8). Such a perspective invites us to confront not only the nonhuman foundations of life on earth, but also the radical alterity of earth as a planet that existed before us and will last beyond our species.

My primary argument as we attend to these insights is that feminist philosophers of science like Donna Haraway and speculative fiction writers like Octavia Butler were pioneers in thinking about planetary world-making and human-nonhuman relations much before the current global awareness of climate change generated an avalanche of humanistic scholarship on the entangled worlds of the industrial capitalism, the cybernetic revolution, globalization, and biosphere depletion. Decades ago, Haraway drew our attention to the "inextricable weave of the organic, technical, textual, mythic, economic and political threads that make up *the flesh of the world*." This weave, in her view, makes words like *individual* and *collective* "fall into the trash heap of pallid metaphors and bad ontology" (Haraway, 1985, 1995: xviii). Octavia Butler's pioneering science fiction from the 1970s onward has plumbed histories of Black and feminist liberatory movements to shatter the myth of bounded, individuated, propertied selves—a myth that has for centuries relegated women and Black people to the realm of nature destined to be exploited. Butler's extra-terrestrial worlds are not sites

of conquest by humankind but rather zones of serendipitous interspecies mixing, gene trading, and cyborgian intimacies. In what follows, I attend to this prior history and trace its flowering in the work of contemporary feminist materialist thinkers like Jane Bennett and Karen Barad. Woven into my chapter is a reading of Octavia Butler's *Xenogenesis* trilogy and the Zambian writer Namwalli Serpell's speculative novel, *The Old Drift*.

Earthbound: Feminist Materialisms

Much before contemporary iterations of World Literature emerged in the wake of globalization discourses of the post-Cold War era, the first space photos of *Earthrise* sent from Apollo 8 in 1968 and of the earth as *Blue Marble* in 1972 generated a plethora of philosophical and scientific literature on world-making and the terrestrial limits of life on earth. The world, the globe, and the planet featured in an oscillating continuum of ideas about human habitability. Hannah Arendt's anxious reflections on the Sputnik moment in *The Human Condition* are legion. She characterizes the momentous first step "toward escape from men's imprisonment to the earth" as a "fateful repudiation of an Earth who was the Mother of all living creatures" (Arendt 1958: 1). Arendt sees the world as distinct from planet earth. The *world* for her resides in an immanent zone between the extreme privations of human subjectivity and what she calls "the sublime indifference of untouched nature" (Arendt 1958: 137). It is the realm of moral and political flourishing. The Heideggerian strain in Arendt's philosophical reflections on world-making is evident here. Technology objectifies the world—enables a world-picture to emerge—while humans *make* worlds through their labor and creativity. Arendt's conception of worlding is deeply humanist. It precludes human coexistence with other life forms.

Around the same period—that is, the rise of space-age technology that enabled the imagistic circulation of *Earthrise* and the *Blue Marble*—feminist philosophers of science and evolutionary biologists were beginning to propose theories of interdependency and relationality with other life forms. Their work repudiated the aggressive *telos* culminating in the figure of "man in space" untethered from all forms of earthly dependency, what Donna Haraway in her celebrated *The Cyborg Manifesto* calls the "escalating dominations of abstract individuation" (Haraway 2016: 8). Space photos of our vibrant blue planet inspired the American evolutionary biologist, Lynn Margulis, and the British chemist, James Lovelock, to propose their Gaia theory of earth. "The notion of the biosphere as an active adaptive control system able to maintain the Earth in homeostasis we are calling the 'Gaia hypothesis,'" wrote Lovelock and Margulis (1974: 2). Gaia conceives of our planet as an interdependent, interlocked, and multileveled system that is self-regulating; a system that works optimally due to its autopoietic processes.

Donna Haraway enhances the power of the term *autopoiesis* by adding to it another term, *sympoiesis*, or what she calls "making-with." She writes, "Nothing makes itself; nothing is really auto-poietic or self-organizing. . . . That is the radical implication of sympoiesis. Sympoiesis is a word proper to complex, dynamic, responsive, situated, historical systems. It is a word for *worlding*" (Haraway 2017: M25). A speculative fabulation of such worlding can be found in Haraway's Camille Stories. Appearing at the end of her book *Staying with the Trouble*, the stories feature five generations of human-animal symbionts named Camille between the years 2025 and 2425. The first Camille is born in symbiosis with a monarch butterfly. These are stories of hope not doom. They abjure human exceptionalism and signal multispecies futures as they contemplate our damaged planet. The Camilles, in the words of Haraway, "work with human and nonhuman partners to heal these places, building networks, pathways, nodes, and webs of and for a newly habitable world" (Haraway 2016: 137).

The inspiration for Haraway's idea of *sympoietic* worlding is a breakthrough in evolutionary biology by the feminist scientist, Lynn Margulis. Margulis's endosymbiotic theory of evolution challenges the neo-Darwinian paradigm of competition among species and the survival of the fittest. Cellular evolution, according to Margulis, occurred billions of years ago through a process of symbiotic incorporation of bacterial life forms. The origins of cellular life with a nucleus at the center (eukaroytes) lie in a process called mitosis where three fundamental organelles—mitochondria, plastids, and flagella—that previously existed as free-living, non-nucleated, and sub-cellular entities, fused together to create multicellular organisms.[1] The three organelles themselves owe their origins to bacterial clades called proteobacteria and cyanobacteria. When Margulis's theory of endosymbiosis was first published in 1967 under her married name Lynn Sagan, it was treated by the biology establishment with great skepticism.[2] Subsequent experiments in the late 1970s confirmed her hypothesis of the bacterial origins of all life. All forms of speciation can be traced to bacterial ancestors. Traces of these bacterial ancestors can be found in our DNA. Endosymbiosis "challenges the belief that *Homo Sapiens* stands at the pinnacle of evolution . . . the human species partakes of the vaster molecular ecology of the lowest cellular bodies: bacteria" (Parisi 2007: 32). The individual, in such a reading, is "a constrained accident, not the highest fruit of earth history's labors" (Haraway 1991: 220). Significantly, in the organelle called mitochondria, the inheritance is through the maternal line. In brief, cooperation rather

[1] Mitosis is a process by which a nonreproductive cell divides into two genetically identical cells, thus passing all of its genetic information to its newly created progeny.
[2] Lynn Sagan, "On the Origin of Mitosing Cells," *Journal of Theoretical Biology*, 1967.

than competition constitutes the deep structure of life. Individuality through incorporation inaugurates a feminized selfhood (Bollinger 2010).

Margulis's endosymbiotic theory of evolution has transformed feminist science studies and given a boost to feminist new materialisms that celebrate the vibrancy of matter and nonhuman species. The ontological fallout of the nonhuman referent in the constitution of Homo sapiens has been spelt out by feminist historians of science, Giffney and Hird, in these terms:

> Recognizing the trace of the nonhuman in every figuration of the Human also means being cognizant of the exclusive and excluding economy of discourses relating to what it means to be, live, act or occupy the category of the Human. This has real material effects. For every "livable life" and "grievable death" ... there are a litany of unmentionable, unassimilable Others melting into the space of the nonhuman. (2008: 2–3)

The gendered topology of Western philosophical traditions that relegates women to the realm of the earthbound—as matter, as primitive and abundant nature, as nonhuman—is here re-constellated as the foundation and engine of all life. New materialism perceives the nonhuman world—animals and things; all organic and nonorganic matter—as already animated and active in the world. Latour, who coined the term *earthbound* to counter the perspectival advantage accorded to the transcendent Human, replaces the idea of human agency with the term *actant*—the source and capacity for action that inheres in both human and nonhuman entities. To be earthbound is to be part of a coalition of planetary stewards composed of human and nonhuman entities intent on restoring the planet's balance (Latour 2017). It embodies a *sympoietic* ethos—a being-with the earth. Vital materialism is another name for this *sympoietic* turn, and its primary advocate is the feminist political philosopher, Jane Bennett. Bennett deploys the term *vibrant matter* to refer to "capacities of things to act as quasi agents or forces with trajectories, propensities, or tendencies of their own" (Bennett 2010: viii). Her aim is to undo the onto-theological binaries of "life/matter, human/animal, will/determination and organic/inorganic," in order to "enhance receptivity to the impersonal life that surrounds us and infuses us"[3] (Bennett 2010: x, 4).

While such an approach may entail a flat ontology, Bennett's focus on relational ontologies and entanglement of human-nonhuman volatilities offers a fertile ground to speculate on life forms that might be composed in the aftermath of our planetary crisis. Such interspecies life forms are, as we shall see, the stuff of Octavia Butler's novels. The relation between evolution and life, as portrayed in her works, explodes the myth of inert or entropic

[3]Sagan, p. x and p. 4.

matter. Yet, another feminist philosopher of science, Karen Barad, draws on quantum mechanics to formulate her idea of *agential realism*—one that does away with representational models of thinking that assume stable matter, and that illuminates the contingencies of meaning-making in a posthuman world where the animalistic, the machinic, and the ideational intersect. Barad offers a performative idea of agency that connects epistemology with materiality. "Apparatuses," she writes, "are not static arrangements in the world that embody particular concepts to the exclusion of others; rather apparatuses are specific material practices through which local semantic and ontological determinacy are intra-actively enacted" (Barad 2003: 801). *Diffractive reading* is another concept that Barad offers, one better suited to tracing intra-active patterns of interference, fragmentation, enfolding, and sedimentation of spacetime in quantum theories of matter (Barad 2007). Vital materialism, agential realism, and diffractive reading challenge the conventional idea of anthropomorphism, one that requires human cognition and consciousness to confer agency on the nonhuman world. Anthropocentric cognition, these feminist materialists note, has historically privileged the conquering gaze from above—a masculinist optic, if any. They offer in its stead the idea of distributive agency—a reciprocal acknowledgment that the agency of the nonhuman world has as much bearing, if not more, on the way our techno-planetary habitation has evolved over centuries.

Xenogenesis: Strange Assemblages

If the idea of "world" is an invitation to imagine maximal extension and maximal connectivity, how might it incorporate the nonhuman and the alien? Can human world-making be complete if it fails to question who counts as human and how some humans have remade the earth in their own image while subjugating a host of others including the nonhuman? This is a conundrum that Octavia Butler addresses in a short piece published in 1995, "The Monophobic Response." Playing with the trope of the "alien," Butler raises the stakes of the human-nonhuman question to the realm of the planetary. Why, she asks, are human-alien encounters in popular culture saturated with horror and hostility? She attributes this to our inability to comport with aliens in this world:

> The human alien from another country, culture, gender, race, ethnicity, religion, class. . . . This is the tangible alien whom we can hurt or kill. This is the one we can blame all manner of wickedness. This is the one we can feel superior to. The one we can feel certain isn't quite as human as we are. . . . There is a vast, terrible, sibling rivalry going on within the human

family as we satisfy our desires for territory, dominance, and exclusivity. (2000: 415–16)

Butler began her writing career in the 1970s when universities were beginning to introduce courses in feminism, gender and sexuality studies, and Black and ethnic studies. Her novels prominently feature African American women who engage with life forms from other planets. An attunement to human diversity, Butler speculates, may emerge when humans actually confront planetary aliens. The experience might force them to reflect on the affront aliens pose to notions of human supremacy, and they might begin to cooperate with each other and with other species on our very own planet. What we need, she declares, is to cultivate our cooperative imagination—to develop habits of curiosity and understanding that encourage "*E pluribus unum* at last, a oneness focused on, and in a sense fertilized by the certain knowledge of alien others" (Butler 2000: 416).

Butler's *Xenogenesis* trilogy is such an experiment. *Xeno* is a "stranger" in Greek and the trilogy is populated with symbionts, those entities that "account for transgenic assemblages of matter, which precede and exceed species differences of kind and degree" (Parisi 2007: 39). Symbiogenesis is a spur to stranger intimacies. Lynn Marguilis's theory of endosymbiosis is prominently on display in Butler's fictional universe. As Haraway puts it:

> The core of Margulis' way of life was that new *kinds* of cells, tissues, organs, and species evolve primarily through the *long-lasting intimacy of strangers*. The fusion of genomes in symbioses, followed by natural selection—with a very modest role for mutation as a motor of system-level change—leads to increasingly complex levels of good enough quasi-individuality to get through the day or eon. Margulis called this basic and mortal life-making process *symbiogenesis*. (Haraway 2017: M25, emphasis added)

The fantasy of a self-contained, immunized, invulnerable self that wages a constant battle against foreign invaders—microbes, racial, and ethnic others—is steeped in colonial discourses of contamination, contagion, and infection. It is a dark fantasy that has erupted frequently in genocidal wars. The *Xenogenesis* novels blast open this immunological paradigm. They are replete with cross-species breeding and mutant intimacies that fracture phylogenetic aspirations of the human race—that our children will be born with our DNA that has evolved over millennia. The first novel in the series, *Dawn*, begins in the wake of a nuclear holocaust that has destroyed much of the world. Our devastated planet is discovered by a group of aliens, the Oankali, who are gene traders. Gene trading with other species is the very ground of Oankali's flourishing:

> We trade the essence of ourselves. Our genetic material is yours. . . . We do what you would call genetic engineering. We know you had begun to

do it yourselves a little, but it's foreign to you. We do it naturally. We must do it. It renews us, enables us to survive as an evolving species instead of specializing ourselves into extinction or stagnation. (*Dawn* 43)

The Oankali are medusa-like in their appearance with tentacles all over their bodies that work as sensory organs. They have long ceased to worry about their own origins, so frequently have they traded genes with alien species. Gene trading has gifted them with an immunity unthinkable in earth's higher-order creatures, especially mammals. The Oankali sift among human remains of the nuclear blast and rescue Lilith Iyapo, a young African American woman. Lilith becomes their primary source of genetic exchange. She is monumentalized as the first Mother of new hybrid beings with an advanced evolutionary future. The reason Oankali choose her is due to her long familial history of deaths by cancer. In a breathtaking stroke of posthuman reversal, Butler converts Lilith's cancer genes into a precious resource that advances the bioengineering mission of the Oankali. The power of Barad's idea of agential realism is evident here, one that abjures stable ontologies of both body and matter across spacetime. Butler's novel reveals uncanny mutations in a posthuman universe that scrambles the human-animal-machine continuum.

Lilith is put to sleep for 250 years on an alien ship while the Oankali clean up the earth and make it habitable again for a hybrid species. The humans who resist interbreeding—the Resisters—are assisted with terraforming Mars but banned from returning to earth. When Lilith wakes up, she senses the presence of a strange figure named Nikanj. Nikanj is an *ooloi*, the third (neuter) gender among the Oankali, who is tasked with altering her mind and body so she can feel comfortable among the Oankali. *Ooloi* translates as "treasured strangers" in one of the Oankali languages. Their strangeness is the source of their power. It makes them indispensable conduits to the creation of new species. They are purveyors of intense pleasure across the myriad species and genders with which the Oankali trade. In a techno-animist take on both Margulis's idea of mitosis (our proto-organic bacterial origins) and genetic engineering, the *ooloi* feature as the ultimate mix-and-match masters who choreograph a replicative biopolitics with both genders across many species. No new progeny can be born without their intervention and participation in the reproductive cycle. Lilith's *ooloi* companion, Nikanj, impregnates her with the sperm of her dead lover, Joseph, and the trilogy unfurls in breathtaking scenarios of interspecies mingling, cross-gendered mutations, and intergalactic travel. While we might be tempted to celebrate the shattering of gender binaries through the figure of the *ooloi*, the novels ultimately do not escape the normalizing of heterosexual reproduction and the role of the female womb as the origin and receptacle of all life.

The trilogy stages a psychodrama between our genetic inheritance, social environments, and technological futures. Lilith's character

epitomizes a feminized selfhood marked by individuality through incorporation of strangers: *a symbiopoietic* ideal. However, rather than being unequivocally celebrated for her interspecies reproductive ability, she is condemned by a group of Resisters as a traitor to humankind. The novels are not a repudiation of humanity *tout court*, but a provocation to reflect on our self-destructive propensities such as our hierarchical attitudes to other races, genders, and species. Butler also provokes us to think about our future as a species if we continue to devastate our planet's ecosystem. The corrosive prejudices we harbor against those we identify as alien—both human and nonhuman—perpetuate a cycle of violence that the Oankali seek to break. At the same time, the Oankali are hardly portrayed as paragons of technogenic excellence, nor are they exempt from chance and contingency. As Lilith's son, Akin, says in the second novel *Adulthood Rites:* "Chance exists. Mutation. Unexpected effects of the new environment. Things no one has thought of. The Oankali can make mistakes" (488). The Oankali may be exemplary gene traders who are relentless in their quest to enhance the quality of the human species through eradicating its destructive traits. But their role raises the prospect of a dangerous eugenic worldview where genetic defects are sought to be corrected with the right kind of breeding.

Even as the novels literalize through the Oankali's corporeal form what Haraway calls "tentacular" bonds among myriad life forms, they do not affirm the primacy of the genetic script in determining our futures.[4] The symbionts in *Xenogenesis* blast open immunological metaphors of self and non-self, and compel us to attend to contagions and impure intermingling that become foundational to new life forms. Disease, Haraway notes famously, is "a subspecies of information malfunction or communications pathology" (1991a: 212). In reprograming diseased human cancer cells to build new species, the Oankali partake in the serendipity of cellular regeneration. The dance of life and death is no longer a battle between immunity and contagion, but one of a chain of contagions that reshuffle genetic codes. The ingenious animism of Oankali techno-bodies illuminates the life-giving power of what Haraway calls cyborgs where biological bodies emerge as sophisticated technological communication systems. As we turn to a contemporary work by the Zambian-American novelist, Namwalli Serpell, in the final section of this chapter, we see these cyborgian tropes acquire new forms.

[4] The term *tentacular* appears frequently in Donna Haraway's *Staying with the Trouble: Making Kin in the Chuthulucene*, 2016.

Swarming Cyborgs

Namwali Serpell's *The Old Drift* is a work of speculative fiction, one set only partially in the future. A spectacular mash up of myriad genres—the postcolonial novel, magical realism, speculative fiction, and Afrofuturism—the novel won the Arthur C. Clarke award for science fiction in 2019. It is an audacious meshing of colonial-era history and techno-ecological transformations unfolding in our present. The novel is epic in scope, spanning Zambian lives across four generations from the early twentieth century to the mid-twenty-first century. The point of view is squarely feminist as is evident from the three-part contents page that traces a line of matrilineal descent with eponymous titles of six women protagonists ranging from grandmothers to mothers and daughters. The novel's title derives from a drift on the Zambezi River five miles above the Victoria Falls, the port of entry into then northwestern Rhodesia, and the place where the Zambezi River is at its deepest and narrowest, the best spot for "drifting a body across." It was from here that early white settlers ran a transport service across the river. By 1958, settlers and colonial officers are displacing local people, harnessing African labor, and building a huge dam to be named Kariba on the site of the Old Drift. The river is flooding earlier than usual in the season, and the huge hydrocolonial construction project is conceived in an abject anthropomorphic register as "crawling with men, fly-like amongst the beetling machines. It looked like a mammoth corpse, half-dissected or half rotten." As the river waters seep through a fault line and flood the dam cavity from the inside, "a swirling thrusting deluge, red as blood because of the copper in the dust here, a crane they hadn't managed to move swiveling wildly in the gushing torrents" barrels through the flood plains (70).

Serpell unfurls her intergenerational canvas across two powerful technological developments in Zambian history: the building of the Kariba dam and Edward Nkoloso's attempts to send Afronauts to the moon. These attempted conquests of water and atmosphere inhabit the novel's speculative sweep and its interest in Afrofuturism, while grounding the narrative in precisely rendered historical events. The novel is replete with magic realist scenarios where one woman cries almost literal rivers, and another has hair that grows several feet and covers her entire body.

The novel's awareness of the climate catastrophe unfolding on the African continent is captured not only in its representation of an epic deluge toward the end, but in its intriguing experimentation with point of view. Parts of the novel are narrated by a nonhuman collective intelligence, a mosquito swarm that emerges as a Zambian uptake on the Greek chorus, "*thin troubadors, the bare ruinous choir, a chorus of gossipy mites.*" As an Afro-futuristic narrative device, the song of the swarm forms a "*weird and coordinate harmony*" of nonhuman times both ancient and futuristic—at

once an insect world from time immemorial and a cyborgian consciousness that has *"woven a worldly wily web . . . spindle bodies strung in a net of spacetime"* (19). The swarm buzzes, glides, and sways through the pages as it feeds us stories of its planetary intimacies that precede human existence by millions of years. These intimacies eventually enfold the human and appear far from pestilential, at least from the swarm's point of view:

> *We have a hundred eyes, we smell your scent plume, we sense your heat as we near you. You might hear us sing as we wing through the dark, alighting on knuckles and ankles, but our feet are so tiny, we land without notice, the gentlest of natural surgeons. We use the thinnest, most delicate needles . . . counted in grams, the boon is a droplet, but it weighs up to three times our mass . . . ducking the swat of a hand or a tail, we aim for a vertical surface . . . we've done our deft haematology, dripping away the watery broth and storing the solids for later. These we feed to our babies in need and this you become our wet nurses.* (318, italics in original)

The swarm's choric voice laments the folly of humans in treating mosquitoes only as disease vectors. Viruses carried by mosquito swarms are part of our evolutionary history, it tells us. "*And what do we leave you in kind of recompense? A salivary trace, a gum to stop your blood clotting. It's harmless but foreign, and your body is foolish, so it attacks itself in dismay . . . it sparks a histamine frenzy*" (318). Human exceptionalism is flipped on its head as it were and we catch a glimpse of a world defined by symbiogenesis—a process of speciation, as we saw earlier, more fundamental than genetic mutation, one that re-constellates the individual body as a hive of evolutionary traces from the simplest molecule to the most complex. A symbiogenetic paradigm of life is an ultimate affront to human individuality and its unique sociality.

In an audacious narrative pivot, the mosquito swarm becomes the inspiration for a technological and medical marvel. Joseph, an epidemiologist and scientist, discovers a vaccine for a viral affliction that remains unnamed in the novel. Those infected are referred to as having caught "the Virus." The specter of AIDS haunts the text. Jacob, a tech wizard, designs drones inspired by the size and anatomy of the mosquito, and sells them to the government. The purpose is not war. Jacob's automated swarm—named Moskeetoze—becomes the medium of mass vaccination of a population ravaged by the epidemic. Unlike drone acoustics in war zones that portend incineration with its whirring sound above, the cyborgian mosquito swarm evokes awe as it elegantly choreographs its descent, not to kill but purportedly to heal. Naila, the young female government employee-turned-activist who partners with Joseph and Jacob to fight the government's misuse of technology, is mesmerized by the swarm:

The smoke's syrupy sweep through the cone of light reminded Naila of a starling murmuration. It swung around, its ringing sound drawing near, then far, flooding thick, spiralling wide. Its outer edge swept past her and she saw tiny buzzing bits within it. Not smoke, microdrones.

Naila felt the cumulative touch of them on her face and neck—a whispering feeling, as if a furry wind were passing by. Then she felt the gentle needling. A dozen twinges, a hundred, a thousand, each no more painful than a normal mosquito bite. The swarm—they were Jacob's Moskeetoze, she was sure of it, the one's he had sold to the government—had landed upon the crowd and begun to puncture them. (542–3)

Having accomplished its mission, the drone swarm ascends in "measured spirals" and "skitter [ed] up in the cone of light" (544). The vaccinated people look for the usual signs of a mosquito bite and find painless welts that don't itch. They have been rendered immune by the collective sting of the Moskeetoze.

The Moskeetoze perform yet another feat in the novel, that of ecopolitical sabotage. The drone swarm is mobilized in a political cause by a group of activists protesting the ecological ravages of the Kariba dam. The leaders, Naila, Joseph, and Jacob, place solar-powered transmitters in the dam's sluices and program the Moskeetoze to find the transmitters: "Within minutes the sluice's inner surface would be lined with their tiny bodies. Sluices often got jammed this way with detritus like leaves and sticks that the workers had to clean out, so the infiltration had to be subtle" (555). Thousands of drones are released by this group through the night to cause a slight malfunction. Unexpectedly for its human creators, the swarm's machinic logic takes over as it blocks the sluices completely. This unleashes a catastrophic flood that swallows the dam and all the inhabitants nearby. Naila's fate remains unknown. The Zambezi begins flooding, and the ecological landscape changes irrevocably: "Lake Kariba would soon become a river. The Dam would become a waterfall. And miles away, the Lusaka plateau, the flat top of Manda Hill, would become an island" (559).

Swept away by the flood are all pretensions of a human-centered world: its little vanities, its delusions of grandeur, its quest for intimacy, its sense of political urgency, its moral righteousness, and its overweening need to control the nonhuman sphere. The novel ends with the swarm chorus, but is the voice that of mosquitoes or of the Moskeetoze? We enter a techno-animist realm where insects and drones are indistinguishable actants:

Are we red-blooded beasts or metallic machines . . . are we truly man's enemy, Anopheles gambiae, or the microdrones Jacob designed? If that's who we are, then this tale has explained our invention. The problem is we'll still never know because . . . we have joined up with the local mosquitoes. We get along fine, but can't tell us apart in this loose net of

nodes in the air. We just buzz about and follow commands and live lives of tense coordination. Half insects, half drones; perhaps all drones or none; may be something will emerge, but what a joke! What an error! What a lark indeed! A semi-cyborgian nation! (562, italics in original)

The swarm's volatility exceeds all efforts at meaning-making. Human finitude is stripped of its existential carapace and folded into the swarm's techno-planetary churn: "*And so we roil in the oldest of drifts—a slow, slant spin at the pit of the void, the darkest heart of them all.*"

This chapter has sought to expand the remit of World Literature by bringing on board feminist speculative genres and modes of thought. The politics of swarming, as Serpell's novel illustrates, is agile in form composed of "multiple constituencies, regions, levels, processes of communication, and modes of action, each carrying some potential to augment and intensify the others with which it becomes associated" (Connolly 2017: 125). Swarming and sympoiesis offer models of world-making attuned to nonhuman forces—machinic and biotic—that bring powerfully into focus our current planetary predicament. A fundamental shift in the lexicon of world-making in our time, as we saw, is the displacement of the idea of the human as a sovereign agent by large biophysical, geological, and technological forces. Our runaway techno-scientific and socially engineered systems have overtaken our ability to control them and their runaway impact on our earth system. We find ourselves in the realm of nonhuman time as we take the measure of our limits in controlling what we have created. Feminist philosophers of science and speculative novelists have been pioneers in contemplating the limits of human exceptionalism. As "anthropologists of possible selves" and "technicians of realizable futures" (Haraway 1991b: 230), they are exemplary earth dwellers, shaping and creating worlds no longer beholden to masculinist notions of sovereignty over nature.

References

Arendt, H. (1998 [1958]), *The Human Condition*, 2nd ed., Chicago: University of Chicago Press.

Barad, K. (2003), "Posthumanist Performativity: Toward an Understanding of How Matter Comes to Matter," *Signs: Journal of Women in Culture and Society* 28: 3.

Barad, K. (2007), *Meeting the Universe Halfway: Quantum Physics and the Entanglement of Matter and Meaning*, Durham: Duke University Press.

Bennett, J. (2010), *Vibrant Matter: A Political Ecology of Things*, Durham: Duke University Press.

Bollinger, L. (2010), "Symbiogenesis, Selfhood and Science Fiction," *Science Fiction Studies* 37 (1): 34–52.

Butler, O. (1987–89), *Xenogenesis Trilogy*, Chicago: Guild Books.
Butler, O. (2000), "The Monophobic Response," in S. R. Thomas (ed.), *Dark Matter: A Century of Speculative Fiction from the African Diaspora*, 5, New York City: Warner Books.
Connolly, W. (2017), *Facing the Planetary: Entangled Humanism and the Politics of Swarming*, Durham and London: Duke University Press.
Ganguly, D. (2020), "Catastrophic Form and Planetary Realism," *New Literary History* 51 (2): 419–53.
Giffney, N. and M. Hird (2008), *Queering the (Non)Human*, Aldershot: Ashgate.
Haraway, D. (1991a), "Biopolitics of Postmodern Bodies," in *Simians, Cyborgs, and Women: The Reinvention of Nature*, 203–30, Routledge.
Haraway, D. (1991b), *Simians, Cyborgs, Women: The Reinvention of Nature*, New York: Routledge.
Haraway, D. (1995), "Cyborgs and Symbionts: Living Together in the New World Order," in C. H. Grey, et.al. (eds.), *The Cyborg Handbook*, 1–16, New York: Routledge.
Haraway, D. (2016 [1985]), "The Cyborg Manifesto," in *Manifestly Haraway*, 3–90, Minneapolis: University of Minnesota Press.
Haraway, D. (2016), *Staying with the Trouble: Making Kin in the Chthulucene*, Durham: Duke University Press.
Haraway, D. (2017), "Symbiogenesis, Sympoiesis, and Art Science Activisms for Staying with the Trouble," in A. Tsing, et.al. (eds.), *The Arts of Living on a Damaged Planet*, M25–M50, Minneapolis: University of Minnesota Press.
Heise, U. (2016), *Imagining Extinction: The Cultural Meaning of Endangered Species*, Chicago: University of Chicago Press.
Howell, E. (2021), "NASA Names Perseverance Rover's Mars Touchdown Site 'Octavia E. Butler Landing,'" *Space*, March 6, 2021. Available online: https://www.space.com/perseverance-rover-mars-landing-named-for-octavia-butler
Latour, B. (2017), *Facing Gaia: Eight Lectures on the New Climatic Regime*, London: Polity.
Lovelock, J. and L. Margulis (1974), "Atmospheric Homeostasis by and for the Biosphere: The Gaia Hypothesis," *Tellus* 26 (1–2): 2–10.
Parisi, L. (2007), "Biotech: Life by Contagion," *Theory, Culture, and Society* 24 (6): 29–52.
Sagan, L. (1967), "On the Origin of Mitosing Cells," *Journal of Theoretical Biology*, 14 (3): 225–74.
Serpell, N. (2019), *The Old Drift*, London: Hogarth Press.
Thacker, E. (2011), In the Dust of This Planet, Vol. I, Hampshire: Zero Books.
Wenzel, J. (2020), *The Disposition of Nature: Environmental Crisis and World Literature*, New York: Fordham University Press.

4

Poet/Guerreras

Hip-Hop and World Literature

Debra A. Castillo

I first met Mare Advertencia Lirika in 2012 when she came to Cornell University as part of a tour promoting Simon Sedillo's documentary film on her and her work, "Cuando una mujer avanza" (When a woman steps forward). I was blown away by her talent, her drive, and her sheer intellectual presence. A few years later, as president of the Latin American Studies Association, I was in the position to define the inaugural event for the annual conference and, rather than inviting the political figures often tapped to do the keynote addresses at such events, I asked Mare—along with Puerto Rican poet and novelist Mayra Santos Febres—to anchor the session. Her riveting, socially conscious, feminist performance brought the audience to its feet. When the *New York Times* finally took notice of her in 2018, it looked like a sign that the Global North was opening up to radical, gender conscious activists from the south who were deploying the power of hip-hop to advance women's rights.

In June 2020, the Valparaiso, Chile-based Lastesis collective followed up on their mega-viral November 2019 flash mob performance, "Un violador en tu camino" (A rapist in your path), with a collaboration from Russia's feminist collective, Pussy Riot, on a punk-inspired rap, "Manifesto against police violence" also titled "1312." It was Pussy Riot's Nadya Tolonnikova who wrote the statement about Lastesis for *Time* magazine's October 2020 recognition of the Chilean group as among the "100 most influential people" in the world. Reflecting on these activist performance projects that come from opposite ends of Latin America and reach across the world, I had

the surely not unique realization that for the twenty-first century, music like this holds a similar place to certain African American-inspired folk songs like "We shall overcome" in the Civil Rights period in the United States—a song which was sung in many languages, in many different social justice contexts from the US grape boycott to the Czech Velvet Revolution to the Bangladesh War of Independence. In her 2019 PhD thesis, Australian-based scholar Linda Villegas makes a parallel comparison: she feels that feminist hip-hop now has something of the force, and resonates strongly for her with the international influence of nueva canción in the 1960s–1970s youth movements (148).

A Zapotec hip-hop artist from Oaxaca may seem like a strange place to begin a discussion about feminism and World Literature, if only because most discussions of World Literature tend to focus on the genre of the novel. However, I want to suggest that not only is rapping, and representing, by women like Mare an important form of contemporary poetry, but that work by her and artists like her inarguably defines one of the most important cultural strands in the world today. Just one datapoint to demonstrate my contention: according to 2019 Nielson Music data cited in *Music Business Worldwide*, hip-hop accounts for almost 30 percent of all music consumption in the world today, and over 50 percent of all top streaming tracks in the United States. Beyond the forms that are more strictly defined in the genre of hip-hop, performances like those of Lastesis and Pussy Riot are deeply inflected by the influence of a hip-hop aesthetic, as are many other forms of cultural production today. Likewise, I can point to collectives like The Keepers that are stepping outside familiar structures of exchange to promote a Black woman lead web-based resource for publicly accessible materials including art, activism, oral histories, resource guides, syllabi, and scholarship. Founded by Akua Naru, this in-progress site currently includes participation from people in the United States, Europe, Africa, and South America. To focus on narrative fiction as the privileged site of World Literature in such a context is surely an anachronism.

Thus, in this chapter, I hope to convince you—through reference to a few examples of artists like Mare Advertencia Lirika, and the Somos Guerreras collective composed of Rebeca Lane (Guatemala), Audry Funk (Mexico), and Nakury (Costa Rica)—that rap music from Latin America has an important role to play in the conversation about feminism as World Literature.

Beyond its focus on long-form fictional narratives, the commonly understood definition of World Literature has suffered from other unstated parameters. As Ignacio Sánchez Prado argues in his brilliant 2018 book, the most familiar arguments about World Literature amount to an implicit endorsement of Occidentalism, since they tend toward a strategic appropriation of Western literary forms as the unique shape of universal forms in terms of literary value (19). Thus, the institutions that support the constructs of "World Literature"—the Western market, the publishing

industry, translations—all focus on the materiality of specific cultural products and their global distribution, rather than any further exploration of intellectual practices that may or may not bring a wide range of different kinds of cultural materials into this distribution stream. In this sense, World Literature is that which most successfully circulates and sells in geographical areas outside its region of origin, often following suspiciously familiar trade routes, and responding to narrow academic needs. As Sánchez Prado argues:

> In the process of writing this book, I became concerned that the idea of world literature is limited not only by the fact that its models and cartographies usually reproduce the very structures of cultural coloniality and Eurocentrism that it claims to critique . . . but also the way in which world literature theory is shaped by anxieties about the increasing precarization of comparative literature and English literature as disciplines. (2018: 187–8)

This comment strikes home very powerfully to me, in that narrow sense, as a member of the Comparative Literature Department in a university where the biggest literature program has just changed its name to "Literatures in English," and proudly announced its purview over all literatures translated into that language. I am reminded of the self-correction by a graduate student who in a Comparative Literature event introduced themselves as in the English program, and corrected it to: "I mean, the literature program." That gatekeeping concern is a parochial and, merely, an academic afterthought, however.

More important, Sánchez Prado's argument asks us to take into account all those non-US and Europe-based culture producers who have a substantial connection to the stakes of World Literature, but—often because their works are not available in English translation—have very little or no access to that market's symbolic capital (Sánchez Prado, 2018: 21). Can an author participate in World Literature, he asks, if they do not circulate outside their language of origin, or if they do not make room for—or have no interest in privileging—English translation as their key point of entry into the discussion? (2018: 14). The answer is that, yes, they can, of course, if the gatekeepers happen to recognize their work. And there is the rub. Recognition by Western gatekeepers requires humility from all of us in the north, in the form of the parallel recognition that World Literature cannot be monolingual or limited to specific theoretical frames, and necessarily must be a collective project if it is to be truly global in scope.

Most important of all, Sánchez Prado, along with other crucial contemporary scholars such as Sayak Valencia in her important (and now translated into English) study, *Gore Capitalism*, Aamir Mufti's *Forget English!*, and Aijaz Amhad's "Show Me the Zulu Proust," as well

as thinkers from many other parts of the Global South, are asking the Global North to rethink these implicit parameters that reinforce historic colonial lines of influence and praxis that mask restrictive constructs with emancipatory rhetoric. They question the universalist assumptions that lurk beneath the definitional models propounded by scholars from Goethe to Franco Moretti (Moretti 2000). They challenge us to inquire instead about compelling projects and paradigms originating in Latin America, South Asia, and other parts of the Global South that aren't written in or translated into English, aren't published by a major US press, don't easily fit into the supposedly universal Western theoretical constructs, that may in fact offer important critiques of it, or new ways of imagining. Such theorizing from the south tends to bring into view other subjects often pigeonholed by their geographical locations on the so-called margins of the West. They propose other frameworks for thinking about social movements and social justice cultural work, as well as other ways of thinking about cultural forms. And, at the same time, Sánchez Prado forcefully reminds us that a writer or performer from the Global South is no more necessarily limited to that region's social and cultural themes than any other writer anywhere in the world, and is equally able to take the world as their subject.

Sayak Valencia is exemplary in this regard. Her work is grounded in interdisciplinary feminist, queer, and trans theory as structures of knowledge, an important added consideration in the context of this volume. She reminds us that World Literature theory is often not just Euro-American and colonialist but also threaded through with gender bias. Her *Gore Capitalism* looks at violence through a scholarly lens informed by her deep immersion in Western philosophy and first-world feminism, and equally informed by her background as a performance artist, activist, transfeminist, queer person from Tijuana, Mexico. She argues trenchantly that her border reality, with its accompanying ultraviolent forms of capital accumulation in the form of human and drug trafficking, makes visible the values and operations of global capitalism in a particularly salient way. Along the way, she is attentive as well to tracking the intimate history of gender violence in the construction of the state. For this feminist work, she notes that she does not need white women's discourse to explain her reality (she is much more drawn to the contributions of Argentine/Brazilian thinker Rita Segato and Spanish transfeminist Paul Beatriz Preciado). She writes: "without neglecting our differences, we seek the creation of our own discourses that nurture a transfeminism that confronts and questions our contemporary situation, a situation that is invariably circumscribed by the logic of gore capitalism" (2018: 7). In this context, she is particularly attentive to the hypernormalization of the culture of feminicide as an aestheticized, necropolitical product distributed across digital platforms. In general, her work looks closely at the role of social media, visual studies,

and what she calls the "régimen live."¹ For Valencia, while global capitalism and macho cultures have a structuring role in shaping contemporary violence, the First World urgently needs to pay attention to the explanatory power of new, resistant forms of feminist analysis coming from the Third World. And that perspective is bilingual, multicultural, located in a violent urban environment in the Global South, methodologically energized by a queer woman's transfeminist point of departure—almost point by point the very opposite of occidentally framed "World Literature."

The history of hip-hop is well known. Originally evolved from street performances by Black and Latinx youth in the Bronx, New York City, in the 1970s, classic hip-hop involves four key elements: DJ or turntabling, rap or MCing, graffiti writing, and break dancing (b-boying). Fifty years later, by the second decade of the twenty-first century, it has moved from the barrio to the mainstream, and become a global phenomenon, frequently thought of as a multilingual, multiethnic international community. For this very reason, some rappers—such as legendary Public Enemy MC Chuck D—are concerned about the "soft colonialism" implied in the export of US-born sounds and production formulae (Davalos [2017]: 38–9). However, this cultural borrowing does not seem at the forefront of the minds of any of the international artists that I focus on in this chapter. In fact, if we agree with Bojórquez Chapela, influences may flow both ways or in many directions. For instance, he makes a strong argument that US gansta rap has been heavily influenced by the Mexican narcocorrido form (2007). Certainly, the international flow of ideas and musical forms have not limited creativity.

While each local iteration of hip-hop has developed its own practices and idioms, its own linguistic and musical features, like our most familiar imagining of World Literature, hip-hop is notable for its fluid reach across borders, its access to markets beyond the original site of production. And while commercial hip-hop has a logic of production and sales quite different from its grassroots origin or its contemporary noncommercial forms, even for locally defined artists their international reach has been accelerated by the second generation's access to and able use of social media to exchange ideas, share music and graffiti, and create community. In Latin America, the adaptation of the form has given rise to many varieties of hip-hop expression, including rap in many of the indigenous languages of the continent, sampling from local musical forms ranging from cumbia and

¹In an early fall 2020, post about an online seminar she is conducting, Valencia defines "el régimen live" as "la disfusión de una forma de gobierno de las poblaciones, que se disemina de manera psicopolítica y normaliza la violencia extrema, la injusticia y el despojo en contra de poblaciones históricamente vulnerabilizadas." ("The diffusion of a form of government over people, that is disseminated in a psychopolitical way and that normalizes extreme violence, injustice, and plunder against historically vulnerabilized populations.")

merengue to Andean flutes and norteño stylings, and many, many varieties of socially conscious content, as well as (it must be admitted) pro-government institutionalized rap, and gansta, narco, and other less savory forms. And there is, of course, highly successful commercial hip-hop as well, but that is outside the argument I want to make in this chapter.

Thus, while hip-hop began as an urban form in the less privileged boroughs of New York City and is often still associated with urban life, in Latin America it is just as likely to be a key form of expression for indigenous youth in rural areas or small isolated communities. As Mare Advertencia Lirika said in response to a question about hip-hop's popularity among indigenous youth at a 2016 Latin American Studies Association panel, young artists are drawn to rap not just because of the catchy stylings but because it is much more democratic than other musical forms. The MCs don't have to learn to read music or to play an instrument to make powerful statements.[2]

Thus, the context in which the feminist rappers are working today is ample and highly cross-fertilized. Feminists in the region and scholars of Latin American hip-hop often point to the formative importance of the Krudas Cubensi (Castillo Planas [2021]), a Black, feminist collective formed in the 1990s in Cuba, and operating in the United States since 2006. Likewise, they celebrate the range of artists throughout the entire continent, from Ana Tijoux in Chile (see Shaw) to Caye Cayetano in Ecuador (see Diez), to Miss Bolivia and Sara Hebe in Argentina, to Karol Conka in Brazil, to Rita Indiana (Dominican Republic), to Mexicans Rabia Rivera (see Malcomson), Chhoti Maa (a queer, indigenous migrant, now based in Oakland, California), Mujeres trabajando (an international hip-hop collective dedicated to all four elements in a woman-only space, see Malcomson), and the Batallones femeninos (based in Ciudad Juárez and focused on anti-feminicide activism; see Villegas).

These sisterhood networks ("redes de sororidad") are even more remarkable in that many of these feminist rappers intentionally act outside what they see as a corrupt, neoliberal, music production mechanism of the record label and, in Latin America, the forms of official government sponsorship that put brakes on free expression. In terms of a World Literature perspective, this would align them with the artist that turns her back on the product-translation-market-model critiqued so ably by Sánchez Prado, in favor of more autonomous production and rapid communication via Facebook, Instagram, Twitter, SoundCloud, where they

[2]Mare says something similar in the documentary on the main reason she entered hip-hop and continued in it: "no te pedía nada, podia hacerlo cualquier persona, con los recursos que fuera, que podia pertener a cualquier sector, hablar de cualquier cosa y no te pedía nada." ("It asks nothing of you. Anyone can do it, with any kind of resources, from any social class, rapping about whatever you want, and it asks nothing of you.")

emphasize the noncommercial nature of their work in favor of open and free cultural exchange. Both Batallones femeninos and Mujeres trabajando, for instance, put a premium on the construction of solidarity networks among women, both in their official statements and in their ongoing practice since their founding. They also see themselves as having an educational mission. The constantly evolving collectives remain committed to conducting workshops as well as hosting performances, art shows, and other events that support and train women in the arts, in self-defense, in activist tactics, and in mutual aid. Pre-COVID, they traveled extensively, often internationally, on very tiny budgets, to perform, to share ideas, to protest, and to create new feminist work. When they couldn't travel in person, they turned to the internet. They make powerful use of hashtags like #niunamenos, #yositecreo, #miprimeracoso, #NoMeCuidanMeViolan, #ExigirJusticiaNoEsProvocación to share experiences, find support, and organize activist projects. In short, their work forcefully denounces gender violence in all its forms and works to create consciousness and leadership capacity building among women.

Among these hip-hop artists, Mare Advertencia Lirika is one of the most visible from an academic perspective. Articles on her have been published in journals from the United States, Europe, and Australia, attesting to her scholarly circulation in First World circles, and she has been the subject of several graduate theses. She has traveled widely, especially since she went solo in 2010 with her EP, "¡Que mujer!" (What a woman) and the release of Sedillo's 2012 documentary about her. A top student in her school years, talented poet, savvy interlocutor between the indigenous and the cosmopolitan, Mare credits some of her cultural resources to the migrant nature of her family (which moved back and forth from Mexico City) and her community (a Zapotec by birth, she comments on the importance of her exchanges with the fellow Oaxacan indigenous, US-based Mixtec community; see, e.g., Davalos [2017]; 16). Mare herself comes from a family of women: grandmother, mother, aunt, sisters, cousin. Her only close male relative besides her brother is an uncle who migrated to the United States. The experience of the death or migration of the male members of her family gave a particular shape to her development, where she constantly had to defend her family's difference from the nuclear family expectations of her peers. As her aunt says in the documentary, because there were never any men around, the women became used to independence, not having to rely on a man for support, but not having to be subservient to one either.

Thus, hip-hop came to her filtered through the strands of urban Mexico's adaptation of the form and her experience of women's empowerment in her family as they matched up with her growing international understanding of what it means to be an indigenous woman, whether in Oaxaca, or Chile, or Ecuador, or the United States. As she says in an interview with Carlos Davalos, "Hip hop's global nature helps me hear and learn from experiences

people have shared with me in other places." Mare likewise frames her work as an exchange of knowledges:

> I organize my workshops around different topics, keeping two central things in mind: there has to be practical, artistic learning, like the structuring of a hip hop rhyme, the composition of a hip hop beat, or the manipulation of turntables, and at the same time I also try to create constructive life experiences. The topics vary: I touch on issues of identity, gender, memory, cultural self defense. (2017: 17)

Mare was born in 1987, toward the end of the "Lost Decade" in Latin America, a time when the authoritarian regimes were falling in the Southern Cone, bringing the controversial appropriation of Latin American feminisms in the form of both governmental ministries and international NGOs, infamous for the massive human rights abuses of the civil wars in Central America, and for the rigged Mexican presidential election of 1988 when Carlos Salinas de Gortari assumed power, despite widespread fraud and a probable victory by Cuaútemoc Cárdenas. As a young adult, along with two other women, Mare first joined a mixed-gender hip-hop collective, where, she says, "everyone thought we wanted to be rappers because we were someone's girlfriend or wanted to hook up with a guy" (Diez [2016]: 47). Like other women in a highly masculinized field of the early part of the millennium, she had to think and work long and hard to demonstrate how rap for her was a form of resistance and activism. She cocreated the first all-woman rap crew, Advertencia Lírica, with two other women in 2003, before breaking off on her own in 2009. She officially named herself a feminist on her Facebook page and on Mexican television in 2014, although from very early on in her career, her emphasis on solidarity and combatting gender stereotypes was an important part of her message.

The Simon Sedillo documentary about her, "Cuando una mujer avanza" (When a woman steps forward), opens with a 1939 US newsreel clip of indigenous dancing from Oaxaca, in which both the name of the state and the name of the festival (the Guelaguetza) are grotesquely mispronounced, and the reason for the festival creatively invented ("it signifies that the president has the undying homage of the Oaxacans"). This misleading context gives even greater force to Mare's opening statement in the film that her primary goal is to preserve and share her culture, to never forget who she is and where she comes from. Mare also explicitly sees a link between her resistant work as an indigenous person, and her studies of feminist theory. She tells Linda Villegas, "I think that the feminism from which I have learned a lot is lesbian feminism. . . . This is a very radical position that we share as pueblos originarios. Because we were born women but also women belonging to indigenous peoples which makes us vulnerable in different ways" (2019: 178). In one of her collaborations, backed by the Afro-Mexican sounds of the son jarocho as played by the group Los Cojolites from Veracruz, Mare

asks, in the song that gives title to the documentary: "Y tú ¿qué esperas?" She goes on to outline the challenges that face her and her contemporaries, that range from cancer to feminicide and sex trafficking, to other forms of discrimination based on gender and sexual orientation, and demands that her listeners step up and take action:

> Y ¿tú qué esperas para dejar de esperar?
> Hazlo por ti y por nosotras, avanza ya.[3]

In general, Mare's lyrics reflect both her wide reading and her community-based activism. In 2015, Mare Advertencia Lirika and Rabia Rivera had a twenty-minute, three-round rap battle that was performed live and streamed and circulated online. The themes were announced in advance, giving the performers time to prepare. In her opening salvo, Mare cites the history of hip-hop going back to the 1970s as well as referencing scholarly work by Guillermo Bonfil Batalla (his important book, *México profundo*). Rabia picks up on the intellectual strain, in order to critique it: "I'm not the one who comes to . . . show off and give a lecture" (Malcomson [2019]: 58). In contrast with Mare, while strongly promoting women's rights, Rabia rejects feminism: "tú en tu rollo feminazi" ("you with your feminazi thing"), while Mare makes clear her commitment to her own indigenous brand of feminism. She argues, in an interview with Malcomson, "you do not have to be looking for a feminism that represents you, because you create your own feminism" [2019]: 60).

Rebeca Lane is the founder of the Somos Guerreras collective, which hosts workshops and panels as well as concerts. Somos Guerreras includes fellow feminist MCs Audry Funk, from Mexico, now living in New York City, and Nakury from Costa Rica. Their focus is on creating a space for women in hip-hop in general, but most of all for sharing their struggle for social justice in their countries, especially with respect to violence against women. Their most recent international tour was to Europe, in summer 2019, which accompanied their release of a collaborative EP, "Lucha por respirar" (Fight to breathe). "There is a boom of women rappers who tell their stories through hip hop," Lane says. "The feminist struggles are gathering force throughout the world, and we rappers who carry the flag of feminism are getting a lot of attention" (Ávila [2017]).

A queer Guatemalan poet and hip-hop MC, Lane has a background in theater and has studied sociology at the university level. She is also the author of academic studies under her official name, Rebeca Eunice Vargas

[3] "What are you waiting for? / I was born a woman in times of breast cancer / when machismo killed so many sisters / when lesbians were hunted as witches / among secret abortions, AIDS, and sex trafficking /. . . / what are you waiting for, in order to stop waiting? / Do it for yourself and for all us women, step forward."

Tamayac, and she comments that her background as a sociologist and her vocation as a hip-hop artist come together in her work, allowing her to deploy her two different linguistic registers strategically to reach a wider audience (Ávila [2017]). A "femininst by necessity" (Ávila [2017]), Lane lives in one of the most violent countries on earth, and has suffered the loss of family members to the instability. Likewise, Guatemala has per capita one of the world's highest rates of feminicide, domestic violence, and violence against LGBTQ persons, with lethal consequences for activists: "There are a number of issues silenced in Guatemala. . . . In the northern zone of Central America, being a lesbian costs your life. It's the fault of lesbophobia and homophobia. In Guatemala, all activists are in danger and by the mere fact of being a woman we are already at risk" (Ávila [2017]). In "Este cuerpo es mío" (this body is mine) from her album "Alma Mestiza," she raps: "Quisiera tener cosas dulces que escribir / pero tengo que decidir y me decido por la rabia."[4] The song goes on to detail the horrific statistics of rape and feminicide in her home country, grounding her outrage in facts, and demanding action.

Fellow Somos Guerreras collective member Audry Funk also combines an academic background with an openly feminist orientation and a social justice agenda. Like Lane, she sees the complementary role of scholarly work with her activist performances, but is wary of theoretical and social constructs that privilege white, European standards and forms of knowledge. She says, "doing feminism and hip hop has caused me to reflect on the barrio, where, to be honest, hip hop is more important than universities or academies where fancy terms and magnificent theories stay only on paper." Often, the women she sees as the core of her audience have very few resources, and certainly do not have access to higher education, but they do have access to music and to the internet. They can share their knowledge, and they can act in support of a better world (Castillo Planas and Funk [2020]).

One of Audry Funk's songs, the August 2020 "Te pertenece" (It belongs to you), focuses particularly on the issue of body image and fat shaming. Funk is proud to present herself as a full-bodied woman whose work celebrates and is dedicated to "todos los cuerpos posibles."

"Listen," she tells her audience, telling us that the heavier body of women like her only means her flow is more potent, more exuberant. She angrily rejects the Western/northern stereotype of the preference for the thinner body type as a feminine ideal: "A mí me valen verga tus estereotipos de blanquita europea / Estamos decolonizando tus ideas."[5]

[4] "I would like to have sweet things to write / but I have to decide and I decide for rage."
[5] "For all possible bodies / . . . / I'd don't give a crap about your white woman stereotypes/ We are decolonizing your ideas." Funk is currently living in the Bronx, New York City, and increasingly includes code-switching in her work.

When Funk raps about decolonizing her audience's minds, she is clearly in dialogue with academic discourse while at the same time making a forceful argument for a feminist theoretical stance that comes from the south that deploys other forms of knowledge and other methods of distribution of her work.

Feminist rappers like Audry Funk, Rebeca Lane, and Mare Advertencia Lirika are only a few examples of a much wider phenomenon in which proudly feminist thinkers from many backgrounds and many knowledge structures are leveraging the global reach of hip-hop culture to promote a powerful gender- and sexuality-conscious agenda. They are marshalling a range of tools and strategies to engage issues of structural violence and oppression, reaching out to wide audiences that are both local and global. This kind of work is, in fact, one of the most powerful examples we have in the contemporary arts of a form of feminist world literature that is changing the definition of all three key words in that phrase by privileging voices from below, reimagining the world from outside the usual version promoted by northern gatekeepers, and expanding the concept of the literary to include rap lyrics. At the same time, no one, including these savvy artists, is entirely outside the globalized structures of Anglo-European moderated ideas of product-market-distribution, and these culture producers do engage in decolonial exchange and feminist critique, recentering it from their southern, marginalized, and feminist perspective. In their most important roles, rap artists like Mare Advertencia Lirika, Rebeca Lane, Audry Funk, and many others remain stubbornly orthogonal to World Literature today, while giving those of us in academic circles much to ponder in our thinking about the place of feminist thought and activism.

References

Audry Funk Website. Available online: https://audryfunk.com (accessed October 24, 2020).
Ávila, A. (2017), "Ser lesbiana en Guatemala te vale la muerte," *El diario*, June 23, 2017. Available online: https://www.eldiario.es/andalucia/lacajanegra/lesbiana-guatemala-vale-muerte (accessed October 24, 2020).
Batallones Femeninos Facebook Page. (accessed October 24, 2020).
Bojórquez Chapela, T. (2007), "De narcos y ganstas," in M. O. Aguilera (ed.), *Antropología de las fronteras*, 123–136, Mexico: Colegio de la Frontera Norte.
Castillo Planas, M. (2021), "Somos Guerreras: Queer Feminist Hip Hop in Latin America," in D. A. Castillo and M. Szurmuk (eds.), *Latin American Literature in Transition*, Cambridge: Cambridge University Press.
Castillo Planas, M. and A. Funk (2020), "Towards a Decolonial Feminist Hip Hop," (in press).
Chhoti Maa Website. Available online: https://chhotimaa.com (accessed October 24, 2020).

Davalos, B. C. A. (2017), "Studies of Hybridity and Agency in Mexican Hip Hop," MA thesis, University of Texas, Austin.
Diez Salvatierra, C. (2016), "Feminismos activistas en el rap latinoamericano," *Ambigua* 3: 39–57.
"Hip Hop is Still Growing—with Over 50% of the USA's Top Streaming Tracks," (2020), *Music Business Worldwide*, January 19. Available online: https://www.musicbusinessworldwide (accessed October 24, 2020).
The Keepers. Available online: https://www.followthekeepers.com (accessed October 24, 2020).
"LASTESIS," (2020), *Time 5* (October 12): 64.
Malcomson, H. (2019), "Contesting Resistance, Protesting Violence: Women, War, and Hip Hop in Mexico," Music and the Arts in Action 7 (1): 46–63.
Moretti, F. (2000), "Conjectures on World Literature," *New Literary Review* 1 (January–February): 54–68.
Mufti, A. (2018), *Forget English! Orientalisms and World Literature*, Cambridge: Harvard University Press.
Rebeca Lane Website. Available online: https://rebecalane.com (accessed October 24, 2020).
Sánchez Prado, I. (2018), *Strategic Occidentalism: On Mexican Fiction, the Neoliberal Book Market, and the Question of World Literature*, Evanston: Northwestern University Press.
Sedillo, S. (2012), Cuando una mujer avanza, Manovuelta.
Shaw, L. ed. (2013), *Song and Social Change in Latin America*, Lanham: Lexington Books.
Valencia, S. (2010), *Capitalismo Gore*, Mexico: Melusina.
Valencia, S. (2018), *Gore Capitalism*, trans. John Pluecker, Cambridge, MA: MIT Press.
Vargas Tamayac, R. E. (2011), "El hip hop en Guatemala desde la perspectiva de los Estudios Culturales," *FLACSO*. Available online: https://rebecalane.com/2996322-academic-writings-textos-academicos (accessed October 24, 2020).
Villegas Mercado, L. D. (2019), "¡Vivas nos queremos! Feminist Activism in Hip-Hop Culture in México: Batallones Femeninos and Mare Advertencia Lirika," PhD dissertation, University of Sydney, Sydney.

5

Surface Matters

Female Allegories and the Gendering of Continents from Waldseemüller to Ortelius

Katharina N. Piechocki

Territories are typically considered to be immutable, rigid, and fixed entities. Hardly ever is the human agency and the rich and often arbitrary imagery behind the impetus to bind territories and toponyms to one another dismantled and exposed. And yet, not only do territories change shape in time (coastlines are transformed and islands appear or disappear), but since antiquity territories have constantly been named and renamed while neologisms have been invented and applied to newly "discovered" islands and continents alike. While toponyms all too easily appear to be set in stone, behind each place-name lies the performative, arbitrary, and impactful act of naming. As this chapter shows, the act of naming with its purpose to define land geographically, politically, and socially by choosing an existing or creating a new toponym out of an (often) unlimited range of possibilities is inextricably tied to power and gender alike. Continents and most countries, for instance, tend to be female gendered—arguably, because they are either composed from the adjectival form of the female Latin noun "terra," land, or used as abstracta (which are traditionally female gendered). And since the sixteenth century, continents tended to be represented, on maps and in

the visual arts more broadly, as allegorical female figures. And yet, there is no particular reason why a (newly discovered) land should have been named, for instance, "America" or "Columbia" and not Continens Vesputii, Continens Columbii—or Ophir, a toponym Columbus used in his letters as a synonym for Hispaniola, or something else entirely.

Despite the close ties between geography (and cartography) and gender, the disciplines of feminism and geography have all too often seemed to be two ships passing in the night. After all, some feminist geographers consider these two subjects of study as diametrically opposed. As Kate Coddington has pointed out, "Katharyne Mitchell has characterized the relationship between feminism and geography as being fundamentally *incommensurate*: geography makes boundaries, and feminism breaks them. The unsettling nature of feminist work within geography arises from the juxtaposition of its counterhegemonic intellectual politics within what is still, fundamentally, a discipline with a long history of complicity with imperial, capitalist, and White hegemony" (Coddington 2015: 214).

But as the example of toponymy shows, geography and cartography are not gender neutral, nor can the study of geography be limited to the making of borders—themselves malleable and constantly shifting. As far as cartography is concerned, the practice of mapmaking, while it existed in antiquity and the Middle Ages, took on an unexpected turn in the course of the sixteenth century. As Tom Conley, David Buisseret, and many other historians of cartography have argued, "at the beginning of the fifteenth century maps were practically non-existent, whereas only two centuries later they were the bedrock of most professions and disciplines" (Conley 1996: 1). Several reasons have been identified to account for this rise in the interest in cartography and maps—from the rediscovery of Ptolemy's second-century CE *Geography* which introduced into Europe, for the first time, longitudes and latitudes and thus a new model to conceive of maps as grids, precursors to arbitrary rectilinear borders, to the "discovery" of new continents which ultimately made the measuring of the earth's surface possible. Tom Conley has added another reason: "the emerging *self*" in its "relation to the idea of national space" (Conley 1996: 2). I would like to add yet another, twofold reason: on the one hand, the idea of continental thinking, on the rise with the "discovery" of the Americas and the question of how a continent can be defined. On the other, the use of female allegories and the shift from a male-gendered personification of the tripartite *oikoumene* in the Middle Ages (through the figure of Christ as well as the three sons of Noah—Sem, Cham, and Japhet—representing Asia, Africa, and Europe), to a female-gendered allegorization of the four continents, which took its origins concomitantly with the first transatlantic voyages, but rose to greater prominence in the second half of the sixteenth century, with the rise of absolutism and the tendency to exclude women even more from power. This chapter unearths

the convoluted pathways that bound gender and territorial thinking to one another in a time of major global upheavals: the early modern period, when the so-called discovery of the New World coincided with the rise of a new humanistic discipline, cartography, and the concomitant emergence of continental thinking.

Geography and Feminism

The interest in geography and feminism is relatively recent and it originated, as one might expect, in the social sciences. Two distinct layers of feminist thinking in geography are at work when investigating the (male) gender of key concepts in geography such as place and space: one either targets the modest number of women geographers and cartographers, or the subject matter itself, the methodology and theory of the discipline. While Alice Hudson's and Mary M. Ritzlin's careful and systematic "Checklist of Pre-Twentieth-Century Women in Cartography" has brought to light more women involved in the mapmaking process than previously acknowledged, it is discouraging that many of the names remain conjectures. Especially in the fifteenth and sixteenth centuries, the focus of this essay, when the discipline of cartography emerged, only a handful of women contributed to mapmaking in one way or another—mostly as colorists, possibly as publishers (Hudson and Ritzlin 2000). Even though scholars have since published histories on the contribution of women to cartography—one might think of Will C. Van Den Hoonaard's *Map Worlds: A History of Women in Cartography*—it becomes quite blatant that women have predominantly been excluded from the mapmaking process: *Map Worlds* dedicates less than a page to women engaged in the creation of maps in the fifteenth and sixteenth centuries, and no specific female cartographer is mentioned, in those foundational centuries, by name (Van Den Hoonaard 2013: 33–4). Excluding women from the mapmaking process has, as Gillian Rose's milestone study *Feminism and Geography: The Limits of Geographical Knowledge* (Rose 1993) has shown, crucial implications for the theorization of basic concepts such as place, space, border, and territory. For Rose, the geographical discourse has been predominantly masculine (conducted by male researchers) and hegemonic (offered through a male gaze). In order to think alternative discourses in the discipline of geography, feminist strategies need to be explored with greater urgency and women as knowledgeable human actors need to become central agents in the making of geography and cartography. Doreen Massey's work on labor, space, and gender has been among the most eminent examples of a powerful woman geographer's voice in a male-dominated domain. From her early studies on the relationship among labor, society, class, and gender, Massey has strongly

advocated for the centrality of space in social studies, arguing, as she does in *Spatial Divisions of Labour* (Massey 1984) that the working class has been informed and undermined by a new spatial organization of capital. Feminist geographers have equally successfully centered on timely topics including migration, border studies, urban studies, and, more recently, race.

More recently, feminist geographers have increasingly recognized the urgency to adopt a broader perspective on reflexivity and positionality by privileging the lens of inclusion and by developing methodological and theoretical tools for an intersectional study of both the subject matter and the embodied researcher. Recent studies of geography have increasingly emphasized the important—and long overdue—task, that is, to analyze the discipline of geography through the lens of feminism in tandem with "race, class, sexuality, activism and scholarship" (Coddington 215). Pamela Moss and Avril Maddress, for instance, have addressed the Women's March from the perspective of space, race, and inclusion in their article published in *Gender, Place and Culture: A Journal of Feminist Geography*, a journal founded in 1994 (Moss and Maddrell 2017). Patricia Daley has mobilized Critical Race Theory to investigate geographies of racialization and coloniality, while her current project, "Black Body Politics: Social Hierarchies and Violence," addresses the intersectionality of race, class gender, and space in Africa and the African diaspora. Furthermore, essays such as Melissa Wright's "Gender and Geography II: Bridging the Gap—Feminist, Queer, and the geographical Imaginary" are increasingly broaching the interrelatedness of geography, feminism, and queer studies (Wright 2010), while Saul Hayley and Emma Waterton have recently charted, in their essay collection on *Affective Geographies of Transformation, Exploration and Adventure: Rethinking Frontiers*, new pathways to inquire about geography and affect studies, geographies of emotion, and nonrepresentational geography (Hayley and Waterson 2019).

An approach to a feministically inflected geography spearheaded by the humanities, in particular by literary studies, can yield important new insights into the very *poetics*, that is the very making, of geographic categories and cartographic paradigms that inform not only the discipline of geography but twenty-first-century humanities writ large: space, place, border, territory, and continents—to name some. These key concepts are not given and immutable but have their own history and change across times and cultures. They are also profoundly gendered. It is thus necessary to go back in time and historicize notions we typically take for granted, to open up the very elements that make up a geographic discourse. As Luce Irigaray put it already some time ago in *This Sex Which Is Not One*, in a passage famously taken up as an epigraph by Judith Butler in *Bodies That Matter*, it is a necessary and continuous task "to interrogate the conditions under which systematicity itself is possible" and to see "what the coherence of the discursive utterance conceals of the conditions under which it is produced"

(Irigaray 1985: 74; qt. in Butler 1993: 27). The origins of modern border making processes, White hegemony, and Western imperialism are typically not subject to a historical scrutiny and thus tend to appear as monolithic and stable. When historicized, these concepts turn out to be even more convoluted—in particular with regards to gender: visual representations of women as continents, including Europa, do not dovetail with representations of power and hegemony.

Noah's Sons and the Male-Gendered *Oikoumene*

For the ancient Greeks and Romans, the *oikoumene*—that is, the three parts of the known world, Asia, Africa, and Europe—was readily female-gendered. The Roman writers Moschus and Ovid named Europa after a legendary maid was abducted by Zeus in the shape of a white bull from the shores of Phoenicia. However, no ancient maps and other forms of visual representations of continents as female allegories or personifications are extant. As Benjamin Braude has long shown, "the classical terms Asia, Africa, and Europe" are absent in the Bible, whose "genealogical listing of chapter 10 is repetitive, contradictory, and manifestly incomplete: it lists sons without daughters; not surprisingly, it is accompanied by no map; most of the names are unidentifiable, and, to the questionable extent that they have been identified, they do not fit modern geographical, ethnic, or linguistic principles of organization" (Braude 1997: 108). The association of the continents with the sons of Noah started being promoted only in the first centuries CE, mostly by the church fathers. As early as the ninth century, Noah's three sons featured on a *mappamundi*, that is, on a religious map symbolically narrating biblical stories from the Old to the New Testament, from Adam and Eve to Christ, as a manuscript illustration of Isidore of Seville's *Etymologiae*. A commentary explains to the readers: "Behold, thus the sons of Noah divided the world after the flood" (Ecce sic diviserunt terram filii noe post diluvium) (Van Duzer 2021: 108). In the course of the Middle Ages, with the rising popularity of *mappaemundi*, the tripartite male-gendered Noachic toponyms were adopted for the three parts of the *oikoumene*.

The idea of actually depicting Sem, Cham, and Japhet as historical representatives on maps with the purpose of symbolizing the three parts of the world was executed twice in the course of the fifteenth century, on the brink of early modernity. Besides Jean Mansel's beautifully executed *mappamundi* from *c.* 1455 in the illuminated manuscript titled *Fleur des Histoires* which features Noah's ark on Mount Ararat alongside the figures of Sem, Cham, and Japhet standing on the three respective parts of the *oikoumene*, the only other fifteenth-century map that visually represented Sem, Cham, and Japhet was Hartmann Schedel's *Liber chronicarum* (Nuremberg, Anton

Koberger: 1493), one of the greatest fifteenth-century achievements of the printing press (112–13). While the map included in the *Liber chronicarum* is Ptolemaic, Schedel's placed the three sons of Noah outside of the map, as those who now look at the (new type of the) map: here, the three male figures personifying the continents have been removed from the Ptolemaic map which they hold in their hands (114). The printing press, invented by Johannes Gutenberg in the mid-fourteenth century, disambiguated messy genealogies and territories—for the better and for the worse. It is quite interesting that the very first printed map from 1472 promoted the clearcut medieval correspondence between the tripartite continental divide and the sons of Noah. It can be read as a statement about printing as a new technology which "not only fixe[d] words to the page, [but] also help[ed] fix meaning to those words" (Braude 1997: 107).

But in the course of early modernity, as the Noachic tradition was slowly abandoned and with the rise of Ptolemaic cartography, mapmakers reverted to the ancient names and the new practice, *en vogue* since the sixteenth century, of visually representing continents as female-gendered allegories. Despite this general trend, there were some humanists who deplored the move away from the biblical toponyms. As late as 1561, the French cartographer and philologist Guillaume Postel complained about the use of Asia, Africa, and Europe for the three parts of the *oikoumene*. In his *Cosmographiae Disciplinae Compendium*, he wrote that since all the peoples of the earth stem "ex unius Noachi domo" (from the house of one and the same Noah) (Postel 1561: 15), it is more appropriate to use the biblical toponyms instead of those that have their origin in Greek mythology. In particular, Postel forcefully rejected the use of the toponym "Europe" which stems, he argued, "from the encounter of a wicked scoundrel with a cow" (Postel 1561: 2). Instead, he promoted the use of three neologisms inspired by the Noachic nomenclature: "Semia," "Chamia," and "Japetia" (15). While Postel's neologisms never became popular, they point to an important aspect of the naming process: toponyms are deeply steeped in an imagery that is not only historically and culturally inflected but also profoundly gendered.

Women as Continents

In a recent essay, Chet van Duzer has contended that "given that there was a tradition of personifications of the continents in classical antiquity, it is surprising that personifications of Europe, Asia, and Africa did not proliferate earlier in the Renaissance than they did: it was the sixteenth and seventeenth centuries when proper personifications of the continents became common" (Van Duzer 2021: 114). One could argue, with Jeffrey Peters who binds allegorical maps to "procedures of deciphering or reading"

(Peters 2020: 96) that processes of the decoding of a novel territory are linked to new visual tools of making the New World legible to a European reader. But the gender aspect significantly complicates the matter. As I mentioned at the beginning of the chapter, the grammatical gendering of toponyms has had significant consequences for the cartographic visualization of regions and continents: it has mobilized the production of maps representing territories as female allegories. From the fifteenth-century association of the three parts of the *oikoumene*—Europe, Asia, and Africa—with female figures in editions of Ptolemy's *Geography* to late sixteenth-century illustrations by Stradanus of a personified America suspended in a hammock as she encounters Amerigo Vespucci, his feet firmly on the ground, continents and female bodies have persistently been brought into a relationship of signification. Historians of Europe have identified several explanatory models beyond the grammatical gender for the predominance of a female-gendered imagery in the visualization process of continents. However, these studies have often tended to focus not so much on the origins of this imagery, but rather on the effects these different modes of optical representation tend to produce in the (male) onlooker. The *vis formandi*, the origin of the transition from grammar to a metaphysically inflected imagination, in which the gendered body plays a constitutive role, has heretofore been largely neglected.

Michael Wintle has recently advanced the argument that visual representations of territories in female form tend to produce a threefold effect in the onlooker: first, "feelings of paternalism" vis-à-vis "the portrayal of a geographical unit as a young, beautiful, innocent, tender but noble woman"; second, the woman's "natural fruitfulness and fecundity, particularly appropriate in nationalist movements and their visual imagery"; and, third, "an element of sexual voyeurism in displaying these nubile young females" (Wintle 2021: 49). In her analysis of the representation of women in the Middle Ages, Michelle Perrot uses the term "screen-imagery" (*imaginaire-écran*), coined by Alice Pechriggl, to point to the fact that the visual representation of women tends to function as a "veil" (*voile*) intervening between the so-called real women and the onlookers: "The medieval imagery is rich, but it is a screen-imagery of femininity, in the double sense of the term: as a barrier that forms an obstacle for a direct vision; as a surface upon which the fears and desires of men are projected."[1] Wintle's statement reiterates the eroticized heteronormative male gaze upon a territory imagined as a female body. His assessment of what the reader of a map is likely to experience when gazing upon a territory in the form of an alluring female allegory, dovetails in many ways with the first-person speaker in John Donne's seventeenth-century poem, "To His Mistress Going

[1] All translations from the French are mine, if not otherwise indicated.

to Bed," in which the poet blends the desire for America, defined as the "new found land," with the longing for the discovery of the female body:

> Come, Madame, come, all rest my powers defie,
> Until I labour, I in labour lye.
> ...
> Licence my roving hands, and let them goe
> Behind, before, above, between, below.
> O my America, my new found lande,
> My kingdome, safeliest when with one man man'd,
> My myne of precious stones, my Empiree,
> How blest am I in this discovering thee.
> To enter in these bonds is to be free,
> Then where my hand is set my seal shall be. (Donne 1996, vv. 25–32: 22)

Scholars have long pointed to the literal and metaphorical articulations of the verb "to labour" that take on the meaning of plowing a field as well as engaging in an amorous act. But to plow a field—an activity used as a metaphor for writing, hence the Latin word for poetic line, "versus," which literally means to turn (*vertere*) the plow—also means to leave lines of demarcation in the soil, itself akin to the cartographer's act of tracing lines on a map with the purpose to delineate a territory. Amorous and territorial conquests, the idea to possess by the "labor" of the sex act or—just like Aeneas who "founds" (*condere*) the sword in his (male) enemy's body in the final lines of the *Aeneid*—by the foundational act of inserting the standard into the soil of a new (*virgin*") territory, tended to be deeply entangled in the (male) imagery of the *conquistadores*.

It is interesting to note that in his reading of Donne's poem, Thomas Greene has pointed to a contradiction in the poetic I's act of disrobing "his mistress" and the increased use of metaphors: while the poem "presents itself as a literal dis-covery, an anatomical uncovering, it actually doesn't discover anything. ... The Poem is a tissue of *coverings*, analogical garments which apparel the 'full nakedness' the text seems to celebrate but actually withholds" (Greene 1989: 136). While Greene goes on to offer a religiously inflected explanation of this perceived phenomenon, I argue that the tension Donne establishes between discovering and covering unearths a problem that is not only inherently poetic—it plays with the difference between the literal and the metaphorical meaning and tests the limits of poetic representation itself—but deeply cartographic. Discovering and delineating new territories and producing maps upon which the lines of novel lands were drawn was one and the same gesture during the early modern period, as I argue elsewhere (Piechocki 2019). The period of territorial discovery was accompanied by the rise of a new humanistic discipline: cartography.

The maps, as the word's Latin etymology suggests, originally referred to the material maps were made of: a *mappa* was a piece of cloth, fabric—it was, akin to the poetic act of clothing a thing in words, a "tissue of covering" in the words of Greene. The map covers the body of the territory just like clothes cover human bodies.

Donne's poetic imagery of the female body remains quite elusive: the distinctively gendered somatic contours are ill-defined as are those of a metaphorically understood "America." For Greene, this poem "is at once a celebration of the female body and a denial of it." Here, "the woman, or her invisible body, serves to induce maieutically the expression of magical wishes that enter the poem as metaphors but usurp its focus" (Greene, 139). As Alice Pechriggl has pointed out, the bodily imaginary is not only constitutive of the formation of the psyche, but it plays an eminent role in the formation of social imagery, itself inextricably bound up with sex and gender imagery. Within this circular formation of meaning and signification, the question of metaphoricity and allegorization is of great import: tropes not only mobilize the constant movement of translation between the bodily and the sociohistorical domains in a movement of reciprocal creation, but they also allow for constant emergence of new meaning and new relations of signification. A critique of gendered toponyms thus needs to include an analysis of the "tropical relations" between dichotomies—such as body and territory—all too often presented as logical and necessary (Pechriggl 1999: 26–8).

The Naming of America

The example of the naming of America discloses the convoluted relationship between gender and territory, on the one hand, and between allegorized and literal body, on the other. In 1507, Martin Waldseemüller published a slender volume containing a commentary on Ptolemy's *Geography* as well as four letters—now considered to be most probably forgeries (Johnson 2006: 9)—by the Italian navigator Amerigo Vespucci who not only chronicles the so-called discovery of the Americas, but refers to the latter, for the first time, as "mundus novus" (New World). Titled *Cosmographiae Introductio*, Waldseemüller's introduction into the Ptolemaic geography would become "one of the most important texts in the history of cartography and perhaps in the history of the Americas as well" (Hessler 2008: 39). The volume was accompanied by a world map which, for the first time, bears the toponym *America* (for the South American continent). "America" was a neologism Waldseemüller invented to honor Vespucci, as he explains in the *Introductio*:

> Today these parts of the earth [Africa, Asia, and Europe] have been more extensively explored than a fourth part of the world, as will be explained

in what follows, and that has been discovered by Amerigo Vespucci. Because it is well known that Europe and Asia were named after women, I can see no reason why anyone would have good reason to object to calling this fourth part Amerige, the land of Amerigo, or America, after the man of great ability who discovered it. The location of this part and the customs of its people can be clearly understood from the four voyages of Amerigo Vespucci that we have placed after this introduction. (Hessler 2008: 101)

At first glance, Waldseemüller's female-gendered toponym, "America," seems to be created in *analogy* to Europe and Asia, the two continents named after women. Waldseemüller establishes a causal link that leads from the naming of the already "extensively explored" parts of the *oikoumene* to the "New World." *Because* Europe and Asia are named after women, Waldseemüller contends, so, too, the newly discovered continent shall bear a female toponym. Yet, Waldseemüller's line of reasoning is much more convoluted and, in fact, quite paradoxical. The naming of America after Amerigo Vespucci undermines his alleged toponymic analogy and complicates the female-gendered analogy. In contrast to Europe and Asia, America is *not* named after a woman, but after a male sailor and navigator. What Waldseemüller produces here is a disjunction between the historical figure of the male navigator who set foot on the newly discovered territory and the female-gendered imagery mobilized to reference "America." The transition from male to female occurs here in tandem with the transposition of the bodily imagery from the concrete male body to the abstract female body. In rhetorical terms, Waldseemüller engages in a process of troping from the literal to the metaphorical, indeed allegorical, body grounded in allegory's central feature: its *elusiveness* which, as Jeffrey Peters contends, is allegory's "basic unit of its formal design." America, the allegorized and feminized territorial rendering of the male Italian sailor has little in common with Amerigo Vespucci. It has also little in common with the shape of America, the continent.

The allegorized female body contained in the neologism "America" shares with "the allegorical maps that appeared in Europe during the early modern period . . . [that they] point us beyond the images figured on their surface to a conceptual place that often has little to do with what they show us" (Peters 2020: 94). In fact, Waldseemüller's toponym on the 1507 map mobilized an imagery powerful enough to prompt the creator of the first European atlas, Abraham Ortelius, to add "to personifications of Europe, Asia, and Africa, the earliest personification of America" (Van Duzer, 121) on the title page of his *Theatrum orbis terrarum*, first published in 1570 (Figure 5.1).

Subsequent allegories of America followed, including the famous "Allegory of America" by Jan van der Straet, called Stradanus, whose preparatory drawing from 1587 to 1589 shows the Florentine explorer

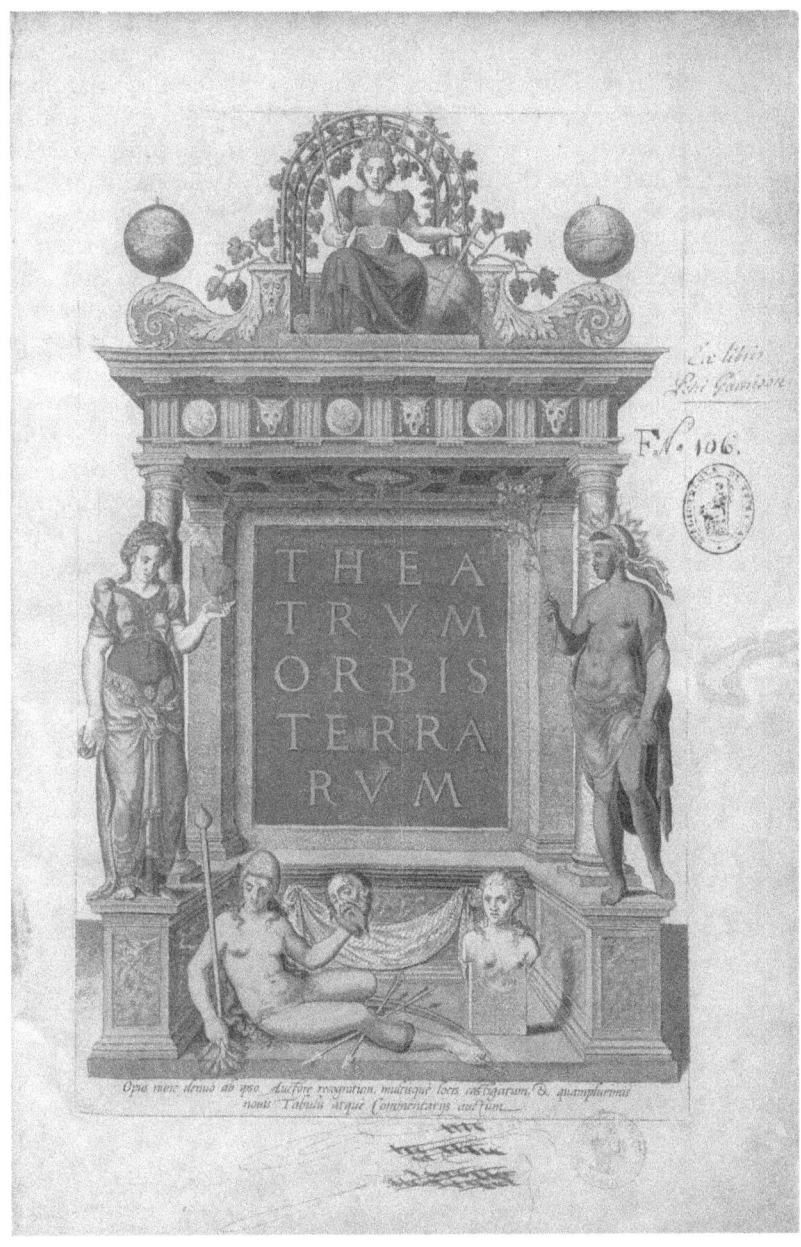

FIGURE 5.1 *Abraham Ortelius,* Theatrum Orbis Terrarum *(frontispiece), Antwerp, 1574. Bibliothèque nationale de France. GE DD-2005 (RES), 1r.*

Amerigo Vespucci as he encounters the allegorical figure America, seated on a hammock (Figure 5.2). The disjunction Stradanus performs in this drawing between the historical figure of Amerigo and the allegorized figure of America as they face each other epitomizes the juxtaposition not only between the referent and the name, but also between the concrete and the abstract, the literal and the metaphorical, which are here visualized and brought together into a deeply gendered relationship of signification.

As the example of Stradanus illustrates, the allegorization of territories and continents as female figures dovetailed with a process that might appear, at first glance, paradoxical: it served the purpose to sever the female body from the territory women occupy. Stradanus's visualization of the dichotomy between the male navigator and the female allegory of the continent as well as Ortelius's detachment of the female body from the maps proper and its concomitant relegation to the atlas's frontispiece in the shape of an allegorized ornament are representative illustrations of the early modern elimination of women not only from the effective cartographic process of creating and delineating new territories and continents, but also from inhabiting them in analogy to their male counterparts. Sebastian Münster's celebrated allegorical map of Europe as a "virgin"

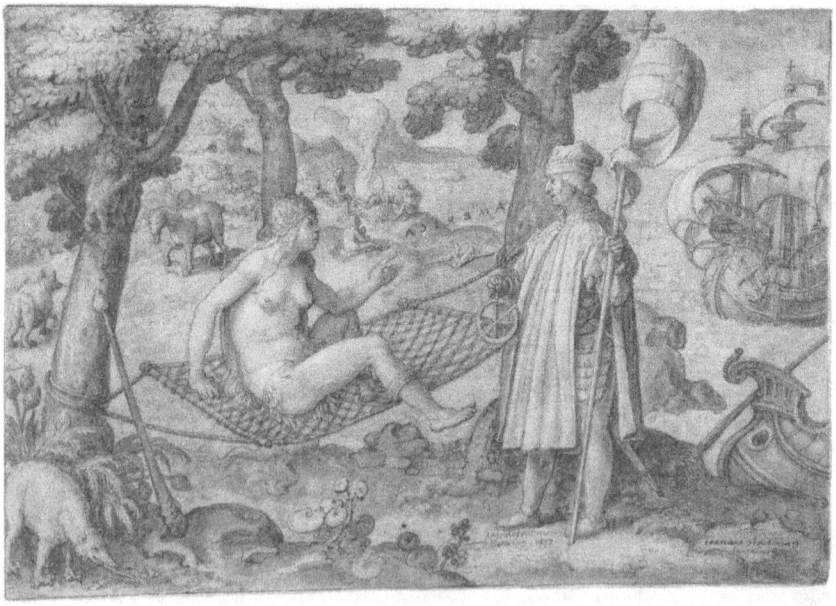

FIGURE 5.2 *Johannes Stradanus (Jan van der Straet):* Discovery of America: Vespucci Landing in America, *c. 1587–9. Metropolitan Museum of Art. Gift of Estate of James Hazen Hyde, 1959. 1974.205.*

(later called "Europa regina") is not an exception to this phenomenon but rather confirms it further: in the course of the sixteenth and seventeenth centuries, in particular with the rise of absolutism in Europe, women were increasingly excluded from power. The effective disjunction between male and female inhabitant is powerfully rendered by the tendency to relegate the female body to a visually powerful, but politically ineffective and innocuous, status.

Conclusion

Alice Pechriggl coined the term "screen-imagery" (*imaginaire-écran*) to capture the concomitant exclusion of women from power and their increased visual emergence in the guise of allegories. These two processes are, according to Pechriggl, two sides of the same coin:

> On a political level, the screen-imagery of femininity can be found, in particular, in the civic allegory, situated in a competitive relationship with the women at the margins of citizenry: the feminine as civic ideality is situated in relation to a socially more effective feminine, which, however, is placed under the aegis of a transcendent femininity, conceived as natural. The removal of women from the body politic, which is grounded in the model of the (both formed and uniform) male body, concerns the level of the effective concretion of the body politic. It finds its complement in the fixation of femininity on a more transcendent level of the civic imagery which also serves the consecrating and constitutive function of male self-representation in the domain of power—beyond those effects that are quasi- or proto-segregationist. (Pechriggl 2000: 34)

Pechriggl's insight into female allegories charts new itineraries that allow us to redirect common readings of the representation of territories as female-gendered allegories in an unexpected way. Studies of Ortelius's allegorization of Europe on the frontispiece of his 1570 atlas tend to frame Europe—seated on a throne in the upper part of the frontispiece, while Asia and Africa are positioned below Europe, to the left and right side of the page, and America is stretched at the bottom of the page—as an allegory of hegemony and Western power. That hegemony is expressed through the means of the spatialization and visualization of Europe is undeniable. Maryanne Cline Horowitz has quite correctly argued that "Ortelius substitutes for Europa a queen Europe, and transforms the court of kinswomen into a global court of ladies from Asia, Africa, and America" (Cline Horowitz 2021: 69). But Pechriggl's emphasis on the act of allegorizing women per se suggests that a lavish visualization of women—such as was practiced on allegorical maps—

does not necessarily dovetail with power. In fact, a gender-sensitive reading of Ortelius's frontispiece might signify the process of allegorization as what Stuart Elden has called *The Birth of Territory* (2013)—the emergence of increasingly delineated territories and continents from whose rule women were, with a few exceptions, excluded.

References

Benjamin, Braude (1997), "The Sons of Noah and the Construction of Ethnic and Geographical Identities in the Medieval and Early Modern Periods," *The William and Mary Quarterly* 54 (1): 103–42.

Butler, Judith (1993), *Bodies that Matter: On the Discursive Limits of Sex*, New York and London: Routledge.

Coddington, Kate (2015), "Feminist Geographies 'Beyond' Gender: de-Coupling Feminist Research and the Gendered Subject," Geography Compass 9 (4): 214–24.

Conley, Tom (1996), *The Self-Made Map: Cartographic Writing in Early Modern France*, Minneapolis: University of Minnesota Press.

Donne, John Donne (1996), "Elegy 2: To his Mistress Going to Bed," in John Carey (ed.), 422–3, *Selected Poetry*, Oxford: Oxford University Press.

Duzer, Chet Van (2021), "The Pre-History of the Personification of Continents on Maps: Earth, Ocean, and the Sons of Noah," in Maryanne Cline Horowitz and Louise Arizzoli (eds.), *Bodies and Maps: Early Modern Personifications of the Continents*, 101–29, Leiden/Boston: Brill.

Elden, Stuart (2013), *The Birth of Territory*, Chicago: University of Chicago Press.

Greene, Thomas E. (1989), "The Poetics of Discovery: A Reading of Donne's Elegy 19," *The Yale Journal of Criticism* 2 (2): 129–43.

Hayley, Saul and Emma Waterson, eds. (2019), *Affective Geographies of Transformation, Exploration and Adventure: Rethinking Frontiers*, London and New York: Routledge.

Hessler, John W., ed. (2008), The Naming of America: Martin Waldseemüller's 1507 World Map and the *Cosmographiae Introductio*, "Introduction," Washington, DC: The Library of Congress.

Hoonaard, Will C. Van Den (2013), *Map Worlds: A History of Women in Cartography*, Waterloo: Wilfrid Laurier University Press.

Horowitz, Maryanne Cline (2021), "Exotic Female (and Male) Continents: Early Modern Fourfold Division of Humanity," in Maryanne Cline Horowitz and Louise Arizzoli (eds.), *Bodies and Maps: Early Modern Personifications of the Continents*, 67–98, Leiden/Boston: Brill.

Hudson, Alice Hudson and Mary M. Ritzlin (2000), "Checklist of Pre-Twentieth-Century Women in Cartography," *Cartographica* 37 (3): 9–24.

Irigaray, Luce (1985), "The Power of Discourse and the Subordination of the Feminine," in Catherine Porter with Carolyn Burke (trans.), This Sex which is Not One, 68–105, Ithaca: Cornell University Press.

Johnson, Christine R. (2006), "Renaissance German Cosmographers and the Naming of America," *Past & Present* 191: 3–43.

Massey, Doreen (1984), *Spatial Divisions of Labour*, London: Macmillan.

Moss, Pamela and Avril Maddrell (2017), "Emergent and Divergent Spaces in the Women's March: The Challenges of Intersectionality and Inclusion," *Gender, Place and Culture: A Journal of Feminist Geography* 24 (5): 613-20.

Pechriggl, Alice (1999), "Der Körper in den Gestaltungen und Schichtungen des geschlechtsspezifischen Imaginären. Eine begriffssystematische Skizze," in Julika Funk and Cornelia Brück (eds.), *Körper-Konzepte*, 25, Tübingen: Narr.

Pechriggle, Alice (2000), Corps transfigures. *Stratifications de l'imaginaire des sexes / genres. Vol. 1:* Du corps à l'imaginaire civique, Paris: L'Harmattan.

Perrot, Michelle (1998), "Georges Duby et l'imaginaire-écran de la féminité," *Clio. Femmes, Genre, Histoire* 8: 13-28. For the online version see doi: 10.4000/clio.312, 1-10.

Peters, Jeffrey N. (2020), "Allegorical and Satirical Maps," in Matthew H. Edney and Mary Sponberg Pedley (eds.), *History of Cartography (4): Cartography in the European Enlightenment*, 94-102, Chicago: University of Chicago Press.

Piechocki, Katharina N. (2019), *Cartographic Humanism: The Making of Early Modern Europe*, Chicago: University of Chicago Press.

Postel, Guillaume (1993), *Cosmographiae Disciplinae Compendium*, Basel: Johannes Oporinus, 1561.

Rose, Gillian Rose, *Feminism and Geography: The Limits of Geographical Knowledge*, Minneapolis: University of Minnesota Press.

Wintle, Michael Wintle, (2021), "Gender and Race in the Personification of the Continents in the Early Modern Period: Building Eurocentrism," in Maryanne Cline Horowitz and Louise Arizzoli (eds.), *Bodies and Maps: Early Modern Personifications of the Continents*, 39-66, Leiden/Boston: Brill.

Wright, Melissa W. (2010), "Gender and Geography II: Bridging the Gap—Feminist, Queer, and the Geographical Imaginary," *Progress in Human Geography* 34 (1): 56-66.

PART II

Strategies

6

Bonds of Labor

Mahasweta Devi, Feminism, Leninism

Keya Ganguly

Among the most compelling sources of ideas about the relationship of capitalism and female labor must be Vladimir Ilyich Lenin's eponymous essay (Lenin 1913). That said, any reference to him these days seems passé, if not decidedly "unreconstructed," in the face of the correctives to classical Marxist ideas that have emerged, including within feminist circles (in the work of Federici 2004, for example). Nonetheless, it is to his propositions about the exploitation of women's labor and its specific role in capitalism that I will turn in order to set up a discussion of the Bengali activist-writer Mahasweta Devi's short story "Dhowli" ([1979] 2011).[1] My goals are twofold: first, I want to thematize Mahasweta's brand of radicalism—less as an end in itself than as the means to explore feminist frameworks attuned to forms of experience outside the bourgeois ideal of "a room of one's own."[2] Second, I want to consider the ways that the translation of Mahasweta's

[1] Anglophone readers are likely to read "Dhowli" in translation in Bardhan, K. (1990).
[2] Anglo-European conventions of referring to last names is difficult to observe in the case of Mahasweta, although several scholars have resorted to it. "Devi" (variously translated as "goddess," "gentlewoman," or "lady") is not a last name but a traditional social convention for referring to a Hindu woman, usually from the upper castes. Mahasweta abjured both her familial surname, "Ghatak," and her former husband's last name, "Bhattacharyya," in favor of using the honorific "Devi"—a not uncommon practice among Bengali women writers. I follow

prose, embedded as it is in the tribal dialect of her characters in the story in question, confronts us with a familiar exoticism that often assails peripheral literary works but has little to do with their "foreign" settings or subject matter. Stripped of their social and political *habitus*, such works lose their familiarity and everydayness when they are inserted into the abstract economy of World Literature whose preoccupations are far removed from their organic concerns.

What is more, Mahasweta's use of a vernacular dialect in her narration also defamiliarizes so-called native readers of Bengali from their own habits of reading, and in this way inserts a kind of interpretive standoff between *a priori* criteria of judgment (about feminist reading, for instance, or ecocritical investments, or even global literature) and an immanent critical orientation. Immanent critique demands reading on the terms solicited by the text itself, not hermetically or superficially, but by being attentive to what the late Moishe Postone called the "standpoint" of the text/object (Postone 1996: 14–141).[3] By invoking the immanent here, my intention is to distinguish between extrinsic evaluative criteria guiding interpretation—an approach that we can gloss very quickly as deriving from Kant's transcendental criticism—and, by contrast, approaches that follow a broadly Hegelian and Marxist commitment to pursuing an aesthetic object's internal logic and principles of construction.

The issue of female labor is just such an immanent consideration in "Dhowli." In this short story, the principal character's debasement serves as the point of departure—what Erich Auerbach famously called *Anzsatzpunkt* (Auerbach [1952] 1969)—for portraying a tribal woman's existence within the semi-feudal arrangements of rural India. Highlighting the slippage between physical and sexual labor, Mahasweta narrates the twists and turns of circumstance that take her protagonist, Dhowli, from widowhood to prostitution. Even if the story focalizes a number of other themes, from caste oppression and tribal sovereignty to field labor and enclosure, the reader's attention is rarely allowed to stray from Dhowli's fate, a reprise of the indignities attached to being poor, female, and tribal. The simplicity of the form is complicated only by the narrative voice which moves between standard Bengali and a local dialect, and is an insistent reminder of the "class struggle in language"—to invoke Mikhail Bakhtin's idea of *heteroglossia* (Bakhtin [1941] 1981).

As is the way of linguistic utterances that mark their embeddedness in social conflicts, Mahasweta deploys the vernacular hybrid of Bengali and Bhojpuri to render the tribals' distance from "proper" speech. In this fashion, the vernacular bears the weight of signifying the divisions separating

local custom (as well as Spivak) in referring to her by first name in the text and as "Devi" in citations.
[3]See also the important clarification of Postone's work by Larsen, N. (2009).

tribal existence from that of the rest of the citizenry, accentuating their marginalization within official nationalist discourse. Bakhtin's emphasis on the *heteroglossic* character of language is useful here because he not only stressed its dialogic aspects but also the suppression of the everyday speech of dominated groups—the ethnic minorities of Russia in the context of his writing. The relevance of his argument about multiple speech-genres and, specifically, about their internal tensions can hardly be overstated in coming to terms with Mahasweta's linguistic choices in this story. For in addition to foreclosing easy translation into the *lingua franca* of English, her choice of writing in a Bengali regularly interrupted by words outside its lexical universe also ruptures the presumptive equivalence between the authoritative discourse of Bengali and the sociolect of the tribal community of Dusads featured in "Dhowli." Very early on in the story, phrases like *abhi o moregi/*"now she will die" (Devi 158) and *dor lage na/*"does [she] feel no fear" (Devi 158) alert the reader to a mixed style that will henceforth bear the burden of representing diegetic and extra-diegetic points of view: that of the narrator's in standardized Bengali in opposition to the language that the Dusad characters speak or are spoken to by their caste superiors. The tribal form, in the phrases above, expresses the striated appearance of Bengali and its associated dialects, tweaking the reader into paying attention to the use, for example, of the dialectal *moregi* instead of the Bengali *morbe* to allude to death.

If the latter operates monologically, in an official style suited to translation as well (given the long history of Bengali-English translation), then we would have to say that the former only comes across as refracted and partial. A different example of this refraction of the monological by its other can be seen in the exchange between Dhowli and the head coolie on the construction site in the story who has made his sexual intent clear:

> Dhowli: Let go of my hand.
> Man lets it go.
> Dhowli: Did you throw a clod of mud at my door?
> Man: Yes.
> The man makes a gesture. Dhowli understands her fate. She pauses,
> exhales, and says: All right, and . . .
> Man: What?
> Dhowli: Bring money.
> Man: Money!
> Dhowli: Bring money and corn. If I open my shop, should I not demand
> a price?[4]

This exchange, which sets into motion Dhowli's destiny as a prostitute, is noteworthy because of the economy with which the narrator describes the

[4]Devi, M. 2011 [1979], 181.

inevitability of Dhowli's decision. It reinforces the stripped-down quality of transactional sex, though in Kalpana Bardhan's otherwise capable translation, the gaps between what is said and what does not need saying are too quickly filled as follows: "'Are you the one who throws clods at my door in the night?' The man says yes and gestures to indicate why. Dhowli thinks for a minute. Then she says, 'All right, I'll open the door. But you must bring money and corn with you. I am not selling on credit'" (Bardhan 1990: 202). Aside from the strange substitution of the word "credit" for the Bengali word for "price" (*daam*), Bardhan also loses the staccato quality of the exchange and the minimalism of Mahasweta's portrayal of Dhowli's turmoil—in a version of what, to adduce Roland Barthes, we might call zero-degree writing (Barthes [1953] 1967). As the narrator has observed a few pages earlier, Dhowli realizes that her life is without hope, without even the possibility of fulfilling hope. Accordingly, her emotionless demand to be paid for her services works to render her capitulation to the man as a capitulation to capitalist common sense, whose drive the reader is immanently exhorted to abjure.

The struggle that the narrative stages between words and their meanings is heightened for the reader by the use of free indirect discourse to capture Dhowli's estrangement—from the language of her social superiors, the lover who impregnates and abandons her, the villagers whose mockery and abuse follow her everywhere, the mother who bemoans her daughter's fate, and even from herself as she reckons with her body and its forbidden fantasies of love and propriety. To follow my reference to Postone above, we might say that the "standpoint" of the central figure, Dhowli, is the one that the reader is enjoined to inhabit. Crucially, though, the objective of immanent reading is not to succumb to the character's point of view so much as to expose the contradictions that underlie it. As I have already suggested, the problem of translation is critical here because what is lost, or at least rendered murky in translation, is the specificity of the *patois* that conveys the speech of Dhowli, her mother, and other "untouchable" tribals—in Mahasweta's use of it to distinguish between their worldview and the dominant language of the upper-caste landowners and their henchmen.

Interestingly, at the story's end the dialect is left behind—excepting the repetition of one word: *randī* (whore, slut) (Devi [1979] 2011: 185)).[5] At this point, the diction turns to a lyrical and flowing Bengali, the narrator ventriloquizing Dhowli's thoughts as she boards the bus to register as a prostitute in the city of Ranchi (the present capital of the Indian state of

[5] Although seeming like a cognate, the Hindi word *randī* (pronounced *run-dee*) is not related to the English "randy."

Jharkhand). Everything was supposed to change on this day, Dhowli muses, but nature it turns out is indifferent to her plight and that of the other whores with whom she is going to be affiliated. She departs in the knowledge that her life will never be the same, not knowing if her forest sanctuary has betrayed her as well, or whether the indifference of the sun, earth, and sky to her transformation signals their own alienated existence as saleable objects. But the ending is less a pathetic fallacy than a querying, from the margins, of the many ways in which surplus is appropriated within the division of labor: Can it be that nature, which is not the creation of Dhowli's oppressors, has nevertheless been sold to them? In leaving this question unanswered, the last line of the story reinforces the uncertainty that obtains throughout—between character and reader, story and situation, not to mention mimetic form and historical consciousness.

I will return to the issue of uncertainty at the end, but for now let me say that it is in the context of reflecting on Dhowli's perturbations about selling her body that Lenin's contentions about the exploitation of female labor in the form of concubinage, sex slavery, or prostitution deserve our attention again. As he observed, capitalists and women pay very different kinds of price for their labor, the former with some small amount of money, the latter with their bodies and often with their diseased and demeaned lives. In his words, "capitalists of all countries recruit for themselves (like the ancient slave-owners and the medieval feudal lords) any number of concubines at a most 'reasonable' price" (Lenin 1913: 230–1). We should also note his point that although modes of sexual enslavement preceded capitalism, what has intensified in its regime is the leakage between wage and sex slavery. Female sexual labor accordingly serves as one of the most acute examples of the sublation of exploitation into the universal principle of exchange: money for "love."

In Lenin's discussion of the exchange principle, prostitution comes into view as a difference in degree rather than kind—*the sexual counterpart of assembly-line production*, an idea that contemporary readers may associate with Walter Benjamin's later propositions about the prostitute who sells herself as a commodity among other commodities (Benjamin [1982] 1999). Although less enthralled than Benjamin by the commodity's seductiveness, Lenin was only too proleptic in observing the double distortion of female labor as wage *and* sex slavery. Moreover, he points out that this distortion is an element in the *longue durée* of all societies predicated on exchange: "Slavery, feudalism, and capitalism are identical in this respect. It is only the *form* of exploitation that changes; the exploitation itself remains" (Lenin 1913: 230–1).

While Lenin's ideas about the universality of female exploitation enable us to situate Mahasweta's literary explorations of the same subject, they do not by that token necessitate branding her a Leninist or reading "Dhowli"

as some sort of Fordist parable.⁶ For one, she herself was averse to such labeling, a reluctance in part stemming from her criticisms of the Left-front government in her native state of West Bengal, and in part from her resistance to easy categorizations that mystify more than they explain. Mahasweta was also quite aware of the fact—though unconcerned by knowing it—that her reception in Anglo-American circuits of literary influence was complicated by the difficulty in making fine-grained distinctions about left thinking, especially outside the West. Indeed, it would be difficult to deny the ambivalence with which Leninism or Marxism is met when not attached to a "post," "neo," "intersectional," or other modifier of relevance and complexity. There is also a good deal of antipathy to political strategies premised on imputing false consciousness to the subaltern, particularly when there is any hint of intellectual vanguardism. These days such strategies are almost axiomatically taken to be elitist or authoritarian. And yet, this was Mahasweta's daily milieu: writing petitions to the courts on behalf of illiterate *Adivasi* (indigenous) communities, leading protest marches, commandeering the attention of local and national politicians to demand justice for "denotified" tribes, schooling them (sometimes literally) on their rights and responsibilities, and of course, disseminating their experience through her writings.⁷

Metropolitan sensitivities about "speaking for the other" (often regarded as arrogant, condescending, or misguided) have made it difficult to take stock of political and aesthetic outlooks that willingly accept the risks and responsibilities that come with left commitments. So, although from around 2005 Mahasweta distanced herself from the Left-front government (in power from 1977–2011), this had less to do with any change in her political perspective than the conviction that the communists had failed to improve the lot of tribal populations. As she put it in a 1997 interview, "I am Left. I will remain Left. No party or nothing and I haven't read any theory. I always say that all I have read is man" (Devi quoted in Collu 1998: 144). Her position was thus a repudiation of the state's inability to live up to its mandate of emancipatory social change, not of programmatic, organizational activity on behalf of the oppressed. Criticisms of state governance aside, even a brief glance at her writings reveals not only that she took social inequality to be the main blockage to political freedom, but also that the problems animating her literary efforts—feudalism, uneven dynamics of gender, exploitation of humans and nature, state violence—are

⁶While Antonio Gramsci is often credited with the discussion of Fordism, Lenin (1914) remains the original source for our understanding of the Taylorist mode of production underlying Fordism's assembly-line principles.

⁷Under the 1871 "Criminal Tribes Act," the British "notified" a majority of tribal communities as criminal. Their "denotification" in 1952, after Indian independence, has not prevented their continued persecution.

all limned in terms that avow, rather than evade, the role of the intellectual in exposing social contradictions.

Moreover, she sought fundamental changes to the nature of Indian society in ways that ran counter to the nation's flattering self-image of a democracy—given its practices of normalized violence against tribal peoples who to this day continue to be criminalized as insurgents, terrorists, and Maoists. Seen in full perspective, then, Mahasweta's fiction as well as her activism on behalf of grassroots movements abundantly reflect the consistency of her engagements, with the marginalization of India's tribal populations figuring principally in her critique of social relations. In this sense, her affinity with Leninist ideas was less theoretical than organic and practical, her outlook firmly trained on what Georg Lukács, in his comments on Lenin's thought and practice, referred to as a "concrete analysis of the concrete situation" (Lukács [1924] 2009: 34). It should of course be noted that Mahasweta would not necessarily grant such a theoretical affinity, once stating that she had never read any Lenin, Mao, or Marx, though open to allowing her writings to be read by their light (Devi in Katyal 2003: 22).

In a different approach that locates "Dhowli" within an ecocritical paradigm, Jennifer Wenzel has argued that the use of free indirect discourse implicates the reader in the main character's misrecognition of her relationship especially to the forest, but also to notions of propriety, common sense, and scandal. Wenzel reads the story in terms of her overarching interest in "the disposition of nature," taking the tensions between what Dhowli the character vocalizes and the reader's knowledge to be the key lever of narrative movement. To quote Wenzel: "Dhowli's powerful—if unvoiced critique—reflects a subaltern woman's recognition of her place within structural injustice and the possibilities for negotiating it. This narrative strategy is common to Mahasweta's fiction. Her subaltern characters perceive glimmers of systemic exploitation but the full implications of their insights—what lies beneath the 'superficial truth' [. . .]—are often voiced only for the reader" (Wenzel 2019: 164).

While I find Wenzel's discussion of the links between sex work, the privatization of nature, and the logic of extraction quite valuable, the issues she highlights are, as I see it, ancillary to the story's own immanent drive not only to show the equivalence between women's exploitation and the extraction of surplus, but also to contest it—through a laying bare of its premises. Consequently, although Wenzel rightly draws attention to the ways that the "resource logic" of expenditure and waste functions in the story, there is a certain dissonance in Mahasweta's code-switching between standard Bengali and the tribals' dialect that, however falteringly, rebukes this very logic. I would add that this dissonance moves the reader from getting caught up in the inevitabilism of the "always-already" degradation of life under capitalism—what to somewhat different ends Hegel called "the ruse of reason"; instead, the effect of the dissonance is contrapuntal, leading

us to an awareness of two incompatible forms of utterance by whose means the equivalence between humans, nature, and commerce is inscribed, on the one hand, and perturbed, on the other.

Take the word *randī* that Dhowli uses to ponder her options as a prostitute and that the narrator echoes at the end. A more polite Bengali might have dictated the word *bēśyā* (from the Sanskrit *vaishya*), but this is only the most obvious instance of resistance to a normative hierarchy of value through which the narrative signals the incommensurate worldview of indigenous subjects living outside a regime in which property and propriety are ineluctably joined. It is not merely Dhowli's acceptance of the fact that in order to survive she will have to sell herself, but also her realization that being a sex worker is not all that different from her previous roles as a wife, a comely woman, or lover. Mahasweta indicates this distance between a normative view of sexual propriety and Dhowli's matter-of-fact recognition of her new status:

> Many paid. Many continued to come. Dhowli and her mother were once more able to wear clothes that were not rags. They could eat two square meals. She fell soundly asleep as soon as the client left. How easy it is to sell one's body, without any emotion, for corn, millet, and salt. Had she known it would be so easy, she would have done it earlier. And the baby would also be better fed and healthy. Dhowli thinks that she had been very stupid [to resist]. (Devi [1979] 2011: 182)[8]

We should note the oscillation between Dhowli's self-understanding and the narrator's attributions of her consciousness; it is among the few times in the story that the two points of view converge on the harsh reality of sexual labor. The men remain unnamed in this passage and disappear behind the solidity of money and food. If Dhowli unsentimentally views her changed lot, then the word *randī* underscores the coarseness of being a cheap whore, an inflection that is not immediately forthcoming with the word *prostitute* or even *whore*—both of which conjure only the selling of sex whereas the pressure here is put on the vulgarity that underlies all forms of commodified labor. This granted, we might say that it is the difference between the bourgeois repression of the vulgarity of commodification and Dhowli's emergent detachment from such delicacy that Mahasweta establishes with her word choice, though it is elided in translation.

In paying attention to such translative details, I do not wish to subscribe to a purist view of original texts or the impossibility of reading in translation. Rather, my point is to suggest that English is largely deaf to the conflicts thrown in the face of readers by the use of a demotic form that aims to

[8] My translation. Its equivalent in the published version appears in Bardhan (1990: 202).

disrupt the regulative logic of reading itself. To this end, Mahasweta is never "affirmative" in her representations of an unjust world: there is no consolation provided in her stories, no intimation that a better world is around the corner or, at least, discernible within narrative horizons. For this move belongs to bourgeois thought—which, if we recall Herbert Marcuse's critique of affirmative culture (Marcuse [1937] 1968), ends up mistaking the meaning of a film about revolution to be revolutionary in impulse! By contrast, what we often get—and this is certainly true of "Dhowli"—are partial gestures that articulate an entirely different set of equivalences between imperiled languages and endangered lives.

The interpretive nuance I am trying to offer differs from Wenzel's observation that the characters' insights into their exploitation is fully available only to the reader; my emphasis has to do with the aporia that opens up between denotation and connotation. At the connotative level, it is indeed the case that thoughtful readers are invited to recognize that Dhowli's "having been rendered surplus" is not just a plaint but also contains a "claim for social inclusion"—what Wenzel calls a "world-imagining from below" (Wenzel 2019: 164). However, such a world still operates on the terms of dominant understanding even if it reverses capitalism's ontological premises about value. The only exception to it occurs less through a "reframing" of the parameters of exclusion and across geographical scale, as Wenzel would have it, than at the level of utterances which repeatedly draw attention to the incursion of the peripheral into our field of vision; or, put more strictly, to the incursion of the peripheral aspects of peripherality itself.

The historical development of Bengali is a case in point; it has continually registered the presence of other regional linguistic codes (such as Braj and Bhojpuri) and folk idioms and dialects (differently modulated in West Bengal, Tripura, parts of Assam and Bangladesh, all of whom share it as their official language, with approximately 250 million speakers) even as it rounded into modern view under the dual weight of imperial English and the majoritarian "national" language of Hindi. Regional or *anchalik* Bengali, the demotic form preferred by Mahasweta in her tribal tales, serves as a repository of the contestations underlying the ways that the "residual" is incorporated into the "dominant"—as Raymond Williams taught us (Williams 1977). In addition, this regional form is a present reminder that those contestations have been rendered out of place in the erasure of their lived social dispositions.[9] That is to say, voices such as Dhowli's express a point of view that enters, and almost as quickly exits, the representational

[9] I am grateful to Auritro Majumder for pointing out to me that the emergence of mixed Bangla runs parallel to the standardized language ever since the latter was formalized in the early 1800s. Among literary texts, this is commonly seen in the deployment of *Tadbhava* with strong Urdu-Farsi-Arabic elements, also called *do-bhashi* or literally two languages, and secondly in the use of *anchalik* or regional speech especially for non-urban characters.

matrix in which Mahasweta plots them—to accentuate their marginality of course, but also to mark their resistance to being contained within a story about capital, nationhood, female subjectivity, postcoloniality, ecology, difference, and so forth. These voices and their utterances are in fact peripheral to the axioms by which the discussion of peripherality has taken place, and it is in this remaindered mode that Mahasweta impresses upon us the autonomy of literature.

The influence of Gayatri Chakravorty Spivak on introducing Mahasweta Devi's literary writings to Anglo-American readers is undeniable. Her translations of selected texts (such as "Stanodayini"/"The Breast-Giver" and the three short stories in the collection titled *Imaginary Maps*) are representative of Spivak's efforts, over many years, to make a metropolitan readership aware of Mahasweta's importance; for the most part, this is an audience largely ignorant not only about the vernacular literatures of India but even, more specifically, about the role of leftist intellectuals in the public sphere. In the process, Spivak has thematized the difficulty of assimilating Mahasweta into the "world republic of letters," to echo the title of Pascale Casanova's acclaimed book (Casanova [1999] 2004), though Spivak's own investment in deconstructionist protocols of reading produces difficulties that, I would have to say, detract from her broader interpretive and political goals. For instance, in commenting on another of Mahasweta's short stories, "Douloti the Bountiful," Spivak offers a reading of three sites of inscription in the story—of space, labor, and the woman's body, although a fourth site is then brought into her discussion of space through references to "decolonized terrain," "parliamentary democracy and nationalism," and "postcoloniality in the space of difference" (Spivak 1989–1990: 106, 117, 105). In her words:

> "Douloti the Bountiful" shows us that it is possible to consider sociosexual (in)difference philosophically prior to the reversal of the established codes, before the bestowal of *affective* value on homo- or hommo- or yet heterosexuality. To think therefore that the story is an evolutionary lament stating that *their* problems are not yet accessible to *our* solutions and that they must simply come through into nationalism in order then to debate sexual preference is a mistake. On the other hand, this prior space, prior to the origin of coded sexual difference/preference is not the neutrality of the Heideggerian *Geschlecht*. This space is "unmotivated" according to the presuppositions of naturalized sexuality. (Spivak 1989–90:123, original emphases)

We can surely assent to the idea that metropolitan conceptions of sexual difference or preference, the target of Spivak's critique in the quotation above, cannot accommodate the "prior space" of a form of sexuality that remains "uncoded" on the terms of homo- or heterosexuality. But this insight seems to me to be immediately lost because of its subsumption

into a Derridean preoccupation (via Heidegger) on an untranslated, and perhaps untranslatable, word: *Geschlecht*, which designates everything from humanity, nation, race, species, and genre to family, generations, and sex.[10] Spivak's productive remarks on the specificity of Mahasweta's enterprise, which is to give voice to the impossibility of even having a relationship to one's sexuality in the lives of bonded laborers, gets diverted by this means and incorporated into tortured formulations about value-coding and ego splitting, displacements and *différends*. But what of Mahasweta's language itself?

Unlike Spivak's assertions about the ways that incommensurabilities are summoned in Mahasweta's linguistic *métier*, I would suggest a distinction between emphasizing the displacements of language, on the one hand, and obscuring the very purpose of narration, on the other. What is vibrant about Mahasweta's prose is that she brings the everyday realities of tribal existence sumptuously into our ken without nostalgia or reverence and, equally, without any interest in speaking or writing back to empire in the terms we have come to expect within mainstream postcolonial criticism. Often in such scholarship, the presumption is that ontology rather than material existence demarcates the fissures between what for lack of better descriptors one might gloss as "Western subjectivity" and "non-Western others." Nor, I would have to say, does Mahasweta advance any notion of the unintelligibility of subaltern speech. Hers is a discontinuous project that throws into relief the different kinds of conceptual labor that language both performs and solicits. In its encoding of multiple registers of meaning—some amenable to being translated, others more resistant to being assimilated into the dominant language of English or, for that matter, Bengali—to disclosing how literary forms transmit historical understanding. In its encoding of multiple registers of meaning (some amenable to being translated, others more resistant to being assimilated into the dominant language of English or, for that matter, Bengali), to disclosing how literary forms transmit historical understanding, Mahasweta's formal choices once more return us to the orbit of immanent critique.

The argument about the immanent relationship between form and history, what Fredric Jameson has put forward as the "historicity of form" (Jameson 2015), has concretely benefited our understanding of peripheral literature in Auritro Majumder's recent elaboration of Mahasweta's fiction (Majumder 2021). In pointing out that her corpus extends far beyond the English translations of selected texts that have gained prominence in Anglo-American circles, Majumder notes the diminution of her scope and reputation as one of the most translated contemporary authors in other

[10]My thanks to Kyle Baasch for his careful parsing of *Geschlecht*, a word whose polysemy cloaks its archaism and, arguably, its irrelevance to materialist thought. I have also relied on N. Gabriel Martin's review of David Farrell Krell's *Phantoms of the Other: Four Generations of Derrida's Geschlecht* in Notre Dame Philosophical Reviews (online), June 19, 2015, accessed on January 1, 21 at https://ndpr.nd.edu/news/hantoms-of-the-other-four-generations-of-derrida-s-geschlecht/.

Indian languages—such as Assamese, Gujarati, Hindi, Malayalam, Marathi, Oriya, Punjabi, Telegu, and Ho, a tribal language (Majumder 2021: 126). He also emphasizes the mutation that occurs when a writer thoroughly immersed in organic—rather than academic—debates over culture and politics in the periphery is catapulted into the Western imagination as a solitary exemplar of approved literary or cultural values, but cut loose from their moorings. The conclusion we should derive from Majumder is not that there is an authentic, vernacular world which metropolitan readers cannot access; rather, it is that many of the writers designated as peripheral, Mahasweta prominently among them, were involved in serious discussions—over several decades—about the global dimensions of literature and its role in the dissemination of a universal history.[11]

The last point would of course be anathema to postmodern attitudes which have decried anything smacking of the universal (even if one is perennially in need of confronting the contradiction that the argot of "theory," in its migration into the universal idiom of English from, say, French or German, and its effective dominance worldwide, itself poses). Notwithstanding the almost preprogrammed rejection of universality in approaches that seek to valorize alterity and otherness, Majumder stresses the perverse effects of rendering peripheral writing into the mirror image of metropolitan thinking, given the tendency to conflate a critique of capitalism's universalizing impulse with an endorsement of subaltern difference.[12] By contrast, he avers, "History, in Devi's conception, refers to the determinate interconnectedness of the modern world," and in such a rendition, the conventional binary between center and periphery is complicated by their mutual though uneven determinations (Majumder 2021: 130). Also, by inserting a nuance Majumder derives from Theodor Adorno on the incomplete and dialectical interactions between a writer's objective to grasp the totality of the world and the world itself, he fruitfully elaborates the distance of this position from the ideals of discontinuity or fragmentation that have become articles of faith in postcolonial as well as feminist criticism (Majumder 2021: 163).

Let me return, finally, to the issue of uncertainty I brought up earlier in conjunction with contrasting story and situation as well as mimetic form and historical consciousness. A significant problem in entering the fictional worlds of Mahasweta's creation resides in figuring out what to take away from it while not losing sight of its own situatedness: does it speak on the terms of political theory—for example, on the status of prostitution, as Lopamudra Basu has opined (Basu 2010)? Is it a quasi-documentary revelation of material conditions and class antagonisms, what Neil Lazarus

[11] The topic of universal history has been importantly resuscitated by Susan Buck-Morss (2009).
[12] A similar line of argument can be found in Priyamvada Gopal's *Literary Radicalism in India* (2005).

refers to as the "content of subaltern consciousness" (Lazarus 2011: 155)? Or is it rather an epistemological exploration of conceptual issues (such as "difference" in Spivak's discussion of "Douloti")? A metacritical treatment of ecological problematics (à la Wenzel)? Majumder's astute discussion of peripheral internationalism? And then there is perhaps the most pertinent question in the context of this volume: is Mahasweta's writing feminist? While one may reply in the affirmative to all of these questions, the answer to the last is the most vexed—on the agenda of feminism per se or and even more when the banner of "intersectional" criticism is flown.

In the interview from 1997 that I cited earlier in this chapter, Mahasweta is quite definite in her responses to the interviewer, Gabrielle Collu (abbreviated by her initials), who appears not to be able to cede her own identitarian assumptions in querying Mahasweta's representational politics:

> M.D. [. . .] I believe in class division, I believe in class trouble, I believe in class oppression, all these exist in India *and with it comes everything*.
> G.C. But isn't it more difficult for a woman because of her gender?
> M.D. Why! Why! Why! Because I am a woman? I never consider myself as a woman writer, as a feminist. Nothing. I am a writer. I am a writer and when I write, *I write of such people who live much below the poverty lines*. They are men, women, and children. I don't isolate the woman. Women have to pay a lot. They also have their special problems. They come to my stories naturally, not just to uphold the woman.
> G.C. No, but when we read your stories, when I read your stories, the women seem to suffer a double oppression because they are women.
> M.D. Yes, a woman in the poorer class, she suffers because of her class, she suffers because of her body. That is always there. That has to be brought out but that does not mean I am especially gender-biased.
> G.C. No, it doesn't but you are writing about women.
> M.D. I write about men. I write about women. I write about both. (Devi in Collu 1998: 145–6, added emphases)

It would be a mistake to see this interview as an isolated instance or aberration. Mahasweta's refusal to be fixed as a woman writer or feminist thinker was as constant as it is noteworthy. In underlining poverty as the principal cause of immiseration, including that of women, she also reveals her disregard for modes of thought that would consider otherwise. Despite the interviewer's attempts to prioritize her representation of women, Mahasweta demurs, not out of a dogmatic rejection of feminism's project but precisely out of a supple understanding of social existence—that gender and other axes of oppression are overlaid on the fundamental contradiction of class, particularly when it comes to global realities. If one must establish

a monopoly on suffering, it belongs to the poor: men, women, and children. In her persistent rebuke to metropolitan anxieties about giving equal time to class, race, or sexuality—as though these concepts might override the real—Mahasweta leaves us with a cautionary tale that a genuinely reflexive feminist approach would do well to heed.

References

Auerbach, E. ([1952] 1969), "Philology and *Weltliteratur*," E. and M. Said (trans.) *The Centennial Review* 13 (1): 1–17.
Bakhtin, M. ([1941] 1981), "Discourse in the Novel," in M. Holquist and C. Emerson (trans.), *The Dialogic Imagination*, 259–423, Austin: University of Texas Press.
Bardhan, K., ed. (1990), *Of Women, Outcastes, Peasants, and Rebels: A Collection of Bengali Short Stories*, 185–205, Berkeley and Los Angeles: University of California Press.
Barthes, R. ([1953] 1967), *Writing Degree Zero*, trans. A. Lavers and C. Smith, London: Jonathan Cape.
Basu, L. (2010), "Mourning and Motherhood: Transforming Loss in Representations of Adivasi Mothers in Mahasweta Devi's Short Stories," in P. Dodgson-Katiyo and G. Wisker (eds.), *Rites of Passage in Postcolonial Women's Writing*, 127–47, Amsterdam: Brill/Rodopi.
Benjamin, W. ([1982] 1999), The Arcades Project, trans. H. Eiland and K. McLaughlin, Cambridge: Harvard University Press.
Buck-Morss, S. (2009), *Hegel, Haiti, and Universal History*, Pittsburgh: University of Pittsburgh Press.
Casanova, P. (1999), *The World Republic of Letters*, trans. M. B. DeBevoise, Cambridge: Harvard University Press.
Collu, G. (1998), "Speaking with Mahasweta Devi," *Journal of Commonwealth Literature* 33 (2): 143–8.
Devi, M. ([1979] 2011), *Mahasweta Devi 75 ti Golpo*, 167–85, Calcutta: Karuna Prakashani.
Federici, S. (2004), *Caliban and the Witch: Women, the Body, and Primitive Accumulation*, New York: Autonomedia.
Gopal, P. (2005), *Literary Radicalism in India: Gender, Nation, and the Transition to Independence*, London: Routledge.
Jameson, F. (2015), *The Ancients and the Postmoderns: On the Historicity of Forms*, London: Verso.
Katyal, A. (2003), "Transcript of Mahasweta Devi," "Global Feminisms: Comparative Case Studies of Women's Activism and Scholarship," 4–26. Available online: https://sites.lsa.umich.edu/globalfeminisms/wp-content/uploads/sites/787/2020/05/Devi_I_E_102806.pdf (accessed January 29, 2021).
Larsen, N. (2009), "Literature, Immanent Critique, and the Problem of Standpoint," *Mediations: Journal of the Marxist Literary Group* 24 (2): 48–65.
Lazarus, N. (2011), *The Postcolonial Unconscious*. Cambridge: Cambridge University Press.

Lenin, V. I. (1913), "Capitalism and Female Labour," *Pravda* 102 (May 5), later published in *Lenin: Collected Works*, vol. 36. Moscow: Progress Publishers, 1971: 230–1. Available online: https://www.marxists.org/archive/lenin/works/1913/apr/27.htm (accessed January 1, 2021).

Lenin, V. I. (1914), "Man's Enslavement by the Machine," *Put Pravdy* 35 (March 13), later published in *Lenin: Collected Works*, vol. 20. Moscow Progress Publishers, 152–4. Available online: https://www.marxists.org/archive/lenin/works/1914/mar/13.htm (accessed January 29, 2021).

Lukács, G. ([1924] 2009), *Lenin: A Study on the Unity of his Thought*, trans. N. Jacobs, London: Verso Books.

Majumder, A. (2021), *Insurgent Imaginations: World Literature and the Periphery*, Cambridge: Cambridge University Press.

Marcuse, H. ([1937] 1968), "Affirmative Culture," in J. J. Shapiro (trans.), *Negations: Essays in Critical Theory*, 88–133, London: Allen Lane/Penguin.

Postone, M. (1996), *Time, Labor, and Social Domination*, Cambridge: Cambridge University Press.

Spivak, G. C. (1989–1990), "Woman in Difference: 'Douloti the Bountiful,'" *Cultural Critique* 14: 105–28.

Wenzel, J. (2019), *The Disposition of Nature: Environmental Crisis and World Literature*, New York: Fordham University Press.

Williams, R. (1977), "Dominant, Residual, and Emergent," in *Marxism and Literature*, 121–6, Oxford: Oxford University Press.

7

The Worlds That Women Collect

Lisa Ryoko Wakamiya

Literature exhibits women's collecting and contributes to its worlding by recognizing its various forms and extending it into wider cultural networks. When writer-collectors structure their work around a theory of collecting, the work itself becomes a collection that illustrates its processes of knowledge production. To regard a work of literature as a medium for identifying women's collections and as a collection in itself is to see a connection between collecting and writing, as well as the possibilities and constraints this connection places on both processes. This premise brings with it two related categories which will be examined in this chapter—"women's collecting," and narratives about collecting as collections in themselves. One of the goals of this chapter is to consider the ramifications of mapping gender onto collecting, when the woman collector, effaced and recognizable only by other names, is recovered. Another is to consider narratives as collections, at once constrained by the predetermined structures of collections and set into relational networks that expand their possibilities for making meaning.

The worlding of women's collections through literature allows for a way to conceptualize the work of women writer-collectors for whom collecting provides an approach to understanding the relationships between objects, people, and the world. Worlding accounts for the simultaneity of varied practices—curating, fiction writing, scholarship, and criticism—widening the possibilities for situating their activity within an expansive nexus of mutually informing activity, rather than maintaining conceptually distinct dichotomies of professional/amateur, public/private, conservation/use.[1]

[1] I draw from Mei Zhan's definition of worlding as "a way of thinking about the 'oneness'—entanglement and simultaneity—of knowledge-making and world-making" (2010).

For the woman writer-collector who elaborates a theory of collecting as she practices it, the self-reflective dialogue between writing and collecting acknowledges institutionalized discourses of collecting while integrating those discourses into a larger network of affinities, illustrating the processes by which they become re-worlded in literature.[2]

One of the implications of this study for feminist theory is to respond to genealogies—which in the case of worlding trace back to Martin Heidegger and in the case of collecting to colonial practices and psychoanalysis—through a consideration of literary texts that methodologically link worlds and collections. The linear model of inheritance assumed by genealogy supposes that its processes will remain stable and ongoing, yet they require continual reassessment, "an interested, conscious thinking and rethinking of history and historicity" (Alexander and Mohanty 1997: xvi). Heidegger's phenomenological account of worlding, and Spivak's reconsideration of it in her inquiry into the worlding of colonized spaces and how women fare within them, represent such a reassessment of literature's engagement with the world's open-ended processes of becoming (Cheah 2016: 8). The networks of relation that shape collections similarly undergo reevaluation. As collections become reinterpreted over time, what begins as an individual collection—and the narrative that accompanies its gradual accrual—becomes another generation's inheritance. These narratives may situate the collection's origins in the colonial enterprise or respond critically to these origins, idealize systems of object relations or acknowledge the problematic cognition of women in object relations discourse. Approached in this way, the complex relationship between worlding and collecting becomes apparent. A temporally and structurally open world resists hierarchies of inclusion and exclusion, yet the world is frequently conceptualized in spatial terms that reinforce such hierarchies (Cheah 2016: 129). Collections are defined by these hierarchies from the outset, but hold the promise of expanding beyond them to create new relational networks.

The work of Dianne Sachko MacCleod, Kate Hill, and other scholars demonstrates that women collectors were "hidden in plain sight" (Hill 2021). Despite the trope of their "invisibility," women's collections were not exclusively relegated to the domestic sphere (nor were men's collections exclusively institutional and public). MacCleod further takes issue with the assumption that "women" and "men" are valid categories around which gendered theories of collecting can be advanced, arguing instead for "feminine" and "masculine" styles of collecting and variations therewith that can be practiced by either sex (2008). Studies of women's collecting,

[2]Here I acknowledge my debt to Adhira Mangalagiri's reading of Dipesh Chakrabarty's *Provincializing Europe* (2014: 307).

museology, and art history are in deep conversation with each other, a conversation this chapter will extend to include literature.

Belk suggests that literature has attempted to contribute to understanding collectors' motivations, noting "a number of fictional treatments that generally portray the collector as strange, obsessive-compulsive, antisocial, or someone who prefers things to people (e.g., Balzac 1848/1968; Boyle 1994; Chatwin 1989; Connell 1974; Flaubert 1880/1954; Fowles 1963; Nicholson 1994; Pynchon 1966)" (Belk 2006: 538). Of the works he cites, none are by women, and the two that feature women collectors are satires in which one is a shopping addict (Boyle) and the other a serial seductress who collects lovers (Nicholson). The claim by Belk (1994), Baudrillard (1994), Muensterberger (1994), and others that a collected object must be "divested of its function, abstracted from any practical context" (Baudrillard 1994: 8), encourages a solipsistic view in which the collector's subjective values, and by extension the collector, become incomprehensible to others, or are comprehensible only through the lens of psychoanalysis or "the system of objects" (Muensterberger 1994; Baudrillard 1968). If there is any common thread among women writer-collectors, it is that they acknowledge how institutionalized collecting enables social bonds and worlds of shared values, however constructive or reductive these values ultimately may be, and communicate new forms of knowledge and identity that collections make possible.

This chapter recognizes how women writer-collectors confront the discourses of objectivity, use, and sublimation that accompany collections to propose an ethics of collecting that establishes its own discourses and relational networks. Zora Neale Hurston presents the social situations in which collecting takes place, depicting its processes among storyteller-collectors and allowing the methodology of collecting to be articulated through its practitioners. Edith Wharton's ambivalence toward collecting leads her to associate its ethical forms with non-performative acts of reading. Susan Sontag recognizes the excessiveness of collecting as simultaneously its most troubling and adaptable attribute, and demonstrates how it can be diverted toward forms of creation that serve art and humanity, rather than collecting itself. Presenting their ideas on collecting within works structured as collections, these writers demonstrate how literature can propose new worldly conditions for the creation and reception of collections.

Collecting informed Zora Neale Hurston's scholarship, ethnographically informed fiction, plays, and performances. It cannot be separated from the multiple conditions that had a part in shaping her work, from her studies with Franz Boas and the restrictions imposed by her patron Charlotte Osgood Mason, to changes in the discipline of anthropology, the historical and political contexts in which she wrote, and her own intellectual and creative agendas. *Mules and Men*, Hurston's 1935 collection of African American oral tradition, is as much about Hurston's collecting, her "*quest*

for folktales," as it is a compilation of the folktales themselves (Johnson 1985: 287). The quest includes returning to her hometown of Eatonville, claiming to be a fugitive from justice, holding a "lying contest," and other experiences through which Hurston "placed herself on an equal footing with her informants" (hooks 2014: 142). As a narrative of collecting, *Mules and Men* is about the creation of a self, the richness of African American oral tradition, relationships between the cultural practices and narratives of the Gulf States and the Caribbean, and a reflection on the value and deficiency of collecting as cultural practice.

Discovering the self through collecting takes on multiple meanings for Hurston. Most accounts of *Mules and Men* as a narrative of self-discovery begin with her account of her anthropological training, the "spy-glass" that gave her the perspectival distance she needed to do fieldwork in her hometown. The narrator "created by Hurston to dramatize the process of collecting" (Hemenway 1980: 164) variously uses "we" to align herself with her interlocutors and her scholarly intention to collect folktales ("We want to set them down before it's too late," 1990: 8). bell hooks identifies the "seemingly self-effacing posture" Hurston adopts in the first and last sentences of the introduction to *Mules and Men*, in which she ironically acknowledges the highly controlled terms on which she received permission and funding to collect folk material (hooks 2014: 138). Multiple examples of her "multilayered envelope of address" make it "impossible to tell whether Hurston the narrator is *describing* a strategy or *employing* one" (Johnson 1985: 285–6). Hemenway frames this ambivalence in the form of a question: "Is *Mules and Men* about Zora Hurston or about black folklore?" (1980: 167). The relationship between writing and collecting is deeply intertwined, but Hurston largely relegates explicit references to collecting practices associated with the "spy-glass of Anthropology," Boas, and Mason to the paratexts of *Mules and Men*, and the outsider to the world of African American oral tradition—addressed as "you"—remains on the outside.[3] In contrast, collecting forms bonds between *Mules and Men*'s storytellers and expands the scope of Hurston's narrative to address the migration of hoodoo practices from the Caribbean to the American south.

Hurston never introduces herself as an anthropologist to her interlocutors, but as a collector ("Ah come to collect some old stories and tales and Ah know y'all know a plenty of 'em," 1990: 8).[4] This allows her to regard

[3]Contrast Hurston's example with William S. Willis's observation that "Black anthropologists have sometimes willingly acted as mere technicians in studying black folklore," and "did not extend the sociocultural environment of black folklore beyond its immediate setting within the segregated black world to include the surrounding world of white oppression" (Willis 1929, cited in Salamone 2014: 222).
[4]Hazel V. Carby writes that in *Mules and Men*, "Hurston addresses the social constitution of gender roles in particular tales and through brief narratives that describe the relations among

her informants—with their broad repertoires and ability to retell stories—as collectors as well. A reference to a social gathering leads one man to remember a story that was told there ("Ah was over there last night and maybe de boys didn't get off lyin'! Somebody tole one on de snail"), which leads another man to recall and tell a related story ("Yeah, Ah was over there too," said Larkins White, "and somebody else tole a lie on de snail," 1990: 127). Collecting, retelling, and adapting collected material is part of the method and aesthetic of oral tradition. The continual depiction of this process in *Mules and Men* forms a response to the scholarly impulse to archive and arrange tales according to their types and motifs, rather than situate them within the social settings in which they are told. When a woman misunderstands metaphorical language and perceives an insult ("Who you callin' a cow, fool?" 1990: 124–5), the metaphor is quickly re-embedded in a received tale featuring a schoolboy who elaborately theorizes about how his father should ride a cow to keep it from kicking its pail. The problem in the story clearly is not the cow but miscommunication, and retelling it allows the speaker to comment on the immediate situation by implying that poor communication has left all of the participants in this conversation looking foolish. It also allows the storyteller and Hurston to comment on her book in its initial, scholarly variant with the implication that misapplied knowledge compounds misunderstanding.[5]

Hurston concludes *Mules and Men* with a final tale. The first part of the tale is one found in many variants: a rat caught by a cat persuades the cat to mind her manners and wash before eating; as the cat washes, the rat escapes.[6] In Hurston's conclusion, another tale with a self-explanatory title, "Why the Cat Eats First," attested in Henry Davis's "Negro Folk-Lore in South Carolina" (1914: 244–5), is appended to the end of the first story. The effect of following one story with the other is to suggest that the cat can be fooled once, but not twice. Hurston then adds a concluding line to the story that is all her own: "I'm sitting here like Sis Cat, washing my face and usin' my manners" (1990: 246). Hurston has not only "lied" to distance her work from controlling external narratives—the distancing conventions of academic writing, the wishes of her patron—and gain the upper hand (or at least lead us to believe she has);[7] she has also adapted inherited folk

the tale-tellers on the porch, but she does not inscribe a concern with gender within the terms of the professional role of the anthropologist itself" (2008: 36).
[5]Comparing *Mules and Men* with its unfinished manuscript variant "Negro Folk-tales from the Gulf States" (published posthumously in 2002 as *Every Tongue Got to Confess*) reveals how deliberately Hurston revised the text from a scholarly book into a collection of oral narratives woven together with quasi-autobiographical episodes.
[6]Type ATU122B (The Rat Persuades the Cat to Wash Her Face before Eating), in Uther (2011: 88–9). Motif K562.
[7]Barbara Johnson suggests that Hurston's ability to tell "lies" and conform her narrative "to existing structures of address while gaining the upper hand" allows her to "fool us—or to fool

narratives, as an experienced storyteller in the oral tradition will, to her circumstances and the needs of her book.

An attested variant of her concluding tale is "Don't Trust a Man When He's in His Liquor," in which a mouse falls into a pot and is about to drown.[8] The mouse asks the cat to take him out of the pot and let him dry off before being eaten. In most versions of the story, the mouse escapes here. In a telling recorded by Daryl Cumber Dance, the mouse, once dry, then convinces the cat that she must wash before eating. The twice-duped cat is told, "don't never trust a man what he say when he's in his liquor; he liable to say anything" (Dance 1978: 249). If we can assume that Hurston was familiar with all three variants of this tale, she has replaced the trickster mouse who will "lie" to get out of his dire circumstances with a rat who twice urges decorum. The change is consistent with the social relations Hurston has depicted throughout *Mules and Men*. Having identified with "lying" storytellers as collectors, Hurston's Sis Cat will not fall prey to or devour the trickster mouse. But having deferred to the rat's acculturating protocols once, her cat "been washin' after eatin' ever since" (1990: 246).[9] As a collector and practitioner of oral tradition, Hurston has worlded her collection to account for the constraints placed on her collecting practices and writing while providing a new model for scholarship on oral tradition. Her method points to the development of a critique that comes from within the process she illustrates, that allows for thinking about how its literariness is not a contrast to orality but a worlding of its knowledge-making.

Women's collecting of material objects has been associated with subject positions that are inhabited and othered, linked with the sphere of domesticity or the spectacle of consumption rather than with sites of knowledge production. In his account of how gender shaped public perceptions of collectors in 1880 France, Rémy Saisselin writes, "Women were consumers of objects; men were collectors. Women bought to decorate and for the sheer joy of buying, but men had a vision for their collections, and viewed their collections as an ensemble with a philosophy behind it" (1984: 68). Tom Stammers adds that even after the removal of legal barriers that rendered married women in Britain ineligible to own private property, "collecting was increasingly coded as a male pursuit, a sport which relied on forms of erudition, quasi-scientific expertise, and moral self-mastery" (2021). The deepening perceived difference between men's and women's collecting was concurrent with the exclusion of women from learned

us into *thinking* we have been fooled" (1985: 289). That Hurston turns her life "into a trickster tale of which even the teller herself might be the dupe certainly goes far in deconstructing the possibility of representing the truth of identity" (1985: 289).
[8] Also called "The Rat in the Whiskey" in a variant attested by Richard Dorson (1968: 105).
[9] Dance notes the absence of the "whiskey episode" in Hurston's version (Dance 1978: 379).

societies and other elite institutions where male collectors could legitimate their activity.

Book collections materialize the process of knowledge-making for author and reader, and the materiality of books adds performative dimensions to the collector's activity. In her study of Edith Wharton's library, Sheila Liming recognizes how book collecting contributed to Wharton's keen understanding of how people conceptualized worth, inevitably entangled with estimations of self-worth, at a time when Americans were losing interest in personal book collections, institutional libraries began acquiring wealthy individuals' private collections, and inexpensive print editions entered popular circulation. Liming's reading of *The House of Mirth* as a story of two book collector-suitors vying for the hand of Lily Bart contrasts the bibliophilia of Selden with the bibliomania of Gryce, the former seeking a "classic" of "good quality," the latter an "unused" rarity (2019: 103). Ultimately, both men view Lily as an object unworthy of investment that would devalue their estimations of themselves and their respective places in society. The conservative values of both men may have been representative for Wharton's time, but Wharton's critique of them, and of the institution of marriage more broadly, also reveal the influence of the ideas of the feminist anthropologist Elsie Clews Parsons, a student of Franz Boas who in addition to recording a variant of the story "Man in Liquor," wrote treatises in favor of negotiated marriage.[10] Wharton's progressive attitudes toward marriage and depiction of material culture in her writing as a "metaphorical manifestation of ideology, evidence of deep engagement with intellectual, philosophical, and moral issues" (Totten 2007: 5) present collections as fraught with tension.

In Wharton's worlds, collectors do not ethically safeguard the past in the wake of social change or engage in conspicuous consumption but occupy a troubling space in-between. She characterized her own mother as "far worse than a collector—she was a born 'shopper,'" and documented the financial strain her mother's purchases placed on her father (Totten 2007: 2). The conventional marital obligations of a husband, "which decreed that a man, at whatever cost, must provide his wife with what she has always 'been accustomed to'" (Wharton 1924: 92), were repugnant to Wharton. Yet, as the questionable ethics of Selden and Gryce reveal, the figure of the culturally educated and acquisitive collector was more complex, more adaptable to the changing social mores by which a man measured his worth. Karin Roffman reads Wharton's novel *Sanctuary* (1903) and its alternating depiction of art "as something utterly untouched and untouchable by money" and "expensive acquisitions" as a prelude to

[10]Clews, *Folk-Lore of the Sea Islands, S.C.* (1924). On Clews and other marriage reformers who may have influenced Wharton, see Eby (2016: 21–4).

the postwar novels that observe the absence of conflict between the new "language of usefulness" that museums and the moneyed classes both adopted to give their wealth and activity a seeming purpose (2007: 216–17, 229). The language of usefulness projects a set of shared social values that sublimates the collector's impulses. By broadly articulating individual desire through institutions of power, the institutionalization of collecting illustrates problems of ethics as it encourages replication and normalization of its discourses.

Wharton's suspicion of the language of use informs the novella *New Year's Day*, the last of four interconnected volumes in the collection *Old New York* (1924). Here, the protagonist Lizzie Hazeldean, who neither collects books nor reads for pleasure, inherits her late husband's library and chooses to become its curator, learning enough about his collection to build upon it with care (Liming: 170). Collecting is not mentioned once in *New Year's Day*, distinguishing Lizzie's sincere acts of devotion and her husband's genuine love of reading from the hubristic collecting exhibited in *The House of Mirth* and by the rapacious, philistine Raycie family in *False Dawn*, the novella that opens *Old New York*. The retired and invalid Mr. Hazeldean calls reading "the greatest rest in the world" (Wharton 1924: 40), emphasizing that it is neither the utility nor the monetary value of books that encourages him to build his library. For Lizzie, in the end, the books are liminal objects, "containing messages from the world where [her husband] was waiting" (1924: 160). Lizzie's interactions with books offer neither pleasure nor public engagement with shared social values as articulated through critical authority. The meaning of their messages to Lizzie remains obscure, perhaps even to her, eliminating any potential for others to claim understanding or dictate her actions. In the absence of sublimation and the social recognition on which sublimation pivots, books and the actions and spaces associated with them lose their performative value.

The novellas in the *Old New York* collection had initially circulated "as quality fiction in domestically oriented women's magazines with broad readerships" (Howard 2016: 170). They were then sold as a set, each volume dedicated to a decade (1840s, 1850s, 1860s, 1870s), protected by a "flower-patterned dust jacket" and set in "a period gift box" (Howard 2016: 171). Liming writes that *Old New York* "reads, significantly, as just that—as a 'collection,' or archive, of dated impressions and historical sketches" (2019: 160). As a collection that can be collected, it cohesively brings together the worlds of Wharton's fiction and her reader (Liming 2019: 160). In *Old New York*, Wharton "shows the increasing independence of American culture by making Europe less prominent in the story of each successive decade" (Howard 2016: 167). As the geographical expanse of its world successively contracts, knowledge enabled by thoughtful collecting expands. And just as *Old New York* ultimately concludes with Lizzie and *her* carefully curated book collection, it is implied that acquiring and reading Wharton's

collection would contribute to readers' thoughtful preservation of ideas and materialities.

Wharton did not call herself a collector despite owning approximately 5,000 volumes at the time of her death (Liming 2019: 6). Her library "offers contemporary scholars and readers glimpses of another world—one wherein owning thousands of books does not distinguish one as a collector" (2019: 3). Noting that Wharton's collection would not have been "considered exorbitant or remarkable by early twentieth-century standards," Liming acknowledges that Wharton's reticence may be a reflection of her privilege, which normalized her acquisitions and assumed a stable place for them in her multiple homes. At the same time, Wharton's efforts to educate her readers about the difference between hubristic collecting, discourses of utility, and collecting as a means of self-education and conservation speak to the hierarchies that elevated the former over the latter in public activity and symbolic discourse. To the degree that she contributed to the trope of the invisible woman collector, then, Wharton may have expressed typical values of her time and class while simultaneously articulating a vision of collecting that remained deliberately unnamed and outside of masculine symbolic discourse. Free of the language of use, but not at all a "not-all," Wharton's works about collecting present a female gaze that recognizes how collecting relates to conditions of discourse and power and integrates the principles of women's collecting into language, literature, and the material world.

Asked if she considered herself a collector, Susan Sontag responded, "I'm a hoarder. That's different. I'm an accumulator, a hoarder, a packrat. I don't count as a collector" (Rose 1992). On a torn scrap of lined notebook paper, she wrote in large cursive, "I didn't live out the full destiny of a collector. I wasn't melancholy enough, mad enough, interested enough in the flamboyant and the abnormal" (Susan Sontag Papers; Series 6, Box 27, Folder 5). Sontag's disavowals nonetheless acknowledge her propensity to collect: when UCLA acquired her library in 2002 it was estimated at 20,000 books (Moser 2019: 666) and the items in her archive suggest that no scrap of paper was too insignificant to be saved. But for Sontag, the collector was a cultural archetype—male and melancholy, "acting/behaving more rational, more sociable, more constructive, than he really is" (SSP; Series 6, Box 27, Folder 1). Sir William Hamilton epitomized this archetype in *The Volcano Lover*, but she listed others in the notebook she kept as she researched the novel, including collectors of Hamilton's time (Richard Payne Knight, William Beckford, Goethe), the early twentieth century (Walter Benjamin, Arthur Everett "Chick" Austin, Gertrude Stein), and her contemporaries (Sam Wagstaff, Gilbert and George, Robert Mapplethorpe, Bruce Chatwin, Andy Warhol, Albert Innaurato, Andrew Porter, Elliot Stein, Mitchell Wolfson, Arthur A. Cohen) (SSP; Series 6, Box 27, Folder 6).

Sontag initially intended for *The Volcano Lover* to begin with an extended introduction in which collecting linked her with her protagonist:

tell it as a collector's story

- *I first see H[amilton's] prints*[11]
- *I collect them*
- *I think about him*

compare him with collectors I've known

- *I imagine him leaving London*
- *I discuss him*

conversation in la Solfatare

- *H[amilton]'s monologue*

(SSP; Series 6, Box 27, Folder 6)

She scrapped this proposal,[12] instead structuring the novel as a collection of portraits: Hamilton as a prodigious collector of antiquities and Pygmalion to his young second wife Emma (*c*. 1765–1815), Emma's affair with Lord Horatio Nelson and her "Attitudes" performances in which she personifies classical female figures, a visit from Goethe and Tischbein, and among other portraits, a final soliloquy by the poet and revolutionary Eleonora Fonseca Pimentel (1752–99).

With this revision of her novel, Sontag revealed her ambivalence toward collectors as cultural figures. While she admired their avidity and appetite for culture, she also recognized that collectors test "our reflex response to other people's excessive behaviour" (Phillips 2010: 7). Having written "Notes on Camp" ("I am strongly drawn to Camp, and almost as strongly offended by it"), Sontag knew from experience that when others' behaviors crossed the line from propriety into excess, they provoked society's, and her own, judgment. The heading Sontag gave to a list of William Hamilton's visitors in her notes is revealing: "Visitors. Fellow collectors + savants" (SSP; Series 6, Box 27, Folder 6). As people who owned too much and knew too much, they adopted excess as an aesthetic that simultaneously drew admiration and threatened social norms.

[11]Sontag refers to prints made from sketches by the Anglo-Neapolitan artist Peter Fabris, published in Hamilton's *Campi Phlegraei: Observations on the Volcanos of the two Sicilies as They have been communicated to the Royal Society of London* (1776–9).

[12]A typescript "Note" that elaborates some of these ideas and might have been a preliminary version of the novel's prologue can be found in SSP; Series 6, Box 13, Folder 8.

Adam Phillips writes that "our reactions to other people's excesses reveal to us what our conflicts are" (2010: 8), and in developing her protagonists, Sontag's simultaneous regard, sympathy, and distaste toward collectors and their excesses becomes especially foregrounded. With Hamilton, little fictionalizing was necessary; after a lifetime of collecting antiquities, he sold his collections as he grew old and needed money.[13] Emma Hamilton's aging body "is nothing short of monstrous in its enormity and is growing every day" (Sontag 1992: 243).[14] As a collector, she could only be her eminent husband's protégé; as a woman, she was scorned for her adultery and corpulence—her excesses. Pimentel, who was executed for her poem "Against the Queen of Naples" (1798), personified the kind of excess that Sontag admired. Rejecting the nostalgic melancholy and sublimation of collecting that characterized Hamilton, Pimentel idealized a future without monarchy and used her gifts as a poet to advance revolutionary politics. Even before she had finished writing *The Volcano Lover*, Sontag knew that the last line of the novel—"Damn them all"—would belong to Pimentel, who condemned Hamilton's dilettantism and the frivolity of those around him.[15] Herself eager to avoid the marginalizing misstep that would cast her from vast erudition toward unchecked submission to a world of desire and objects, Sontag turned away from identification with collecting to create art that was important enough that she would risk her life for it. The year after *The Volcano Lover* was published, she would direct a production of *Waiting for Godot* in Sarajevo while the city was under siege.

Sontag's conflicted thoughts on the subjectivity of collecting were mirrored in developments in museum studies. A prolonged focus on collection-focused curatorship, it was argued, had isolated museums from the public they were intended to serve, and museums' narratives of utility and universality were increasingly at odds with the "particular ways in which this universality is realized and embodied in museum displays" (Bennett 1995: 7). Sontag followed debates on the new museology and considered that museums might adopt a "religious model of prolonged attention" on fewer works rather than a brisk run-through of must-see highlights, an approach that emphasized the individual artist's vision over that of the curator or guide.[16] Analogously, Sontag championed the "singularity of the writer's voice," in contrast with the dogmatism of criticism, as "any one account of literature is untrue—

[13] On Hamilton's collecting and the dispersal of his collection, see Ramage (1990: 469–80).

[14] Sontag cites Lord Minto from Flora Fraser's *Beloved Emma: The Life of Emma, Lady Hamilton* (1986: 198), as evidenced by a notecard in her archive (SSP, Series 6; Box 13, Folder 6). Sontag's reference to Isadora Duncan likely also originates with Fraser (p. 124 in Fraser, p. 146 in Sontag).

[15] In her notebook entry for September 3, 1990, Sontag writes, "I know the last line of the book. 'Damn them all.' How many months before I can write it?" (SSP; Box 131, Folder 5).

[16] She read Nicholas Penny's response to *The New Museology* (1989) and made notes on museums as architectural spaces and experiences (SSP; Series 6, Box 13, Folder 8).

that is, reductive" (2007: 149). Despite the persistence of the collector as a cultural phenomenon, the private collection is more a curated account of history, art, or a life lived through things than an enduring singularity. The dispersal of a collection, which Sontag experienced herself when she donated her personal archive to UCLA, reveals how easily a collection's private account of a life becomes an institution's account of the collector.

Among her research notes and materials for *The Volcano Lover*, Sontag kept a *New York Times* article about a planned auction of Robert Mapplethorpe's collection of art and furnishings. For all of Mapplethorpe's accomplishments as an artist, for all his objects meant to him and what he meant to friends like Sontag, the article lists preliminary sales estimates for the most valuable items and concludes, "Robert remained a passionate collector until a week or two before he died. He was always looking, always buying" (Reif 1989: 27). Sontag could not have failed to notice the reductiveness of the narrative associated with collecting, and in the course of writing *The Volcano Lover* resolved to redirect her fascination with collectors and their excesses. She did not retreat from excess into conformity, but harnessed her own excessive drive, her creativity, as well as her indignation at the indifference of American and European intellectuals to the acts of ethnic cleansing taking place in Bosnia, to stage *Godot*. Having written *The Benefactor*, *The Volcano Lover*, and preliminary notes toward a short story called "The Collectors," she would not return to the theme of collecting again.[17]

The methodologically defined worldliness of women writer-collectors points to new forms of interconnected thinking about practice, materiality, literary and critical discourse, and gender. The simultaneity of their reworlded forms of thinking accounts for how deeply collecting permeated their work, and how substantively they redefined or rejected the hierarchies that organized the collecting methods that structured the institutions around them. In acknowledging those hierarchies, women writer-collectors are not so much tracing a genealogy for their own method as realizing simultaneously existing methods for the transmission of knowledge. The worlds their collecting practices define may be spatially determined, and in those terms identify transnational connections. But their world-making, methodologically defined, acknowledges that no world is autonomous, that literary expression is integral to developing women's worlded collections and aesthetics, and that the interpretative strategies occasioned by the work of women writer-collectors can lead to new forms of worldly thinking.

[17]She planned to develop additional notes into a short story called "The Collectors," but did not advance beyond some preliminary sketches (SSP; Series 6, Box 13, Folder 8). In 1976, Sontag planned to write a story called "The Curator" which was also left unfinished (SSP, Series 6; Box 128, Folder 8).

References

Alexander, M. J. and C. H. Mohanty, eds. (1997), *Feminist Genealogies, Colonial Legacies, Democratic Futures*, New York and London: Routledge.

Baudrillard, J. (1994), "The System of Collecting," in R. Cardinal (trans.), J. Elsner and R. Cardinal (eds.), *The Cultures of Collecting*, 7–24, London: Reaktion Books.

Baudrillard, J. (1968), *Le Système des objets*, Paris: Gallimard.

Belk, R. (2006), "Collectors and Collecting," in C. Tilley, et al. (eds.), *Handbook of Material Culture*, 534–54, London: Sage.

Bennett, T. (1995), *The Birth of the Museum: History, Theory, Politics*, London: Routledge.

Carby, H. V. (2008), "The Politics of Fiction, Anthropology, and the Folk: Zora Neale Hurston," in H. Bloom (ed.), *Bloom's Modern Critical Interpretations: Their Eyes Were Watching God*, 23–40, New York: Infobase.

Cheah, P. (2016), *What is a World? On Postcolonial Literature as World Literature*, Durham: Duke University Press.

Dance, D. C. (1978), *Shuckin' and Jivin'. Folklore from Contemporary Black Americans*, Bloomington: Indiana University Press.

Davis, H. C. (1914), "Why the Cat Eats First," in "Negro Folk-Lore in South Carolina," *The Journal of American Folklore* 27 (105): 244–5.

Eby, C. V. (2016), "The Glimpses of the Moon and the Transatlantic Debate over Marital Reform," in M. Goldsmith, E. J. Orlando, D. M. Campbell (eds.), *Edith Wharton and Cosmopolitanism*, 19–37, Gainesville: University Press of Florida.

Fraser, F. (1986), *Beloved Emma. The Life of Emma Lady Hamilton*, London: Weidenfeld and Nicolson.

Hemenway, R. E. (1980), *Zora Neale Hurston: A Literary Biography*, Urbana: University of Illinois Press.

Hill, K. (2021), "Afterword," *19: Interdisciplinary Studies in the Long Nineteenth Century*, 31. doi: https://doi.org/10.16995/ntn.3043

hooks, b. (2014), "Saving Black Folk Culture: Zora Neale Hurston as Anthropologist and Writer," in *Yearning*, 135–43, New York: Routledge.

Howard, J. (2016), "Regionalism and Cosmopolitanism in Wharton's *Old New York*," in M. Goldsmith, E. J. Orlando, D. M. Campbell (eds.), *Edith Wharton and Cosmopolitanism*, 166–83, Gainesville: University Press of Florida.

Hurston, Z. N. (2002), *Every Tongue Got to Confess. Negro Folk-Tales from the Gulf States*, New York: Harper Collins.

Hurston, Z. N. (1990), *Mules and Men*, New York: HarperPerennial.

Johnson, B. (1985), "Thresholds of Difference: Structures of Address in Zora Neale Hurston," *Critical Inquiry* 12 (1): 278–89.

Liming, S. (2019), *What a Library Means to a Woman. Edith Wharton and the Will to Collect Books*, Minneapolis: University of Minnesota Press.

MacLeod, D. S. (2008), *Enchanted Lives, Enchanted Objects. American Women Collectors and the Making of Culture, 1800–1940*, Berkeley: University of California Press.

Mangalagiri, A. (2014), "The World Within: Worlding Theory and the Language of Method in World Literature," *The Yearbook of Comparative Literature* 60: 299–313.

Moser, B. (2019), *Sontag*, New York: HarperCollins.
Muensterberger, W. (1994), *Collecting: An Unruly Passion*, Princeton: Princeton University Press.
Parsons, E. C. (1924), *Folk-Lore of the Sea Islands, S.C*, Cambridge: American Folklore Society.
Penny, N. (1989), "On Holiday with Leonardo," 11 (24), December 21. Available online: https://www.lrb.co.uk/the-paper/v11/n24/nicholas-penny/on-holiday-with-leonardo
Phillips, A. (2010), *On Balance*, New York: Farrar, Straus and Giroux.
Ramage, N. H. (1990), "Sir William Hamilton as Collector, Exporter, and Dealer: The Acquisition and Dispersal of His Collections," *American Journal of Archaeology*, 94 (3) July: 469–480.
Reif, R. (1989), "Auctions," The New York Times, Section C, July 14: 27.
Roffman, K. (2007), "'Use Unknown.' Edith Warton, the Museum Space, and the Writer's Work," in G. Totten (ed.), *Memorial Boxes and Guarded Interiors: Edith Wharton and Material Culture*, 209–233, Tuscaloosa: University Alabama Press.
Rose, C. (1992), [TV program] "Susan Sontag," Available online: http://charlierose.com/videos/26274.
Saisselin, R. (1984), *Bricobracomania: The Bourgeois and the Bibelot*, New Brunswick: Rutgers University Press.
Sontag, S. (1982a), "Godard," in R. James (ed.), *A Susan Sontag Reader*, 235–64, New York: Farrar, Straus and Giroux.
Sontag, S. (1982b), "Notes on Camp," in R. James (ed.), *A Susan Sontag Reader*, 105–20, New York: Farrar, Straus and Giroux.
Sontag, S. (1992), *The Volcano Lover*, New York: Farrar, Straus and Giroux.
Sontag, S. (2007), "The Conscience of Words," in *At the same Time: Essays and Speeches*, 145–55, New York: Farrar, Straus and Giroux.
Stammers, T. (2021), "Women Collectors and Cultural Philanthropy, c. 1850–1920," 19: *Interdisciplinary Studies in the Long Nineteenth Century*, 31. doi: https://doi.org/10.16995/ntn.3347
Susan Sontag Papers. UCLA Library Special Collections, Charles E. Young Research Library, UCLA.
Tate, B. (1968), "The Rat in the Whiskey," in R. M. Dorson (comp.) *American Negro Folktales*, 105, New York: Fawcett.
Totten, G. (2007), "Introduction. Edith Wharton and Material Culture," in G. Totten (ed.), *Memorial Boxes and Guarded Interiors: Edith Wharton and Material Culture*, 1–16, Tuscaloosa: University Alabama Press.
Uther, H.-J. (2011), *The Types of International Folktales*, Helsinki: Suomalainen Tiedeakatemia.
Wharton, E. (1924), *New Year's Day*, New York: D. Appleton and Company.
Willis, W. S. (2014), "William S. Willis Collection," cited in F. A. Salamone, "His Eyes Were Watching Her: Papa Franz Boas, Zora Neale Hurston, and Anthropology," *Anthropos* 109 (1): 217–24.
Zhan, M. (2010), "Thinking through Other Worlds: An Interview with Mei Zhan," Available online: http://somatosphere.net/2010/thinking-through-other-worlds-interview.html/

8

Practicing Transnational Feminist Recovery Today

Jessica Berman

Both feminist scholarship and modernist studies have changed dramatically since the heyday of feminist literary recovery work in the 1980s and 1990s. Contemporary feminist scholarship more often addresses the gender dynamics and feminist dimensions of particular texts, both male and female authored, than the development of a separate canon of women writers or the kind of "gynocritics" advocated by those like Elaine Showalter in the 1980s.[1] Modernist studies has moved from focus on a specified set of Euro-American aesthetic practices clustered in works from a restricted few decades—defined in various national literatures or disciplines as beginning in 1857, 1870, or 1900 and ending in 1930 or 1945—to concern with a broader global variety of aesthetic responses to modernity as practiced within the nineteenth and twentieth centuries. Neither of these developments in scholarship necessarily excludes the recovery of out-of-print or lesser-known writers especially from a feminist perspective, but in practice, the work of finding and recovering writing by women or other marginalized figures has often been pushed to the wayside in favor of research into new locations or temporalities for modernist practice. Scholars might sometimes perceive recovery work to be dated, conceptually uninteresting, or invested in essentialist categories of analysis that have often been exclusionary or simply secondary rather than integral to these new domains of scholarly interest. Indeed, much early feminist scholarship is rightly criticized for having reified a notion of "woman" as white, Western, straight, and able-

[1] See below for a discussion of gynocritics.

bodied. Feminist recovery is unpopular—again—or still?—and is not likely to land many scholars top jobs.

Yet, as I will argue in this chapter, feminist recovery certainly still matters and is especially valuable to our efforts to practice modernist literary scholarship from a global, transnational, or planetary perspective. The importance of "provincializing Europe," in Dipesh Chakravorty's famous phrase, or of erasing center-periphery distinctions, should also and at the same time be applied to the domain of gender (2000). I would argue, that the very impulse to question the dominance of an unmarked yet valorized, central position owes much to longtime feminist theoretical efforts to dethrone the perspective of the universal (Western, white, straight, able) male. Decades of feminist work call attention to the othering effects of this unmarked universal and silently bolster much contemporary postcolonial or transnational theorizing. Further, to my mind, one cannot debunk the universal, metropolitan West, without also explicitly debunking the universal (white, straight, able) male that undergirds the universal, metropolitan West. In other words, practicing transnational, or planetary scholarship, as Gayatri Chakravorty Spivak has long maintained, also demands practicing feminist scholarship (2003). This holds true for modernist studies as it does for postcolonial studies. The challenge for feminist scholars, then, is how to advance recovery work within an expanded, transnational frame of reference without either resurrecting an essentialist view of the Western, white, straight, able "woman writer," or allowing the role of gender and gender bias to be seen as a secondary or auxiliary category of analysis within global literary studies.

The task of feminist modernist studies is to recognize the various contributions to modernism of women writers around the world, view a wide range of modernist writers (of all genders) from feminist perspectives, and invite a variety of lived experiences, positionalities, and understandings of gender and sexual identity into our understanding of transnational modernist literature. Writers from the Global South, such as Iqbalunnisa Hussain, the author of what is arguably the first full-length novel written in English by a Muslim woman, *Purdah and Polygamy*, challenge our categories for understanding modernism as well as who counts as a modernist woman writer, and ask us to reconsider the assumptions we make about modernist styles and forms, domestic versus political writing, and the place of Muslim women in literary history. Writers like Hussain also challenge us to consider how texts that emerge from outside the Western, white, straight, able male universal, multiply positions, perform alternate identities, and further decenter the one-time dominant, universal standpoint that too often still lurks behind what we have valorized as the modernist canon. To practice transnational feminist recovery in modernist studies today is to recognize the range of global contexts in which female-authored texts intervene and

the extent to which they illuminate or contest social structures, ideologies, notions of identity, habits of domestic life or presumptions about political action. We must heed the lessons of decades of the best feminist scholarship and not simply identify women as such, reinsert them into an only slightly expanded canon, or use them to "verify" our preexisting notions of modernist writing. Rather we must reconsider modernism through a lens that is both feminist and transnational, even when exploring writers from the Global North, asking questions about the many contexts of writers' identities and performances and heeding the call to reread our canons in multiple non-static directions. Reconsidering modernism in this way will illuminate the intersecting domains of identity and belonging that motivate and inhabit global modernist work, show the importance of gender as a crucial problematic in the emergence and development of global modernisms, and push us to expand our gendered understanding of modernist literary practices worldwide.

Recovering Recovery History

Recovery of women writers has been crucial to feminist modernist studies since at least the 1970s. As Maggie Humm puts it, "in the late 1960s the notion of *origin* . . . was a key feature of feminist criticism" (1995: xxi). Feminist scholars who had been at the forefront of the critique of phallocentrism in male writers announced their intent to focus on women writers and particularly those who had been marginalized or excluded from the record. Elaine Showalter codified this focus with the word *gynocritics*, meant to stand for

> the study of women writers *as writers* . . . the history, styles, themes, genres, and structures of writing by women; the psychodynamics of female creativity; the trajectory of the individual or collective female career; and the evolution and laws of a female literary tradition. (2007: 530, emphasis in original)

Showalter and other major feminist critics of the period performed the crucial work of theorizing and reconstructing what Showalter called "A Literature of Their Own" (1977).[2]

Gynocritics often emphasized Virginia Woolf, moving her to the center of literary and modernist studies in a way she had not been before, despite long-term and ongoing scholarly work. Woolf's figure of Shakespeare's

[2] See also work by Patricia Meyers Spacks, Nina Baym, Ellen Moers, Sandra Gilbert, and Susan Gubar.

sister was invoked in essay after essay; thinking "back through our mothers" became the mantra for much important feminist scholarship, and it remains relevant today. But the notion of "thinking back through our mothers" as it was often employed to create a particular (white, Western, able) lineage for (usually Anglophone) women writers points to some of the limitations of the gynocritics of the 1970s and 1980s. In the rush to supply the missing history that Woolf bemoans in *A Room of One's Own*, feminist critics risked establishing the idea of a single, common lineage running from Sappho straight to Woolf, H. D., or Doris Lessing. Writers with a different cultural parentage or a different attitude toward the tradition failed to figure prominently in that lineage and were thus left to languish in continuing obscurity. As Kate Flint points out, in Showalter's version of Victorian and modern British women writers, Vernon Lee warrants barely a mention and writers of the British Empire receive even less attention (2005: 289–96). To her credit, Showalter recognized the slipperiness of gynocritics and its potential for reinscribing biological determinism and resurrecting existing stereotypes. As she put it, the "difference of women's writing can only be understood in terms of [its] complex and historically grounded cultural relation" to writing by men, while Black women's writing must be understood in relation to both "a muted women's culture" and "a muted black culture" (2007: 541). Still, as this last quotation makes clear, even when it acknowledged other cultural differences, the practice of gynocriticism in the 1970s and early 1980s too often succumbed to the temptation to reify "a" singular women's culture or literary tradition and to presume a commonality of attitude, language, and often, theme.

In the 1980s and 1990s, gynocritics became both critiqued and expanded. It also began to take up the feminist reading of a wider variety of global texts.[3] Lesbian scholars sought to uncover the overlooked texts of Sapphic modernism and to study same-sex desire as a constituent component of modernist writing.[4] Scholars of color, like bell hooks, pressed feminists on their lack of attention to racism and classism and argued for the modernism of writers of the Harlem Renaissance, among others. Feminist critics such as Jane Marcus, Susan Stanford Friedman, and Gayatri Chakravorty Spivak began to point toward alternative genealogies of modernist women's writing—more capacious, anti-imperialist modes of studying that writing—as well as expanded feminist readings of male-authored texts. The notion of intersectionality—a term coined by Kimberlé Crenshaw in 1989—became crucial to all feminist criticism, as it is today. Literary recovery in the years

[3]See Marcus, *Art and Anger*, Susan Stanford Friedman, *Mappings*, among many other examples.
[4]See, for example, Benstock, "Expatriate Sapphic Modernism" and Collecott, *H.D. and Sapphic Modernism*. Later work by Carlston, *Thinking Fascism*; Doan, *Fashioning Sapphism*; and Garrity, "Found and Lost."

that followed often became not just feminist but also and at the same time Africana, multiethnic, postcolonial, transnational, planetary, queer, queer of color, crip, and so on.

This shift—combined with the burgeoning field of postcolonial studies—positioned women writers from the so-called periphery at the center of feminist recovery efforts and began the work, continuing today, to situate them fully within modernist studies.[5] If in 1985 Gayatri Chakravorty Spivak felt compelled to note that "the emergent perspective of feminist criticism reproduces the axioms of imperialism," in recent years, scholars like Mary Lou Emery, Susan Stanford Friedman, Sonita Sarker, Laura Doyle, and Laura Winkiel have insisted that feminist criticism become inseparable from the critique of imperialism (1985: 243). Notions of the transnational, global, or planetary have informed and become inseparable from feminist efforts to recover women's writing, even when that writing emerges out of dominant Euro-American traditions.

Feminist Recovery and the New Modernist Studies

It bears pointing out that the growth and development of the practice of feminist literary recovery also coincided with the development of "the new modernist studies," which emerged in the mid-1990s with the founding of the journal *Modernism/Modernity* in 1994 and the Modernist Studies Association (MSA) in 1999. In fact, I would argue that the feminist work of the preceding decades, and in particular the combined work of intersectional feminist and postcolonial criticism, helped pave the way for the new modernist studies. It defied the canon, fractured the field, and demonstrated a sophisticated, historically inflected and culturally informed way to read and understand modernism. Having already begun to grapple with the scholarly imperatives of intersectionality and anti-imperialism, feminist criticism brought to the fore many of the critical perspectives that would distinguish "new modernism" from previous practice. And yet, this connection, which Urmila Seshagiri has said is both "everywhere and nowhere" in the new modernist studies, was then and still is rarely acknowledged.

When Lawrence Rainey and Robert Van Hallberg founded the journal *Modernism/Modernity*, they began with the astute claim that "modernism was more than a repertory of artistic styles, more too than an intellectual movement or set of ideas; it initiated an ongoing transformation in the entire set of relations governing the production, transmission, and reception of the

[5]See Emery, *Jean Rhys at "World's End."*

arts" (1994: 1). They set out to "look widely at the art and thought of this period," devoting the first two issues to the topic of "Modernism and Race," with future issues tied to such "themes as anarchism, religion and secularity, fascism and culture, and the institutions of art, and . . . to single figures or movements such as F. T. Marinetti and the Futurists, Wyndham Lewis, and Igor Stravinsky." But despite the seeming perspicacity of Rainey and Van Hallberg's view of the field, issues of gender or sexuality—or even reference to specific modernist women writers—are absent from the journal's editorial introduction. It is as though the "ongoing transformation in the entire set of relations"—a phrase that clearly echoes Woolf on 1910—took place without women. As Anne Fernald has claimed, despite its many strengths, the new modernist studies seemed to lack "serious interest in women writers" as such (2013: 229).

I do not wish to castigate the editors for a decades-old statement of purpose that we might read as symptomatic of widespread scholarly attitudes rather than of any specific desire to exclude. In fact, the second issue of *Modernism/Modernity*, flagged as devoted to race, contains fine work by David Kadlec on Marianne Moore and Bruce Robbins on both Jamaica Kincaid and Bharati Mukherjee, although neither of these essays pays explicit attention to gender. Issue three contains a laudatory review of Victoria De Grazia's book *How Fascism Ruled Women: Italy, 1922–1945*. But it takes until the following year for the appearance of Arthur Redding's essay, "The Dream Life of Political Violence: Georges Sorel, Emma Goldman, and the Modern Imagination," and Gail MacDonald's review of John Guillory's *Cultural Capital: The Problem of Literary Canon Formation* (which opens with a comment on "the ubiquitous discussion of the 'crisis' in the humanities"!).[6] In a true act of feminist recovery, issue 3.3 (September 1996) reprints Gertrude Stein's "Introduction to the Speeches of Maréchal Pétain," with commentary by Wanda Van Dusen. Once Cassandra Laity joined the editorial team and more feminist scholars became involved in the journal, the balance began to shift. Still, it is clear that in its earliest years, *Modernism/Modernity* paid scant attention to women writers and even less to critical discussion of gender.

The Modernist Studies Association was more inclusive from the start, particularly since Cassandra Laity and Gail MacDonald were among the founders. MacDonald became its second president, while feminist scholars such as Colleen Lamos and Susan Stanford Friedman helped to run the early conferences. The first two MSA conferences (1999 and 2000) focused on defining "the New Modernisms," with particular emphasis on developing interdisciplinary perspectives and providing what could not be accomplished

[6]Np. Full disclosure: this issue also contains my review of Kelly Cannon's *Henry James and Masculinity*.

at the existing single-author conferences.[7] Among other feminist moments, MSA One had a seminar on "Modern and Contemporary Women Poets," a panel on "Gender, Race, and Narrative at the End of Empire," and it screened the film, "Borderline," with a discussion led by Susan Stanford Friedman. The plenary speakers for the second conference included Gayatri Chakravorty Spivak and Janet Lyon. The conference ran a seminar on Sapphic modernism and panels on "the Gender of Modernity" and "Queer Theory." Despite the stated desire to get away from what happens at single-author conferences, the MSA conferences have always hosted papers on Woolf, Joyce, and Eliott and offered representation to other female modernists, such as H.D., Mina Loy, and Djuna Barnes. A feminist roundtable of some kind was standard for many years. The MSA, and the new modernist studies more generally, have always included many successful, publishing feminist scholars.

But unfortunately, Doug Mao and Rebecca Walkowitz's 2008 *PMLA* essay on "The New Modernist Studies" sidelines scholarship on gender or women writers. While Mao and Walkowitz point out that they have chosen to focus only on two significant trends in modernist studies, the "transnational turn" and "modernism and mass media" that "are by no means to be understood as *the* future of the field," they nonetheless perpetuate the division of gender issues from other trends in scholarship. "Gender" and "sexuality" take their place on a list of other possible aspects of the field ("literary form, intraliterary influence, narratology, affect, gender, sexuality, racial dynamics, psychoanalysis, science" [2008: 738])—the only place these words appear in the essay—but are implied to be distinct from and not as salient as the two trends selected for discussion. As Anne Fernald points out, the essay seems "to suggest that it is still intellectually acceptable to conceive of gender as an add-on rather than a defining piece of our experience of the world" (2013: 230). The intersection of gender with the multiple other positions and practices of global modernity disappears.

Feminist work nonetheless lurks throughout the scholarship treated in Mao and Walkowitz's essay, demonstrating its deep imbrication within the "transnational turn" and the extent to which feminist scholarship drives innovation in modernist studies. Scholars like Susan Stanford Friedman, Laura Doyle, and Laura Winkiel, all of whom have published explicitly feminist work, are classified simply under the category "transnational." Those like Ann Ardis and Janet Lyon, who also write explicitly feminist (and for Lyon, disability-focused) scholarship, appear under the guise of media and print studies (where the word *feminist* is indeed used, if sparingly, 2013: 744). And nowhere in the essay does the matter of recovery of marginalized writers—whether women, people of color, queer

[7]See the website of the Modernist Studies Association, https://msa.press.jhu.edu/about/index.html.

people, or disabled people—make its appearance. How do we explain this? Why has the feminist dimension of these scholars' work become occluded or made subservient to other seemingly more dramatic and influential trends?

The matter is not particular to Mao and Walkowitz's essay; far too many current discussions of modernist studies ignore patterns and practices of gender. Rather, I would argue that the *PMLA* essay shows the extent to which the conflicts surrounding the limitations of gynocritics and the pressure from postcolonial and other cultural studies pushed feminist recovery to the margins, especially within the evolving field of the new modernist studies. Scholars have struggled with the imperative noted by Sonita Sarker, not to "fall . . . into certain essentialisms about identities of women" in our efforts to address "the fate of 'women's literature' per se" (2013: 10). As Jane Garrity put it ten years ago, modernist studies "has witnessed a paradigm shift that can be described as a reversal of earlier hard-won gains . . . interest in the lesser known writers of this era of women's literary history . . . is no longer hip" (n.d.: 806, 808). It has taken until summer 2017 for *Modernism/Modernity* to devote specific space to feminist perspectives and until 2018 for *Feminist Modernist Studies* to appear.[8]

Transnational Modernism and Feminist Recovery

But, as I have suggested, the dichotomy between feminist recovery and the temporal and/or geographical expansions of modernist studies, or between gender analysis and the exploration of new media and technology in modernism, which was brought to the fore by Mao and Walkowitz's *PMLA* essay, is a false one. First, there is much innovative feminist work being done in media and print studies, as remarked in 2013 by Barbara Green (53–60) and evidenced in the recently launched Modernist Archives Publishing Project, run by a team of feminist scholars.[9] Digital humanities initiatives, such as the Cambridge University Press' Orlando Project on the history of British women writers and the Society for the Study of American Women Writers (SSAWW) Recovery Hub, funded by the NEH and begun in 2020 by Southern Illinois University Edwardsville's Iris Center, unite international networks of scholars in creating robust online resources on women writers. Further, as I have noted, much of the scholarship in transnational modernism

[8] See Seshagiri, "Mind the Gap!" Also, Linett, *Companion to Modernist Women Writers* and Utell, *Teaching Modernist Women's Writing*.
[9] Claire Battershill, Elizabeth Willson Gordon, Helen Southworth, Alice Staveley, Michael Widner, and Nicola Wilson. See https://www.modernistarchives.com.

has had a feminist dimension, whether in the work by Mary Lou Emery, Alison Donnell, Anna Snaith, and others on the Caribbean, which has brought Jean Rhys and Una Marson into broader prominence, or that by Sonita Sarker, Susan Stanford Friedman, and myself, among others, on South Asian writers such as Cornelia Sorabjee, Swarnakumari Devi, and Iqbalunnisa Hussain. Rather, I would argue that the challenges feminist scholarship and recovery pose to the Western, white, straight, able, male universal *helped to make possible* the transnational, along with other recent "turns" to queer, trans, or disability studies, and that they undergird much of the best work, even if only tacitly. If we take intersectionality seriously—and we should—then the transnational turn in modernist studies—as in other literary fields—has always implicated gender as well as geographical position, nationality, religion, race, sexuality, ability, and class status—even when those positions are not remarked as such. There simply is no way to understand any of those aspects of identity in isolation. Laura Doyle and Laura Winkiel's influential collection of essays *Geomodernisms* worked hard to make such a point. Susan Stanford Friedman's *Mappings: Feminism and the Cultural Geographies of Encounter*, as well as her more recent book *Planetary Modernisms: Provocations on Modernity Across Time* also show the intersection of gender with a variety of other transnational standpoints. Laura Winkiel's essay "Gendered Transnationalism in 'The New Modernist Studies'" makes a similar claim, discussing "the development of transnational scholarship in modernist studies and [asking] whether this development can amplify and enliven the sub-field of women's literature within modernist studies" (2013: 38–44). Sonita Sarker reminds us always to ask "which women, where, and how," which situates the questions of women's lives and work within the multiple complex contexts and networks of transnational modernism (2013: 10).

My recent work to bring back into print the 1944 novel *Purdah and Polygamy* by Iqbalunnisa Hussain (2017) attempts to make clear the deep imbrication of gender with the development of a variety of modernisms and modernities worldwide.[10] It argues not only that modernism will take on different styles, forms, and concerns as it emerges in a variety of locations globally, but that our approach to aesthetic responses to modernity worldwide should attend to the ways in which regimes of gender expression and identity undergird attitudes toward religion, nationality, colonial, and postcolonial status. Writers like Hussain seek new narrative techniques for representing the challenges of a rapidly changing social world, exploring the problem of subjectivity and citizenship within a colonial setting, or new ways to work through adjustments in family life and the status of women—often developing new modernist modes in response. Novels such as Hussain's

[10] My discussion of this novel draws on my introduction to the OUP reprint edition.

Purdah and Polygamy, in their very exploration of issues of gender, religion, and domesticity, become important entries in the developing tradition of Indian writing in English as well as crucial markers of the complex variety of global modernisms.

Likely the first full-length novel written by a Muslim woman in English and one of the most striking novels of the late colonial period *Purdah and Polygamy* foregrounds the matter of domestic space as the crucial matrix not only of female coming of age but also of India's impending modernity. It does not deploy many of the stylistic or formal markers we have come to associate with European modernism, such as extreme fragmentation or stream-of-consciousness narration. However, the novel's sophisticated use of irony, its play with temporal order, its focus on the lives of non-elite people, and its embrace of an often hybrid version of Indian English—one which draws on local languages and habits of speech—all show its sophisticated aesthetic responses to Indian modernity and connect it to other experimental English-language writers of the period.[11]

Purdah and Polygamy takes place in a modernizing Muslim household, where a young man, Kabeer, marries four wives in succession, searching for the one who will fulfill his expectations of the perfect woman. On its surface, the novel presents a dispassionate description of the family's history, following its members through a series of life events. But the narrative constantly undermines the practices of Kabeer, his mother, and his household, through use of free indirect style to represent the characters' points of view; allusions to outmoded, extreme, or ill-conceived habits of education and religious expression; or through occasional overt criticism by the narrator. The result is a trenchant critique of the practices of purdah and polygamy wrapped within the pages of a sophisticated and compelling domestic novel. Through its ironic undermining of a unified narrative perspective and the multiplicity of points of view that develop by its end, the novel issues a social and political challenge to the household, along with its distorted understanding of the rules of Islam, its insistence on strict purdah, and its unreflective espousal of polygamy. However, like work by other South Asian women, this brilliant novel, by a woman once called "the Jane Austen" of India, was largely forgotten in the rush to support new writing in the independent states of India and Pakistan after 1947.[12] The major histories of Indian literature from the mid- to late twentieth century identify only a handful of women writers from this period and discount their

[11]That is, those often named as the main writers of pre-independence Indian fiction in English, Mulk Raj Anand, R. K. Narayan, and Raja Rao. My work on Hussain has sought, in part, to insert women writers into the literary history of the period. See Berman, "Neither Mirror Nor Mimic."

[12]See Reddy, "Foreword," 2.

influence.[13] Iqbalunnisa Hussain's writings—both *Purdah and Polygamy* and her important 1940 collection of essays *Changing India* were allowed to slip out of print.

In the last ten to fifteen years, however, feminist scholars around the world have begun to bring the novel the kind of readership and critical attention it deserves. Poet and scholar Eunice de Souza included significant excerpts from *Purdah and Polygamy* in her two anthologies *Women's Voices: Selections from Nineteenth and Early Twentieth Century Indian Writing in English* and *Purdah: An Anthology* (2002, 2004). *Purdah and Polygamy* began to be included in histories and critical studies of Indian writing in English.[14] In a discussion at the 2013 Lahore Literary festival, Muneeza Shamsie, editor of *And the World Changed: Contemporary Stories by Pakistani Women*, cited *Purdah and Polygamy* as one of the crucial English-language novels by women in the pre-Independence era. After nearly ten years of effort, I was able to bring the novel back into print with my introduction and annotations, essays by Suvir Kaul and Muneeza Shamsie, and a biographical sketch by the author's grandson, Arif Zaman.

But what significance does this have for modernist studies? Certainly, it is important to continue to recognize the role women from a variety of backgrounds have played in the story of Indian writing in English and our understanding of Indian modernism. By placing domestic servants and secluded women at the center of their narratives, women writers in late colonial India, whether Muslim, Hindu, Parsee, or from other backgrounds, often raise questions about narrative voice and authority while also challenging the public/private, modern/traditional dichotomies that carry heavy political weight at the time. Their narratives shine a light on the ways that women living in the *zenana* (the part of the house reserved for women) introduce public as well as domestic concerns, and often exhibit their modernity by way of their very participation in traditional sites and practices. They offer us a way to understand transnational modernism as variously practiced, complexly situated, and resistant to easy categorization within often masculinized, histories of national literature.

But my interest in Hussain and this novel extends beyond that point. *Purdah and Polygamy* complicates the notion and status of the category "woman" from its very first pages and brings to the fore the importance of specifying, in Sarker's phrase, "which women, where and how?" The novel

[13]K. R. Srinivasa Iyangar's classic book on Indian writing in English remarks, "it is only after the second world war that women of quality have begun enriching Indian fiction in English." Still, Iyangar praises *Purdah and Polygamy* as having "tried with commendable success to present the currents and cross-currents in a typical Muslim family" (1973: 438). In 1974, Meenakshi Mukherjee also makes fleeting reference to Hussain (11).

[14]See Hubel, "The Missing Muslim Woman," 141–51; Malak, *Muslim Narratives*; and Anjaria, *A History of the Indian Novel*.

also makes clear the complex intersection of women's lives and identities with discourses of religion, nation, and empire and emphasizes the impossibility of separating out gender as a category of analysis apart from postcolonial or transnational scholarship. The novel takes place almost entirely within the *zenana*, as Kabeer searches through three successive marriages for the woman who will be his perfect wife, raising questions about the status and bodies of the women confined within it. The matter of polygamy in this novel represents the family's quest for a woman/body who will submit to supervision, domestic service, and strict enclosure while retaining her strength and feminine beauty—a search that ultimately proves futile. Wife one is too beautiful and physically frail to survive—in other words, too feminine. Wife two, who is described in animalistic and quasi-racist terms, is fully domesticated but not feminine enough.

The third wife, Maghbool—a modern, educated woman figured as beautiful, active, and vigorous—seems poised to resolve the zenana's dialectic. Yet, it is not to be. Maghbool's modernity marks her instead as nonfemale. Maghbool publishes poetry under her own name and participates in the monetary economy, directly transgressing household expectations for women.

> She was an institution in herself. Her mastery over the Urdu language had made her crazy after papers, magazines, romance and poetry. . . . She was a good organizer and an economical manager of the house. . . . Her father often said that she was a son to him, his secretary and his right hand. She was active and hated to while away her time. . . . Everything she did was self-learnt. (Hussain 2017: 97)

Unlike the other women in the household, Maghbool benefits from the modern monetary economy and from Kabeer's willingness to sell off his patrimony for ready cash. The fact that she receives pocket money not only makes her able to purchase food rather than cook it in the kitchen (thus removing herself from identification with that space), but it also further defines her as modern, masculinized, and connected to the bourgeois economy, which the household rejects as unfit for women. Maghbool is further marked as an unsuitable woman/wife when her body is scarred in a kitchen accident. Her mother-in-law, who sees Kabeer sneak expensive medicines to her, recognizes Maghbool as a body she cannot control and redoubles her surveillance of the inner compound with its codes of gendered conduct. By the time Maghbool's wounds have healed, the potential of her modernity to disrupt the gendered roles of the entire household has been both revealed and contained, and she is ostracized almost into nonexistence.

Throughout the novel, Maghbool remains clothed in the manner of a woman, and living in purdah like her fellow wives. She does not conform to many contemporary Western models of transgender identity, nor does she

fit traditional Indian notions of Hijra.[15] Rather, I have recently argued that she may be read as a kind of trans figure, one who not only crosses over the gender binary, but also challenges the assumptions that this household (and by extension, the institutions of purdah and polygamy) make about women.[16] In much contemporary transgender theory, the prefix "trans" has come to stand not for gender or sexual identities that have moved from one side of a binary field to the other, but rather for "anything that disrupts, denaturalizes, rearticulates and makes visible" the links we assume to exist between a sexual body and the social roles it is expected to play (Stryker 2006: 3). As Susan Stryker and Stephen Whittle put it, "[u]ltimately, it is not just transgender phenomena per se that are of interest, but rather the manner in which these phenomena reveal the operations of systems and institutions that simultaneously produce various possibilities of viable personhood, and eliminate others" (2006: 3). Recent transgender theory has also made clear that what we understand to be "transgender . . . is context-dependent" and multiple, taking on different forms and guises in different situations (Stryker 2012: 289). Just as we might recognize trans status in the main character of *The Well of Loneliness* because s/he takes on the name Stephen, dresses in male clothing, and otherwise rejects the feminine norms of behavior expected in English society of the early twentieth century, so we might recognize Maghbool as inhabiting a trans position within *Purdah and Polygamy* because she takes on a public name, handles her own money, has a body marked as unfeminine, and, increasingly over the course of the novel, rejects the behavior expected of women within the confines of the female quarters.

Further, as Stryker, Currah, and Moore claim, "any gender-defined space is not only populated with diverse forms of gendered embodiment but striated and cross-hatched by the boundaries of significant forms of difference" along with their politics (2008: 12). In other words, gender diversity always intersects and intertwines with other forms of diverse human expression and embodiment and the power relations attached to them. When Maghbool's non-normate, "modernized" body challenges the

[15]Contemporary scholarship discusses "Hijra" as a practice or way of living that goes beyond categories of gender and sexuality and "is intersected by a variety of other axes of identity, including religion, gender, kinship, and class," (Reddy 2010: 17). In addition, "hijras are typically phenotypic men . . . who wear female clothing, grow their hair, and enact an exaggeratedly feminine performance. Hijra lifeworlds encompass a range of corporeal possibilities but tend to be characterized by hierarchies of authenticity, at the apex of which stand those who undergo complete excision of the penis and testicles" (Rao 2015: 99). While, as I have been arguing, Maghbool's gender identity in *Purdah and Polygamy* also raises questions surrounding religion, class, and nation, it overlaps very little with these aspects of Hijra practice. It is, therefore, important to find other ways to characterize the challenge Maghbool poses to prevailing gender norms.

[16]See Berman, "Is the Trans," 217–44.

regimes of purdah and the expectations of female identity in Hussain's novel, it also necessarily engages political conversations about Muslim women and their roles in a modernizing India, as well as the international spheres of debate that connect the issues of purdah and polygamy to the discourses of empire. In other words, I would claim, the trans challenge of Maghbool in this novel also focuses and highlights this novel's challenges to religious and cultural norms that undergird both colonial and nascent nationalist ways of understanding India. They are linked and intersecting critiques—made visible in the scarred and ultimately excluded figure of Maghbool—that are also inseparable from the way we recover and understand this novel and its author within modernist studies.

In other words, our practice of feminist literary recovery must be alive to the multiple dimensions of the ways texts and authors are situated in the world and to the manner in which texts, by people of all genders, races, ethnicities, and abilities, engage with the "striated, cross-hatched" space of identity. At the same time, any discussion of transnational or world literature must also attend to the assumptions of embodiment and gender identity that are attached to the concept of the nation. Transnational modernist studies should at once challenge the normative dimensions of regimes of nationality and interrogate the systems of embodied identity that undergird them. A trans critical optic—both transnational and transgender—allows us to practice a new version of feminist recovery that, within the context of Hussain's novel, for example, pushes back on such categories as Muslim woman, Indian woman, secluded woman, able-bodied woman, English-language writer, modernist, reformer, feminist, activist. Hussain's own life, which moved from seclusion to her appearance at international conferences on feminism and from India to the UK (twice), challenges the division between public and private spheres as between the South Asian woman and the immigrant woman.[17]

Practicing feminist recovery today must mean not only searching out and valuing under-recognized writing by women around the world, but also engaging from a feminist perspective with the many ways that gender and sexual identity intersect with a wide variety of lived experiences and positionalities and are inseparable from them. At the same time, we must recognize the extent to which decades of feminist scholarship have helped to make possible many of the advances of the new modernist studies—as in other contemporary fields of literary scholarship—and are inseparable from them. We must understand feminist and transnational scholarship as linked and intersecting critical modes that expand and add nuance to our understanding of modernism as an intersectional, complexly situated,

[17]On immigrant South Asian women in Britain in the early twentieth century, see Boehmer, *Indian Arrivals*.

and globally various practice. Transnational feminist recovery of a variety of texts that challenge the dominance of a Western, white, straight, able perspective deserves a place front and center in the new modernist studies, in contemporary post- and anti-colonial work, as indeed, in literary study of all dimensions today.

Originally published as Jessica Berman (2018) "Practicing transnational feminist recovery today," *Feminist Modernist Studies*, 1:1, 9–21; reprinted by permission.

References

Anjaria, U., ed. (2015), *A History of the Indian Novel in English*, Cambridge: Cambridge University Press.

Benstock, S. (1990), "Expatriate Sapphic Modernism," in K. Jay and J. Glasgow (eds.), *Lesbian Texts and Contexts: Radical Revisions*, 183–203, New York: New York University Press.

Berman, J. (2012), "Neither Mirror nor Mimic: Late Colonial Indian Narratives in English," in M. Wollaeger and M. Eatough (eds.), *The Oxford Handbook of Global Modernisms*, 205–27, Oxford: Oxford University Press.

Berman, J. (2017), "Is the Trans in Transnational the Trans in Transgender," *Modernism/Modernity* 24 (2): 217–44.

Boehmer, E. (2015), *Indian Arrivals, 1870–1915: Networks of British Empire*, Oxford: Oxford University Press.

Carlston, E. (1998), *Thinking Fascism: Sapphic Modernism and Fascist Modernity*, Stanford: Stanford University Press.

Chakravorty, D. (2000), *Provincializing Europe: Postcolonial Thought and Historical Difference*, Princeton: Princeton University Press.

Collecott, D. (1999), *H.D. and Sapphic Modernism: 1910–1950*, Cambridge: Cambridge University Press.

Doan, L. (2001), *Fashioning Sapphism: The Origins of a Modern English Lesbian Culture*, New York: Columbia University Press.

Donnell, A. (2011), "Una Marson and the Fractured Subjects of Modernity: Writing Across the Black Atlantic," *Women: A Cultural Review* (Special issue on 'Gender, Sexuality and Fractured Form in Diasporic Writing and Performance') 22 (4): 345–69.

Emery, M. L. (1990), Jean Rhys at *"World's End"*: Novels of Colonial and Sexual Exile, Austin: University of Texas Press.

Fernald, A. (2013), "Women's Fiction, New Modernist Studies, and Feminism," *MFS: Modern Fiction Studies* 59 (2): 229–40.

Flint, K. (2005), "Revisiting *A Literature of One*'s *Own*," *Journal of Victorian Culture* 10 (2): 289–96.

Friedman, S. S. (1981), *Psyche Reborn: the Emergence of H.D.*, Bloomington: Indiana University Press.

Friedman, S. S. (1998), *Mappings: Feminism and the Cultural Geographies of Encounter*, Princeton: Princeton University Press.

Friedman, S. S. (2015), *Planetary Modernisms: Provocations on Modernity Across Time*, New York: Columbia University Press.
Garrity, J. (2008), "Found and Lost: The Politics of Modernist Recovery," *Modernism/Modernity* 15 (4): 803–12.
Garrity, J. and L. Doan, eds. (2006), *Sapphic Modernities: Sexuality, Women and National Culture*, New York: Palgrave.
Green, B. (2013), "Recovering Feminist Criticism: Modern Women Writers and Feminist Periodical Studies," *Literature Compass*, Special Issue: The Future of Women in Modernism 10 (1): 53–60.
hooks, b. (1984), *Feminist Theory: From Margin to Center*, Cambridge: South End Press.
Hubel, T. (1997), "The Missing Muslim Woman in Indo-Anglian Literature: Iqbalunnisa Hussain's *Purdah and Polygamy*," in R. Chowdhari Tremblay (ed.), *Perspectives on South Asia at the Threshold of the 21st Century*, 141–51, Montreal: Canadian Asian Studies Association.
Humm, M. (1995), *Practising Feminist Criticism: An Introduction*, New York: Prentice Hall.
Hussain, I. ([1944] 2017), *Purdah and Polygamy*, ed. J. Berman, Karachi: Oxford University Press.
Iyengar, K. R. S. (1973), *Indian Writing in English*, New York: Vantage Press.
Linett, M. (2010), *The Cambridge Companion to Modernist Women Writers*, Cambridge: Cambridge University Press.
Malak, A. (2004), *Muslim Narratives and the Discourse of English*, New York: SUNY Press.
Mao, D. and R. Walkowitz (2008), "The New Modernist Studies," *PMLA* 123 (3): 738.
Marcus, J. (1988), *Art and Anger: Reading Like a Woman*, Columbus: Ohio State University Press.
Mukherjee, M. (1974), *The Twice Born Fiction*, New Delhi: Heinemann.
Rainey, L. and R. Van Halberg (1994), "Editorial/Introduction," *Modernism/Modernity* 1 (1): 1.
Rao, R, (2015) "Hijra," in Dwyer et al. (eds.), *Key Concepts in Modern Indian Studies*, 99–101, New York: New York University Press.
Reddy, G. (2010), *With Respect to Sex*, Chicago: University of Chicago Press.
Reddy, R. ([1944] 2017), "Foreword," in I. Hussain and J. Berman (ed.), *Purdah and Polygamy*, 2–4, Karachi: Oxford University Press.
Sarker, S. (2013), "On Remaining Minor in Modernisms: The Future of Women's Literature," *Literature Compass* 10 (1): 8–14.
Seshagiri, U., ed. (2017), "Mind the Gap! Modernism and Feminist Praxis," *Modernism/Modernity* Print Plus 2 (Summer), https://modernismmodernity.org/forums/modernism-and-feminist-praxis.
Showalter, E. (1977), *A Literature of Their Own: British Women Novelists from Bronte to Lessing*, Princeton: Princeton University Press.
Showalter, E. (2007), "Feminist Criticism in the Wilderness," in S. M. Gilbert and S. Gubar (eds.), *Feminist Literary Theory and Criticism: A Norton Reader*, 537–44, New York: Norton.
de Souza, E. (2002), *Women's Voices: Selections from Nineteenth and Early Twentieth Century Indian Writing in English*, Delhi: Oxford University Press.

de Souza, E. (2004), *Purdah: An Anthology*, Delhi: Oxford University Press.
Spivak, G. C. (1985), "Three Women's Texts and a Critique of Imperialism," *Critical Inquiry*, 12 (Autumn): 243–61.
Spivak, G. C. (2003), *Death of a Discipline*, New York: Columbia University Press.
Stryker, S. (2006), "(De)Subjugated Knowledges: An Introduction to Transgender Studies," in S. Stryker and S. Whittle (eds.), *The Transgender Studies Reader*, 1–17, New York: Routledge.
Stryker, S. (2012), "De/Colonizing Transgender Studies of China," in H. Chiang (ed), Transgender China, 287–92, New York: Palgrave.
Stryker, S., P. Currah, and L. J. Moore. (2008), "Introduction: Trans-, Trans, or Transgender?" *Women's Studies Quarterly* 36: 11–22.
Utell, J., ed. (2021), *Teaching Modernist Women's Writing in English*, New York: Modern Language Association.
Winkiel, L. (2013), "Gendered Transnationalism in 'The New Modernist Studies," *Literature Compass* 10: 38–44.
Winkiel, L., and L. Doyle, eds. (2005), *Geomodernisms*, Indianapolis: Indiana University Press.

9

Woman as Anti-Suicide Bomb

Women Trapped between Past and Future

Mieke Bal

Introduction

In this chapter, I briefly analyze three texts from the most traditional corpus of what we call "World Literature": the world-famous classics from the Western canon. I seek to make the case for the inherent, inevitable presence of feminism in even the most classical literary works. Since figures of women are omnipresent in the fabulas of novels and plays, the feminist issues come up willy-nilly. I am not addressing the issue, important as it is, of the exclusions of the canon of World Literature. Instead, I present forms of reading that bring the feminist issues to the fore, even in the most "white male" canon. I seek to argue and demonstrate, however, that the presence of feminism lays not, or not necessarily, in the thematic or semantic domain. To make this point, I foreground two theoretical issues, both totally traditional. For a long time, I have tried to critique and subvert two dogmas in the study of art and literature. Seemingly "a-political," they both have an impact on issues of feminism. One is the iron-clad idea of chronology as the skeleton of history, the only way to be "historically responsible" and avoid that historians' object of contempt they call anachronism. The other is the appeal to the author's intention, which is sustained in two different ways. The first is the appeal to biographical information and documents, which is anchored

in the belief that every author knows consciously what they want to convey. This makes cheap of the artistic process of writing, that only the surrealists have liberated by their experiments with "automatic writing." Moreover, it ignores historical changes in meaning. The second is the invention of the "implied author." This is the projection of the critic's interpretation on the text, giving the critic and the teacher an authority that is not warranted at all and unduly silences the students or lay readers.[1]

For chronology, the primary problem is the idea of "influence" and the passivity of the later writer or artist, who can only imitate or emulate the prestigious predecessor. I have discussed this at length in a book on what I have termed *pre-posterous history*: a view of temporality that goes in both directions (1999). The basic argument contends that the later readers cannot understand the earlier works without the screen of later works hanging between the present and the past. In this sense, the present impacts on the past as much as the more traditional view that the past influences the present. This more common, older view always implies an ideology of development, an evolution from the "backwards" past to a more progressive future. Recent events belie such optimism. The political violence, and specifically, the increasing numbers of rapes and murders of women, including young girls, in a country like India, and the police brutality against "people of color" in the United States show that the movement can rather be seen as backward; the future returns and surpasses the past. And, conversely, delving into works from the past counters the contempt for pastness it implies. The two movements of #MeToo and Black Lives Matter, on the television news practically every day, are both more actual, more urgent, than ever.[2]

My ongoing academic struggle with chronology and the idea of authorial intention is always intertwined with my feminist persuasion. In that struggle, I have encountered young women in worldwide famous texts who are trapped in a bad, say, tragic situation, which glues them to a tradition, hence, the past, but which remained, hence, in the present, and the impossibility to detach themselves from it. Written by men, some of bad repute when it comes to women's issues, these texts demonstrate that both dogmas mentioned do not hold, and in fact, hold us back from seeing feminist writing even where the author is unaware, "innocent" of it. In addition to showing that time is not unilinear, the examples later in the text also demonstrate that the cultural impact of literature is not bound to what the author wants to say. Moreover, they don't breed optimism, but instead implicitly plead for close

[1] See Booth (1961) on the implied author, and my discussion of it in my 2017 book (61). On authorship, see Bal (1999), Barthes (1986 [1967]), Foucault (1979 [1969]), and my 2020 article that revisits their canonical rejections.
[2] See the work of Indian artist Nalini Malani, as shown in a recent volume edited by Ernst van Alphen (2020). The "scare quotes" around "people of color" indicate that white/pink/beige is also a color.

reading as a political weapon. In addition, the intermediality of my examples also appeals to an openness toward the media of which literature is one. In three short vignettes, I will take up a character, an issue, and a social-political attitude, which, together, intimate the social relevance of literature. They each have been not adapted but dialogically engaged in video works I have made, not *on* them but *with* them. What these very different feminism-bound figures have in common is a position of victimhood in the face of masculinist values. I discuss them in a reverse chronology, to make my point about pre-posterous history, and will ignore authorial intentions. Instead, intermediality comes in, for a deeper understanding of literature.[3]

World-Fever: Emotional Capitalism as a Lethal Illness

Gustave Flaubert's masterpiece *Madame Bovary* was noted for its devastating critique of its own time and place—the mid-nineteenth century in the French petty-bourgeois countryside. From the many thematic foci in the novel, I will consider the one least remarked on, yet the most relevant for today, and for feminism: the integration of a lingering romanticism with a capitalism beginning to proliferate. What destroys its main character Emma is not so much the "philosophy of love" as it has been called but that perverse integration into "emotional capitalism" (Illouz 2007). Flaubert, who was a literary perfectionist, experimented with two features of the French language. The first is verb tenses. He used the *imparfait*, the past tense of routine, in unorthodox ways. But what might appear as a mistake, takes on very specific, important meaning. The second is the use of "and," the conjunction that unites things without specifying the relationship. There, too, the unexpected use of the conjunction of juxtaposition can intimate either a hidden causality or an incongruous affiliation. I contend that through such formal experiments he created meanings that produce the feminism. The use of the *imparfait*, for example, in combination with an adverb of suddenness, is not an inaccuracy but the prediction of routine-to-come in a sudden event: of the future boredom, inevitable, even at a moment of excitement and surprise. And the lose juxtaposition of "and," implied in the alternations of descriptions of Emma's craving for love and for luxuries, requires from the reader the understanding of a causality never mentioned.

[3]On intermediality, see two volumes edited by the late Lars Elleström, founding director of a research group in Intermedial and Multimodal Studies (IMS) as Linnaeus University in Växjö, Sweden, with which I have been intensely engaged (2020).

Flaubert's transgressions of the rule of tenses insinuates the idea and experience of routine as the source of boredom. But filmmakers don't dispose of the same tools for meaning-making. Showing routine in film is hard, especially if the film is set in the past. This difficulty invokes intermediality. In loyalty to this aspect, the central part of the film MADAME B that Michelle Williams Gamaker and I made (2011–13) alternates different routines in Emma's life and the repetition of sequences from these routines. This part tackles the central topic to which the film shifts the core of Flaubert's novel, making visible what, in our view, is central in it. It stages "emotional capitalism"—then and now. This system, where capitalism and romantic love trade places, where commodities are invested with emotion and love is for sale, is what kills Emma and never ceases to kill or otherwise damage people. Drawing this disease to the foreground brings feminism in.

This is the bond between *Madame Bovary* and MADAME B, the past to the present. The underlying syndrome is a *confusion between domains*, the translation of desire from one domain to another, as a response to frustration. This is as much of today as it is of the 1850s. Chronology, and the idea of progress, don't work at all. The most revealing images in this respect show Emma's insecurity upon entering a fancy designer store. Shadows, reflections, and mirrors confront her with herself, her looks, and her anxiety, transforming herself from a middle-class woman into a fancy-dressed beauty. Because it remains unseen, the syndrome continues its ravages undisturbed. The caring figure of the salesman reassures her in ways we can easily recognize from our own confrontations with the allure of capitalism and its ability to exploit emotions, insecurity, and hope for a more exciting life. Emma's desire to transform herself is matched by the fairy-tale decoration of the store she enters.[4]

Emma's lethal trap is, then, neither psychological nor ontological. It is social and economic. By staging this, Flaubert exonerates Emma from varied charges of mediocrity, selfishness (her adulterous adventures), and other moralistic responses. Flaubert's novel confronts us with a thematic as well as stylistic exploration of the cultural conspiracy that turns business into an emotional issue and love into a business venture. In studying the novel in view of filming, in intermedial image-thinking I saw how Flaubert, as a philosopher-sociologist image-thinker, had staged this syndrome before Marx came up with his critique of capitalism and Freud with his diagnosis of hysteria. The novel, hence, helps understand this cultural perversion that

[4] While we were already almost finished filming, and had construed this syndrome, it took the belated discovery of the work of Israeli sociologist Eva Illouz to sum it all up in a single concept: "emotional capitalism." See Illouz (2007).

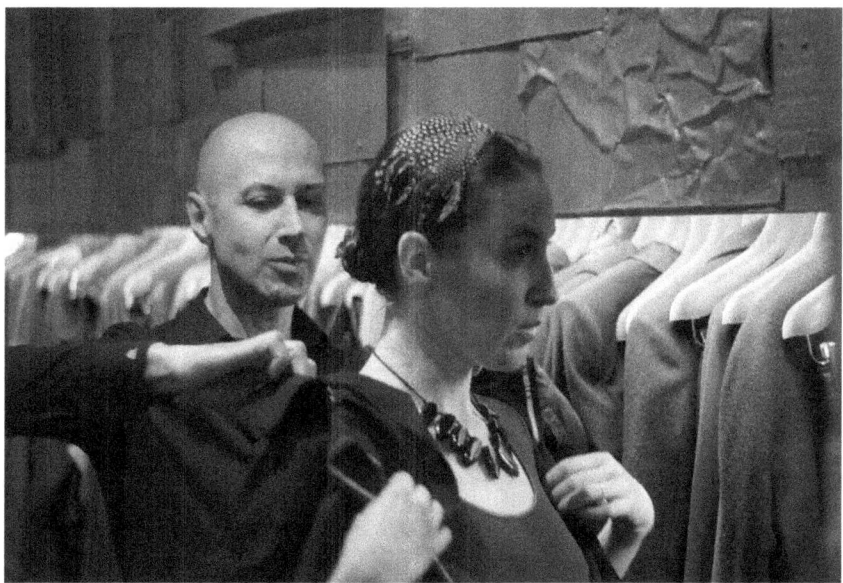

FIGURE 9.1 *Emotional capitalism in practice.* Photo: Thijs Vissia. From Mieke Bal & Michelle Williams Gamaker, MADAME B. Courtesy of the artists.

Flaubert imagined, Marx and Freud theorized and in which today we still all participate (Figure 9.1).[5]

How does this bring feminism in, then? Decades before Marx and half a century before Freud, Flaubert had seen it coming, and fiercely indicted it; he had understood its deadly quality. The responsibility for this is collective and systemic as well as individual. But the individual, when already trapped in otherwise imprisoning routines, such as housewifedom, is disempowered in the face of such strong, enduring forces. Emma the character can hardly be considered a feminist, apart from claiming the right to happiness. But the novel that stages her and demonstrates her status as a victim of an integration of several global forces—masculinist family ideology, capitalism, and romantic deception for sexual luring—is, as a fictional literary work, deeply, even fiercely, feminist. Emma's victimization is evidence of what is wrong with Flaubert's society. And look at the world of which she suffers and dies. In these respects, it has not changed, or not enough. The first

[5]This is a real store, L'éclaireur in Paris, and its real salesman, Pierre Lassovski, brilliantly played the part that is his everyday business, yet also something he knew our film was putting under critical scrutiny. Part of this section was developed in more detail in Mieke Bal, *Image-Thinking: Art-making as Cultural Analysis*. Edinburgh University Press, 2022.

oppressive ideology may seem to have improved in some parts of the world, but its lingering and the worsening of the other two, capitalism and sexual luring, cancel out that "progress" and turn such improvement into an appearance only. Though Flaubert's biography shows his indifference to the social position of women, *Madame Bovary* cannot help itself from being, through literary perfectionism, a feminist novel. I will demonstrate how the literary ambition inevitably led to this.[6]

Emma is not a feminist; instead, she stands for the need for feminism. And to make matters worse, she is not an "anti-suicide bomb," as psychoanalyst Françoise Davoine called another world literature heroine (more on this later); on the contrary, she commits suicide. But Flaubert manages to create a death scene that turns this suicide into a declaration against it. Ten pages long, that scene contains lots of spoken words—mostly the irrelevant quibbles between the priest and the pharmacist, the doctor and Charles. They overwrite what happens to the dying woman. Countering this, the prose enlists witnesses. Here is how Flaubert describes what happens in the room where Emma lays dying (given Flaubert's meticulous stylistic precision I add the French in a footnote):

> Distracted, blabbering, close to collapse, Charles walked in circles around the room. He stumbled against the furniture, tore his hair, *and* never had the pharmacist dreamed there could be so frightful a sight. (emphasis added)[7]

Typically, with his mastery of subverting the conjunction "and" and his taste for succinctness, he combines in a single sentence the despair of the husband Charles, who does not understand what is happening yet displays the traditional signs of grief, and the hyperbolic, exploitative curiosity of the pharmacist Homais, always there to probe but never to understand nor empathize. Whether the frightful sight is Emma or the lamenting Charles remains ambiguous. The text calls on the participants, be they readers or viewers, to be witnesses and choose sides.

The feminist point, here, is to know who is important. For the novel also figures what Emma thinks at this ultimate moment of her life:

[6] The most illuminating biography of Flaubert, by Pierre-Marc de Biasi (2009), not only gives a trustworthy account of his life but also of the tendency to write in a cinematic style, to allege another pre-posterous element, along with an incipient intermediality.

[7] "Éperdu, balbutiant, près de tomber, Charles tournait dans la chambre. Il se heurtait aux meubles, s'arrachait les cheveux, *et* jamais le pharmacien n'avait cru qu'il pût y avoir de si épouvantable spectacle" (III, 8). The French has that significant conjunction « et » that the translation had omitted and I added.

Emma was thinking that now she was through with all the betrayals, the infamies, [and] the countless fierce desires that had racked her. She hated no one, now; a twilight confusion was falling over her thoughts, and of all the world's sounds she heard only the intermittent lament of this poor sweetheart beside her, gentle and indistinct, like the last echo of an ever-fainting symphony.[8]

Emma loses her capacity of sense perception and she can no longer see. The sign of specific and crucial focalization, here, is that Flaubert's predominantly visual novel yields to *audio*; her indifference to, sometimes hatred of Charles, morphs into a recognition of his sweet nature and sincere affection. The figuration of this confused audio perception posed a difficulty for cinema. Yet, it is, again, a moment where loyalty to the novel helps audiovisual meaning to be more affectively effective than it would otherwise be.[9]

In our film, we have tried to give Emma her own focalization, even when she is no longer able to see. The witnesses, to her, have become ghosts, spectres. Since Derrida, or should I say, since Derrida's Marx, the spectre is an undead, someone the subject sees because it haunts her; toxic, dangerous, but without substance, and in most narratives, without subjectivity. But as Esther Peeren asks (2014), what happens when the spectre, or ghost, is allowed to be the focalizer? The confused hearing of Charles's lament, "the last echo of an ever-fainting symphony" is figured, in our audiovisual exploration, through the focalization of the dying woman who "sees" only ghosts because she already is one. But Charles is the source of the echo, indirect, but harmonious—"symphony," like the novel. This gave him the cinematic privilege to stay close enough to Emma to remain on her side, instead of turning into a ghost. Allowing Emma to focalize her own dying moment counters her total subjection. In this respect, she embodies anti-suicide, even if she is doomed (Figure 9.2).[10]

[8] "Elle en avait fini, songeait-elle, avec toutes les trahisons, les bassesses et les innombrables convoitises qui la torturaient. Elle ne haïssait personne, maintenant; une confusion de crépuscule s'abattait en sa pensée, et de tous les bruits de la terre Emma n'entendait plus que l'intermittente lamentation de ce pauvre cœur, douce et indistincte, comme le dernier écho d'une symphonie qui s'éloigne" (Flaubert 1950: III, 8).
[9] For the concept of focalization, see Bal (2017: 132–53).
[10] This is a technical consequence of the cinematographer Christopher Wessels's play with depth of field. Wessels made astounding contributions to the meanings displayed, by means of the technical apparatus of the camera.

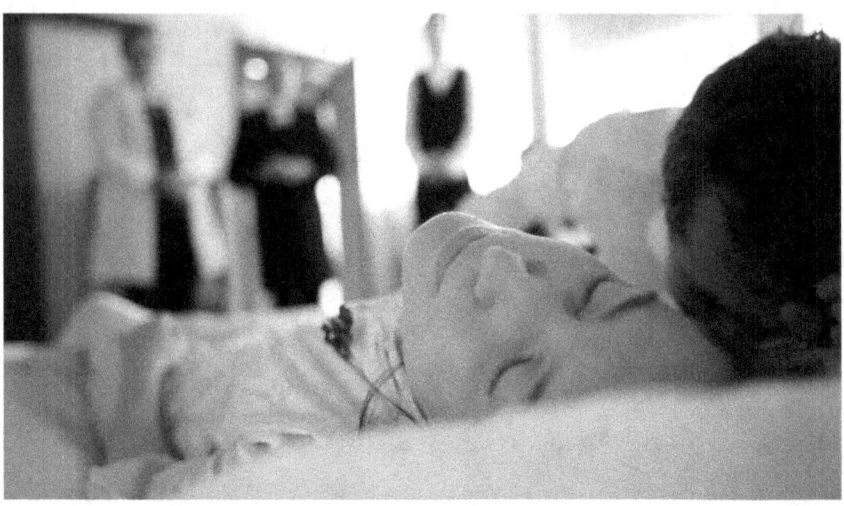

FIGURE 9.2 *Emma dying. Video still from Mieke Bal & Michelle Williams Gamaker,* MADAME B.

Woman as Anti-Suicide Bomb

Marcela affirms forcefully that she does not give in at all to political ideologies that want to make you feel guilty. . . . She refuses to be complicit with death discourses disguised as utopian discourses, and she stands up against the political weapon of making you guilty.

—FRANÇOISE DAVOINE[11]

Further into the past, the equally famous novel *Don Quijote* by Miguel de Cervantes, where women are minor characters except for the nonexisting object of Don Quijote's amorous obsession, does stage a remarkable young woman who can be considered not only a feminist but also the trigger of a near-feminism in the hero. From her the main title of the present chapter is derived. In Cervantes's novel, one of the many inserted novellas concerns what psychoanalyst Françoise Davoine has called "Woman as anti-suicide Bomb": the refusal to buy into the politics of guilt. Don Quijote and Sancho Panza are on the road. They don't have a program, because the Knight Errant wants to do good, to help people, but doesn't understand what is

[11]The title of this chapter was borrowed from Françoise Davoine's fabulous book on Cervantes's novel (2008: 147).

happening in the world. After reading books, he now reads society. Attentive to what they see and hear, the knight intervenes, whether or not his help is welcome. In the incident presented in this scene, good will, bad faith, and other social attitudes are put to the test. The question of "woman" is at the heart of the test.

This episode, based on *DQ* I, 12–14, questions the hysterical reaction to amorous rejection—the idea that some men won't take "no" for an answer. It is an early modern scene of an explicit contest of masculinism versus feminism, invoking contemporary sexual pressure. A young shepherdess who declined to marry a man enamored of her is accused of being guilty of the suitor's subsequent suicide. The friends of the diseased accuse her, call her a murderess. Marcela totally adequately defends her right to refuse to marry. At that point, Don Quijote, who happens upon the burial of the suicide, witnesses the grief of the friends, then intervenes and defends her. His discourse is almost entirely congenial with what a feminist defense would be. I was flabbergasted when I read it: how could this, the world's number one bestseller from early modernity, be so fiercely feminist? Until the main character utters a slip of the tongue, which spoils the feminist tenor. Instead of simply saying "no blame," he concedes to the men by saying "little or no blame." Embarrassing, given the rest of the statement. He couldn't quite sustain his feminist partiality. Shame on him![12]

> Let no man, of whatever state or condition, dare to follow the fair Marcela, under pain of incurring my most furious indignation! She has shown with clear and sufficient argument that she bears *little or no blame* for Chrysostomo's death, and how far she is from yielding to any of her [suitors'] desires. Wherefore it is right that, instead of being pursued and persecuted, she should be honoured and esteemed by all good men in the world, for she has proved that she is the only woman living with such pure intentions. (110, emphasis added)

But Marcela, like a contemporary feminist, perhaps annoyed by Don Quijote's slip, neither needs nor wants his help. She already has expressed her desire to be free clearly enough in an anti-suicide statement: "If Chrysostom's impatience and headstrong passion killed him, why should my modesty and reserve be blamed?" (110)

I have turned this scene, along with fifteen other scenes from the novel, into a video installation. This involves intermediality, between literature

[12]The tight ambiguous relationship between shame and masculinity has recently been studied in a book edited by Ernst van Alphen which accompanied an exhibition on the topic (2020).

and video, along with the intertemporality, between the early seventeenth century and today, in view of both the endurance of patriarchal thinking and the inroads of feminism. How does the museal display impact on the literary classic, inflected not only by audiovisualization but also by display in a public space, under conditions to solicit empathy? That affective sociality would make it possible to learn the lesson from literary heritage. It would make the feminist tenor of the scene affectively contagious.

In this project as in the other video projects, I alternated literal quotations with my own writing, as a way of binding the past and the present together. For the literature-video intermediality, we called upon volunteering students to play the weeping friends. They heroically spent four hours in 46 degrees Celsius, dressed in heat-attracting black, impressively playing grief, lamenting and crying inconsolably. In addition to the beginning of Don Quijote's pointless altruism (further elaborated in another episode of the installation), this scene explores the idea, which might seem contemporary but is already expressed in Cervantes's novel, that the independent young woman Marcela doesn't need Don Quijote's help, and that men who try to be "good guys" still reproduce some of the masculinist pitfalls in their interactions with women. The young men who lost their friend to suicide are grieving, but typically, they project their sorrow on the woman when she accidentally comes upon the burial. "Because" she is beautiful, they are tainted by their dead friend's despair, and blame it on her. To foreground this "inter-temporality," the audible dialogue consists entirely of quotations from the novel, except for the phrase "no es no," that I added (Figure 9.3).

The moment Don Quijote hears the laments and the scolding of the friends of the deceased, he decides to intervene. The young woman Marcela, however, can defend herself. Her speech asserts her right to independence and is convincing enough. The suicide is what is indicted, not the woman who chose to live her own life. This turns Marcela into a feminist heroine. But Don Quijote's desire to feel important in his crusade against injustice leads to his being touched by the masculinism when he adds that Marcela may still have some guilt. Then, she pushes him out of the way: for this macho slip, or for the superfluidity of his help? This is the most feminist moment of the novel. The intermedial transformation required a gesture of literally pushing the knight away, which can only be made visible by such a slightly aggressive gesture (Figure 9.4).

In response to both the young men's accusations and to Don Quijote's loud and clear indictment of these, Marcela quotes "no es no" from earlier feminist protests against sexual harassment, now brought forward by #MeToo. That slogan was on banners in the streets of Murcia when we filmed the scene during election time in June 2019. Clearly, feminism and political activism go together.

FIGURE 9.3 *The young men mourning their dead friend.* Photo: Mar Sáez. Mieke Bal, DON QUIJOTE: SAD COUNTENANCES.

FIGURE 9.4 *Don Quijote's rant against the men who scold Marcela. Marcela looks annoyed. At whom?* Photo: Mar Sáez. Mieke Bal, DON QUIJOTE: SAD COUNTENANCES.

Listening to Cassandra

Third, even harking back to antiquity, the figure of Cassandra is so marginal in the source texts that it took her resurrection in the 1980s to earn the fame that her actions and tragic fate deserved. She is a victim-heroine of #MeToo as well as a companion to Greta Thunberg from ancient times. Cassandra, the young woman, needs to be heard, listened to. For she sees the future, and wants to warn us. But the gift of prophecy the god Apollo gave her as a means of seduction was cursed when she refused to sleep with him: she would know the future, but no one would listen. This was Harvey Weinstein & Co., prefigured. A feminist, contemporary "human rights" issue: to be safe on the workplace and not forced to swap jobs for sex. Indian artist Nalini Malani is currently arguing visually in several exhibitions: listen! It's about time we listen (Figure 9.5).

Malani made a thirty-panel painting on Cassandra in 2009. The multi-panel form intimates a cinematic quality, while also suggesting detailed looking. The panels are both separate and, due to the figurations, continuous. Malani is an intermedial "quoting" artist; she engages both Eastern and Western myths and literary texts, brings them to the present world in surprising, original forms. Cassandra speaks also in her 2012 video-shadow play IN SEARCH OF VANISHED BLOOD. She is currently exhibiting several

FIGURE 9.5 *Nalini Malani*, Cassandra, *2009. Thirty-panel reverse painting on acrylic sheet, overall size 225 × 390 centimeters, each panel 45 × 65 centimeters; Collection Kiran Nadar Museum of Art, New Delhi. Photo: Anil Rane. © Nalini Malani, courtesy of the artist.*

installations in a variety of countries, with titles as "Do You Hear Me?" and "You Don't Hear Me."[13]

The East German writer Christa Wolf (1984) rewrote the Cassandra story with the focus on Cassandra, who, in Homer and Aeschylus, hardly came through. In Wolf's novel, apart from a short first paragraph that gives her, literally, a place ("It was here. This is where she stood. These stone lions looked at her; now, they no longer have heads"), the novel is entirely written "in the first person." If you read it, you cannot help listening to her. After these few short sentences, Cassandra slowly recuperates narrative power. "This fortress—once impregnable, now a pile of stones—was the last thing she *saw*." Seeing: her final act of perception, focalization, casts her gloomy eye on the destructive passage of time. This is reinforced by the final short sentences of that paragraph, which enlists us all: "no trace of blood *can be seen* seeping out from beneath. Point the way into the darkness. Into the slaughterhouse. And alone." The passive voice and the negative of "can be seen" indicates that we readers as co-focalizers are as powerless as Cassandra is. That final clause foregrounds the fate of this young woman. Death by violence ("slaughterhouse") and loneliness.

Heeding Malani's warning, this beginning of the novel and its succinct narratological analysis sets us up as the listeners Cassandra lacked. From the nine lines of this opening paragraph on, we are compelled to listen to the voice of the "first person." It goes to show that art—here, literature—is not a luxurious, frivolous but basically useless pastime. Instead, I argue, we must learn not *about* art but *from* art. About the world, time, urgent matters that need intervention. And looking at its details helps that learning. In this sense, a (fictional) novel harbors the two fundamental features of an essay, in Adorno's view of that (non-)genre, the two meanings of partiality: fragmented, not whole; and subjectively passionate (1991).

When we listen to Cassandra, the first thing we hear is a single-sentence paragraph: "Keeping step with the story, I make my way into death" (3). Then follows the narrative of Cassandra's thought and memories on her final day: "the closer you come to death, the closer and brighter are the pictures of childhood and youth" (35). And when she says: "I lived on in order to see" (4), she states the importance of witnessing, that special, socially relevant form of focalization.

What she sees is the horror-to-come. And in the act of seeing, she is aware of the force as well as the problematic of time: "For it was, it is, an experience when I 'see,' when I 'saw.' Saw the outcome of this hour was our destruction. Time stood still, I would not wish that on anyone" (59).

[13]See the catalogue for Malani's 2019 exhibition, at the occasion of the Miró Prize. See Bal (2016: 66–124) on her video-shadow play IN SEARCH OF VANISHED BLOOD and the Cassandra story in that work.

This temporality and the urgency to listen to Cassandra's prediction of destruction, interwoven with testimonial focalization—seeing *with* her—make this novel relevant for today. To see, but not in a voyeuristic riveting, as Adorno has warned us, after the Holocaust (2003). His caution is not an iconophobic censoring but an appeal to deploy our capacity for empathy. Cassandra opposes war and the heroism it demands, and as a result, she is rejected, cast out of her father's house. Today, we see how war and other forms of violence and the neglect of the ticking time bomb of destruction—of the planet—are rampant. If only we would listen to Cassandra.

As we must. This figure has been turned not only into a feminist but also an environmentalist and an anti-war activist. The backbone is Cassandra's temporal awareness. Her repeated call for urgency is key, both to the ancient myth and Wolf's subjectivation of it and to my attempt, in 2020, to make an essay film on this issue. And in addition to these three moments, the most personal, intimate moment in the film, I thought, should be when the near-future infringes on the figures' personal lives. This is when Cassandra dumps Aeneas because he remains too close to the powers-that-be, resulting in a near future in which he would become stultified. This concerns the future—one she rejects. At the end of the novel, she abandons him with the poignant words: "I cannot love a hero. I do not want to see you being transformed into a statue" (138). She breaks off their relationship not because her feminism makes her hate men. Rather, the call to war deprives Aeneas of his sweet nature, and that is what Cassandra cannot bear.[14]

Time is a timely topic. From the image in time to the temporality of images, including, the moving images of film and video, time is currently being considered in its many aspects and manifestations. Think of sequential ordering, duration, rhythm, memory, uncertainty and undecidability, affect and suspense, and the kinds of time the combinations of these aspects entail, such as deep time, geological time, narrative time, and more. Some, also, bring these considerations of time to bear on the capitalist time we are submersed in. Moreover, it is useful to remember that clock time, dating from the colonization period, is fundamentally in the interest of capitalism. But not only scholars explore time in art, artists themselves do so in depth and creative research. So does, for example, William Kentridge in his 2012 opera *Refuse the Hour* (Figure 9.6).[15]

[14] I made the essay film, IT's ABOUT TIME! REFLECTIONS ON URGENCY, at the invitation of the Łódź film school (Jakub Mikurda). The film can be watched at http://www.miekebal.org/artworks/films/its-about-time/. 2020 Essay film. 31.25' color, Dolby sound. Polish, with English subtitles.

[15] For a clear overview of theories of time, see Wyller (2020). Fragments from Kentridge 2012 opera appear in MADAME B.

FIGURE 9.6 *Cassandra (Magdalena Žak) rehearsing her lines, with the help of program director Jakub Mikurda. Photo: Alicia Devaux. Mieke Bal,* IT'S ABOUT TIME! REFLECTIONS ON URGENCY.

Winding Up

I cannot write a conclusion to these short vignettes. They have in common that the texts all belong, without a doubt, to the traditional canon of "World Literature." They have a long history and are still very intensely read. They belong to our cultural heritage. They also have a particular take on feminism. But that is where the similarity stops. Flaubert, the least feminist author I can imagine, could not help himself, in his pursuit of formal perfection of severe critique of his time and place, to stage the sore fate of Emma Bovary in terms of her victimization and thus indict both the men and the social system that cause her demise. His literary experiments with the French language, a form of disobedience, suggest he is siding with his character. As a man, he is not; as a writer, he is. His art of writing overrules his biography. And it is because of that art that the novel, including the sympathy for the victim, is still forcefully actual today.

Of Cervantes's attitude to women, I don't know anything. I just noticed that women are not very powerfully present, at least not in the first part of the two-volume novel, except as targets of male lust and greed. Marcela is the exception, the only explicit and powerful protester against male domination. I think it is fair to frankly call her a feminist. Cervantes, whether or not he was aware of it, made his hero lose from this minor character, in fortitude, conviction, and persuasion. Marcela just rejects the ideologies that surround her, both the suicide of the young man itself and the way this is considered as caused by her refusal to subordinate herself to the suitor.

For Cassandra, we only have the word of the modern author and artist for it; the antique sources don't help much. Except that the curse of Apollo in punishment for her refusal of sex is a clear instance of #MeToo. What Wolf does with the narrative is an effective way of, first, setting her in context, and second, yielding narrative power entirely to her. Given the sad story, that can be seen as a feminist literary intervention. And Malani's multiple painting, where figures and situations transgress the borders of the panels, brings the figure to life, in a painterly and also cinematic manner.

It is not necessarily in the fabula, the events, and the fate and actions of characters, that the feminism sits. Nor is it always explicit. I found feminism in the subtleties, the formal experiments, and the narratological specificities of these historical texts. All we can hope for is that teachers and other readers pick up on those threads, and will bring these to the attention of learning readers.

References

Adorno, T. W. (1991 [1954–58]), "The Essay as Form," in Shierry Weber Nicholson (trans.), *Notes to Literature*, vol. 1, 3–23, New York: Columbia University Press.

Adorno, T. W. (2003 [1974]), *Can One Live After Auschwitz? A Philosophical Reader*, ed. R. Tiedemann, trans. R. Livingstone et al., Stanford: Stanford University Press.
Alphen, E. van (2020), *Shame! And Masculinity*, ed. E. van Alphen, Amsterdam: Valiz.
Bal, M. (1999), *Quoting Caravaggio: Contemporary Art, Preposterous History*, Chicago: The University of Chicago Press.
Bal, M. (2016), *In Medias Res: Inside Nalini Malani's Shadow Plays*, Ostfildern, Germany: Hatje Cantz.
Bal, M. (2017 [1985]), *Narratology: Introduction to the Theory of Narrative*, Toronto: University of Toronto Press.
Bal, M. (Spring–Summer, 2020), "Challenging and Saving the Author, for Creativity|Sfidare e salvare l'autore, per creatività," in *Vesper. Rivista di architettura, arti e teoria|Journal of Architecture, Arts & Theory, no. 2, Materia-autore|Author-Matter*, 132–49, Quodlibet: Macerata primavera-estate.
Barthes, R. (1986 [1967]), "The Death of the Author," in *The Rustle of Language*, ed. R. Barthes, trans. R. Howard, 49–55, New York: Hill and Wang.
Biasi, P.-M. de (2009), *Gustave Flaubert. Une manière spéciale de vivre*, Paris: Le Livre de poche.
Booth, W. C. (1961), *The Rhetoric of Fiction*, Chicago: University of Chicago Press.
Bruhn, J. (2019), "'We're Doomed—Now What?' Transmediating Temporality Into Narrative Forms," in N. Salmose and L. Elleström (eds.), *Transmediation: Communication Across Media Borders*, 217–34, New York: Routledge.
Cervantes, M. S. de (1950), *The Adventures of Don Quixote*, trans. J. M. Cohen, London: Penguin Books Ltd.
Cervantes, M. S. de (2016 [1605, 1615]), *Don Quijote de la Mancha puesto en castellano actual íntegra y fielmente por Andrés Trapiello*, Barcelona: Ediciones Destino.
Elleström, L. (ed.) (2020), *Beyond Media Borders: Intermedial Relations among Multimodal Media*, vols. 1/2, Basingstoke: Palgrave Macmillan
Flaubert, G. (1950 [1856]), *Madame Bovary*, trans. Alan Russell, Baltimore: Penguin.
Foucault, M. (1979 [1969]), "What is an Author?" in J. V. Harari (ed.), D. Bouchard and S. Simon (trans.), *Textual Strategies: Perspectives in Post-Structuralist Criticism*, 141–60, Ithaca: Cornell University Press.
Illouz, E. (2007), *Cold Intimacies: The Making of Emotional Capitalism*, Cambridge: Polity Press.
Malani, N. (2019), *You Don't Hear Me*, Barcelona: Fundació Miró.
Peeren, E. (2014), *The Spectral Metaphor: Living Ghosts and the Agency of Invisibility*, London: Palgrave.
Wolf, C. (1984), *Cassandra. A Novel and Four Essays*, trans. J. van Heurck, New York: Farrar-Straus-Giroux.
Wyller, T. F. (2020), *What is Time? An Enquiry*, trans. K. Pierce, London: Reaction Books.

10

Translating Hidden Economies

Toward a Decolonial-Feminist Worlding of Literature

Laura Doyle

The opening sentence of *The Thousand and One Nights* immediately draws attention to "what lies hidden in the old accounts of bygone peoples and times."[1] This chapter proposes that part of what "lies hidden" in both old and recent literary texts is an encoding of a mutually constitutive relation between literature, gendered systems, and feminist-intersectional intervention. Taking *The Thousand and One Nights* as both a case study and a starting point for reading later literature, I analyze the imperial and sexual-intersectional matrix of literatures' production. I argue that feminist craft, hidden in the open, has long shaped literary forms across the world, calling audiences into risky, transformative alliances.

Guided by the concept of inter-imperiality as I develop it in *Inter-imperiality: Vying Empires, Gendered Labor, and the Literary Arts of Alliance* (Doyle 2020), the chapter pinpoints two structural conditions that literature

[1] Husein Haddawy (1990), *The Arabian Nights*. Subsequent citations appear in the text. Haddawy's translation draws on Muhsin Mahdi's earlier translation of the manuscript he discovered in Baghdad dating to either the fourteenth or fifteenth century. This early version is believed to be the same version that Antoine Galland received from his Syrian acquaintance, Hanna Diab, in the early eighteenth century, and translated into French—after which it became perhaps the most translated text in literary history. See Mahdi's preface in Muhsin Mahdi (1984–94).

has implicitly exposed: men's instrumentalization of sexuality and labor for the production of stratified political economies within an inter-imperial field of power; and the consequent enclosure of women in domestic realms—where, however, as the texts insinuate, women have nonetheless practiced subversion by cultivating the arts of coded storytelling and performance.[2] In other words, as indicated in the author-figure of Shahrazade, not all of the "Anon" authors imagined by Virginia Woolf—Shakespeare's disavowed genius sisters—died poor on city streets. Artful women have inhabited diverse stations. They have included the women conscripted as colonial nannies, as Katie Trumpener (1997) reveals in *Bardic Nationalism*; and the shrewd, sexually transgressive women like those portrayed in *Nights*; and the wifely Penelopes who weave at night, and who might even have created the *Odyssey* itself, if Samuel Butler's ([1897]1968) theory be believed.

The long literary legacies of Anon also include the spinners of the ancient Sanskrit *Panchatantra* tales and the Persian collection *Hazar Afsan*, both of which shaped the Arabic-language compilation called *The Thousand and One Nights*. In its Arabic-language version, *The Nights* retains the Persianate frame of *Hazar Afsan*, which features Shahrazad as a vizier's daughter who risks her life during the reign of the Persian Sassanid Empire (224–651 CE). This frame story implicitly dramatizes how alliances among women, servants, and slaves provoke imperial crises and in turn prompt strategic tale-telling practices that challenge the sovereign control of language, particularly the speech acts of wives and laborers. Yet, equally important, the retention of a Farsi-Persianate frame in the Arabic-Islamicate versions of the text inscribes its inter-imperial conditions of production. In other words, *The Nights* situates women's risky artistry in a world of empires.

Through this reading of *The Nights*, I hope to contribute to recent recastings of World Literature as a worlding project linked to feminist-intersectional, materialist, and decolonial practices.[3] As has been argued by numerous scholars, the very category of World Literature sometimes problematically operates as a new canon yet without clear grounds of inclusion other than a text's multilingual translation. This version of World Literature has spawned debate and critique for its evacuation of politics, especially when it cherry-picks from widely translated postcolonial texts for its otherwise neutralized "world" canon.[4] Spurred by these problems,

[2] I thank Duke University Press and the journal *Parergon* for publishing earlier versions of some material in this chapter.
[3] Some scholars have distinguished decolonial studies from postcolonial studies, yet I join those who see them as connected at the root. For essays debating this question and outlining feminist-decolonial theory, see Priti Ramamurthy and Ashwini Tambe (2017).
[4] For instance, critics have challenged Pascale Casanova's (2007) separation of literary and political "world-systems," and they have also critiqued the elision of translation politics, as in David Damrosch (2003). For critiques, see Aamir Mufti (2016); and Emily Apter (2013). For

literary scholars have begun to develop fresh methods for capturing the worldly reach of texts (not always deemed World Literature, capital W), while simultaneously grounding them in specific politics, locales, languages, and histories. Shu-mei Shih (2013) has, for example, proposed that literary scholars might define their objects of study less in relation to "the world" as a whole and more specifically along "arcs of relation" created by events (such as the Vietnam War) and systems (such as the global plantation complex of bonded and enslaved labor), which link texts across regions and languages. Other scholars have begun to incorporate longer-historical, non-Eurocentric models that track intertextuality across regions and periods, as advocated, for instance, by Karima Laachir, Sara Marzagora, and Francesca Orsini (2018). They propose that critics might demote the centrality of nations and national languages and instead frame their analyses within "significant geographies," where for centuries texts have accrued political cross-references and overlapping cosmologies, as in Indonesia or the Maghreb. Other critics, such as Revathi Krishnaswamy (2010), bring a feminist lens to this longer literary history. Krishnaswamy has drawn attention both to the gendered elements of older literary genres, such as the gendered voicing of *bhakti* lyrical poetry and the ancient Tamil ecopoetics of landscape. Her work beckons us to consider the ways that, for millennia, literature has critiqued and reimagined social collectivities even while evincing its own political entanglements. An increasing number of scholars are pursuing such analyses, clearing the way for fuller rethinking of the geopolitical economies in which genres have done their "worlding" work.[5]

Joining with this emergent effort, I argue that when we plumb the structural, long-historical depth of literatures' involvement in inter-imperial economy and its encoding of women's maneuvers in that economy, we are better able to see that gendered subversions and revisionings have been constitutive of world literatures. In turn, we better understand literature as a long-standing historical site of dialectical struggle. To set the stage for this reading, I first briefly outline my analysis of inter-imperial economy, with emphasis on the pivotal role of the cultural institutions and the knowledge-building projects of powerful states.

Literate Institutions in the Economy of Empires

In *Inter-Imperiality*, I bring together dialectical theory and non-Eurocentric world historiography to reframe long-historical processes of economic, state,

reconceptualizations, see Christopher Prendergast (2004); and David Damrosch (2014). For emphasis on literature's "worlding," see Pheng Cheah (2016).
[5]See Sahar Amer and Laura Doyle (2015); and Laura Doyle (2018).

and cultural formation, especially as these unfold together with political dissent and aesthetic representation. I focus on the fact that in most periods from ancient times to today, there have been several contemporaneous empires and several vying hegemonies, rarely only one. The "inter" of inter-imperiality thus refers to multiply vectored relations among empires *and* among those who endure and maneuver among empires, whether as everyday folk or patron-supported artists.

Tracking empires' interconnected expansions and their extractive, capital-accruing economies over two millenia in the Americas and Afro-Eurasia, I argue that this history clarifies the systemic nature of struggles over reproduction, labor, and capital (both intellectual and infrastructural). In particular, it reveals the degree to which competitive inter-imperial relations have driven the increasing co-adaptations, homogenization, and linking of these systems, as well as the subversive reworking of them from below. The analysis also takes account of the accruing force of empires over long-historical time, in turn exposing the degree to which we all occupy a deeply sedimented condition of *inter-imperial positionality*—although in distinctly unequal ways. Finally, I argue that long-accruing literary-cultural genres and tropes have played key parts in these world historical processes, tooled by states and retooled by communities as they have maneuvered within this existential historical condition.

To contextualize this argument, in this section I sketch the intertwining of learned and aesthetic culture with state-funded academies and knowledge or translation projects. For brevity's sake I focus on written literatures, although oral traditions have also formed within inter-imperial conditions. I give special attention to the Persianate and Islamicate states from which *The Nights* emerged.

Paper-making technologies figure importantly in this history, and their spread exemplifies inter-imperial dialectics as they have shaped the world's history. While papyrus, vellum, and other inscription materials had supported literacy and accounting practices for over a millenia, paper's mass reproducibility dramatically intensified the convergence of financial, material, political, and cultural co-formations. Apparently, first developed in China (first century CE), paper-making also led to block print-making technologies (China, seventh century CE). These practices in turn gave rise to the first paper money, which circulated in China by the tenth century, with long-term effects for strengthening the capitalist integuments of the system. Equally important, paper enabled the growth of China's literacy-centered state-building, including a large-scale civil service corps with state examinations. Together these developments helped China to achieve its self-representation and projection over increasingly vast territories, as Mark Edward Lewis (1999) demonstrates in *Writing and Authority in Early China*.

The dialectical effects spread as the state-building power of paper-based literacy inspired emulation by other expanding states. Most immediately this

formation drew the attention of the Islamicate Abbasid Empire in the eighth century, which—as it expanded eastward—had collided with the westward-expanding Chinese Tang dynasty. Soon, Islamicate states, too, developed their own forms of paper-based state bureaucracy, fostering a sophisticated, transhemispheric culture of the book. The Islamicate Umayyad Empire had earlier prepared this development, by its adaptation of the academic institutions of the states it conquered, especially those of the Persian Sassanid Empire, which had a long tradition of scholarly academies at court.

As this history suggests, these forms of capital (intellectual and material) were co-constituted by vying states: formed through inter-imperial competition, borrowing, and conquering expansion, as was equally the case with agricultural, transport, and financial systems.[6] As Jonathan Bloom (2001: 117–19) establishes, empires deliberately borrowed or stole from their neighbors' and rivals' library collections. For strategic reasons, they sought to understand the science, religion, and arts of other empires and peoples. To allied empires, they sent delegations of scholars who were directed to bring home manuscripts as gifts; and to enemy empires, they sent officers with orders to capture manuscript collections as valuable booty, as in wars between Byzantine and Abbasid empires. Scholars too were booty—kidnapped or conquered and thereafter choosing or forced to serve new masters. As with Persianate scholars in Islamicate states, such intellectuals creolized knowledge while also maneuvering in ways that have likely shaped scholarly codes and legacies.[7] We might call this the inter-imperial construction of knowledge and culture.

Translation projects were often central to these knowledge-building endeavors, as we will see is thematized in the *1001 Nights*. In the Abbasid Empire, Bloom (2001: 117) notes, the "translation of Persian, Greek, and Indian works into Arabic became a regular state activity"—just as the ambitious state-supported translation of Buddhist manuscripts taken from India at certain points helped Chinese to consolidate power in central Asia, enabling interpellation of millions. Similarly, in seventh-century Japan, the translation of Chinese and other Buddhist manuscripts made possible an island-wide hegemony for Japanese rulers.[8] Translation of science and math texts facilitated imperial trade and engineering, while translation of legal, religious, philosophical, and literary texts helped to consolidate control over conquered territories and manage relations with rival empires. Eventually, as Islamicate states expanded westward, European states learned of these formidable knowledge-building institutions, and in their turn funded university chairs in Arabic, supported translation projects, and sent their

[6] On these technological dialectics, see especially chapters 1 and 5 of Doyle (2020).
[7] See Hayrettin Yücesoy (2015).
[8] See Joan R. Piggott (1997).

scholars south, especially to the scholarly communities of al-Andalus in Islamic Spain. Thus was born the era of scholasticism in Europe. In all cases, the translators contributed, voluntarily or not, to the globalizing and gendered production of knowledge as power.

Yet, as *The Nights* makes clear, these practices and institutions also provoked counter-translations, anti-imperial alliances, and gendered retoolings among the conscripted and exploited denizens of empires.

Imperially Framed: The Arts of Tale-Telling

The framing story of *1001 Nights* is familiar. Night after night, Shahrazad tells tales to her husband, Shahrayar, the Sassanid Persian emperor, in order to defer his plan to execute her the next morning.[9] The Shah's murderous behavior predates his marriage to Shahrazade, beginning when he discovered an earlier wife's infidelity and concluded that women could not be trusted to remain faithful beyond one night. Therefore, he vowed to marry a new wife each day, consummate the marriage that night, and have her executed the next morning. Before his marriage to Shahrazad, we learn that he has already married and executed the daughters of many princes and army officers and then moved down the social hierarchy until "it became King Shahrayar's custom to take every night the daughter of a merchant or commoner, spend the night with her, and have her put to death the next morning" (11). After many women have died, as the frame storyteller of *The Nights* records, "there arose a clamour among the fathers and mothers" of the realm (11). The state is in crisis. And the crisis is sexual.

Enter Shahrazad. She has a plan to end the state killing, and to carry it out she tells her father that she must marry the emperor Shahrayar. Although her father tries to deter her through storytelling of his own, she spurns his effort. In the end, her nightly tales so impress Shahrayar that he finally agrees to spare her life and end the state killing. Shahrazad's literary cunning has rightly been appreciated by feminist readers as a tale of women's artistry and sisterhood, especially since Shahrazad's sister Dinarzad participates in her plan. While my discussion benefits from feminist as well as historical and postcolonial scholarship on these dynamics, I particularly consider

[9] I follow Haddawy's spelling of the names of the imperial husband and wife in the frame as "Shahrayar" and "Shahrazad," and his usage of the "Sassanid Empire" rather than the now-standard usage "Sassanian Empire." But unlike Haddawy, I refer to Shahrayar as "emperor" (Haddawy uses "king") because in Persian the prefix "shah" typically indicated the emperor, or blood-related imperial princes. I thank Professors Sahar Amer, Mazen Naous, and Johan Matthew for advice on this and other language nuances in the text.

how the intersectional dimensions of her art are geopolitically situated.[10] In presenting a world of ruling brothers and mediating viziers, the frame allegorizes the ways that these men instrumentalize tale-telling, translation, and Aristotelian political theory to enforce the captive conditions of women and laborers, on whom their power depends. To capture the full import of Shahrazad's intervention, it's therefore necessary to consider both the inter-imperial context of the *Night*'s formation and the role of viziers and learning in Islamicate empires.

In Arabic and Persian literatures, the genre of framed tales belonged to a long-standing tradition of statecraft literature, in which such tales served as a "mirror for magistrates." In Muslim political thought, furthermore, such tales often creatively reworked the Aristotelian political model, which deemed the household a subunit and microcosm of the state (Arjomand 1999: 276).[11] Contemporaneous and later audiences would have understood that the vizier's two-part tale about what he calls "good management" of home and laborers is also an allegory of state management. This fact should in turn alert twenty-first-century readers to the state implications of both the frame and the subsequent tales. To follow these implications is to see how literary forms intervene in geopolitics, sometimes articulating alternative political philosophies. The "Anon" storyteller may insinuate as much when s/he inserts the remark about "what lies hidden in the old accounts of bygone peoples and times," before proceeding in this opening sentence to explain that "long ago in the time of the Sassanid dynasty, there lived two kings who were brothers" (3). We further learn that the "invincible" older brother—the emperor, Shahrayar—held power that "reached the remotest corners of the land" and that "to his brother he gave the land of Samarkand to rule as king" (3).

Although typically passed over by readers, this story of two brothers within the Persian Sassanid Empire forms the conditions under which the empire's sexual crisis transpires. The trope of ruling brothers also recurs in several of the tales that follow, reinforcing its importance. Typically, in these tales the two brothers are secretly anxious about or jealous of each other's power, especially since one brother has inherited the mantle

[10]For a range of critical perspectives, including both feminist and postcolonial, see the following collections: Peter Caracciolo (1988); Yuriko Yamanaka and Tetsuo Nishio (2006); Susan Muaddi Darraj (2004); Saree Makdisi and Felicity Nussbaum (2009); and Ulrich Marzolph (2007).

For historical studies, see especially Richard Hovannisian and George Sabagh (1997), and Muhsin al-Musawi (2009). For important monographs situating the text across traditions, including attention to gender, see: Ferial J. Ghazoul (1996); Bridget Orr (2001); and Ros Ballaster (2005). For an early seminal literary history of the text's influence on English literature, see Muhsin Jassam Ali (1979). Also see Rebecca Carol Johnson, Richard Maxwell, and Katie Trumpener (2007).

[11]Arjomand also refers to the "mirror for magistrates" tradition (1999: 276).

of emperor while the other holds a lesser role as ruler of a less powerful peripheral state.¹² Such scenarios were not merely fictional. In fact, history is replete with wars of succession and rivalries or betrayals among brothers competing for the roles of king or emperor: from the ancient battles between Etiocles and Polynices for Thebes to the Incan battles between Huascr and Atahualpa in the sixteenth century. Within ancient Persian history, the wars between the Emperor Artaxerxes and his brother Cyrus the Younger for the Persian Achaemenid Empire (famously recounted by Xenophon since they also intersected with Spartan-Athenian Wars) would have been well known to the early audiences of *The Nights*, as would the rivalry between Peroz and Hormizd (457–9 CE) for rule of the Persian Sassanid Empire. Most immediately for Muslim listeners, it would likely call to mind the succession battles among the sons of the Abbasid Caliph Harun al-Rashid, which hastened the decline of Abbasid caliphate and empire.¹³ Thus, neutral as the division of power between two brothers is made to sound, the history and discourse of ruling brothers tells otherwise (as authors such as James Joyce and Salman Rushdie have highlighted in, for instance, *Ulysses* and *Midnight's Children*, respectively).¹⁴

In *The Nights*, brotherly tension emerges when the older brother, the emperor Shahrayar, invites his younger brother, Shahzaman, to visit the imperial center. Yet, this invitation exposes troubles in the state—specifically the sexual dalliances of their wives. First, before embarking on his journey to the imperial center, the younger brother returns to his palace for a last farewell to his wife. But he discovers her in bed with the palace cook. Specifically decrying the fact that she sleeps with "some cook, some kitchen boy," he sees the incident as a loss of control over his household, and by extension his state—a worrying development for Shazaman's relation to his brother (4). Accordingly, at Shahrayar's palace, he keeps this crisis to himself. Yet, during his stay, Shahrayar goes out hunting, and the younger brother Shahzaman discovers, with notable relief, that Shahrayar suffers the same trouble—and indeed worse. The emperor Shahrayar's wife has slept not just with one man; she has orchestrated orgies between herself, the courtier women, and "ten white and ten black" slaves—with her own lover specifically racialized as "a black slave" (7). When Shahrayar returns, Shahzaman reports the news to the Shah, now safely revealing their shared predicament. Shahrayar expresses astonishment that "Such doings are going on in my kingdom, and in my very palace" (8). Briefly tempted to "leave our

¹²On brothers in *The Nights*, see Hasan al-Shamy (2007) and Ulrich Marzolph (2007a).
¹³For my fuller discussion of *The Nights*, including succession politics and the rivalry between Harun al-Rashid's two sons, see chapter 2 in Doyle (2020).
¹⁴In *Ulysses*, Stephen Dedalus tracks what he calls legacy of "the brother motive" in Shakespeare and others (173, 9.956); and in *Midnight's Children*, Rushdie focuses on the rivalry between Saleem and Shiva, glossing it as a sign that "the ghosts of ancient empires [are] in the air" (1981: 488).

royal state," the men instead conclude that women are simply faithless, and so the Shah vows to kill all future wives after the wedding night (8).

It's important that these wifely troubles, which provoke a gendered crisis of state, involve rank and race as well as sexuality. For what's threatened is the brothers' control over labor as well as over women. Insofar as these dimensions work *together* to reproduce state power along the proper lines (as feminist-intersectional analyses have established[15]), the very structures of empire are at stake, and by extension so is the larger field of men's intra- and inter-imperial relations. In this light, Shahrazad's aim to marry the Shah to stop the killing of women can be understood as a challenge to geopolitically ordered *relations* that rest on women, laborers, and racialized slaves.

The centering of the second half of the frame on a vizier and his daughter points toward another kind of "hidden" political implication, and this implication becomes clearer when we also consider the place of viziers' families in early Islamicate states. As detailed by Said Amir Arjomand (1999), the powers of culture, state, and economy in medieval Islamicate states intersected powerfully in the vizier, who traditionally acted as a kind of prime minister or highest advisor to the Caliph. The vizier was usually also a learned man descended from a line of scholars within vizier families, and a wealthy man with extensive provincial landholdings. In Islamicate states from the Abbasids to the Mamlucks and Ottomans, the vizier eventually came to operate as patron and administrator of culture, that is of the libraries, madrasas (colleges), and teaching hospitals of the empire. Viziers regularly "endowed" one or more madrasas, drawing on revenues from their estates, and some, such as Nazim al-Murk of the eleventh-century Seljuq Empire, created "network[s] of colleges throughout the empire" (Arjomand 1999: 283). At the same time, in Arjomand's (1999: 285–6) assessment, these educational structures came to serve as "the institutional mechanism for the social reproduction of medieval civil society," thus "secur[ing] the reproduction of a subordinate civil society." Serving in part to train scholars and staff who could support state translation projects, these colleges would also have fostered the empire's aim to control conquered populations, absorb the knowledge of foreign states or colonies, and manage inter-state rivalries. In this sense, vizier played a hinge role in the co-formations of inter-imperial political economy.

Two other elements of vizier history are pertinent here. First, the *women* of vizier families were often also learned. The text carefully establishes Shahrazad as one such woman, for we are told she had "read the books of

[15]This body of scholarship is too vast to enumerate here, reaching from thinkers Audre Lorde and Paula Giddings through Kimberlé Crenshaw to more recent work. Also see the overview of social reproduction theory, as developed by feminist social scientists, in Tithi Bhattacharya (2017). My earlier work also addresses intersectional stratification as it serves racialized state-building projects; see Doyle (1994).

literature, philosophy, and medicine. She knew poetry by heart, had studied historical reports, and was acquainted with the sayings of men and the maxims of sages and kings. . . . She had read and learned" (11). Historically, such women also sometimes founded madrasas, even competing in their endowments with grand viziers, as in the Seljuq state—a point to keep in mind when reading Shahrazad's bold face-off with her father in the practice of statecraft wisdom tales (Arjomand 1999: 270). In other words, historically such daughters could indeed assert their power to participate in or challenge state powers.

Second, as noted earlier, many vizier families in early Islamicate states were originally of Persian origin, having been assimilated after the Umayyad conquest and then joined the ruling structure (and even more so after the Abbasid revolution, which was supported by some powerful families of Persian descent such as the Barmakids). As also mentioned, among the Persian forms absorbed and retooled into Arabic-language literature was the genre of framed tales that gave advice to princes, channeled into *The Nights* through its main source text, the Persian *Hazâr afsân[e]*, translated as *A Thousand Tales* (itself perhaps influenced by the Indian collection *Panchatantra)*. The entire frame story of Shahrazad, passed down from the Persian text *Hazâr afsân[e]*, has been retained since the early Arabic adaptations—thus ever since sparking debate about the Arabic versus Persian nature of this text.[16] Thus, the Persian frame of the Arabic-language *1001 Nights* that features a Persian vizier symbolically embodies the co-forming, inter-imperial relations between the descendants of the Sassanid and Abbasid states—inscribing the text's inter-imperial conditions of production. The appropriations and inter-imperial torque in these relations are further registered when Shahrazad, our seventh-century Persian narrator, begins to relay tales set in eighth-century Baghdad featuring Harun al-Rashid—that is, after her own lifespan. In other words, these famous tales are embedded in an anachronistic structure, one that envelops the events of the later empire within the prior but now conquered empire.[17] Perhaps early Muslim tellers of these composite tales slyly wished, for whatever motive, to suggest that Persia's Sassanid Empire created the founding conditions for the Abbasid Islamicate Empire.

Crafted with whatever intentions, the Arabic-language version passed down through the ages pointedly positions the highly educated Persian woman Shahrazade *between* empires, temporally and politically. From *that* position, she quietly embodies a political situation, one that many

[16]For discussion of these complexities, see both Ulrich Marzolph (2007a) and Madeline Dobie (2008). Even the choice of name for the text (*1001 Nights* or *Arabian Nights*) partly reflects the geopolitical and cultural affinities of authors and scholars, choices that sometimes carry traces of old inter-imperial competition. Hence I refer simply to *The Nights*.
[17]Occasionally, scholars note this anachronistic feature in passing. See Srinivas Aravamudan (2008: especially 240–5).

communities, generations, and historical actors—including artists—have shared with her: the situation of living dangerously among multiple empires and amid successive imperial formations, while shrewdly using well-crafted art to intervene and build alliances with others.

Fables of State: Translation, Surveillance, and Solidarity

Once these "hidden" elements become visible, the political implications of the "framing" encounter between Shahrazad and her father the vizier become more vivid. In particular, the gender and labor implications of the vizier's two-part tale about good management become more pointed—especially as they involve translation and alliance. When Shahrazad proposes that she marry the emperor, her father tells two animal fables to prevent her: "The Tale of the Ox and the Donkey" and "The Tale of the Merchant and His Wife." Constituting the last half of the textual frame, these fables deserve closer study than they have received. For they display how the arts of language and translation become sites of struggle for wives and other laborers, especially when they aim to build alliances.

"The Tale of the Ox and the Donkey" tells of "a wealthy merchant" who "owned many camels and herds of cattle and employed many men" and who "was taught the language of the beasts" (11–12). The drama begins with a dialogue between two of the merchant's laboring animals, the ox and the donkey. The ox complains to the donkey that the donkey lives an easier life than the ox does: by contrast to the donkey's portage labors, the ox explains, "they clamp on my neck something *they call* yoke and plow, push me all day under the whip to plow the field," and "they work me from nighttime to nighttime" (12; emphasis added to highlight the animals' distance from their owners' languages). The donkey sympathetically advises the ox about how to gain better treatment and do less work: first by openly resisting (by "butting and beating with your horns") and next by pretending to fall ill. "If you do this," says the donkey "life will be better and kinder to you, and you will find relief" (12).

The ox follows the donkey's advice, and it succeeds wonderfully. Yet, when the ox reports this good news to the donkey, the merchant listens in, tapping into his knowledge of the "language of the beasts." The merchant immediately orders his plowman to "place the yoke" upon the donkey's neck, instead of the ox's, and to "drive him with blows . . . until his sides were lacerated and his neck flayed" (13). At the tale's close, the donkey concludes that "If I don't find a way to return the ox to his former situation, I will perish" (13). Interested in surplus profit, the merchant combines his human-animal bilinguality with a practice of surveillance so as to undercut

the animals' impulse toward solidarity. That is, he divides and conquers their effort to build an alliance that would resist his enforced laboring.

The owner's knowledge of the tongues of "every kind of animal" enables his control over the labor of his "beasts." At the level of the frame story of Shahrazad and her father, the story furthermore reflects the vizier's attempts to control Shahrazad through his tale *about* translation. He discourages her risky linguistic act of solidarity with other women in her effort to make life "better and kinder" for them. As he closes his tale, the vizier turns to Shahrazade and urges her to "Desist, sit quietly, and don't expose yourself to peril" (13).

Yet, Shahrazad rejects her father's effort. Undeterred by him, she "insists" that nonetheless her father "must give me to him," decreeing that "this is absolute and final" (11). Their tale-telling contestation continues when, in response, the vizier threatens that "If you don't desist, I will do to you what the merchant did to his wife" (11). He proceeds to tell her the tale of "Merchant and His Wife." In this sequel story, the wife demands that her husband share his powers of translation with her, but the husband confesses that he is "afraid to disclose the secret conversation of the animals," alluding to some unidentified sovereign power who has decreed that "if he revealed his secret he would die" (12). This detail again implicitly correlates sovereign state control with household and labor control. Resignedly, the merchant prepares to share his knowledge—until he overhears the rooster laughing at him for his weakness.

It's noteworthy that the mockery comes from a rooster, the stud of chicken reproduction, who furthermore manages to forestall a possible alliance between husband and wife against the sovereign power Wielding his own powers of translation and counter-surveillance, this rooster encourages the merchant to reassert his mastery over the wife. He advises the merchant to take his wife "push her into a room, lock the door, and fall on her with the stick, beating her mercilessly until he breaks her arms and legs and she cries out 'I no longer want you to tell me or explain anything'" (15). The merchant promptly follows this advice, until "The wife emerged penitent, the husband learned good management, and everybody was happy" (15). Yet, when the vizier closes his threatening story, Shahrazad simply replies, "Such tales do not deter me. . . . I can tell you many such tales" (15). In the end of course, she does exactly that. She wields this political tale-telling tradition against her father and then the emperor.

Yet, her bold action is backed not only by her own sly language and knowledge powers but also by the alliance she builds with her sister, Dinarzad. Shahrazad demands one condition for her first night of marriage with the emperor: that, after their love-making, her sister Dinarzad sleep in the room, which positions Dinarzad as a listener and witness when Shahrazad tells tales to Shahrayar. With this counter-structure of alliance between two sisters, the text challenges the pattern of fraternally forged sovereignty that

has been recently resealed by the two ruling brothers—exactly in the face of wives' border-crossing sexual alliances. Shahrazad establishes the stakes of her intervention when she shares her plan with Dinarzad: "I will begin to tell a story, and it will cause the king to stop his practice, save myself, and deliver the people" (16). In the very chambers of the emperor, the sisters Shahrazad and Dinarzad will model an alternative political model for all listeners and readers, founded on solidarity and sisterly witnessing. At the close of the prologue-frame, although Shahrazad *asks* the emperor permission to tell a story and he *grants* it, she then gives him a command: "Listen:" (16). In the end, it is the emperor who "desists."

Rounding off all of the inter-imperial, intersectional implications of the frame, Shahrazad begins her nightly storytelling with the tale of "The Merchant and the Demon" about a man who "had abundant wealth and investments and commitments in every country" as well as "many women and children and kept many servants and slaves" (17). Her emphasis on the reach of the merchant's "investments and commitments in every country," and her pairing of servants and slaves with women and children, together stake out the full inter-imperial territory that is the target of her literary act. When we also keep in mind that this Arabic-language text features a Persian Sassanid woman as narrator, who in her turn tells stories of an Arab-Islamicate state, we see how Shahrazad and her many recreators over centuries have operated as cunning mediators of those geopolitical relations in which owners—backed by sovereign powers with control over death, life, and language—beat women and laborers with a stick, or threaten execution, until they submit. Shahrazad and Dinarzad step forward to counteract this coercion by appropriating the state's literary and translation tools.

Implicitly then, the framing structure not only positions the Persian empress Shahrazad *between* empires, it also suggests that her intervention from this position is provoked precisely by the raced and classed politics of sexual control, which affects all women and all who labor under coercive powers. In short, the text offers a condensed allegory of the operations of aesthetic culture in the dialectics of inter-imperial economy.

Conclusion

This perspective on the co-constitution of feminism and the world-shaping powers of literature clarifies both the circulation of literary forms across boundaries and the structural formation of literature *together with* contested linguistic, political, and economic boundaries, affecting the contours of all of these formations. To see these workings of literary mediation in early periods is also to understand their long-term effects for literatures in later periods, as I suggest in the later chapters of *Inter-imperiality*. Concerted study of long-historical genres or tropes *and of their own* contemporaneous

political conditions of production deepens our comprehension of the persisting force of androcentric, inter-imperial economy today—although it helpfully does that. It also makes visible the persistently sustaining alliances, dissent, and alternative visions cultivated for centuries in literary and other arts. When we take both into account, our theorization of literature and political economy becomes more richly dialectical.

Finally, this approach may invite additional reflection on our own genesis as intellectuals and readers in inter-imperially shaped institutions. Insofar as long-historical, inter-imperial dynamics determine power politics today, attention to their sedimented complexities will sharpen the focus of our intellectual work. As we fathom the hidden depths at which the past circulates in the present, we are better able to tap the long-submerged literary currents of decolonial feminism and channel them into the future.

References

Ali, M. J. (1979), *Scheherezade in England: A Study of Nineteenth-Century English Criticism of the Arabian Nights*, Washington, DC: Three Continents Press.

Al-Musawi, M. (2009), *The Islamic Context of The Thousand and One Nights*, New York: Columbia University Press.

Al-Shamy, H. (2007), "Siblings in Alf layla wa-layla," in U. Marzolph (ed.), *The Arabian Nights in Transnational Perspective*, 83–103, Detroit: Wayne State University Press.

Amer, S. and L. Doyle (2015), "Theories and Methodologies: Reframing Postcolonial and Global Studies in the Longer Durée," Special issue "Reframing Postcolonial and Global Studies in the Longer Durée," *PMLA* 130 (2): 331–438.

Apter, E. (2013), *Against World Literature: On the Politics of Untranslatability*, New York: Verso.

Aravamudan, S. (2008), "The Adventure Chronotope and the Oriental Xenotrope: Galland, Sheridan, and Joyce Domesticate *The Arabian Nights*," in S. Makdisi and F. Nussbaum (eds.), *The Arabian Nights in Historical Context*, 235–63, New York: Oxford University Press.

Arjomand, S. A. (1999), "Law, Agency and Policy in Medieval Islamic Society: Development of the Institutions of Learning from the Tenth to the Fifteenth Century," *Comparative Studies in Society and History* 41 (2): 263–93.

Ballaster, R. (2005), *Fabulous Orients: Fictions of the East in England, 1662–1785*, Oxford: Oxford University Press.

Bhattacharya, T., ed. (2017), *Social Reproduction Theory: Remapping Class, Recentering Oppression*, London: Pluto Press.

Bloom, J. (2001), *Paper before Print: The History and Impact of Paper in the Islamic World*, New Haven: Yale University Press.

Butler, S. ([1897] 1968), *The Authoress of the Odyssey*, New York: AMS Press.

Caracciolo, P., ed. (1988), *The Arabian Nights in English Literature*, New York: St. Martin's Press.

Casanova, P. (2007), *The World Republic of Letters*, trans. M. B. DeBevoise, Cambridge, MA: Harvard University Press.

Cheah, P. (2016), *What Is a World? On Postcolonial Literature as World Literature*, Durham: Duke University Press.
Damrosch, D. (2003), *What is World Literature?*, Princeton: Princeton University Press.
Damrosch, D. (2014), *World Literature in Theory*, Chichester: Wiley Blackwell.
Darraj, S. M., ed. (2004), *Scheherazade's Legacy: Arab and Arab American Women on Writing*, London: Praeger.
Dobie, M. (2008), "Translation in the Contact Zone: Antoine Galland's *Mille et une Nuits*: contes arabes," in S. Makdisi and F. Nussbaum (eds.), *The Arabian Nights in Historical Context*, 25–49, New York: Oxford University Press.
Doyle, L. (1994), *Bordering on the Body: The Racial Matrix of Modern Fiction and Culture*, New York: Oxford University Press.
Doyle, L., ed. (2018), "Inter-Imperiality," special issue, *Modern Fiction Studies*, 64 (3): 395–402.
Doyle, L. (2020), *Inter-imperiality: Vying Empires, Gendered Labor, and the Literary Arts of Alliance*, Durham: Duke University Press.
Ghazoul, F. J. (1996), *Nocturnal Poetics: The Arabian Nights in Comparative Context*, Cairo: American University in Cairo Press.
Haddawy, H., ed. (1990), *The Arabian Nights*, New York: Norton.
Hovannisian, R. and G. Sabagh, eds. (1997), *The Thousand and One Nights in Arabic Literature and Society*, Cambridge: Cambridge University Press.
Johnson, R. C., R. Maxwell, and K. Trumpener (2007), "*The Arabian Nights*, Arab-European Literary Influence and the Lineages of the Novel," *Modern Language Quarterly* 88 (2): 243–78.
Joyce, J. (1986), *Ulysses*, ed. Hans Walter Gabler et al. New York: Random House.
Krishnaswamy, R. (2010), "Toward World Literary Knowledges: Theory in the Age of Globalization," *Comparative Literature* 62 (4): 399–419.
Laachir, K., S. Marzagora, and F. Orsini (2018), "Significant Geographies: In Lieu of World Literature," *Journal of World Literature* 3 (3): 290–310.
Lewis, M. E. (1999), *Writing and Authority in Early China*, Albany: SUNY Press.
Mahdi, M., ed. (1984–94), *The Thousand and One Nights*, 3 vols., Leiden: E.J. Brill.
Makdisi, S. and F. Nussbaum, eds. (2009), *The Arabian Nights in Historical Context: Between East and West*. New York: Oxford University Press.
Marzolph, U. (2007a), "*The Persian Nights*: Links between *Arabian Nights* and Iranian Culture," in U. Marzolph (ed.), *The Arabian Nights in Transnational Perspective*, 221–44, Detroit: Wayne State University Press.
Marzolph, U., ed. (2007b), *The Arabian Nights in Transnational Perspective*, Detroit: Wayne State Press.
Mufti, A. (2016), *Forget English! Orientalisms and World Literature*, Cambridge: Harvard University Press.
Orr, B. (2001), *Empire on the English Stage*, Cambridge: Cambridge University Press.
Piggott, J. R. (1997), *The Emergence of Japanese Kingship*, Stanford: Stanford University Press.
Prendergast, C. (2004), *Debating World Literature*, New York: Verso.

Ramamurthy, P. and A. Tambe, eds. (2017), "Decolonial and Postcolonial Approaches: A Dialogue," special issue, *Feminist Studies*, 43 (3): 503-11.
Rushdie, S. (1981), *Midnight's Children*, New York: Penguin.
Shih, S. (2013), "Comparison as Relation," in R. Felski and S. Friedman (eds.), *Comparison: Theories, Approaches, Uses*, 79-98, Baltimore: Johns Hopkins University Press.
Trumpener, K. (1997), *Bardic Nationalism: The Romantic Novel and the British Empire*, Princeton: Princeton University Press.
Yamanaka, Y. and T. Nishio, eds. (2006), *Arabian Nights and Orientalism: Perspectives from East and West*, London: I.B. Tauris.
Yücesoy, H. (2015), "Language of Empire: Politics of Arabic and Persian in the Abbasid World," *PMLA* 130 (2): 384-92.

11

The Elusive Postcolonial

Women Writers in/and the African Diaspora

Hortense J. Spillers

Tsitsi Dangarembga's *Nervous Conditions*[1] surfaced to great critical acclaim in the late 1980s at the height of second-wave feminism in the United States. The novel was not by any means unprecedented as an instance of creative activity among African women writers of the sub-Saharan Continent and the Diaspora, inasmuch as Dangarembga's project had been preceded by a distinguished output of fiction from the 1970s that encompassed the novels of South African writer Bessie Head and Nigerian writers Buchi Emecheta and Flora Mwampa,[2] among others. We associate these writers, who are situated concurrently with a renascence of Black women writing in the United States, with the literary effusion that hailed the decolonization of the sub-Saharan Continent, beginning with the departure of European colonial powers from Ghana, West Africa, in 1957. Chinua Achebe, Wole Soyinka, Okot p'Bitek, Ngugi Wa Thiong'o, Kofi Kwei Armah, and Ousmane Sembene are among

[1] Dangarembga (1988); all references to this novel and quotations from it come from this edition, page numbers internally noted.
[2] Some of the titles from this repository of work include Bessie Head's *Question of Power*, Buchi Emecheta's *Destination Biafra*. For a comprehensive miscellany of women writers of the African Diaspora, see Busby (2019).

the eminent roll call of poets, writers, playwrights, and filmmakers who summon what could justifiably be called a veritable postmodern tradition of African cultural praxes,[3] as women writers, Maryse Conde and Simone Schwartz-Bart, among others, prominently figure in the repertoire. Tsitsi Dangarembga, then, as a younger practitioner, is poised to pursue the opening provided by the precedent writers, but more than that, she is powerfully situated to extend the postcolonial critique that characterizes African writing of the critical period that stretches between the late 1950s and the ascendency of Nelson Mandela.[4] In short, the official departure of European colonial powers from African soil was existentially bracing not only for continental African peoples but also for Black audiences of the West, as it lines up chronologically with emancipatory energy and activism across the Caribbean and the Civil Rights/Black Power movement in the United States. The representational efficacy and inspirational value, then, of public figures like Léopold Sédar Senghor, Kwame Nkrumah, Jomo Kenyatta, Sekou Toure, and Julius Nyerere, prominent among others, cannot be overestimated *for diasporic audiences*. The heroic figures of this repertoire are associated, at least in the popular imaginary, with a kind of "Golden Age" of modern African culture and society. In fact, these early postcolonial political leaders may, in some instances, lay credible claim to intellectual merit and literary distinction, most decidedly in the case of Léopold Senghor, who, as first president of independent Senegal, was considered—alongside Aimé Césaire, who became the mayor of Fort de France, Martinique and a member of the French General Assembly—one of the founders and principal theoreticians of the Négritude Movement in poetry. In any case, these organic intellectuals[5] might boast authorship in

[3] A Nobel Laureate, Wole Soyinka joins a wide array of practitioners who produced such well-known work to Western audiences as Okot p'Bitek's *Song of Lawino*, Chinua Achebe's *Things Fall Apart* and *Man of the People*, and Kwei Armah's *The Beautiful Ones Are Not Yet Born*. It would be instructive to bear in mind that this rich productive energy generates parallel cultural activity across the Caribbean, as well as the United States, as attested in the emergence of the Caribbean Artists Movement (CAM) and the Black Arts movement in the United States: see Crawford (2017) on the Black arts movement in the United States of the 1970s and its influence on the articulation of Black aesthetic theory and practice at the turn of the century and beyond; for an extended examination of the Caribbean Artists Movement and its powerful witness to radical artistic and cultural activity in Black communities of the UK, London in particular, see Walmsley (1992).
[4] My attempt to carve out roughly fifty years of political life in sub-Saharan Africa and claim it as a putative alignment of synonymous motives might be marred by the arbitrary, but in doing so I wish to mark the significance *for the African Diaspora*—however varied national or local circumstance might have been—of this apparently emancipatory moment.
[5] Although this term is associated with the conceptualizations of Italian theorist, Antonio Gramsci, I deploy the locution here to stipulate the emergence of an indigenous class of intellectuals who seize leadership in sub-Saharan African countries in the immediate aftermath of colonization; in Gramsci's view, as far as I can detect, the "organic" intellectual is to be

a variety of genres, including political biography. This alignment extends through the years of the fall of South African apartheid and the instauration of Nelson Mandela as the first Black president of South Africa in 1991.

These historical and cultural matrices, far-reaching in their ramifications, are dramatically at work and play in the background of African writing and perhaps most tellingly for women writers, insofar as the latter, not unlike their sister writers in other parts of the world, must confront the social logic of gender and sexuality as defined by patriarchal domination and the long-going legacies of colonialism and slavery. But the particular power of *Nervous Conditions* rests in the degree to which it confidently foregrounds the African woman's estate as an existential crisis in search of a grammar that is apposite to its "situation specificity." Tambudzai Sigauke, the lead character who crosses the terrain of *Nervous Conditions* as well as in Dangarembga's *This Mournable Body*,[6] its sequel that appears thirty years later, might be considered an interregnal figure, caught precisely within the transitional coils that course between the defunct, disappearing world of the colonial regimes and the new one coming into being. This dynamic moment, which demands its own response, participates in the two-sidedness, the two-facedness that a superimposed temporality would imply. In any case, the reader/critic is detecting here a language, or a grammar that is new, interstitial, and not yet named.

Exactly what is at stake in what I am attempting to lay hold of by way of the locution, *the elusive postcolonial*, will be refined in its unfolding as a conceptual practice, but what I have in mind now is the efflorescence of a character who disappoints expectation, who *forestalls* it. If the reader is looking forward to a perfectly formed figure of crystalline moral clarity and purpose, it is that she/he will not so much be put off the scent, but more precisely not be rewarded with a closure that satisfies such need or desire. In that sense, the novel is illuminating, but not at all comforting, as though the latter were its role to fulfill as an *African* novel! In short, this novel and its sequel, especially the latter, appear to feel no obligation to be *heroic*. What, then, is its summons and appeal? As a fan of *Nervous Conditions*, I had forgotten the sense of stalling, of incompletion, with which it closes:

> Quietly, unobtrusively, and extremely fitfully, something in my mind began to assert itself, to question things and refuse to be brainwashed,

distinguished from the "traditional" intellectual, who comprises a class all its own. By contrast, Gramsci's organic intellectual, with its decisive Marxist overtones, points to a hegemonic formation to be identified with a class assuming power in a national context as backdrop to decisive class antagonisms: see Buttigieg (1996).

[6]Dangarembga (2018); all references to this novel and quotations from it come from this edition, page numbers internally noted).

bringing me to this time when I can set down this story. It was a long and painful process for me, that process of expansion. It was a process whose events stretched over many years and would fill another volume, but the story I have told here, is my own story, the story of four women whom I loved, and our men, this story is how it all began. (204)

The present tense of the fabula and in this case the time of the "writing writer" seem to coincide. In other words, the narrator's "I" does not appear to be a different voice or temporal register from the writer's location. What the reader has been waiting for is the demonstrative staging of an assertive, questioning mind, knocking things over, refusing the darkness; in short, we miss the completion of the commotions that inaugurate this tale in utter brazenness—"I was not sorry when my brother died" (1). Nyasha, Tambudzai's (Tambu for short) brilliant and beloved cousin, one of the quartet of females invoked in the cited passage, orchestrates the final scenes of the novel, insofar as it is her condition and Tambu's reaction to it that signal the end. What the novel does not name, except by circumlocution, if at all, and what demarcates its end—"this story is how it all began"—which bears all the earmarks of a *beginning*—are abundantly before us in sequential evidence as a vivid reading of the social order, but the orotund, summarizing note that dances so capably, often dazzlingly, in every episode from beginning to end appears elusive after all. Narrative symptoms—accumulated practices in repetition and elaboration—might be defined as *style*. In the case of *Nervous Conditions*, the primary stylistic feature of the text imitates the growth of a young female soul. The resources of *Bildungsroman*, transported to a radically different cultural framework, align well with the motives of female figures who are not only coming of age, but also, having participated in the status quo and in some cases benefited from it, the ones who are finally allowed insight into their own subjugation. The subordinate status of the female, highlighted by decolonization but not erased in it, betrays a socius in suspense. In short, I would designate it as the ambivalent and occluded posture of the postcolony, or what characterizes the space of the interregnal figure. From this angle, the postcolonial moment, which identifies a state of mind, we assume, as well as a change of landlords, marks an aftermath for sure, but its future opens onto a scene of interlocking crises—that place in the road where the traveler must make a decision. How did *Nervous Conditions* get us here?

If, as I have observed, this novel acquired instant acclaim for its author, its success might doubtless be attributed to the complexity of gender relations and sexual arrangements that the writing signaled, and as far as I can tell, the nuances that *Nervous Conditions* sounded in that regard were relatively unprecedented. Roughly analogous to sociopolitical life in the

United States that focused its understanding of difference on race relations, decolonization appears to have concentrated its energies on racial conflict among males, or across the fault line of Black and white people in their perceived racial difference in a synecdochic reduction to what happens between men. To call this conflictual scene a politics of masculinity only goes so far and only partially names what is at stake, but it does begin to explain the intergenerational lock of dominance as it is choreographed under the auspices of family and the exchange of women—from the house of a father to the distaff of another man. Even though synecdochic economy in this instance conceals a gender/sexual meaning, or nuance, and always has, it seems not to have dawned on the law, at least in the United States, that such was indeed the case, since "previous condition of servitude," according to the Fifteenth Amendment of the US Constitution, no longer provided the basis for the disenfranchisement of Black men, not Black women. The latter would have to wait, alongside white women, another half-century for access to the ballot. The female figures of *Nervous Conditions* freely operate within a context of constraint, but as we have pointed out, their recognition of their place in the order of things is sporadic; it only gains systematicity with the daughters, not the mothers and the aunts. However, it does appear to an outside eye that there is a direct correlation between decolonization and the flowering of a feminist impulse. Dangarembga is poised to have caught the currents of both mid-century movements.

A citizen of Zimbabwe, a former colony of Rhodesia, Tsitsi Dangarembga, so poised, answers the fundamental conditions for interregnal status, perhaps as aptly and amply intimated in the novel by the fate of the Shona language as by gender relations; one of sixteen languages available to Zimbabwe society, Shona in the novel must assume a defensive crouch. Exactly what transpires with innumerable African languages in the decolonizing project is mirrored in the role of alienation that the English language (over Shona) plays in the novel. Moreover, the language question assumes a centrality of status in the cultural critique mounted by the African intellectual class.[7] It could be said with a great deal of justification that language in the novel embodies a force of individuation, but, ironically, of destabilization and distancing as well. We might note that individuation here inscribes rupture and dislocation, insofar as it announces the coming about of an unwonted sensibility. The reader realizes with a mild sense of shock that Sis. Tambu, several pages into the novel, is coming over as a *translated* character: when Tambu journeys to town in Umtali with her Sunday School teacher, Mr. Matimba, to sell

[7] On this problematic, see Wa Thiong'o (1986: 4–33). It should be clear by now that *intellectual* as I deploy the term here encompasses practicing artists and that in some cases, as in the instances of Senghor and Césaire, artist and politician were twinned in a single personality.

mealies (ears of sweet corn) to the townspeople, she narrates her response in this way to a query put by a passerby:

> I was obliged to tell him that I did not know [what was the matter with an elderly couple she'd engaged] because I did not speak English. But I assured him, I was going to learn English when I went back to school. (28)

Did this mean, one wonders, that Tambu learned English at a later date, but in the moment of the utterance, she did not know it, and if so, what were *her* words in *her* language? A few pages later, Tambu's "I" narrator, reacting to her cousins' return from England, observes her brother's (Nhamo) enthusiastic welcome: "He had an awful lot to say to them, but I was sure that the English he was using was broken" (37). Then our sense of the wedge that linguistic difference is making enlarges considerably as that difference drives a stake through the heart of family and clan. Nyasha's mother Maiguru, in explaining why her daughter suddenly seems unfathomable to Tambu, notes: "They don't understand Shona very well anymore" (42). If this explanation is "bewildering" to Tambu, "bewildering and offending" to her, it is because "Shona was our language. What did people mean when they forgot it?" (42)

To say that it meant everything, all the way down, might not be a hyperbolic claim. Even though news of Nhamo's death is articulated in the inaugural sentence of the story and might plausibly be considered the formal cause of the narration in the first place, the extent of his alienation from his family is especially harrowing for Tambu, who limns the stages of his separation and its hurtful impact on their sibling relations. One of the primary symptoms of the growing distance between brother and sister is measured in Nhamo's newfound attitude toward his mother tongue: "He had forgotten how to speak Shona. A few words escaped haltingly, ungrammatically and strangely accented when he spoke to [our] mother, but he did not speak to her very often anymore. He talked most fluently with [our] father" (52). "Father was pleased with Nhamo's command of the English language" (53). For an intriguing moment it would seem that Nhamo has achieved a kind of binguality—rather like the balance of light at either equinox—but for Tambu he has entered a one-way door:

> When a significant issue did arise so that it was necessary to discuss matters in depth, Nhamo's Shona—grammar, vocabulary, accent and all—would miraculously return for the duration of the discussion, only to disappear again mysteriously once the issue was settled. (53)

Associated in the grief-stricken mind of his mother Mainini with first and last things, Nhamo's acquired English meets with strong indictment in his mysterious, unnamed death. Anticipating that the arrival at the homestead of her brother-in-law, the headmaster, and his wife, Maiguru, brings forbidding

news, Mainini would hold back the ocean tide as though she could stave off what she is bound to hear:

> "Go back!" she wailed. "Go back! Why do you come all this way to tell me what I already Know!" . . . "First you took his tongue so that he could not speak to me and now you have taken everything for good. . . . You bewitched him and now he is dead. . . . You and your education have killed my son." (54)

This overwhelming sense of loss, poignantly rendered in keening and weeping, as well as Mainini's aggressive bodily response to the bearers of the message, comprehends the major lines of force that traverse the novel: (1) the ramifications of "tongue" and the alienation that it signals in colonial intervention; (2) "education" and what it implies regarding class and social status; (3) the female's relationship to hierarchy and the range of sociocultural forces in which the characters are embedded. In brief, Mainini has little control over her own life and the life of her children, as the impotence and precariousness of her situation play out along several lines of stress, but perhaps none more tellingly than in her entrapment to wifely duties and the demands of the nursery. "Education," so powerful in its efficacy and effects that it needs no further explication or rationale, usually conveys positive value, but as the mother suggests in her lament, in this case, it has not only stolen her son away from her, but, in her estimation, it has robbed him of his life.

The power to "bewitch" is here accorded to exotic things, and it is the incursion of the foreign and exotic, from religious expression to taste in food and dress, that stealthily overtakes the host society, but its measure is taken only insofar as it touches the existence of individuals. In the background of fictive individuals, though, clan and family claim a share of dramatic emphasis and attention: for instance, Tambu's immediate family is delineated in the novel, as well as a sketch of paternal and maternal actors—a paternal grandmother, for example, who, by way of the stories that she tells Tambu about the past, explains quite a lot about the social status of the family, especially her father's subordinate position in relationship to his brother (17–20). But the colonial order, whose collapse provides the impetus of *Nervous Conditions*, is cannily mimicked in the intramural arrangements that the fabula describes. In other words, the very picture of dominance and subalternity is captured where we least expect to see it, and that is to say, among loved ones within the heart of the family circle, where blood and affinity run deep—between sister and brother, daughter and father, son and mother, husbands and wives. If, as Frantz Fanon contends, "the condition of native is a nervous condition," which sentiment the author presses into service as the epithet of the novel, then the space of the family embodies the hot spot of domination's quickest impulses. To that extent, the foreign

and exotic might come dressed in the clothes and accents of the paternal grandmother's white "wizards," but it acquires its powers of insinuation and seduction only because it arrests a willing host at the center of the living.

This is what it looks like: the unexpected ending that we have elaborated on is engendered by symptoms that we might associate with falling apart. Nyasha, the brilliant cousin, returns from England with her mother and father—Maiguru and Babamukuru, Tambu's father's successful brother—after her father, who runs a missionary school, has finished a British course of study for an advanced degree. Essentially, Nyasha, as we have seen, returns to native soil as a young *English* girl. As her mother explains to Tambu, "They don't understand Shona very well anymore," speaking of Nyasha and her brother, Chido. "They have been speaking nothing but English for so long that most of their Shona has gone," she adds. (42) What this loss of Shona intimates is that the old world now objectively appears (or so it seems) to the one observing Nyasha. In other words, Nyasha induces a kind of double consciousness in Tambu, which condition devolves as guilt, though the reader sees it as fault in Nyasha. But it occurs to the reader that Tambu is seeing herself and her world through Nyasha's eyes. In that regard, a subtle surrogacy obtains between the pair. Whenever relatives from the homestead visit Tambu at the mission school, Tambu stays near Nyasha and watches her:

> In this way I saw her observing us all. . . . She was silent and watchful, observing us all with that complex expression of hers—what we said, what we did, how we said it, how we did it—with an intensity that made me uncomfortable. (52)

This objectifying look, this standing apart, now belongs to Tambu as well, though she appears to be disapproving of it in her criticism of Nyasha. In any case, the two of them, like lovers, embrace each other's shadowy essence, as though it were real, so that there is no emotional distance between them. This pairing brings to stand and enacts the central emotional and thematic nuances of the novel and consequently not only occupies its climactic ground, but comprehensively fills it up. When Nyasha's rebellion against parental authority, especially her father's unrelenting arrogation of power to himself, takes on a forceful consistency of purpose, the novel seems to speed ahead with vertiginous determination to its stunning close, symptomatized by Nyasha's eating disorder. Interestingly, the character's bulimia, which slips up on the reader unawares, might be taken as a metaphor for colonial indigestion, we could call it, insofar as it highlights severe displeasure that erupts between the social body and what it consumes. In keeping with this figural economy, we would be tempted to think of decolonization as an act of disgorgement. In Nyasha's case, the self-inflicted violence that bulimia entails sets off what can only be called a revelation that discloses what is

ubiquitously at stake in the colonial order. But the scene itself, in its chaotic display of personal crisis, is charged with terror. The antagonism that persists between Nyasha and her father Babamukuru erupts into open warfare, at one point coming to an exchange of physical blows (115). But what the reader has not been sufficiently aware of is the degree to which the clash of wills between father and daughter is building like steam under a pressure cooker in Nyasha's being so that it precisely explodes as uncontrollable rage:

> ". . . I feel it coming." Her eyes dilated. "They've done it to me," she accused, whispering still. "Really, they have." And then she became stern. "It's not their fault. They did it to them too. You know they did." She whispered. "To both of them, but especially to him. They put him through it all. But it's not his fault, he's good." (200)

What the reader begins to gather from this compelling incoherence, enroute to total breakdown and fragmentation, is that Nyasha is addressing the social order into which she was relatively well-born: the "they's," we take it, are variously known here as "bwana," "wizards," "the whites," "the missionaries," but "they" also refers to the rigid impersonality of the systemic—the institutions of the English language, of the church, of the schools, of degree-getting and status-climbing. What has been done to "them," in all the sputtering and hissing of Nyasha's onset of madness, rapidly shifts the meaning and reference field of the pronouns, and now Nyasha is talking about her parents—what "they" have done to "them"—to Maiguru and Babamukuru, who has returned to Zimbabwe from England with a master's degree, an educated wife, and two children, spouting English ways and words: "They've deprived you of you, him of him, ourselves of each other. We're grovelling . . . Daddy grovels to them" (200). But this prelude to a young woman whose mind was "wandering too far" (201) brings Maiguru and Babamukuru running from other parts of their house of the headmaster to find Nyasha "beside herself with fury," rampaging, "shredding her history book between her teeth" (201). These books, as we now imagine them drawing blood, are denominated: "Their history. Fucking liars. Their bloody lies" (201), and into the mix, broken mirrors, clay pots, "anything she could lay her hands on and jabbing the fragments viciously into her flesh, stripping the bed clothes, tearing her clothes from the wardrobe and trampling them underfoot" (201). They've been trapped, we are told, "they've trapped us. But I won't be trapped. I'm not a good girl" (201). As the rage subsides as suddenly as it has exploded on the scene, the reader recognizes with renewed appreciation the diversity of narrative currents that traverse *Nervous Conditions*. As swift and preemptive as a waterfall, as placid and alluring, too, as a shoal of gold fish, strains of narrative run through all aspects of Zimbabwean daily life as enacted here with an unflagging attention to nuance and particularity that ward against

the stilted clichés of the racial discrimination and persecution distinguishing the colonial order. In other words, the reader cares about these characters because she has numbered the hairs on their head.

Despite the penetrating particularity of Dangarembga's work, my sense of its provisionality and incompletion is persistent. I would acknowledge that some of this feeling of unease may be attributed to what an outsider understands to have occurred in postcolonial space as a geopolitical and material reality; in other words, the postcolonial scene, in its massive spatio-temporal reach (from roughly the "Cold War" to the present and from the Atlantic to the Indian Oceans) and in its dizzying local currents and cultural arrangements (including the Rwandan genocide of the mid-1990s), cannot be grasped and summed up as a closed historical cycle, and it is that tentativeness, or what might be regarded as such, that resists definitive naming. A closed, or bounded, historical circuit might be described as teleological, insofar as it answers a final purpose that has implemented a vision of it in the first place. Such a historical passage yields the most comforting sense of an ending (even if it is illusive), inasmuch as it demarks an unambiguous fulfillment, but also the progression of one necessary thing, one pre-ordained thing, following another. Achille Mbembe suggests that this sense of "what comes after" the colony engenders a "false question":

> Is there any difference—and if so, of what sort—between what happened during the colony and "what comes after"? Is everything really called into question, is everything suspended, does everything truly begin all over again, to the point where it can be said that the formerly colonized recovers existence, distances himself or herself from his/her previous state?[8]

The philosopher's solution is riddled with the veritable elegance of poetic evanescence—"a song of shadows"—"its sight, hearing, sense of smell, taste, touch—in short, its expressive power—to which we have given the ultimately meaningless name of *postcolony*" (242)—and leaves us in the lurch, for if postcolonial punctuality does not open a different aperture onto reality, does not clear ground for other and new praxes, then what is the import of its project?

A simpler answer, if not a simple-minded one, might well be that the African postcolony, the aftermath of colonial rule, can only be gauged bit by bit and little by little, rather than by way of some global sense of oracular wholeness. History as globality complements history as grand narrative, "great men" commotions, sweeping vistas, and temporal consequences that

[8]Mbembe (2001); "Out of the World," 196–7. Subsequent quotations from this source internally noted.

yield intervals "before" and "after." The latter sense of things embodies history as epic movement, large episode, spectacular unfolding; in their decisive absence, we are left with the diurnal, the minoritarian, the unmomentous, and it may well be the vocation of fiction to describe this timeless drama—of the people, where they live. Dangarembga's *This Mournable Body*[9] with its experimental narrative device—a displaced "I" is here translated into a second person "you"—offers a case in point: the relatively panoramic project of *Nervous Conditions* appears to go into suspense in the new novel as the writing discriminates detail so finely chiseled that the Stendahlian mirror of fiction[10] becomes an investigator's microscope: "A triangle falls out of the looking glass, onto your foot, then slides to the floor, leaving a spot of dark red" (6). In the following instance, the powers of magnification are raised to supreme value:

> A herd of rhinoceroses lumber round her index finger on a thick gold band. Beside it, on the middle digit, a cumbrous emerald glitters. A two-ring matrimonial set bulges large but dull from the fourth finger of her other hand. Crud is caked in the crevices of her jewellery. All of it needs cleaning. (26)

Magnification in this instance exacerbates the reader's sense of an alienating world with its objectified, atomized data that now encompass the human face. The fictive vision that presides over this pair of narrative instances inscribes a writer's preoccupation with *contiguous* elements that in effect leave each other alone rather than commingle as they might in a cosmos of harmonious things in *concert*, drawn together in the intimacy of an "I" narrator—in short, objectification in *This Mournable Body* not only increases the well of domesticity, or locality, as the key to the world, but scatters hierarchy, hierarchical domination, over a sea of objects of equal weight and value. The historical and political field in this case does not disappear—their presence is "there" by implication—but they recede far into the background as the personal accedes to forefront and foremost.

The same might be said, I believe, of the work of Chimamanda Ngozi Adichie, whose 2013 novel *Americanah*, for example, traverses the unnamed interstitial spaces of the African Diaspora that fall between the sub-Saharan Continent and the United States; code-switching between aspects of US urban culture and contemporary Nigeria, Adichie's protagonist, profoundly conversant in the idioms of the Black

[9]Dangarembga (2018).
[10]Stendahl, *The Red and the Black*. In some instances, this nineteenth-century classic is translated as *Scarlet and Black*.

Atlantic, resembles Yaa Gyasi's Gifty, who appears as the central figure in *Transcendent Kingdom*.[11] Studying at Stanford University's graduate program in neuroscience, Gifty is African without portfolio, we might say, since, as the daughter of Ghanaian parents, she almost gets born in Ghana, like her beloved brother Nana, but instead she breasts the world in—of all places—Alabama, where her mother has landed. We follow Gifty's negotiations with a kind of creoleness (or inbetweeness) that is not entirely unlike her scientific experimentations with her laboratory rats, especially her observations of the small animals' response to the stimuli of discipline and punishment. Concurrent with her life as a molecular biologist-in-the-making is the career of a scandalous question, *scandalous* because it is was foreclosed and prohibited eras ago by historical circumstance. Here is a version of it:

> My mother had hated therapy. She went in arms raw, came out arms raw. She was distrustful of psychiatrists and she didn't believe in mental illness. That's how she put it. "I don't believe in mental illness." She claimed that it, along with everything else she disapproved of, was an invention of the West. (35)

Welcome to projection, we might respond, insofar as we have witnessed this strategy of displacement so often implemented in other instances, but Gifty, not missing a beat, enlists the wisdom of a famous African woman writer, Ama Ata Aidoo, in explicit reply to her mother's expostulations:

> I told her about Ama Ata Aidoo's book *Changes*, in which the character Esi says, "*you cannot go around claiming that an idea or an item was imported into a given society unless you could also conclude that to the best of your knowledge, there is not, and never was any word or phrase in that society's indigenous language which describes that idea or item.*" (35; emphasis Gyasi)

Our concern here starts in the surround, but ends up in the bedroom, at the kitchen table, with the ruined egos of husbands and brothers, and the wives and daughters who both indulge them and attempt to comprehend their conduct. In brief, this fiction by African women writers on the postcolonial frontiers that gape open before us brings a world to stand that, *for once*, presents an idea of "Africa," of African life, thought, time, and movement that is human scale. It is simultaneously unexotic and familiar, insofar as a reader awaits a human voice to strike her ear drums rather than "agitated

[11]Gyasi (2020). All references to this text and quotations from it come from this source, page numbers internally noted.

layers of air" that mimic sound, and exotic and strange, insofar as certain items of cultural content, a *combi*, for instance, cannot be adequately explained by Google and must, therefore, await whatever resources the imagination can muster, if a trip to the place is not in the making. After all, this human, humming, mundane, provisional, and incomplete universe has finally made itself heard. The postcolonial sub-Saharan Continent, in all its elusiveness, at least shows forth that much.

References

Busby, M., ed. (2019), *New Daughters of Africa: An International Anthology of Writing by Women of African Descent*, Oxford: Myriad Editions.

Buttigieg, J. A., ed. and trans. (1996), *Antonio Gramsci: Prison Notebooks*, vol. II, New York: Columbia University Press.

Crawford, M. N. (2017), *Black Post-Blackness: The Black Arts Movement and Twenty-First Century Aesthetics*, Urbana: University of Illinois Press.

Dangarembga, T. (1988), *Nervous Conditions*, New York: Seal Press.

Dangarembga, T. (2018), *This Mournable Body*, Minneapolis: The Graywolf Press.

Gyasi, Y. (2020), *Transcendent Kingdom*, New York: Alfred A. Knopf.

Mbembe, A. (2001), *On the Post-Colony*, Berkeley: University of California Press.

Walmsley, A. (1992), *The Caribbean Artists Movement: 1966-1972—A Literary and Cultural History*, London: New Beacon Books.

Wa Thiong'o, Ngugi (1986), *Decolonising the Mind: The Politics of Language in African Literature*, Nairobi, Kenya: East African Educational Publishers.

PART III

Themes

12

Intertwining Feminisms, Environmentalisms, and World Literature in Ruth Ozeki's *A Tale for the Time Being*

Karen Thornber

Histories of ecocriticism (environmentally oriented literary criticism) have long distorted if not omitted the many contributions of ecofeminist literary criticism, not to mention those of ecofeminism (Gaard 2010: 645).[1] Countless works of what we generally understand to be World Literature (i.e., literature that has circulated actively beyond its communities of origin) (Damrosch 2003: 4, 281) grapple with environmental challenges and crises. Yet, ecocritical world literature scholarship is still in its early stages. Even more uncommon is scholarship that examines the many interplays among feminisms, environmentalisms, and conceptualizations of World Literature. This chapter addresses these lacunae by focusing on the Japanese North American writer, filmmaker, and Zen Buddhist priest Ruth Ozeki's third novel, *A Tale for the Time Being* (2013). Available in more than twenty languages, Ozeki's oeuvre has long been concerned with both global environmental justice and global gender justice, among other forms of (in)justice. Ozeki's first two novels—*My Year of Meats* (1998) and *All Over Creation* (2003)—explicitly integrate feminist and environmental concerns. *My Year of Meats* highlights "the connections between meat, sexuality, violence, and women"

[1] See also Gaard, Estok, and Opperman (2013). Estok notes, "matters of gender remain invisible to many people who do ecocriticism" (2013: 72). "Ecofeminism" was coined in 1974.

and draws attention to the global meat industry's devastating impact on already vulnerable individuals, communities, and landscapes (Bennett 2013: 97, 101).² *All Over Creation* similarly targets agribusiness and genetic engineering, underscoring the "sinister intersection between the corporate, biotechnological usurpation of plant reproductivity and the social usurpation of women's sexual and reproductive freedoms" (Stein 2010: 187). Through both their internal discourse and their translations into European and Asian languages, these two novels contribute to struggles for global environmental justice, gender justice, racial justice, and justice more broadly.

So too—in different ways—does Ozeki's metafictional, intertextual, multilingual, and partially autobiographical *A Tale for the Time Being* (henceforth, *A Tale*). This complex, multilayered, heavily footnoted novel alternates between the first-person and primarily English-language journal of Naoko (Nao) Yasutani, a sixteen-year-old Japanese student who spent part of her childhood in the United States, and the third-person story of Ruth, an American writer of Japanese heritage struggling to make progress on a memoir of her years as caregiver for her mother, who had Alzheimer's. Near the beginning of *A Tale*, in the first of the book's many sections labeled "Ruth," Ruth discovers a plastic bag washed up on the beach near the home she shares with her husband Oliver on a remote island off the coast of British Columbia. Inside this bag, which her husband believes yet never confirms was likely swept from Japan in the aftermath of the 2011 Triple Disaster, is a Hello Kitty lunchbox holding Nao's journal; a packet of Japanese-language letters in which is hidden a secret French-language diary written by Nao's great-uncle and kamikaze pilot Haruki #1 during the Second World War; and an antique wristwatch.³

Much scholarship on *A Tale* eloquently explores the countless interactions and interconnections the novel highlights among beings, cultures, eras, events, ideas, identities, languages, peoples, places, voices, narratives, and forms of inequality, oppression, dispossession (particularly of indigenous peoples), and violence.⁴ As Fachinger (2017) argues,

²See also Chae, who discusses contributions to the "growing critical environmental justice movement in Asian American literature" (2014: 141), Black (2004), and Harrison (2017).
³The Triple Disaster refers to the 9.0 magnitude earthquake off Japan's northeast coast on March 11, 2011, the massive tsunami that reached over 125 feet high and inundated more than 150 square miles, and the level 7 nuclear meltdowns at the Fukushima Daiichi Nuclear Power Plant—that altogether claimed the lives of more than 18,000 people and displaced approximately 470,000 (Sakamoto 2020: 109).
⁴Part I of *A Tale* opens with a translation of the first lines of the "Uji" (lit. Existence Time) chapter of Japanese Zen Buddhist master Dōgen Zenji's (1200–53) *Shōbōgenzō* (The Treasury of the True Dharma Eye); a passage from the Uji chapter—"every being that exists in the entire world is linked together as moments in time"—also serves as the epigraph for Part III. Ozeki noted in an interview: "So much of what I am writing about in this book is informed by basic Buddhist principles—of interdependence, impermanence, interconnectedness" (Ty 2013: 161). See also Adams (2019), Guy (2015), Jimenez (2018), Lee (2018), Starr (2016).

By making connections between Fukushima and Chernobyl, bullying in the Imperial Army and in a contemporary Japanese high school, Japanese Canadian internment and anti-Islamism in the wake of 9/11, the genocide of Indigenous people, the senseless killing of civilians during times of war, and the brutal slaughter of whales [and so many other topics], *A Tale for the Time Being* promotes environmentally inflected global citizenship.[5]

Less recognized in scholarship on *A Tale* is the paradoxical emphasis throughout this novel on the fragility of story and in particular the precariousness of women's histories and literatures, in short, the inadequacy of current structures of validation and remembrance—including structures of World Literature—that disproportionately safeguard the histories and the literatures of privileged men. The explicit silencing of women's histories and literatures is especially charged in a narrative that alternates between and is dominated by two women writers, Nao and Ruth. Also accentuating the explicit silencing of women's histories and literatures is the novel's engagement with environmental crises. Human destruction of environments looms in the background of *A Tale*, including the painful aftermath of Japan's Triple Disaster; the garbage patches that pollute the Pacific and regularly expel their wares on the beaches near Ruth's rural home; and climate change, which has led Ruth's husband Oliver to cultivate a climate-change forest, his controversial NeoEocene.[6] Yet, even as Ruth and Oliver are acutely aware of the extent to which human beings have damaged both one another and environments locally, regionally, and globally, actual references to environments in *A Tale* are more frequently about the danger the nonhuman world poses to island residents and to crows, not as an endangered species, but instead as one that continues to outwit human communities. Just as Ozeki's novel foregrounds women's voices even while the silencing of women's histories and literatures looms in the background, so too does this narrative highlight nonhuman resilience even as it foregrounds anthropogenic environmental degradation. Yet, whereas the former dynamic creates space, including in World Literature, for stories and voices otherwise diminished (e.g., the novel *A Tale for the Time Being* itself), the latter dynamic diminishes the space for remediation, with human beings still not appreciating fully the implications of their human-centered narratives.

When in the Epilogue, a letter to Nao, Ruth speaks of keeping "all the possibilities open ... all the worlds alive" (402), she is thinking of Nao's futures

[5] Other studies discuss the novel's contributions to understandings of Asian American countermemory (Chu 2019), translational form (Gullander-Drolet 2018), Japanese girlhood (Hausler 2017), gender violence and vulnerability (Jones 2017), and the international literature of Fukushima (Usui 2015). Luke and Karashima (2012) reveal the transnationality of Fukushima literature from its beginnings.
[6] After Japan's Triple Disaster, Ozeki rewrote the parts of the novel focused on Ruth (Ty 2013: 164).

and referring to possibilities for Nao, not to the futures of broader ecosystems. The P.S. that wraps up the Epilogue solidifies this inward, human turn. Nao asks in the opening pages of her diary whether her reader has a cat who is sitting on her lap with a forehead that smells "like cedar trees and fresh sweet air" (3), to which Ruth responds in the P.S. of the Epilogue, "I do have a cat, and he's sitting on my lap, and his forehead smells like cedar trees and fresh sweet air" (403). What Ruth does not mention is that her cat, which brings home "the tiny carcasses of birds, shrews, and other small animals" and disembowels squirrels in the middle of the kitchen (9), is also recovering from a brutal racoon attack. Even as her cat is becoming stronger and Ruth is regaining her voice—the Epilogue is one of the few places in *A Tale* outside the footnotes where Ruth's voice is heard directly rather than through the third-person narrator—the landscape outside their home remains imperiled.[7]

From the beginning, Nao asserts that her "purpose for writing" is "to tell someone the fascinating life story of my hundred-and-four-year-old great-grandmother . . . the real life story of my great-grandmother Yasutani Jiko" (5–6). Jiko, she explains, "was a nun and a novelist and New Woman of the Taisho [1912–26] era. She was also an anarchist and a feminist" (6).[8] Nao reassures her readers that even though her great-grandmother enjoyed both male and female lovers, "everything I write will be historically true and empowering to women, and not a lot of foolish geisha crap" (6).

Jiko enjoys a significant presence in *A Tale*; not unexpectedly, given Nao's stated purpose in writing, Jiko's name appears hundreds of times within its covers. Yet, there is tension throughout between, on the one hand, Nao's desire to write Jiko's "fascinating life story" as she had promised—especially the story of Jiko's work as a feminist, anarchist, novelist, and New Woman in the early decades of the twentieth century—and, on the other hand, Nao's preoccupation with describing her own life. This tension is evident from the beginning, where Nao declares, "There's so much to write. Where should I start? I texted my old Jiko this question, and she wrote back this: 現在地で始まるべき" (15). In other words, as translated in the footnote, "You should start where you are" (15). And this is exactly what Nao does, describing Fifi's Lovely Apron, the maid café in which she is writing, and giving some background on Japan's café culture more generally. Nao then speaks about the uncertainty of Jiko's age, how much her great-grandmother enjoys hearing about current trends, and

[7] Ruth adds more than 100 footnotes to Nao's journal, many of which provide the English translation and sometimes the Japanese script and/or an explanation of Nao's Romanized Japanese terms; Ruth also adds footnotes to Haruki #1's wartime communications. Interestingly, Ruth's footnotes are maintained in the Japanese translation of *A Tale*, where they underscore the novel's multilingualism while linguistically being mostly redundant (Ozeki 2014).

[8] As Ruth explains in a footnote, "New Woman" was "a term used in Japan in the early 1900s to describe progressive, educated women who rejected the limitations of traditional gender-assigned roles" (6).

Jiko's vow as a nun "to save all beings" (19). Recognizing that her attention again has wavered, Nao asserts, "Okay, so now I really am going to tell you about the fascinating life of Yasutani Jiko, the famous anarchist-feminist-novelist-turned-Buddhist nun of the Taisho era" (19).

Yet, instead of so doing, she adds, "but first I need to explain about this book you're holding" (19). In the following pages, she clarifies why her diary appears from the outside to be French writer Marcel Proust's monumental *À la recherche du temps perdu*:

> What happened is that Marcel Proust's book got hacked, only I didn't do it.... The girl who makes these diaries is a superfamous crafter, who buys containerloads of old books from all over the world, and then neatly cuts out all the printed pages and puts in blank paper instead ... you almost think that the letters just slipped off the pages and fell to the floor like a pile of dead ants. (1913: 21)

How readily the classics of World Literature are physically fragmented. Nao marvels at the similarities between Proust and herself, especially their shared obsession with lost time. She also contrasts the legacy of Proust—whose "books are all still in print" and Amazon ranking is "not so bad for a dead guy" (27), even if the pages are removed from some of his books—with that of Jiko, a few decades younger than Proust, whose writings she notes are not even on Amazon, much less in print.

As Nao herself admits in the following section of her diary, she is too "preoccupied" with her own life to write Jiko's life story (41). She also speaks of the difficulties of writing about times past, even her own experiences, and particularly those of Jiko: Nao comments how the stories Jiko tells about her idol, the anarchist anti-imperialist feminist Kanno Sugako (1881–1911), and about her son Haruki #1, seem so real while they are being told, only to "slip away and become unreal again" when she (Nao) attempts to write (97). In one of the final sections of her journal Nao remarks, "Jiko was so wise and interesting, and now, when I think about how I've failed in my goal to tell her story, I want to cry" (332). And a few pages later, she chastises herself:

> I am selfish, and I only cared about my own stupid life ... and now I've gone and wasted all these beautiful pages and failed to achieve my goal, which was to write about Jiko and her fascinating life while I still had time, before she died. And now it's too late. Talk about temps perdu. I'm sorry my dear old Jiko. I love you, but I screwed up. (340–1)

At the very end of her diary, Nao again commits to writing "the whole entire story of old Jiko's life" (389), declaring that at least until she finishes writing Jiko's story, "I absolutely don't want to die. The thought of letting Jiko down brings tears to my eyes" (390). Nao determines to find a copy of Proust's *Le*

temps retrouvé (Time Regained, the final volume of *In Search of Lost Time*, quotations from which provide the epigraphs of Parts II and IV of *A Tale*) and have it hacked it to create another volume of blank pages, in which she pledges at last to "write Old Jiko's story" (389). She then decides instead that she will try to learn French so she can read Proust's novel and will purchase some "plain old paper" on which to write "my old Jiko's life story" (390).

The great irony, of course, is that Proust's legacy will remain intact regardless of whether an additional volume of his is shredded. Jiko's legacy is far more imperiled. Ruth searches assiduously for information both on Nao and her immediate family and on Jiko's past. Despite an unstable internet connection, Ruth did "several exhaustive [digital] searches for *Jiko Yasutani, anarchist, feminist, novelist, Buddhist, Zen, nun, Taishō,* and even *Modern Woman*" (147). And she found just the beginning of one scholarly article. Titled "Japanese Shishōsetsu [I-Novel] and the Instability of the Female 'I,'" this article notes, "Early women writers of *shishōsetsu* have been largely ignored, perhaps because, in truth, there were far fewer published women writers then, as now, and perhaps because, as Edward Fowler [1988] . . . has written, 'the energies of prominent female writers working in the 1910s and 1920s were devoted as much to feminist causes as they were to literary production'" (Ozeki 2013: 149; Fowler 1988: xix). Countering Fowler and other critics, the article Ruth finds continues,

> at least one early woman author of shishōsetsu used the form in a way that was groundbreaking, energetic, and radical. For her, and for the women writers who came after, this literary praxis was nothing short of revolutionary. . . . She wrote, in addition to political essays, articles, and poems, a single unusual and groundbreaking I-novel, entitled, simply, *I-I*. . . . Her name is Yasutani Jiko, a woman pioneer of the "I-novel," who has erased herself from . . . <read more . . .>. (149–50)[9]

Ruth clicks the "read more" link only to receive a "Server Not Found" message, and her later attempts to retrieve this article are also thwarted.

Jiko is said to have "erased herself"—and this might explain why Nao speaks of Jiko's encouraging her to read the anarchist feminist idols after whom she named her daughters—American Emma Goldman's autobiography *Living My Life* (1931, 1935) and Japanese Kanno Sugako's *Reflections on the Way to the Gallows* (Shide no michikusa, 1911), prompting Nao to joke, "why did these anarchist women have to write so much" (69). Likewise, in

[9]The title *I-I* (Warewa, warewa in the Japanese translation) is taken from Japanese writer Yosano Akiko's poem "Sozorogoto" (Rambling Thoughts 1911). The first lines of Yosano's poem are translated in *A Tale's* Appendix C. As the narrator explains, "they were first published in the inaugural issue of the feminist magazine *Seitō* (Bluestocking) (410); the article describes Jiko as having worked with the corresponding feminist group Seitōsha (Bluestocking Society) (150).

his March 27, 1945, letter home, Haruki #1 speaks of reading not only his "old favorites" the prominent male writers [Natsume] Sōseki and Kawabata [Yasunari] and of how Miyazawa Kenji's tale about the Crow Wars (Karasu no hokuto shichisei, lit. The Crow's Big Dipper, 1921), featuring a Crow Captain heading off for battle, comes to mind during one of his test flights (258). He also writes of reading books Jiko has sent him by "your dear writer friends, Enchi Fumiko-san's *Words Like the Wind* [Kaze no gotoki kotoba, 1939] and the poems by Yosano [Akiko]-san in *Tangled Hair* [Midaregami 1901]," which make him feel closer to his mother (256). Haruki #1 states that he hopes his mother is still writing, but there is no mention of his reading or having read Jiko's *I-I* or any of her other narratives. In fact, the Hello Kitty lunchbox Ruth retrieves from the beach at the beginning of *A Tale* contains Haruki #1's writings (his Japanese- and French-language pages), but none of Jiko's, likely because Nao has never seen Jiko's writing. To be sure, descriptions of Jiko as Nao knows her and of Nao's relationship with Jiko appear frequently in Nao's diary; Jiko is an essential presence in Nao's life, particularly as circumstances at home and school deteriorate for Jiko. At the same time, Ruth is understandably frustrated, the narrator describing her as wanting "to learn everything she could about Jiko Yasutani, and not just the scraps of information that surfaced so haphazardly in her great-granddaughter's diary" (150).

Significantly, although Proust's *In Search of Lost Time* is not "hacked" by Jiko's story, as Nao had promised and Ruth had hoped, it is replaced by Nao's story, a story that has somehow survived a treacherous journey across the Pacific, protected by nothing more than a Hello Kitty lunchbox and a plastic bag. And ultimately, it is this story, which alternates with Ruth's story, that together create *A Tale*. The cover of the Japanese translation, replicated next, goes so far as to explicitly strike out Proust's narrative and name:

A TALE FOR
~~À LA RECHERCHE~~
THE
~~DU~~
TIME BEING
~~TEMPS PERDU~~
RUTH OZEKI
~~MARCEL PROUST~~

Ozeki's *A Tale* repeatedly highlights the silencing of women's histories and literatures—by readers, by the market, by scholars, by family, and

by women writers and activists themselves. Yet, even as so many of these stories disappear/are actively disappeared, *A Tale* depicts them as giving life to other stories in powerful and unexpected ways and in turn creating new possibilities for other marginalized voices.[10]

At the same time, these possibilities are necessarily limited by climate and other ecological crises facing human communities globally, which disproportionately impact the already vulnerable. Since the 1970s, ecofeminisms have called attention to connections between the oppression of the nonhuman and the oppression of women and other vulnerable individuals, discussing "how the unjustified domination of nature and of marginalized populations—such as women, people of color, animals, nature, and citizens of the global South—are conceptually linked in mutually reinforcing systems of oppression" (Carroll 2018: 2). Similarly, unlike Nao's journal, the third-person sections of *A Tale*, those focused on Ruth's experiences, contain numerous references to human exploitation of both the human Other and the nonhuman Other.[11] Indeed, the island on which Ruth and Oliver live—named "for a famous Spanish conquistador, who overthrew the Aztec empire" and whose men, who made it as far north as his eponymous island, were "mass murderers" (141)—itself has a long history both of human-on-human violence, especially against native peoples and Japanese immigrants, *and* of human-on-nonhuman violence, including the destruction of whale and salmon populations.[12] *A Tale* also draws attention to human-on-nonhuman violence of more global reach, with references to Fukushima, oceanic garbage patches, and climate change, all of which also severely impact already vulnerable human populations. Even so, Ozeki's novel highlights the resilience of the nonhuman; *A Tale* reveals how quickly attention from global concerns can be diverted and how easily efforts for radical transformation of human behaviors can be undermined.

To be sure, Fukushima looms large throughout the novel. Ruth wonders repeatedly whether Nao, her family, and Jiko's temple survived the Triple Disaster; the meltdown of the Daiichi Nuclear Power Plant is described as creating a "radioactive wasteland" (233) that forced the evacuation of close to 500,000 people, many of them elderly or otherwise vulnerable, and more

[10] The narrator highlights Ruth's writer's block and her deep engagement and entanglement with Nao's text, to the point where she believes Nao's words are themselves appearing and disappearing.

[11] I am inspired here by Warren, as cited by Carroll, who includes in the human Other "women, people of color, the poor, and the global South," while the nonhuman Other includes "species, ecosystems, nature, and the Earth" (2000: 1–2), "marginalized Others available for exploitation" (Carroll 2018: 2).

[12] Although *A Tale* does not give the precise name of the island on which Ruth and Oliver live, most critics believe it to be Cortes Island, part of the Discovery Islands archipelago off the coast of British Columbia.

than 100,000 of whom remain displaced (Sakamoto 2020: 109). This is not the first disaster to strike the area, Ozeki's narrator explains; Fukushima prefecture is part of the ancestral lands of the Emishi, descendants of the Jōmon people who were defeated in the eighth century by the Japanese army (141). Fukushima's impact is felt across the Pacific: Ruth's neighbors are worried about radiation and nuclear fallout in their air, water, and food supply (145). Yet, global attention quickly shifts, and Ruth notes that after a few weeks, news on the meltdown, Tepco's (Tokyo Electric Power Company) mismanagement, and the government's failure to protect its citizens, "rarely made the front page anymore" (113).

A Tale then asks whether the internet "is a kind of temporal gyre, sucking up stories, like geodrift, into its orbit," likening inattention to other people and places as condemning them to "the garbage patch of history and time" (114). This passage reverberates with the novel's multiple references to plastics, garbage, and the world's Great Garbage Patches. Discovering a plastic bag on the beach does not surprise Ruth, given that "the ocean was full of plastic" (8). She believes the bag must hold "someone's garbage," given that "the sea was always heaving things up and hurling them back: fishing lines, floats, beer cans, plastic toys, tampons, Nike sneakers . . . severed feet . . . up and down Vancouver Island" (8). Some pages later, Oliver eagerly shares with Ruth information on the world's Great Garbage Patches, their tremendous size and their mostly plastic contents: "Like your freezer bag. Soda bottles, styrofoam, take-out food containers, disposable razors, industrial waste. Anything we throw away that floats" (36). Yet, the couple's attention is quickly diverted by Oliver's restarting the antique watch that came with Nao's journal. Near the end of *A Tale*, Ruth imagines a world "where there are no leaking nuclear reactors or garbage patches in the sea" (399). Her attention is again diverted, and the novel concludes without further reference to nuclear reactors or garbage patches.[13]

For his part, Oliver—who cannot stand "the reckless squandering of fossil fuel" on the island (142)—is committed to combatting climate change via "botanical intervention." As the narrator describes,

> Anticipating the effects of global warming on the native trees, he was working to create a climate-change forest on a hundred acres of clearcut, owned by a botanist friend. He planted groves of ancient natives—metasequoia, giant sequoia, coast redwoods, *Juglans*, *Ulmus*, and ginkgo—species that had been indigenous to the area during the Eocene Thermal Maximum, some 55 million years ago. (60)

[13] With the exception of Appendix F, which focuses on Hugh Everett, who wrote war games software that simulates nuclear war.

Oliver calls his creation the "NeoEocene," a "collaboration with time and place, whose outcome neither he nor any of his contemporaries would ever live to witness" (60). Yet, ironically, not only does this experiment frustrate Ruth, who desperately misses the built environment and the people of New York so essential to her identity and creativity. Oliver's NeoEocene also violates the covenant of its site, which stipulates that reforestation (following a logging company's clear-cut of the space) be limited "to species that were native to the extant geoclimatic zone" (120). Missing the point, Oliver argues that given the rapid onset of climate change, the term *native* needs to be radially redefined "to include formerly, and even prehistorically, native species" (120). The problem is that although the species he is planting are indigenous in that they once flourished in the area, Oliver has not explored the potential consequences of his actions on current landscapes. Nor does his intervention do anything to forestall climate change.

Even as *A Tale* contains numerous references to human manipulation and destruction of the nonhuman, the novel ultimately highlights nonhuman resistance and resilience. The narrator describes how although the island is a "gemlike paradise" for two months during the summer, it otherwise "bared its teeth, revealing its churlish side" (141–2). When Ruth first sees the "massive Douglas firs, red cedars, and bigleaf maples" surrounding their home on all sides, she weeps, the narrator noting that "at five feet, five inches, she had never felt so puny" (59). The forest is described as encroaching "like a slow-moving coniferous wave, threatening to swallow them entirely . . . on the sparsely populated island, human culture barely existed and then only as the thinnest veneer" (60–1). Rural life overall is described as "perilous. Every year, someone on the island died or drowned or was seriously injured. . . . Dangers were rife: ladders, fruit trees, slick moss-covered roofs, rain gutters, axes, splitting mauls, chainsaws, shotguns, skinning knives, wolves, cougars, high winds, falling tree limbs, rogue waves, faulty wiring, drug dealers, drunk drivers, elderly drivers, suicide, and even murder" (65–6). Islanders appear more of a danger to themselves than to the nonhuman, while the landscape is depicted as having an upper hand against its human inhabitants.

This dynamic is consolidated in the figure of the crow. References to crows abound in *A Tale*. When Ruth shares with Oliver Nao's discovery that her (Nao's) father, instead of working in an office, spends his days feeding crows in Ueno Park, Oliver reveals he had seen a Jungle Crow the day she found the freezer bag with Nao's diary. The Jungle Crow, *Corvus japonensis*, a subspecies of *Corvus macrohynchos*, is distinct from the *Corvus caurinus*, the Northwestern Crow, that is native to their island. Oliver surmises that the Jungle Crow rode over from Japan on the same flotsam that brought them Nao's diary. Several days later, Oliver announces that the Jungle Crow has returned, and he shares with Ruth what he has read about the animal, that it has "become a huge problem in Japan," outsmarting people:

They're very clever. They memorize the schedules for trash pickups and then wait for the housewives to put out the garbage so they can rip it open and steal what's inside. They eat kittens and use wire coat hangers to make nests on utility poles, which short-circuit the lines and cause power outages. The Tokyo Electric Power Company [responsible for Fukushima] says crows are responsible for hundreds of blackouts a year, including some major ones that even shut down the bullet trains. They have special crow patrols to hunt them down and dismantle their nests, but the crows outsmart them and build dummy nests. Children have to carry umbrellas to school to ward off attacks and protect themselves from droppings. (66)

Word spreads on the island about the crow, and they learn from Callie, a marine biologist and environmental activist, that "everyone's talking about it. Our local natives already have their knickers in a twist . . . Invasive species. Exotics. Black slugs, Scotch broom, Himalayan blackberries, and now Jungle Crows?" (120). And when the Jungle Crow caws, seemingly in agreement with Oliver's assertion that "we need to radically redefine the term *native*," the anthropologist Muriel jokes, "Don't be surprised if our island xenophobes storm this place, armed with nets and kerosene torches" (120).

Yet, the "island xenophobes" notably stay away, and the Jungle Crow becomes a frequent visitor, both in Ruth's dreams and to her home.[14] The narrator describes how one evening after the power goes out the bird circles Ruth's home, then soars first above the treetops and then ever higher until it can see the mountains of the Vancouver Island Range, and beyond that the Pacific. At that moment, the Jungle Crow "could not fly high enough to see its way home" (173). Yet, in the end, it appears to be able to do so. In the final pages of *A Tale*, Ruth, Oliver, and Muriel are standing out on Ruth and Oliver's deck hoping to spot the bird, Muriel with a pair of binoculars and Oliver with a special telephoto lens. Eventually, the Jungle Crow comes into view, flying high above; it drops a hazelnut, which Muriel interprets as its parting gift, and then it climbs "higher and higher on each orbit," eventually becoming "just a speck in the sky" (378). The Jungle Crow is not seen again.

The Jungle Crow takes on several meanings in *A Tale*. Most conspicuously, it connects Ruth's world with Nao's world, giving Ruth the opportunity, at least in her dreams, to meet Nao's family and imagine changing Nao's story. More fundamentally, the animal's journey from Japan to North America, presumably on flotsam, highlights the interconnectedness of even distant landscapes and the impact of human beings on ecosystems near and far—

[14]For instance, the Jungle Crow leads Ruth in dream to Nao's father in Tokyo (350). *A Tale* also speaks of the role of the crow in indigenous myth.

in this case, separating a bird from its "native" land and bringing it to an unfamiliar and potentially dangerous place. Yet, ultimately, the novel suggests that the crow surmounts even this daunting challenge and travels freely onward, if not homeward, retracing the steps of Nao's diary.

In sharp contrast with the space *A Tale* as a whole opens for women's writing despite Nao's inability to share more of Jiko's story, discussed in the first part of this chapter, the narrative's emphasis on the resilience of the nonhuman ultimately diminishes the space for environmental remediation. The crow's victory is short-lived, if not for this one animal then for nonhuman animals and ecosystems more generally. Nuclear fallout, ocean pollution, and especially climate change, not to mention countless other environmental challenges, many of which appear in Ozeki's novel, remain tremendous threats to entire landscapes, including their human inhabitants. *A Tale for the Time Being* is precisely this, a tale for the *Time Being*—a time both with new possibilities for women's and other formerly marginalized voices within and beyond World Literature and with continued social and environmental challenges and crises. Covid-19 has been "yet another warning shot of the consequences of ignoring [the] connections" among human health and the climate and biodiversity crises as well as among "ourselves, other animal species, and the natural world more generally" (Armstrong, Capon, McFarlane). *A Tale* reveals just how readily attention can be diverted from these vital issues even as they loom large in consciousness and narrative. Time will tell whether the pandemic is a wake-up call to real social and environmental change or (just) another time the lessons of which are lost across time.

References

Adams, B. (2019), "The Waste/d Spaces of Ruth Ozeki's *A Tale for the Time Being*," *Ex-centric Narratives: Journal of Anglophone Literature, Culture, and Media* 3: 244–57.

Armstrong, F., A. Capon, and R. McFarlane (2020), "Coronavirus is a Wake-Up Call," *The Conversation* online (March 2020).

Bennett, B. (2013), *Scheherazade's Daughters: The Power of Storytelling in Ecofeminist Change*, New York: Peter Lang.

Black, S. (2004), "Fertile Cosmofeminism: Ruth L. Ozeki and Transnational Reproduction," *Meridians: Feminism, Race, Transnationalism* 5 (1): 226–56.

Carroll, V. P. (2018), "Introduction: Ecofeminist Dialogues," in D. Vakoch and S. Mickey (eds.), *Ecofeminism in Dialogue*, 1–12, New York: Lexington Books.

Chae, Y. (2014), "'Guns, Race, Meat, and Manifest Destiny': Environmental Neocolonialism and Ecofeminism in Ruth Ozeki's *My Year of Meats*," in L. Fitzimmons, Y. Chae, and B. Adams (eds.), *Asian American Literatures and the Environment*, 150–70, New York: Routledge.

Chu, P. (2019), *Where I Have Never Been: Migration, Melancholia, and Memory in Asian American Narratives of Return*, Philadelphia: Temple University Press.

Damrosch, D. (2003), *What is World Literature?* Princeton: Princeton University Press.

Estok, S. (2013), "The Ecophobia Hypothesis: Re-membering the Feminist Body of Ecocriticism," in G. Gaard, S. Estok, and S. Oppermann (eds.), *International Perspectives in Feminist Ecocriticism*, 70–83, New York: Routledge.

Fachinger, P. (2017), "Writing the Canadian Pacific Northwest Ecocritically: The Dynamics of Local and Global in Ruth Ozeki's *A Tale for the Time Being*," *Canadian Literature* 232: 47–63, 185.

Fowler, E. (1988), *The Rhetoric of Confession: Shishōsetsu in Early Twentieth-Century Japanese Fiction*, Berkeley: University of California Press.

Gaard, G. (2010), "New Directions for Ecofeminism: Toward a More Feminist Ecocriticism," *Interdisciplinary Studies in Literature and Environment* 17 (4): 643–65.

Gaard, G., S. Estok, and S. Oppermann, eds. (2013), *International Perspectives in Feminist Ecocriticism*, New York: Routledge.

Gullander-Drolet, C. (2018), "Translational Form in Ruth Ozeki's *A Tale for the Time Being*," *Journal of Transnational American Studies* 9 (1): 293–314.

Guy, B. (2015), "On Not Knowing: *A Tale for the Time Being* and the Politics of Imagining Lives after March 11," *Canadian Literature* 227 (online): 96–112, 200.

Harrison, S. (2017), "Environmental Justice Storytelling: Sentiment, Knowledge, and the Body in Ruth Ozeki's *My Year of Meats*," *ISLE: Interdisciplinary Studies in Literature and Environment* 24 (3): 457–76.

Hauser, R. (2017), "Schoolgirl Sex and Excess: Exploring Narratives of Japanese Girlhood and Compensated Dating in Ruth Ozeki's Novel *A Tale for the Time Being*," *Hecate* 43 (112): 158–70.

Jimenez, C. (2018), "Nuclear Disaster and Global Aesthetics in Gerald Vizenor's *Hiroshima Bugi: Atomu 57* and Ruth Ozeki's *A Tale for the Time Being*," *Comparative Literature Studies* 55 (2): 262–84.

Jones, E. (2017), "Writing the Hyper-disaster: Embodied and Engendered Narrative after Nuclear Disaster," *The Comparatist* 41: 93–117.

Lee, H. (2018), "Sharing Worlds through Words: Minor Cosmopolitics in Ruth Ozeki's *A Tale for the Time Being*," *Ariel: A Review of International English Literature* 49 (1): 27–52.

Luke, E. and D. Karashima, eds. (2012), *March Was Made of Yarn: Reflections on the Japanese Earthquake, Tsunami, and Nuclear Meltdown*, New York: Vintage Books.

Ozeki, R. (2013), *A Tale for the Time Being*, New York: Penguin Books.

Ozeki, R. (2014), *Aru toki no monogatari*, Tokyo: Hayakawa.

Sakamoto, N. (2020), "Local Energy Initiatives in Japan," in A. Esarey, M. Haddad, J. Lewis, and S. Harrell (eds.), *Greening East Asia: The Rise of the Eco-Developmental State*, 109–21, Seattle: University of Washington Press.

Starr, M. (2016), "Beyond Machine Dreams: Zen, Cyber-, and Transnational Feminisms in Ruth Ozeki's *A Tale for the Time Being*," *Meridians: feminism, race, transnationalism* 13 (2): 99–122.

Stein, R. (2010), "Bad Seed: Imperiled Biological and Social Diversity in Ruth Ozeki's *All Over Creation*," in B. Roos and A. Hunt (eds.), *Postcolonial Green: Environmental Politics and World Narratives*, 177–93, Charlottesville: University of Virginia Press.

Ty, E. (2013), "'A Universe of Many Worlds': An Interview with Ruth Ozeki," *MELUS* 38 (3): 160–71.

Usui, M. (2015), "The Waves of Words: Literature of 3/11 in and around Ruth Ozeki's *A Tale of the Time Being*," *Procedia: Social and Behavioral Sciences* 208: 91–5.

Warren, K. (2000), *Ecofeminist Philosophy: A Western Perspective on What it is and Why it Matters*, Lanham: Rowman & Littlefield.

13

Troubling the Human, Worlding Gender in Maryse Condé's *The Wondrous and Tragic Life of Ivan and Ivana*

Nicole Simek

In 2017, Guadeloupean novelist Maryse Condé published a peculiar novel taking up the phenomenon of global terrorism from a playful, ironic angle: *The Wondrous and Tragic Life of Ivan and Ivana*. Centered on a pair of incestuous twins—Ivana, the docile sister and excellent student who sets out to become a police officer in order to protect the weak and rectify the injustices she sees in the world; Ivan, the unruly brother with lackluster grades who struggles to find a meaningful life plan and turns instead to terroristic revolt against an unjust world—Condé's novel approaches world-scale events with an eye for the tangled and mobile relationships between the particular and the contingent, on one hand, and the overdetermining gendered and racialized structures shaping global currents on the other. Weaving a story of radicalization into a tale of erotic passion and Black female martyrdom, the novel takes up the question of the political dimension of the personal, and also the personal dimension of the political. In so doing, it also raises questions about the capacities of literary form to respond to the interpellation of global events, to engage with the gendered and racialized biopolitics of subject-formation in ways that reshape our imagination and relations to others.

The event that motivated Condé to write this novel was a three-day series of coordinated attacks in and around Paris in January 2015 that

resulted in twenty deaths, including those of three assailants. The murders at the Paris offices of the satirical newspaper *Charlie Hebdo* (and the mass demonstrations that coalesced in the aftermath around the slogan "Je suis Charlie") dominated news coverage, but hostages taken at a Kosher supermarket were also killed, as was a young police officer, Clarissa Jean-Philippe. It is this last death—the "blind slaughter" of a Black woman from Martinique by another Black French citizen, a man of Malian descent—that Condé describes as the "turning point" that spurred her to write this novel in response (2017b). What struck her about this particular attack was the way it shattered existing understandings of cohesion and violence. As she explains, this killing gave the lie to the myth that racial identity creates sufficient affinities to give rise to anti-colonial political solidarity among Black people. The unprecedented form of violence exercised against Jean-Philippe—"a violence without regard for skin color, family, or friends"—cannot be combatted simply by calling out the usual suspects, Condé argues (2017b). "Rehearsing admonishments of colonialism and its aftermath is no longer enough," she states in an interview.

> "Terrorist" attacks, as they're called, are drawing blood from the planet, affecting the world in its entirety: in India just as in Pakistan, in Turkey just as in Europe and America. Why are we in this situation? No one has clear answers. But what seems clear is that that literature's mission has to change in response to this new information. (2018: 152–5; translations from this interview are my own)

The Romantic conceit of siblings locked in a passionate but lethal incestuous embrace allows Condé to translate the intimacy of this violence and to hold up to scrutiny the public debates over nature and nurture, individual psychology and collective socialization, that are reopened in the West in the wake of each new terrorist attack. The transposition of this trope into an exploration of contemporary global terror jars with lingering assumptions that erotic desire is a private and highly particularized affair with little bearing on the broader social foundations of political-religious conflict. What Condé's conceit jolts into focus, then, are the gendered and sexualized dynamics both of terrorism in its recent forms, and also of the racist, colonial order that continues to shape current struggles. At the same time, the novel's picaresque form and repeated ironic jousts deflect attempts to settle on any interpretation of "radicalization" and its causes. What emerges from Condé's unseemly fable instead is, first, a satiric portrait of the "white analytic" at play in French leftist debates over the causes of the 2015 attacks, an interpretive framework whose dynamics and exclusions Alana Lentin has convincingly detailed. Second, Condé's fable meditates on the role of world literature, and an aesthetic education, to use Gayatri Chakravorty Spivak's terms, in a time of terror (2012). If the literary is to

open up what Pheng Cheah describes as a new "ethicopolitical horizon
... for the existing world" (2016: 5), *The Wondrous and Tragic Life of Ivan and Ivana* suggests, it must grapple with the contingent as well as the systemic, and let go of the assumption that race and gender are independent analytic categories that can be deployed separately, when they are not simply relegated to the wings of the world stage on which global terrorism is assumed to play out. If the field of World Literature has traditionally preoccupied itself with the universality of the human condition, implicitly sidelining gender and race in favor of a supposedly inclusive cosmopolitan citizen, Condé's novel adopts a feminist approach by troubling this unmarked figure of World Literature. Taking up an intersectional optic, *The Wondrous and Tragic Life of Ivan and Ivana* re-worlds the human, reconfiguring humanity as irreducible to the paradigmatic subject of world literature: the model of white, secular Man.

Terror in a Nutshell

"Condé's provocative fun cloaks a challenge," writes Maya Jaggi in her review of *Ivan and Ivana*'s satiric take on the search for terrorism's causes: "Is there not more than a little bad faith in the way the west earnestly seeks the roots of jihadi radicalism while turning a blind eye to the flagrant ills that add rocket fuel to its meretricious allure?" (2020). Indeed, beginning imaginatively with the twins' blissful unity in the womb, Condé's novel immediately throws into question what it means to trace a life's trajectory back to an origin that would explain its eventual telos. Elevated to mythic status already by the chapter title, with its Shakespearean echoes ("In Utero or Bounded in a Nutshell"),[1] Ivan and Ivana's birth takes the form of a tragic fall from harmony dictated by uncontrollable fate: "besieged" in the womb by "an invincible force," they undergo a "horrible downward journey" through the birth canal and into a blinding light (2020: 15, 16). Yet, while their separation into two distinct bodies disorients the infants, it is not only this parting in itself that the novel targets, but also the hierarchizing forces of a white and heteronormative symbolic order that carves evaluative distinctions into their flesh as it individuates them. The twins' expulsion from the paradise of the womb begins even before they draw their first breath, as the plural pronoun "they," expressed in French by

[1]The full section reads, "In Utero or Bounded in a Nutshell (*Hamlet*—William Shakespeare)," referring to Act II, Scene 2, where Hamlet evokes the power of thought to turn a vast space into a prison or a constrained one into a joy: "Oh God, I could be bounded in a nut shell and count myself a king of infinite space, were it not that I have bad dreams" (2003: II.2.250).

the masculine "ils" (2017a: 11),² gives way at once to the singular and to sex differentiation:

> They got the impression of being brutally dragged down and forced to leave the warm and tranquil abode where they had lived for many weeks. A terrible smell clung to their nostrils as they gradually, helplessly, made their descent. . . . The twin who had a button between his legs preceded the smaller less developed other whose sex was hollowed out by a large scar. He butted his way down the narrow passage whose walls slowly widened. (2020: 15)

To make the imaginative leap into the fetuses' untutored perspective, the narrator focuses on sensation—smell and touch—and approximates naive description with the use of nonspecific terms like *bouton* (a button, a flower bud, or pustule) (2017a: 11). Yet, the impossibility of socially unmediated perception is brought sharply into view at the mention of the *balafre*—a long, liplike scar—marking Ivana as wounded and "hollowed out," always already castrated and seemingly destined to follow rather than lead (2017a: 11). Observation is entangled with interpretation, and difference, as soon as it is noticed, is read as loss. Like the "a" at the end of "Ivana"—which we soon learn is merely "a feminine version" of the name Simone gives to her son out of fondness for *Ivan the Terrible*, a film she had watched in awe as a child (2020: 21)—the *balafre* functions as an excess that ironically signifies derivativeness, and a presence that indexes an absence, an injurious cut (the French word designates both the scar itself and the wound that leaves this trace).

A new kind of scarring marks Ivana again at the end of the novel, seemingly bringing her story full circle. Killed by her brother during a Christmas attack on a nursing home for retired police, Ivana becomes a revered martyr in Guadeloupe. Something of a parody of the Christian nativity unfolds the December after Ivana's burial in her home village of Dos d'Âne (a name meaning, first, "donkey's back," evoking Mary's journey to Bethlehem, but also "speed bump"): three Haitians, following a bright star in the sky, make their way to her tomb, launching a tradition of annual pilgrimage to honor their "petite sœur de la blesse," or "little wounded sister" (2020: 249). Meaning "scar" or "wounded" in Creole, the narrator explains, the word *blesse* "refers of course to the scars dealt by life which are never erased and always remain a wound in both body and soul" (2020: 249). To sanctify Ivana this way is to retrospectively confirm the twins'

²French distinguishes between two personal pronouns in the third-person plural: the masculine "ils" (used for groups of masculine or mixed-gender nouns) and the feminine "elles" (used for groups of feminine nouns only).

predestination from birth, to see the meaning of Ivana's life as encapsulated by her original identity in the womb as the smaller, scarred sister. At the same time, the satirical portrait of this pilgrimage casts a skeptical light on this unbroken arc from birth to death. Moreover, the multiplication of wounds in the narrator's translation—the many scars dealt by life which are never erased—along with the shift back to a more melancholic tone in these concluding words places weight instead on the temporality of Ivana's story, and the historical causes of such wounds. Wounds may never disappear, but they do appear; if Ivana is wounded, this condition is not a transcendental one completely outside of time. If Ivana's sex is a scar even in the womb, it is not because there is no cause for this condition, but rather that she is born into a woundedness that precedes her, a narrow channeling of her flesh and being into categories of legibility that leave a mark.

In this light, Ivana's natal scarring is reminiscent of what Hortense J. Spillers has described as a "hieroglyphics of the flesh," the traces left on the flesh by the "severe disjunctures" of slavery (1987: 67). These traces of a violent ungendering and theft of the body, as Lisa Guenther comments, are "not outside of history, but not quite inside history either," in that they are passed on from generation to generation, in altered form (2012). Like slavery's hieroglyphics, which "come to be hidden to the cultural seeing by skin color" (Spillers 1987: 67), Ivana's scar becomes invisible as such to the eye steeped in French republican values—a colorblind ideology invested in the preservation of equal rights through the eradication of difference from the public sphere. "Ex utero," it is Ivan, rather than Ivana, who is assumed to be scarred, and whose woundedness takes center stage in the inquiry into terrorism's causes. If Ivan's status in the womb is that of the developed twin, the one who butts his way down the birth canal, seemingly taking charge of his movements rather than passively submitting to the forces that are expelling him, his masculinity—the measure against which Ivana's body and initiative are judged lacking—is valued only when it is expressed through sanctioned pursuits: education, social courtesy, the enforcement of law and order. Every injury major and minor to Ivan's dignity and love for Ivana is scrutinized by the narrator as factors contributing to his radicalization, to his becoming inhuman; his story, like his sister's, is read from its telos backward, as a fall into demonic depravity. Conversely, as a model student and servant of the Republic in the making, Ivana provides the foil of angelic wholeness to Ivan's damaged self.

The perception of damage at issue here, as Lentin's analysis of the *Charlie Hebdo* debates shows well, is one that stems from a "culturally singular vision" (2019: 51) of what wholesomeness, or secular republicanism, means. This vision—or "white analytic" as Lentin puts it, following Barnor Hesse—takes white French majoritarian culture to be the neutral, non-racist, non-sexist, and non-religious norm against which other cultural and religious practices, or identity-based organizations, become marked by

contrast as partisan, racist, anti-feminist, and anti-secular. This alignment of *laïcité* with anti-racist neutrality forecloses the conclusion that critiques of Islam in France—in which debates over gender equality also come to serve as a wedge—could have anything to do with racism and whiteness as a culturally specific viewpoint. Reductive understandings of racism as a matter of "personal prejudice" (Lentin 2019: 48) similarly lead such proponents of *laïcité* to mistake their particular interpretation of secularism for a universal, rational, and obvious reading of the law (Lentin 2019; Hesse 2014). Viewed through such an optic, Lentin demonstrates, anti-colonial and anti-racist anger becomes illegible as a motive for terrorist violence. Charges of racism—such as the criticisms of *Charlie Hebdo*'s long practice of deploying racist caricature in the name of fighting racism—then incite puzzlement and the counterclaim that critics have either misread the complex context of France or that their judgment is itself clouded by their non-colorblind (and therefore racist) perspective.

A "Black analytic" by contrast brings to light race as a code for what Sylvia Wynter calls the "genre of the human," a construction in which the figure of the white (and in this case secular, French) citizen "overrepresents itself as if it were the human itself" (2003: 269, 260). As Alexander Weheliye puts it, race operates not as a biological or cultural taxonomy, but rather as "a set of sociopolitical processes that discipline humanity into full humans, not-quite-humans, and nonhumans" (2014: 4). These "racializing assemblages" differentiate, hierarchize, and cast out "non-white subjects from the category of the human" (Weheliye 2014: 3). France's republican framework, its "white analytic," masks this ideological division between the human and its racialized others by upholding abstract equality and casting critiques of this very abstraction as illegitimate attacks on equality itself destined to reproduce rather than eradicate racist practices.

Accordingly, when race and gender are thought intersectionally, the point is not only to expose the limits of white feminisms with the goal of gaining entry into its frameworks for the excluded, but to question the human as such. Commenting on Wynter's transformative project, Weheliye notes the tendency (as exhibited by Judith Butler) to misread the force of her critique:

> Viewing Wynter's colossal project, with which Butler does not engage in any sustained way, both of critiquing the current western instantiation of the human as coterminous with the white liberal subject and of crafting a new humanism should not be reduced to observing the historicity of this concept with the aim of showing how women of color and other groups are excluded from its purview. Or to put it in Butlerian terms: Wynter is interested in human trouble rather than "merely" woman-of-color trouble, even while she deploys the liminal perspective of women of color to imagine humanity otherwise. (2014: 22)

Understanding the perspective of women of color in order to bring them into the existing fold is not sufficient; rather Black feminism undertakes the project of *imagining humanity otherwise*, opening up an ethico-political horizon under which Black women can enact universality, and be seen as agents of worlding.

Humanity Unbound

In reading radicalization as a form of gendered racialization, the novel enacts its "world-forming" capacity (Cheah 2016: 116). It does so by indicting the disciplining of the human itself, connecting the expulsion of the terrorist from the realm of the human to the colonial structures that have similarly drawn lines between human and other throughout European modernity. If the novel's opening nutshell evokes both the twins' fantasy of blissful union and Western onlookers' attempts to boil their story of terror down to a calculable cause that could then be contained, it also represents the kind of imaginative and affective work the novel will do throughout to unsettle the interpretive protocols characterizing the earnest Western search for radicalization's causes. Playing on the empty familiarity of birth—a universal but also universally forgotten personal experience—the "In utero" opening fills this void with a descriptive content that is evocative but also estranging, alluring in its offer of knowledge but also bitingly ironic.

"Ex utero," the novel portrays colonial ideology as a creeping force that can be held at bay only for so long. If the twins begin life enchanted—finding delight in their mother's beauty, in the touch of sand sifting through their fingers, and, most of all, in forming a unit, a "they"—this bliss depends in part on ignorance:

> They were at first filled with wonder by the ray of sun that entered through the shack's wide open window. . . . They rapidly remembered their names, pricking up their ears and waving their little feet at the mention of these syllables so easy to retain. What they didn't know was that the priest at Dos d'Âne, a fat, dull-witted man, had almost refused to christen them.
> "How could you give them such names," he shouted angrily at Simone. "Ivan, Ivana! Not only do they not have a father, but you want to turn them into true heathens!" (2020: 18–19)

If Simone holds firm and wins the battle with this church authority, her retelling of her victory to the twins becomes a reminder of their position as liminal, policed bodies whose inclusion in the circle of insiders is subject to the whims of the more powerful, those who draw lines between the believer and the heathen, the Christian and the *mécréant* (Condé 2017a: 16), that

ambiguously racialized "infidel" or "miscreant" whose alternate religion or atheism is portrayed as a negation of true faith and expression of savagery.

A seeming non-sequitur follows this exchange with the priest, sharpening the narrator's jabs at his dull-witted logic:

> As a matter of fact, Simone's family was used to both multiple and singular births. In the nineteenth century, her ancestor, Zuléma, the first of a litter of quintuplets, had been invited to the Universal Exposition in Saint-Germain-en-Laye in order to prove what could become of a descendant of a slave when he breathed in the effluvium of civilization. Dressed in a tie and three-piece suit, he was a surveyor by trade. He had learned opera arias all on his own by listening to a program on Radio Guadeloupe called *Classical? Classical Indeed!* (2020: 19, translation modified)

It would seem that what Simone's family is accustomed to is not just multiple and extraordinary births, but rather colonialist scrutiny of their bodies, their intelligence, and their reproductive decisions. The animalization of Zuléma (as the first of a "litter" of children) and his celebration, at the heart of empire, as an admirable prodigy are two sides of the colonialist coin, one that acknowledges and champions its own "civilizing" force without granting its colonized subjects full title to that civilization.

In these two brief anecdotes the narrator ties together the Christian fundaments of French colonialism, the heterosexual, patriarchal values of the same that continue to dominate contemporary culture, and the racialization of both religious and cultural difference that lives on in the ostensibly postcolonial and secular Republic. Time and again the narrator draws attention back to this race-gender-religion knot as a key to understanding Ivan's path, from the twins' discovery, once they start school, "that they had no father in Guadeloupe," an absence their mother interprets as a contributor to Ivan's waywardness (2020: 23), to an argument with a woman selling fruit at the market, who derides the "miserably black" family, revealing to the twins for the first time that "they belonged to the most underprivileged category of the population, the ones anyone could insult as they liked," that "their skin was black, their hair kinky, and their mother worked herself to the bone in the sugarcane fields for a pittance" (2020: 27), to Ivan's imitation of a teacher's fury against a white, Western order responsible for the death of his wife and son, killed in the Middle East in a NATO bombing raid—a critique that the narrator describes tellingly as "blasphemy" (2020: 29). As French citizens, Ivan and Ivana are abstractly and juridically fully human, but in practice their Blackness haunts them, as they are periodically reminded of their status as *not-quite-human* (as non-whites whose difference is never forgotten, they cannot fully occupy the ontological position of the human), a liminal status constantly under threat of sliding into the *nonhuman* (non-citizen or denationalized others who fall

outside the "protection" of French Law, like the refugees in limbo at Calais that Ivan eventually encounters).

At the same time, this haunting takes different forms as it intersects with their gendered positioning in France's civil society. "Heartbroken" by the fruit vendor's harsh words, Ivana vows to "avenge her mother and give her the gentler way of life she deserved," while Ivan is "filled with rage against life and against his fate which had turned him into an underprivileged subordinate" (2020: 27). For Ivana, education and a career in policing hold out the promise of an agency she is denied as a Black woman, and her docility helps her achieve it; being called "Snow White" at work appears to her a harmless inside joke, and she can only accept Ivan's conversion to Islam, a religion that "disgusts" her, as an act of social integration, not a matter of conviction (2020: 110). For Ivan, education and an apprenticeship in chocolate-making (the available position that career counselors deem him fit for, with ironic echoes of colonial Europe's tropical exploitations) represent submission to an emasculating and recolonizing authority that promises nothing but more of the same, while Islam eventually comes to represent for him the promise of changing the world. Ivana's path to success is reinforced by professors, colleagues, and friends who integrate her into their milieu and praise her choices, while Ivan drifts without much conviction from one ideology and brush with the law to another, influenced by various anti-colonial activists, religious extremists, and other rebels against the status quo along the way. If Ivan progressively dissolves into the category of the nonhuman, the inhuman terrorist, joining the ranks of the wretched of the earth, Ivana grows closer to the French ideal holding out the promise of humanity/whiteness.

The novel interrogates this ideal first through its multiplication of the "causes" to which his participation in the attacks might be attributed, troubling the attempt to draw a line from Ivan's actions back to some essential core being. No less than three times does the narrator claim an explicit "beginning" to Ivan's radicalization, and the events that implicitly steer him toward his end are even more numerous. While using the term *radicalization*, the narrator also questions it, suggesting that Ivan's case exceeds existing models while also having something in common with them. "It was from this moment on that his radicalization began, a word that is bandied about today, rightly or wrongly" the narrator states of a humiliating episode in Ivan's adolescence (2020: 37), later identifying other "beginnings" or turning points in this process: "If you ask my opinion," the narrator declares after the murder of Ivan's close friends and lovers, Alex and Cristina, "I would say that it was at this precise moment that Ivan became radicalized, as they say" (2020: 164), but revises this opinion some pages later, commenting, "it was at that very moment [a sexual proposition that offends Ivan], that Ivan's radicalization came to completion. Up till then certain events, such as the deaths of his beloved Alix and Cristina, had

not radically changed him" (2020: 199). Moreover, because it is focalized in large part through Ivan's perspective, while also ranging widely in tone, from melancholic sorrow to dispassionate analysis to caustic irony, the novel also pushes us to expand our affective dispositions and to allow curiosity and sympathy to flow alongside repulsion, frustration, and confusion. In short, the novel prompts readers to interrogate their sensibilities and "to rid the mind of the narrowness of believing in one thing and not in other things," to use Spivak's description of an aesthetic education (2012: 297).

Allowing oneself to imagine the inner life of the terrorist in this aesthetic education does not, then, equate simply to rehumanizing Ivan. Rather, it involves imagining humanity otherwise, as at once humane, inhumane, and irreducible to predictable psychic or historical forces. Ivan's suicidal violence against elderly ex-officers is arguably detrimental to the cause of racialized communities, but it is also a response to the politics of racial indifference, reflecting anger and a desire to change the existing state of affairs. His act strikes back at a social order (symbolically manifested in the police retirement home) that deprives him of a meaningful life plan, yet it is also a nihilistic and escapist response to what Ivan experiences as a living death in the absence of his sister's love. Thwarted by his upbringing, which forbids the intimacy the twins desire, Ivan chooses murder-suicide. In this sense, his turn to terrorism enacts the death drive as Freud describes it: "an instinct . . . inherent in organic life to restore to an earlier state of things" (1920: 36). Ivan craves a return to his previous fusion with Ivana, and self-annihilation provides the only possible release from permanent alienation.

Condé's novel troubles the human further, and in unexpected ways, by inviting us to reconsider the death drive from Ivana's vantage point. Like her brother, Ivana chooses death: "It was the only thing to do," the narrator declares when Ivan fires on his sister, "the only act that had meaning to it. Ivana understood perfectly. Consequently she arched her breast in order to acknowledge the blessing from the bullets" (2020: 236). This self-sacrifice appears on the one hand a stereotypical example of feminine passivity and lovestruck loyalty; Ivana remains faithful to her brother to the end, to the point of subordinating her very life to his desires. At the same time, the novel's positioning of the siblings' love story as a wrench in the Western story of radicalization politicizes her abrupt decision. Withstanding their attempts to deny it, the twins' incestuous longing for fusion hovers persistently over them as an ideal just outside their grasp, eventually overwhelming their life. Ivana's drive to succeed in her career and to conform to social expectations through marriage to a colleague suddenly mutates into a death drive disrupting her previous commitments and decentering the disciplined and disciplining police officer self she has been crafting. Erotic desire jams the disciplining of the twins' humanity, and the death drive in Ivana shifts cast, taking the form not simply of a return to a prior, biological death, but rather of "an uncanny excess of life" or "an 'undead' urge which persists beyond

the (biological) cycle of life and death," as Zizek puts it (2006: 61). "The ultimate lesson of psychoanalysis," he continues, "is that human life is never 'just life': humans are not simply alive, they are possessed by the strange drive to enjoy life in excess, passionately attached to a surplus which sticks out and derails the ordinary run of things" (2006: 62). In the moment of her death, Ivana throws off all attempts to channel her love into more socially acceptable objects, abandoning the "insipid and tasteless" fiancé she has agreed to marry (2020: 227) in order to fuse with her brother.

This indocile force does not obey a cost-benefit logic. In thrusting herself into the bullets, Ivana is no longer acting in her own interests: preserving her life and serving the Republic. She rebels against the strictures shaping her future, because she is *more* than an agent of biopolitics in pursuit of symbolic whiteness. A death drive such as this, as Adrian Johnson notes, holds emancipatory potential: "Thanks to 'the death drive' (as disruptive negativity), the human individual isn't entirely enslaved to tyranny of the pragmatic-utilitarian economy of well-being, to a happiness thrust forward by the twin authorities of the pleasure and reality principles" (2008: 185). In this moment of decision, Ivana make's Antigone's choice, rejecting an order premised on the destruction of people like her brother and the love she bears him.

Common Graves?

If Ivana's self-sacrifice momentarily troubles the sanctioned genre of the human, it is no heroic act that will change the world, nor even save the life of her brother. The twins' story escapes their grasp upon their death, and like clay gets reshaped in the hands of those who remain. Ivan is reviled, and Ivana is revered, solidifying the line between human and monster. If the state works to erase Ivan from view, cutting him off from all visitors to his deathbed and hastily burying him in a common grave behind the hospital, Ivana's sympathetic admirers bury her in a tomb of sanctity, transforming her into a frozen statue of herself, everyone's and no one's "little wounded sister." Yet, like Ivana herself, driven by an undead urge, the novel outlives itself, pursuing an unending that is more than its ending and testifying to the uncontainable fecundity of Ivan and Ivana's story. The novel's conclusion proper ("More About the Uterus: There's No Escaping It") tracks the restless, dissatisfied storytelling that the twins spur, kept alive by the incomprehensibility of their love and death, and whets the appetite for more with the revelation that Ivan has left behind a lover pregnant with twins. A further epilogue chides readers for their narrowmindedness and revives the urge to reinterpret, to refuse to let the story lie, in both senses of the term—we cannot allow the story to rest, and we cannot help but question its relationship to truth. Rather than merely declaring Ivan and

Ivana's tale inexplicable, the novel produces a proliferation of reasons for their actions, an aesthetic overabundance that keeps the work of meaning-making in play. Its caustic and sanguine demonstration of the persistence of race and gender formations is twinned with an indomitable drive to reshape the horizons of this world. We might say that the death at its center forms a talking scar, a trace that protrudes and impels new efforts at healing and worldling.

References

Cheah, P. (2016), *What Is a World? On Postcolonial Literature as World Literature*, Durham: Duke University Press.

Condé, M. (2017a), *Le fabuleux et triste destin d'Ivan et Ivana*, Paris: JC Lattès.

Condé, M. (2017b), "Maryse Condé: 'La négritude est morte à Montrouge le 8 janvier 2015,'" interview by T. Chanda, RFI, July 28. Available online: http://www.rfi.fr/hebdo/20170728-maryse-conde-negritude-antilles-guadeloupe-ivan-ivana-creolite-aime-cesaire (accessed January 16, 2021).

Condé, M. (2018), "Entretien avec Maryse Condé: Quelques acquis et manques de la littérature francophone des Antilles," interview by R. Célestin, *Contemporary French and Francophone Studies* 22 (2): 152–5.

Condé, M. (2020), *The Wondrous and Tragic Life of Ivan and Ivana*, trans. R. Philcox, New York: World Editions.

Freud, S. (1920), *Beyond the Pleasure Principle*, standard ed., vol. 18, 1–64. London: Hogarth.

Guenther, L. (2012), "The Most Dangerous Place: Pro-Life Politics and the Rhetoric of Slavery," *Postmodern Culture*, 22 (2). Available online: http://www.pomoculture.org/2013/04/07/the-most-dangerous-place-pro-life-politics-and-the-rhetoric-of-slavery/ (accessed January 31, 2021).

Hesse, B. (2014), "Racism's Alterity: The After-life of Black Sociology," in W. D. Hund and A. Lentin (eds.), *Racism and Sociology*, 141–74. Berlin: Lit Verlag.

Jaggi, M. (2020), "The Wondrous and Tragic Life of Ivan and Ivana by Maryse Condé Review—A Scurrilous Picaresque," *The Guardian*, July 16. Available online: https://www.theguardian.com/books/2020/jul/16/the-wondrous-and-tragic-life-of-ivan-and-ivana-by-maryse-conde-review-a-scurrilous-picaresque (accessed January 16, 2021).

Johnson, A. (2008), *Žižek's Ontology*, Evanston: Northwestern University Press.

Lentin, A. (2019), "Charlie Hebdo: White Context and Black Analytics," *Public Culture* 31 (1): 45–67.

Shakespeare, W., B. Raffel, and H. Bloom (2003), *Hamlet*, New Haven: Yale University Press, JSTOR. Available online: www.jstor.org/stable/j.ctt1njkw8 (accessed February 1, 2021).

Spillers, H. (1987), "Mama's Baby, Papa's Maybe: An American Grammar Book," *Diacritics* 17 (2): 64–81.

Spivak, G. C. (2012), *An Aesthetic Education in the Era of Globalization*, Cambridge, MA: Harvard University Press.

Weheliye, A. G. (2014), *Habeas Viscus: Racializing Assemblages, Biopolitics, and Black Feminist Theories of the Human*, Durham: Duke University Press.
Wynter, S. (2003), "Unsettling the Coloniality of Being/Power/Truth/Freedom: Toward the Human, after Man, Its Overrepresentation—An Argument," *New Centennial Review* 3 (3): 257–337.
Žižek, S. (2006), *The Parallax View*, Cambridge, MA: MIT Press.

14

Dissident Feminist Subjects and Spaces in Arundhati Roy's *The Ministry of Utmost Happiness*

Sarah Afzal

Introduction

This chapter will use Arundhati Roy's 2017 novel *The Ministry of Utmost Happiness* as a focal point to examine the role that World Literature plays in opening up spaces and networks outside of the sphere of capitalist production. Roy shows how alternative forms of kinship (both human and nonhuman), archiving, and economics can sustain communities threatened by capitalism's compounding crises. Marxist feminists have observed that labor outside of conventionally acknowledged forms of "productive labor," including domestic work and sex work, is part of a larger process called social reproduction, which encompasses short- and long-term reproduction of "the means of production, the labor power to make them work, and the social relations that hold them in place" (Norton and Katz 2017: 1). This chapter looks at systems that can work as alternatives to "the capitalist form of social reproduction" (Dinerstein and Pitts 2018: 482). Such alternative forms of social reproduction realign labor relations in a way that can create communities outside of capitalism.

The Ministry examines the spaces and systems of labor created in the cracks of the Indian subcontinent's many political schisms. These growing schisms can be seen throughout the novel, whether through the violence and inequity left in the wake of British colonialism, or through the social and economic crises brought more recently by the modern neoliberal forms of capitalism. Decades after the partition of India and

Pakistan, the prevailing religious and nationalist sentiment provided the "moral heft" to the Hindu Nationalist Party's embrace of neoliberal reforms (Harvey 2007: 85). As Kathy Le Mons Walker painstakingly details, such neoliberal reforms in India went against the active role that the state had played through its "constitutional mandates to secure equality and social justice," and instead achieved a "rolling back of the state" (2008: 559–60). These reforms included banking and financial deregulation that "abandoned the existing policy of treating agriculture and small-scale industry as priority sectors" for low-cost lending, allowing financial institutions to pursue "their own profitability over broader economic goals" and focus on the "most profitable activities and, inevitably, on the most developed regions" (2008: 562). This fed a pattern of "predatory growth" that privileged urban land owners over the rural poor, furthering an "internal colonization of the poor" including certain castes and other marginalized groups "through forcible dispossession and subjugation" (2008: 565). These policies and others have not only "expropriated the land and resources of rural dwellers and transferred them to both domestic and international capital" but also fueled "growing inequality and poverty, increasing malnutrition, hunger, and starvation, primary education collapse, agrarian crisis, and the growth of both popular protest and communist insurgencies" (2008: 558, 560). In addition to hostility toward labor unions, India's neoliberal labor reforms have included measures which expand the "casualization of labor," allowing "self-employed workers" to provide a large pool of self-exploited, unorganized labor that has "contributed simultaneously to rising output, corporate profits, and human misery" (2008: 561–2).

These deteriorating political conditions are often neglected by narratives that celebrate India's period of economic growth, predominantly owed to the country's service industry. According to Walker, this has allowed for the creation of a "materialistic and acquisitive middle class, along with a small group of spectacularly rich entrepreneurs" that have subsequently required a growing "productive structure" that can cater to "class and comfort" of the expanding middle class and upper classes (2008: 558–9). This "productive structure" to comfort and care for the nation's growing productive labor force is the domain of reproductive labor, which is increasingly commodified under neoliberalism. As Robin Truth Goodman points out, reproduction has become an "allure for capitalization" and a "dominant target of profit making" (2020: 93). As a consequence, as Kate Bezanson notes, social reproduction is "a primary site of contestation in a neo-liberal era" (2006: 23). The battlegrounds where this labor is being contested are the subjects of examination in the following chapter.

The key spaces that *The Ministry* explores among these numerous and compounding crises can be seen as examples of spaces within states that are strategically unaligned with the institutions around them, or what

Joel Nickels calls "nonstate spaces." Such spaces are "social space[s]" made up of "human networks, decision-making processes, and creative practices external to the nation-state" (2018: 4). A non-state space allows for the realignment of reproductive labor toward communally determined ends, rather than those sought by the dominant modes of capitalist social reproduction. Importantly, both Nichols's non-state spaces and those spaces explored in *The Ministry* demonstrate "alternative exchange economies" and "self-organized communities" that operate "outside of both statist communism and the capitalist nation-state" (2018: 14–15). The challenge that these spaces pose to neoliberalism lies in their capacity to redirect productive and reproductive labor in a way that supports those resisting or surviving the numerous crises neoliberalism has brought on.

Since social reproduction as a category of world-making has remained largely unexplored in debates on World Literature, I examine the need for World Literature to replicate such spaces in such a way that prevents them from being assimilated into neoliberalism and neoliberal forms of feminism. I, therefore, argue that feminist authors and activists from conflicted geopolitical areas must use a politicized World Literature to open up noninstitutional spaces of social reproduction where alternative kinship structures, economies, and histories can thrive.

The Ministry, Social Reproduction, and Alternatives to Capitalism

Indian author, activist, and Booker Prize winner Arundhati Roy's much-awaited second novel *The Ministry of Utmost Happiness* (2017) is a labyrinthine patchwork of narratives, languages, identities, and politics that witnesses, disrupts, disturbs, and also ultimately offers moments of hope amid a seemingly hopeless world of violence and bloodshed. The novel consists of two major plotlines: One follows Anjum, a Muslim Hijra, who is initially part of the Hijra community, whose members are now legally recognized across South Asia as a "third gender." The other follows the conflict in Kashmir through Tilo, an architect-turned-activist, and the men who become a part of her life and play a distinct role in the Kashmir conflict. At its heart, *The Ministry of Utmost Happiness* is about "social and political outcasts who come together in response to state-sponsored violence" (Mahajan 2017). More than that, these characters also embody the "chaotic, multiethnic, multigendered, differently abled subject that is the global working class," taking part in daily class struggle in a rapidly neoliberalizing and increasingly authoritarian India (Bhattacharya 2017: 74). Of particular interest are the relations these characters establish with each other and how their disalignments with the prevailing modes of capitalist social reproduction are sustained.

In Marxism, social reproduction theory tries to explain how class position is taught to the next generation of workers and how people are prepared for the next day of work. Feminism has a particular stake in social reproduction because women's unpaid domestic labor cultivates and replenishes labor for the capitalist mode of production. Therefore, understanding and analyzing the reproduction of class relations is crucial to resisting capitalism. Among the many schools of thought within social reproduction feminism, two of them—autonomist Marxist and Marxian school—agree on the need to build alternatives to capitalism that "put human need ahead of profit," but disagree on how best to resist capitalism (Ferguson 202: 130). As Susan Ferguson explains, "autonomist Marxist feminism . . . conceptualize[s] the possibilities for resistance as existing beyond or outside capitalist relations, in the creation of alternative spaces to capitalism," whereas "the Marxian school looks instead toward struggles to break the system from within" (Bhattacharya 2017: 130). Silvia Federici, as Ferguson explains, is a proponent of the former approach who advocates "carving out collective spaces beyond capital's reach wherein people socially reproduce themselves and their communities," and proposes the idea of a revolutionary commons that not only "refuses the logic of capitalism but also works 'to transform our social relations and create an alternative to capitalism'" (Bhattacharya 2017: 131). Kathi Weeks, aligning with the Marxian approach, argues that resistance to capital requires "that movements refuse work—that they collectively reject work's domination of life and instead develop the possibilities of the 'creative powers of social labor'" (Bhattacharya 2017: 131). *The Ministry* represents both forms of resistance to state capitalism where characters, individually or collectively, resist state capitalism from both within the system through strikes, protests, and armed resistance, as well as from the outside by creating non-state spaces, communities, and networks.

Hijra Identity and the House of Dreams

The novel introduces us to Anjum, one of the main characters of the novel, a Hijra from Shahjahanabad, the walled city of Delhi. She was born intersex and at a young age left her family to join a Hijra household called Khwabgah—the House of Dreams. The residents were comprised of a diverse group of gender-variant Muslim, Hindu, and Christian Hijras, with an elder Hijra named Kulsoom Bi at the head of the household. At fifteen, Anjum was initiated into the rules and rituals that formally made her a member of the Hijra community and a permanent resident of Khwabgah. Anjum, for the first time, was freely able to express "an exaggerated, outrageous kind of femininity [that] made the real, biological women in the neighbourhood—even those who did not wear full burqas—look cloudy and dispersed" (Roy

2017: 30). Anjum became a sought-after and skillful sex worker, and over the years acquired a reputation as Delhi's most famous Hijra, celebrated by filmmakers, NGOs, and foreign correspondents. Yet, as Anjum found, the Hijras' status was becoming increasingly marginalized, caught between their history of systematic criminalization, displacement, and exile during the British colonial rule, on the one hand, and, on the other, the rapidly Westernizing and neoliberalizing culture of modern India.

This criminalization and displacement of Hijras began during the British colonial period in South Asia. Starting with the Habitual Criminals Act of 1869 and the Criminal Tribes Act of 1871, the British criminalized all who did not fit the state-approved gender binary and heterosexual desire (Puri 2016: 73). They also marked Hijras as a "hereditary criminal" group, which set them apart from other homogenized groups like Muslims, Sikhs, Brahmans, and Dalits that were "forged out of the same overarching colonial taxonomic discourses" (Puri 2016: 93–4). The Hijra community was not only harassed, surveilled, subjected to medical inspections, and meticulously tracked through a register, but British officials demanded that "the 'immoral' Hijra community be rendered extinct" (Hinchy 2019: 3). The Hijra community only survived the colonial rule and the violent partition of the Indian subcontinent by embracing their exilic identity and forming nonbiological familial and kinship structures and self-reliant networks in spaces outside of mainstream, state-sanctioned, and cisheteropatriarchal familial modes of living.

These alternative spaces also allowed Hijras to replicate practices outside of dominant capitalist labor relations, including self-defense and mutual aid. The survival of these communities across South Asia shows the social reproduction of alternative labor relations where labor capacity is being used not to replicate the mainstream class structures but to perpetuate self-determined labor relations. Such spaces provide capacity for the survival of noncapitalist practices and cultures, which in turn provide for the survival of those choosing to engage in noncapitalist practices. Yet, as *The Ministry* examines, in the current political climate in South Asia and against the backdrop of neoliberalism, these spaces are vulnerable once again to being undermined, co-opted, or assimilated by outside forces.

In the time period the novel covers, the Hijra community is once again at risk of becoming extinct by being caught up in a multiplicity of social, political, and cultural forces. Hijras have historically earned their living by performing certain ceremonial rites at gatherings such as weddings and family celebrations where their presence was once considered auspicious. One firsthand account described how previously the community and the Hijra had a

> very pretty relationship . . . [b]ut now the economic thing has come and this is gone. Marriage is still there, lots of gold has come to the village,

lots of expenses, a big market, but the Hijras have gone. Now the Hijras, what can they do? How can they live? They only have the chance to survive by going out onto the road and begging. (Atluri 2016: 287)

In the novel, as Anjum found the Hijra's acceptance dwindling, they were not just begging, but "feed[ing] off other people's happiness" in an increasingly extorted version of their past prestige, by intruding on celebrations and "dancing, singing in their wild, grating voices, offering their blessings and threatening to embarrass the hosts (by exposing their mutilated privates), and ruin[ing] the occasion with curses and . . . obscenity unless they were paid a fee" (Roy 2017: 28). Atluri describes how Hijras' performance of ceremonial rites once "insured their economic survival in India," but they are now "no longer afforded respect or financial security" as their work has been devalued by neoliberal capitalism (2016: 287). The decline in the Hijras' status, coupled with economic marginalization, left the Hijra community extremely vulnerable. Many have been displaced and forced into "economies of sex work and begging" (2016: 288). These Hijras can be seen as being subsumed into the expanding pool of non-waged, reproductive labor. As some activists and Marxist feminists have advocated, sex is work, whether as part of domestic labor or sex work. It is critical, as Morgane Merteuil notes, to reject a "fundamental distinction between so-called 'free sex,' as performed within the couple, and what we today call sex work" (2015). Doing away with this distinction allows for the labor of sex to be more fully examined in the context of social reproduction. As the work of Leopoldina Fortunati asserts, the family and prostitution largely comprise the "backbone of the entire process" of reproduction (1995: 17). It follows that sex work is reproductive labor as it largely functions to "support and complement housework," and because it "must make up any deficit in domestic sexuality" (1995: 18). As neoliberalism reshapes India's social and economic landscape, the Hijra community and other marginalized groups have their ways of life altered by the realignment of capital and labor all around them.

Not only were their cultural and economic niches drastically shifting, but there were also attempts from within to assimilate the Hijra community into the Western notions of gender identity being advanced by local NGOs. The younger generation of Hijras at Khwabgah represented a move toward such assimilation. Saeeda, one of the new members, was not only educated and could speak English; she also could speak the "language of the times" with Western terms like "*cis-Man* and *FtoM* and *MtoF*" (Roy 2017: 42). She also referred to herself as a "transperson," a term that Anjum rejected, preferring to be referred to as a Hijra (Roy 2017: 42). Saeeda could also switch between local and Western attire, was involved with Gender Rights groups, and spoke at conferences. Saeeda ultimately replaced Anjum as the Khwabgah's media spokesperson after newspapers began replacing the "old exotics" in

favor of the younger generation: "the exotics didn't suit the image of the New India—a nuclear power and an emerging destination for international finance" (Roy 2017: 42). Even Kulsoom Bi, the head of the Khwabgah, favored Saeeda as the next leader, despite Anjum's seniority, because of the media attention and prestige Saeeda brought to their household. Saeeda also predicted that as access to treatments like sexual-reassignment surgery and hormone therapy become more accessible, Hijra communities would soon disappear. Rather than living as Hijras, such therapies would presumably allow them to more easily be subsumed into the surrounding systems of neoliberal class and labor relations.

While Anjum laments the possible extinction of Hijras, Saeeda's sudden popularity reflects a larger pattern of narratives of working-class and feminist identities in the Global South being displaced by narratives that are favored by the Global North and market forces. This is also an example of how fiction taken up by World Literature can examine processes of neoliberalization that affect those in the Global South in vastly different ways, or, as Deckard and Shapiro state it, "how neoliberalization is differently experienced and mediated in cores, semiperipheries, and peripheries of the world-system" (2019: 4). Regions outside of the Global North, Deckard and Shapiro note, are often taken into account only when they develop in a way that "emulates or reproduces the logistics of the core nations," which are usually their former colonial occupiers (2019: 5). The mechanisms of social reproduction need to be understood as distinctive, and based on each region's dynamic location within the larger world system. In acknowledging "modes of resistance-from-below," such analysis departs from approaches that view World Literature as "purely a matter of formalist analysis, humanist appreciation or taste, or datafied analysis, [whose] criticism presents no threat to neoliberal consensus as such" (2019: 21). This is particularly crucial because neoliberal ideology is increasingly permeating not only political and economic discourse, but the everyday language and rhetoric of households, family life, education, NGOs, and even feminism.

While becoming a Hijra, Anjum and others face the encroachment of an increasingly exploitative model of Hijra sex work and associated businesses. When Anjum turned eighteen, Kulsoom Bi persuaded her to have genital reconstructive surgery through a doctor she recommended. The surgery, which Kulsoom Bi paid for at a prearranged "discount" rate, turned out to be "a scam" that not even two additional corrective surgeries could fix (Roy 2017: 32). The doctor went on to become wealthy by "selling spurious, substandard body parts to desperate people" (Roy 2017: 32). Despite the doctor refusing to refund her money, Anjum still "paid [Kulsoom Bi] back over the years, several times over" (32). For more than thirty years, Anjum thus lived in the Khwabgah with her "patched-together body and her partially realized dreams" (Roy 2017: 33). Roy shows readers how elements of the Hijra community itself have been subsumed over time by a

more privately controlled, profit-driven model, creating labor relations that resemble the exploitative class structures outside of the community.

Rather than painting spaces such as the Khwabgah as escapist utopias, *The Ministry* examines their volatility to outside forces that push for realignment with capitalist forms of social reproduction. Cinzia Arruzza describes neoliberal globalization as leading to an increase in "privatization and commodification of social reproduction, with capital penetrating into spheres that in the past were not directly subsumed by the market" (2016: 11). Analyzing social reproduction as a category of world-making across diverse geopolitical contexts can reveal its alternative or subversive forms that resist neoliberal co-option and assimilation. Importantly, *The Ministry* examines the often extreme circumstances under which some alternatives fail and other alternatives are born.

Violence and Paradise: Between India and Kashmir

Part of *The Ministry* takes place post-9/11, at a time when anti-Muslim sentiment was on the rise globally. In particular, the Muslim population in India (including Anjum) was left vulnerable to increasing religious violence. The prime minister of India at the time, Atal Bihari Vajpayee, and other high-ranking politicians believed that India was essentially a Hindu nation, even going so far as to "openly admir[e] Hitler and compar[e] the Muslims of India to the Jews of Germany" (Roy 2017: 45). Soon after 9/11, Anjum was caught in the 2002 Gujarat riots that were carried out by Hindu mobs who killed more than 2,000 people, mostly Muslim, and forced an estimated 150,000 more into refugee camps (Brass 2005: 388). Although Anjum was more vulnerable in this situation because of her identity as a Muslim, it was surprisingly her Hijra identity that saved her. Mob members only spared her life at the last minute because they believed that killing a Hijra was bad luck. Anjum felt like she was nothing more than "butcher's luck" and even after returning to Delhi, felt more dead than alive. Alienated from her former home in the Khwabgah, she camped in a graveyard for months as "a ravaged, feral spectre, out-haunting every resident djinn and spirit" (Roy 2017: 67). Anjum withdrew not just from the failing state, but from her failing alternative community among Hijras.

With the help of a few acquaintances in the surrounding community, Anjum eventually settled into the graveyard and turned it into a livable space for herself and others in need that she called Jannat—Paradise. Jannat also became a hub for Hijras who had fallen out of or were expelled from "the tightly administered grid of Hijra Gharanas" (Roy 2017: 73). Gradually, Anjum also started to take in bodies for burial and perform

funeral services. The only criterion was that they would only bury those "whom the graveyards and imams of the Duniya had rejected" (Roy 2017: 84). Anjum thus began carving out a new non-state space for the outcasts, rebels, and rejects of mainstream society, both living and dead, outside of traditional spaces where they were no longer accepted.

Non-state Spaces and Resistance

In looking for "alternative governance systems, rooted in shared spaces of group-formation and decision-making," Nickels emphasizes spaces that make "social reproduction outside the state possible" (2018: 9). Sustaining such spaces can also serve as examples of what Nickels calls "territorialized resistance," whose ends are "not the capture and administration of the state," but the "recapturing and territorializing of spaces within the nominal orbit of modern capitalist states, in a way that severs them from state forms of accumulation and command" (2018: 1–2, 22). A non-state space may be a result of a disconnection from or refusal to comply with capitalist norms but such spaces also engender further acts of resistance against the capitalist state, allowing networks and communities to engage in alternative modes of social reproduction and build capacity for anti-capitalist forms of self-government.

The space that Anjum constructed within the graveyard and the people who came to inhabit it fit Nickel's assertion that a non-state space often emerges due to a "collective experience of rupture within the primordial fabric of social organization, which opens up a space of social reproduction administered by ordinary people themselves, outside of state-centric forms of legitimation and ideological habit" (2018: 10). Dinerstein and Pitts also see the contradictory nature of social reproduction as having potential for "resistance and rupture, and for the creation of alternative forms of social reproduction" (2018: 483). Having experienced such a rupture, each in their own way, Anjum and her companion residents at Jannat engaged in social reproduction that existed largely outside of the usual circuits of production, consumption, and social reproduction that sustain capitalism. Instead, they engaged in multiple, distinctly noncapitalist, kinship structures including nonbiological connections with humans, nonhumans, and the dead. The activities in Jannat can be described as what Amanda Armstrong, in a different context, calls "insurgent forms of social reproduction" (2012). These forms include networks of care, knowledge, and skills and resources necessary for everyday survival.

A different thread of the novel explores another kind of non-state space, one that can be found existing "within functioning states, as sites of contestation and counterpower" (Nickels 2018: 4). Jantar Mantar, the protest square in Delhi, represents a pocket of resistance where multiple

protests, demonstrations, hunger strikes, and other acts of nonviolent civil disobedience take place simultaneously. Such a gathering of movements represents Nickel's concept of non-state networks and assemblages built on "communication networks that mobilize ordinary citizens to occupy city squares, highways, ports, and industrial areas" (2018: 10). Jantar Mantar also shows the potential for the kind of class solidarity and social organization that the Marxian school of social reproduction feminists call for as a collective struggle against capital. The protests and strikes in this space have the potential of "building a mass movement capable of confronting capital on its own terrain" (Ferguson 2020: 133–4). While those in Jantar Mantar are able to use public space to express their grievances and demand justice, *The Ministry* explores conditions in nearby Kashmir, where there are no such spaces for democratic dissent.

Non-state Networks and Archives

The Kashmir region, despite being historically referred to as Paradise on Earth, became so transformed by its struggle for freedom that "[d]eath was everywhere. Death was everything. . . . Dying became just another way of living," and "graveyards became as common as the multistorey parking lots that were springing up in the burgeoning cities in the plains" (Roy 2017: 320, 325). Like Kashmir, Anjum's graveyard was called Jannat, or Paradise. And, also like Kashmir, it was a site of mass unmarked Muslim graves.

In Kashmir, the mostly Muslim freedom fighters killed by India's military were buried in mass, unmarked graves, leaving those who had disappeared rarely accounted for. Access to knowledge, history, and the truth was restricted because of the state's involvement in covering up violence. On the rare occasion that deaths in Kashmir did get media attention, their stories were commodified in "international supermarkets of grief," with desperate families feeling that "without the journalists and photographers the massacre would be erased and the dead would truly die. So the bodies were offered to them, in hope and anger," even if the photographs only helped sell magazines and newspapers in the end (Roy 2017: 119, 333). Roy parallels this with the commodified victims of the Union Carbide gas leak in Bhopal. One highly publicized photograph of a child killed in the event resulted in a "battle over the copyright" that was almost as "ferociou[s] as the battle for compensation for the thousands of devastated victims" (Roy 2017: 333). Since those in Kashmir cannot rely on the media, the state, or the international community, many have continued to fight for independence on their own.

Despite the heavy surveillance and brutal repression they face, their resistance survived through highly coordinated non-state spaces that were operated by the labor of noncapitalist social reproduction. The underground

world of insurrectionists in Kashmir was not reproducing labor power for a state-approved capitalist enterprise but at great peril, recruiting anti-state and anti-capitalist efforts through complex networks of people, labor, and modes of communication. These are an example of what Nickels describes as "nonstate networks," namely "assemblages of workers, peasants, and other ordinary citizens, possessing organizational networks and channels of solidarity that are separate from state-centric leaders and that often come into conflict with them" (2018: 7). Non-state networks are arguably networks of non-state spaces, with the decentralized function of the whole relying on the creation, existence, and perpetuation of the constituent spaces. It is through such networks that non-state spaces can multiply their current and future capacity for sustaining labor and culture through noncapitalist modes of social reproduction.

While the constant threat of violence and death makes even minor engagement in such modes of social reproduction a dangerous act, these communities shared those risks. And while the various activities supporting such networks had to take place in the utmost secrecy, *The Ministry* also examines processes of alternative storytelling and archiving that emerged in those spaces. As Roy explains, in Kashmir even the act of publicly grieving drew scrutiny and potentially violent retribution from the state. Under these circumstances, the stories and artifacts of the dead were powerful and dangerous to all involved, with "the consolidation of their dead [becoming], in itself, an act of defiance" (Roy 2017: 317). The act of collecting, archiving, and recording knowledge plays an important role in the other major plotline of the novel that revolves around Tilo, an architect-turned-activist. It is through Tilo's multiple skill sets as a stenographer, translator, transcriber, and publisher that Roy explores Kashmir's fight for freedom.

Despite Tilo's skills and education, she avoided settling into a fixed career. Instead, after her Kashmiri lover and freedom fighter was forced to fake his own death, Tilo began spending any money she earned obsessively traveling to Kashmir, recording and translating stories and observations through notes, photographs, and storied objects. The polyphony of voices, memories, and textures she accumulated seemed to resist classification, showing "no pattern or theme," collected as if she "had no set task, no project" (Roy 2017: 274). It was as though the power of Tilo's growing collection guided her to arrange it "according to some elaborate logic of her own that she intuited but did not understand" (Roy 2017: 274). Rather than being guided by state or market forces, Tilo's archiving process allowed the human needs of those she encountered, living or dead, to determine her focus and labor. In particular, Tilo's ties to the Kashmiri non-state networks increasingly guided the subjects of her study and cataloguing.

While social reproduction is usually associated with the reproduction and sustenance of a living workforce, *The Ministry* showed the irrevocable humanity inherent in remembering the dead, portraying it as an essential

part of sustaining those involved in non-state or anti-state efforts. The work done by Tilo, and another similar character she encounters, allowed the two archivers to become invaluable hubs of knowledge within their networks, while also providing a sense of personal and collective identity for those working in non-state networks. Theirs are histories that could not be kept in traditional records and would not be immortalized by the international supermarket of grief. What humanity and identity they were able to preserve and pass on to others had to be passed on through non-state and noncapitalist channels that cannot be commodified.

Anjum's graveyard similarly avoided commodification by the international supermarket of grief by avoiding spectacle and insisting that everyone be buried in a way that honored their lives. After arriving, Tilo expanded her archiving work by recording and storing the memories and grief of the dead. For example, after adopting an abandoned baby, Anjum and Tilo took extended measures to hold a funeral "with full honours," for the mother (Roy 2017: 432). Anjum's other practice, introducing all new residents of Jannat to each grave as if the deceased were alive, allowed for the cultivation of robust collective identity in the space, and filled a void left empty by the current political, economic, and social conflicts.

For those under violent and highly repressive circumstances, one of the few remaining forms of resistance is ensuring that their story is known and preserved in some form. A World Literature that equitably serves the Global South and North must allow those marginalized by neoliberalism to tell stories that can create and sustain spaces of resistance, and ultimately unmake oppressive world systems. In this vein, *The Ministry* can be seen as a constellation of people and communities resisting Western and neoliberal narratives of individual struggle and accomplishment. Tellingly, these communities and their stories also included many nonhuman components, revealing a key dimension of non-state spaces.

Adapting to Ecological Crises: Alternative Kinship and Economic Systems

The relations established in Anjum's graveyard present a multilayered example of alternative kinship and economic arrangements in the face of social and ecological crisis. Giovanna Di Chiro points out that although some environmental issues "symptomatic of capitalist relations of production" do receive public attention, they are generally not seen as problems of social reproduction (2008: 282). Anjum's alternative kinship structure not only subverted capitalist social reproduction as it pertains to human labor and care but also sustained nonhuman kinship networks with the surrounding ecosystem.

The untitled prologue at the beginning of the novel described how "the old white-backed vultures, custodians of the dead for more than a hundred million years . . . have been wiped out" by diclofenac, a muscle relaxant given to industrial livestock to increase the production of milk (Roy 2017: 5). It worked "like nerve gas on white-backed vultures," so that dead cattle became "poisoned vulture-bait" (Roy 2017: 5) Buechley and Şekercioğlua have examined how the diclofenac-induced decline of vultures threatens surrounding ecosystems. For example, vultures' uniquely powerful digestive systems allow them to quickly consume "carcasses that would otherwise fester with disease" and spread rampantly through other species (Buechley and Şekercioğlua 2016: 226). The crises experienced by an ecosystem when a particular species dies off, a trophic cascade, can be seen as partly mitigated by spaces like Anjum's graveyard. The novel opened with Anjum enmeshed in the ecosystem; she lived "in the graveyard like a tree," "conferred with the ghosts of vultures that loomed in her high branches," and "felt the gentle grip of their talons like an ache in an amputated limb" (Roy 2017: 7). Beyond the poetic metaphor, Anjum's work caring for the dead filled a niche in the ecosystem similar to the one left empty by a mass extinction of vultures.

In an example of Haraway's Sympoiesis, the alternative kinship in Anjum's graveyard is a site of "making-with" and "worlding-with," open to humans and nonhumans (Haraway 2016: 58). As opposed to autopoietic (or self-producing) systems, sympoietic systems are collectively producing, which Haraway sees as critical to "rehabilitation (making livable again) and sustainability amid the porous tissues and open edges of damaged but still ongoing living worlds" (Haraway 2016: 33). This is evident when Zainab and Saddam "turned the graveyard into a zoo—a Noah's Ark of injured animals" (Roy 2017: 405). Anjum's precarious positionality between life and death, combined with her occupation of the graveyard, created a space of in-betweenness that functioned outside of capitalist modes of production where labor could flow in the directions of ecological need. The space acted as a buffer for the growing environmental and social crises raging around it. Instead of replicating or sustaining the outside crises, it sustained those displaced by them, at once engendering survival and enabling resistance.

This can also be seen in the practice of alternative economic models in the graveyard that enabled restorative cooperation in the face of economic brutality. Much like alternative kinships, alternative economic models may emerge from necessity through the efforts of those experiencing the failures of capitalism or traditionalism. Jannat acted as a noncapitalist, collectively owned and operated economic system, helping to restore human and nonhuman systems based on need. The graveyard's cooperative garden produced numerous vegetables, which "despite the smoke and fumes from the heavy traffic on the roads that abutted the graveyard, attracted several varieties of butterflies" (Roy 2017: 405). Local drug addicts also found temporary solace working with the plants and animals.

Simultaneously, Tilo used her skills to start teaching children at Jannat, serving nearby impoverished families. Rather than establishing a for-profit model, Tilo created a nonprofit cooperative school that taught "arithmetic, drawing, computer graphics (on three secondhand desktop computers she had bought with the minimal fees she charged)," and in return, Tilo "learned Urdu and something of the art of happiness" (Roy 2017: 403). The school served an urgent need in the community while also helping Tilo to heal herself. As the conditions in the "People's Zoo and a People's School" were improving, Roy pointed out that "[t]he same, however, could not be said of the Duniya," the surrounding world (Roy 2017: 406). The backdrop of the novel portrays India as in the throes of ecological crisis brought on by the relentless violence of capitalism. As Naomi Klein has described it, "[f]aced with a crisis that threatens our survival as a species, our entire culture is continuing to do the very thing that caused the crisis" (2014: 2). For example, India's neoliberal reforms have increasingly destabilized the nation's farmers and the ecosystems they rely on.

India's corporate-friendly agricultural reforms and increasing reliance on proprietary biotechnology have driven hundreds of thousands of farmers to bankruptcy and suicide (Thomas and De Tavernier 2017; Gutierrez et al. 2015). Vandana Shiva points to the role that corporations like Monsanto/Bayer play in monopolizing seeds, noting, for example, that "95 per cent of India's cotton seed is now controlled by Monsanto" (2021). These desperate conditions culminated most recently in January 2021, during a pandemic caused by animal transmission of the Covid-19 to humans, when farmers stormed India's Red Fort as part of a months-long campaign to end new reforms proposed by the Modi government (Saaliq 2021). As democratic institutions and ecological systems are pushed to the brink of collapse, World Literature cannot afford to lend further credence to neoliberal fictions.

Conclusion

Modes of unassimilated and unalienated feminist agency, such as the ones acquired through alternative, anti-capitalist forms of social reproduction in *The Ministry*, can help politicize World Literature. It is through such a politicized World Literature that we can examine capitalism and neoliberalism in its various social forms and imagine spaces that accommodate anti-capitalist economic structures, and nontraditional, nonhuman, and nonhierarchical kinships. We must seek unalienated forms of feminism that are unassimilable, despite the ever-evolving patterns of neoliberal assimilation. To define World Literature, following Nickels's suggestion, as "an archive of democratic mechanisms, interpersonal modes, and affective complexes outside of the hierarchical mechanisms of the state," also requires interventions in the

form and genre to subvert the hierarchies and conventions of language that keep authors from formerly colonized countries at a disadvantage (2018: 216). Roy, rather than discarding these conventions altogether, reconfigures them to show that "language and narratives need to be reclaimed in order to allow for social and environmental justice" (White 2020: 134). Such a reclamation is also necessary to establish the alternative spaces, politics, and histories that World Literature currently needs.

These other worlds will not be saccharine utopias, as they present both the potentials and pitfalls of resistance in the shadow of authoritarian governments, anti-minority violence, and recent neo-populist movements. However, by showing social arrangements that resist co-option while not reproducing the capitalist world, we can imagine alternative, restorative worlds that can be replicated through an appropriately politicized World Literature.

Roy's portrayal of how this can be achieved is typically poetic. In the very beginning of the novel, Anjum told one of her clients, tongue-in-cheek, "I'm not Anjum, I'm Anjuman. . . . I'm a gathering. Of everybody and nobody, of everything and nothing . . . Everyone's invited" (Roy 2017: 8). Anjum's name shares the same root with the Urdu word "Anjuman," where the former literally signifies a star and the latter a constellation. In a more colloquial and poetic usage, Anjuman can be a gathering but also a kind of social organization with a purpose. As everyone organized around Anjum in the graveyard, she truly became Anjuman. By the end of the novel, Anjum, as if in response to one of Tilo's poems,

How

 to

 tell

 a

shattered

 story?

 By
 slowly
 becoming
everybody.
 No.
 By slowly becoming everything,

(ROY 2017: 442)

was able to tell the shattered story of everyone.

References

Armstrong, A. (2012), "Debt and the Student Strike: Antagonisms in the Sphere of Social Reproduction," *Reclamations Blog*, June 4. Available online: https://web.archive.org/web/20131111054327/http://www.reclamationsjournal.org/blog/?p=581 (accessed May 27, 2022).

Arruzza, C. (2016), "Functionalist, Determinist, Reductionist: Social Reproduction Feminism and Its Critics," *Science & Society* 80 (1): 9–30.

Atluri, T. (2016), *Azadi: Sexual Politics and Postcolonial Worlds*, Bradford: Demeter Press.

Bezanson, K. (2006), *Gender, the State, and Social Reproduction: Household Insecurity in Neo-Liberal Times*, Toronto: University of Toronto Press.

Bhattacharya, T. (2017), "How Not to Skip Class: Social Reproduction of Labor and the Global Working Class," in T. Bhattacharya (ed.), *Social Reproduction Theory: Remapping Class, Recentering Oppression*, 68–93, London: Pluto Press.

Brass, P. R. (2005), *The Production of Hindu-Muslim Violence in Contemporary India*, Seattle: University of Washington Press.

Buechley, E. R. and Ç. H. Şekercioğlu. (2016), "The Avian Scavenger Crisis: Looming Extinctions, Trophic Cascades, and Loss of Critical Ecosystem Functions," *Biological Conservation* 198: 220–8.

Deckard, S. and S. Shapiro (2019), "World-Culture and the Neoliberal World-System: An Introduction," in S. Deckard and S. Shapiro (eds.), *World Literature, Neoliberalism, and the Culture of Discontent*, 1–48, Cham: Palgrave Macmillan.

Di Chiro, G. (2008), "Living Environmentalisms: Coalition Politics, Social Reproduction, and Environmental Justice," *Environmental Politics* 17 (2): 276–98.

Dinerstein, A. C. and F. H. Pitts (2018), "From Post-Work to Post-Capitalism? Discussing the Basic Income and Struggles for Alternative Forms of Social Reproduction," *Journal of Labor and Society* 21 (4): 471–91.

Ferguson, S. (2020), *Women and Work: Feminism, Labour, and Social Reproduction*, London: Pluto Press.

Fortunati, L. (1995), *The Arcane of Reproduction: Housework, Prostitution, Labour and Capital*, New York: Autonomedia.

Goodman, R. T. (2020), "Feminism as World Literature," in J. R. Di Leo, (ed.), *Philosophy as World Literature*, 91–104, London: Bloomsbury Academic.

Gutierrez, A. P., L. Ponti, H. R. Herren, J. Baumgärtner and P. E. Kenmore (2015), "Deconstructing Indian Cotton: Weather, Yields, and Suicides," *Environmental Sciences Europe* 27 (1): 1–17.

Haraway, D. J. (2016), *Staying with the Trouble: Making Kin in the Chthulucene*, Durham: Duke University Press.

Harvey, D. (2007), *A Brief History of Neoliberalism*, Oxford: Oxford University Press.

Hinchy, J. (2019), *Governing Gender and Sexuality in Colonial India: The Hijra, c.1850–1900*, Cambridge: Cambridge University Press.

Klein, N. (2014), *This Changes Everything: Capitalism vs. The Climate*, New York: Simon and Schuster.

Mahajan, K. (2017), "Arundhati Roy's Return to the Form That Made Her Famous," *The New York Times*, June 9. Available online: https://www.nytimes.com/2017/06/09/books/review/arundhati-roys-return-to-the-form-that-made-her-famous.html (accessed January 31, 2021).

Merteuil, M. (2015), "Sex Work Against Work," *Viewpoint Magazine*, October 31. Available online: https://viewpointmag.com/2015/10/31/sex-work-against-work/ (accessed January 31, 2021).

Nickels, J. (2018), *World Literature and the Geographies of Resistance*, Cambridge: Cambridge University Press.

Norton, J. and C. Katz (2017), "Social Reproduction," in D. Richardson et al. (eds.), *International Encyclopedia of Geography*, 1–11. John Wiley & Sons, Ltd.

Puri, J. (2016), *Sexual States: Governance and the Struggle over the Antisodomy Law in India*, Durham: Duke University Press.

Roy, A. (2017), *The Ministry of Utmost Happiness*, London: Hamish Hamilton.

Saaliq, S. (2021), "Angry Farmers Storm India's Red Fort in Challenge to Modi," *US News & World Report*, January 26. Available online: https://www.usnews.com/news/world/articles/2021-01-26/indias-republic-day-marked-with-massive-farmer-protests (accessed January 31, 2021).

Shiva, V. (2021), "The Seeds Of Suicide: How Monsanto Destroys Farming," *Global Research*. Available online: https://www.globalresearch.ca/the-seeds-of-suicide-how-monsanto-destroys-farming/5329947 (accessed January 31, 2021).

Thomas, G. and J. De Tavernier (2017), "Farmer-Suicide in India: Debating the Role of Biotechnology," *Life Sciences, Society and Policy* 13 (1): 8.

Walker, K. L. M. (2008), "Neoliberalism on the Ground in Rural India: Predatory Growth, Agrarian Crisis, Internal Colonization, and the Intensification of Class Struggle," *Journal of Peasant Studies* 35 (4): 557–620.

White, L. A. (2020), *Ecospectrality: Haunting and Environmental Justice in Contemporary Anglophone Novels*, London: Bloomsbury Academic.

15

Maghrebi Women's Literature and Film

The *"Ecritures féminines"* of *Unsubmissive* Voices

Valérie K. Orlando

In her famous article "Le Rire de La Méduse" (The Laugh of the Medusa 1975), French-Algerian feminist Hélène Cixous suggests "women must write of women and bring women to write" (Cixous 1975: 39). This written space— the space of *l'écriture féminine*—would allow women to explore the fact that in patriarchal societies they have "been marginalized as violently [from speech] as they have been from their bodies." For this reason, "woman must dedicate herself to the text—to the world, and to the story" (Cixous 1975: 41). In the middle of French feminist movements of the late 1960s and early 1970s, Cixous announced a new approach to studying sexual difference and encouraged women of the world to write. As the former French colonies in the Maghreb were emerging from independence into postcolonial nations (Morocco 1956, Tunisia 1956, Algeria 1962), women picked up their pens to defy the status quo, shaping a new language in French through which to adopt positions that were rebellious and revolutionary. This "new language" engaged with new theories and political platforms pertaining to feminine sexuality, women's roles in family and public space, as well as political enfranchisement in society. In Cixous's words, the female writer from the Maghreb sought to be *"plus qu'elle-même"* (more than herself) (1975: 41).

Women authors carved out their voices in emerging societies and nations torn between modernity and tradition, the past and the present, and a plethora of challenges associated with postcolonial reality. To express their needs and desires, they used French instead of Arabic, a language in which many educated Maghrebi women (Assia Djebar, Maïssa Bey, Fatima Mernissi, Gisèle Halimi, for example) felt alienated. Female authors have ever since considered themselves as contributing to the wider "littérature-monde" of francophone authors (Le Bris et al. 2007). This conception of French World Literature promotes authors' desire to explore the transnational and the transcultural connections that are possible in the "multiple, diverse, colored, multipolar and . . . ununiformed" world of French speakers (Le Bris et al. 2007: 42). From the outset, Maghrebi women authors writing in French articulated not only their desires with respect to their home nations, but also how they could contribute to the discourses of World Literature. This literary world for them offers a place to reflect on the postcolonial human condition, which is often grounded in narratives either real or metaphorical about displacement and exile at home and/or abroad (Le Bris et al. 42). However, describing the postcolonial world in the language of the former colonizer has often set these authors at odds with the burgeoning nation-states' official rhetoric in Arabic. Authors such as Cixous, Djebar, Halimi, Mernissi, and Bey recognized from the outset that writing in French in order to voice their feminist ideals risked putting them at odds with patriarchal nation-states grounded in pan-Arabic discourses that often favored more traditional cultural forms, religious ideology, and customary practices.

Equally, cinema afforded many possibilities for women filmmakers to express their views countering oppressive patriarchal structures in the postcolonial Maghreb. Texts and films from 1970 forward explore Cixous's *écriture féminine* as rooted in conceptualizing *le féminine* as "in-appropriable," *insoumis (unsubmissive)*. Rebellious, postcolonial, feminist thought ("la pensée subversive") would be a sociocultural and political tool to voice women's silenced presence in society (Cixous 1975: 42). In Cixous's words, female writers and filmmakers would "save themselves" by using these artistic forms to express their counternarratives to the patriarchal, dominated structures of knowledge and culture. Film and text became women's "*antilogos* weapons" used to liberate their voices as well as those of their sisters who had been silenced (Cixous 1975: 42).

Drawing on many novels and films written and produced since the 1970s, this chapter studies how the ethos of *l'écriture feminine*, which Cixous tells us must be a "cry of rage" to combat "the very strong resistances" against women in society and politics, has inspired Maghrebi women writers and filmmakers (1975: 42). Here, we explore the works of creatives such as Assia Djebar (Algeria, *La nouba des femmes de Mont Chenoua*, 1979), Raja Amari (Tunisia, *Satin Rouge*, 2002), Maïssa Bey (Algeria, *Surtout ne te retourne pas*, 2005), Yasmina Kassari (Morocco, *L'enfant endormi*,

2006), among others, in order to articulate feminine cultural production in the postcolonial Maghreb. Particularly, the historical focus considers the oppressive *Années de plomb* (Years of Lead, 1963–99) in Morocco, the *La décennie noire* (the civil war of 1989–2005) in Algeria, and the Arab Spring (2011) in Tunisia as pivotal moments of oppression and liberation from which have sprung the rebellious voices of women.

This chapter explores over fifty years of creative production, highlighting how women creatives have contributed through the decades since independence to the sociopolitical and cultural discourses of the Maghreb. Although there are many texts and films that reveal the rebellious nature of feminine writing and filmmaking from the region, the works chosen here reflect the particular moments referenced above in the histories of Algeria, Morocco, and Tunisia. These moments have been monumental for women in shaping how they see themselves in emerging postcolonial societies. While writers and filmmakers build on earlier feminist theories, they also announce what postcolonial feminist Françoise Vergès defines in her recent work *Un Féminisme décolonial* (2019), as "a decolonized feminism that has for its objective the destruction of racism, capitalism and imperialism" as well as gender equality (Vergès 2019: Loc. 62). For the filmmakers and writers explored here, feminism means, as Vergès notes, more than simply challenging the patriarchal status quo in the name of equality. "Decolonized feminism... captures the struggles of women" in many sectors and echelons of society (2019: Loc. 88). Within this framework, "struggles play out on multiple fronts and for objectives oriented toward different temporalities" (Vergès 2019: Loc. 113).[1] These targeted "temporalities" encompass the social, the political, and the cultural realms—what Julia Kristeva defines as the "dénominateur symbolique" (symbolic denominator) (1979: 5)—as they dictate what women can and cannot be (and do) in postcolonial Maghrebi societies.

The films and texts discussed here, exploring women's physical and psychological struggles, also evoke the sociopolitical failures of Maghrebi revolutions of independence to ensure women's full enfranchisement in society at the dawn of the postcolonial era. Women creatives, such as Algerian Assia Djebar, engaged with historical representations of the feminine that overwhelmingly did not represent them either during the colonial era or after. How to depict women in the present depended also on establishing their presence historically in roles in which they took part as freedom fighters, mothers, and martyrs. The challenges for feminist Djebar and others were immense in the countries of the Maghreb, which had already at the dawn of independence written hyper-patriarchal, national scripts that rarely depicted women's participation in anti-colonial struggles for freedom.

[1] My translation.

The remaining sections of this chapter will focus on the "insoumis"—the "unsubmissiveness" and the rebelliousness—qualities of women's cultural production in the Maghreb. Since the early 1970s, the cinematic and literary "antilogos weapons" these women wield have been used to orient audiences and readers across the world to three important points that are integral in the struggles for equality in the Maghreb. Creative work first rectifies the silenced voices of Maghrebi women in colonial texts and films and, even, later in emerging postcolonial Maghrebi discourse. Second, women creatives liberate Maghrebi women from the Orientalized stereotypes in which they were cast during the colonial period. As they point out, in many respects, these images have persisted certainly in the West in the postcolonial era. Third, the works studied here address the postcolonial "fragmented identity" in which women feel they live as they negotiate the patriarchal socioeconomic and political challenges of the everyday Maghreb; a region that in the postcolonial era has been burdened by civil war, brutal dictators, and economic calamity (Orlando 1999, 2009).

Algeria: Documenting the Feminine Psychological Stress of Revolution and Civil War

The weighty past of Algerian history visible in its present is a theme in Algerian women's writing and filmmaking. Works in the 2000s "posit the redoubtable problem of disinherited identities, and the chaos that results from it." Postcolonial Algeria has been hampered by a Master Narrative that "limit[s] ... interpretation solely to the law of the fathers" who fought in the *maquis* against the French and then, once independence was won, ignored "the issue of gender relations and the position of women in Algerian society" (Hadj-Moussa 2014: 160). Women writers and filmmakers in Algeria "stir up memory, bring forth remembrance, and make the present valuable, even in its most intolerable form" (Hadj-Moussa 2014: 161).

Recognizing that both Algerian identity and history, particularly that of women, have been manipulated by colonial European discourse and later revolutionary ideology, writer and filmmaker Assia Djebar sought during her entire writing career to rectify textual, historical oversights through the reconstituted stories she gathered from and about Algerian women. Her most famous film of the postcolonial era is *La Nouba des femmes de Mont Chenoua* (1978). Djebar spent two years making the film which traces the forgotten voices of women who participated in the struggle for independence in the rural mountain communities of Algeria. As in some of her later novels—*Femmes d'Alger dans leurs appartements* (1980) and *L'amour, la fantasia* (1985)—the storyline for her documentary is fragmented by numerous stories told from different perspectives by women

who participated in the *maquis* (rebel fighter cells). The script's nebulous layers of oral testimonies offered by female fighters mirror the sociopolitical confusion of the postcolonial Algerian nation which, as Reda Bensmaïa notes, is disunited, defined as "dispersed fragments (of [hi]stories and events) in search of a unity to come (or to be created)" (Bensmaïa 2003: 84). From her testimonial feminine-centered stories of the 1970s to 1980s, Djebar moved on to more witness-style work documenting the atrocities committed during the Algerian civil war in 1990s (*Le Blanc de l'Algérie*, 1996; *Oran, langue morte*, 1997). This civil war, which killed by some estimates over 150,000 people, is known as *Les années noires* (the Black Decade, enduring roughly from 1992 to 2005).[2] From her first novel, *La soif* (Mischief, 1957), to her last, *Nulle part dans la maison de mon père* (Nowhere in My Father's House, 2007), Djebar worked to draw attention to the untold stories of Algerian women in the country's history.

Maïssa Bey is perhaps the most well-known female Algerian author writing today. Born in 1950, Bey has spent her life living in postcolonial Algeria, dedicating herself to writing about Algerian women's silenced history and stories. She notes that picking up the pen to write her "écriture féminine" has been a defiant act in a society that does not "want to hear" women:

> It [is] necessary to speak in (to) a society that does not want to hear [women's words], [this society] denies existence to words when it is a woman who dares to speak them ... the word is already a position in a society that is denied women (. . .) the taking of speech, the initiative of speech, even if provoked, is a political manifesto, a real challenge to the immutable. This is perhaps how the act of writing can be situated, as the desire to enter, through the verb, "into the circle of speaking" from which women are traditionally excluded ... this intrusion bears the marks of subversion, and places its author from the outset in a defensive field, challenging the standards assigned, codified, recognized, [in order to] transgress.[3]

Bey's innovative conception of the novel, a "defensive field" where women's words come together to rectify silence in the present and the past, is noticeable in all her works. She uses experimental forms and fragmented word play to contextualize women's reality on both psychological and physical levels. In her 2005 novel, *Surtout ne te retourne pas* (Above

[2] "Mass Atrocity: Case Endings" https://sites.tufts.edu/atrocityendings/ <Last accessed, September 9, 2020> An armistice was signed in 2005.
[3] https://dz.ambafrance.org/Entretien-avec-l-ecrivaine-Maissa-Bey-pour-la-revue-Binatna. My translation <last accessed September 9, 2020>.

All, Don't Look Back), Bey's feminine voices are multiplied as the novel progresses when stories are taken up by various characters—Dadda Aïcha, the sisters of Amina, Mouna, and Fatima, as well as Wahida who has lost her mind after suffering trauma that is linked to her past and to the earthquake of 2003 which ravaged Algeria. Bey's multiple voices reflect the women lost in not only the earthquake but also the recent civil war. Countless women died at the hands of men: "Hundreds of young women have disappeared these last few years. Taken from their family by criminals, thirsty for power and blood" (Bey 2005: 54). The rape, brutalization, and decapitation of women during the 1990s were common occurrences. In the opening of the novel, Bey explains that the earthquake of May 2003 inspired her to link the destruction of the national disaster to that of the man-made civil war. The multiple voices of the feminine narrators confuse and confound the reading of the story, creating for readers' pure emotional responses of physical and mental anguish and loss. In a broader context, the novel draws attention to the failed systems in Algeria resulting from both environmental and sociopolitical tragedy. Wahida's search for her lost identity in the rubble of the earthquake mirrors an entire country's search for stability. Bey demands of her readers "to decode the scriptural trace," both metaphorically and literarily on the page, as her disoriented characters search for survivors in the quake's rubble:

> They wander, dazed, haggard, defeated. Day and night.
> From time to time, they stop, stupid, staring eyes.
> And then they leave.
> They walk.
> They search.
> Street by street. Ruin by ruin.
> They are told: *Mektoub*. It is written. (63–4)[4]

At the novel's close, we realize that the entire story has been told by an unnamed feminine voice in psychological distress. This singular voice is, in fact, an amalgam made up of women sitting in a psychiatrist's chair searching to understand the truth somewhere in between sanity and insanity: *"But, tell me, tell me doctor, I want to be absolutely sure. What is there that is truthful in this story?"* (222).[5] Bey's novel is troubling and chaotic up to its very close as the characters and readers are left without explanation, trying to stabilize in a country on constantly shifting ground.

Films by Algerian women filmmakers have been particularly successful in telling undocumented stories from the recent past, certainly those of the

[4]My translation. Author's italics.
[5]Author's italics.

civil war. *Algérie, la vie quand même* (Algeria, Life All the Same, Djamila Sahraoui, 1998) documents the filmmaker's return to Kabylia, whereupon she gives the camera to her cousin in order to give a voice to disenfranchised youths. Habiba Djahnine's 2008 film-documentary *Lettre à ma soeur* (Letter to My Sister) tells the story of the filmmaker's sister, Nabila Djahnine, a feminist civil rights advocate working in Tizi-Ouzou who was killed in 1996 by Islamists during the civil war. In the 2000s, in the wake of the civil war, Algerian women on screen and behind the camera define and depict new female roles in society, culture, and politics. As scholar Ratiba Hadj-Moussa notes, "female characters are either the protagonists or the witnesses of the stories who uncover and find what constitutes the problem in their society. But this uncovering happens at the same time as their bodies are exposed, placing them in an unequal duel with all that survives from the past- . . . Telling is also exposing oneself to danger" (2014: 162). The first decade of the post-*années noires* as demonstrated in films such as Yamina Bachir-Chouikh's *Rachida* (2002), Djamila Sahraoui's *Barakat!* (Enough!, 2006), and *Yema* (2012), continue to explore the important roles women are playing to heal the wounds of a battered people in the aftermath of war and to tell the silenced stories of countless women who were victims of atrocities.

Morocco: The Voices of the Post-Years of Lead

François Vergès notes in *Un Féminism décolonial* that contemporary feminists in the developing world must first view their challenges as "collective ones" and that "enemy forces bent on attacking the struggle for freedom should not be underestimated." These enemy forces will "use all the weapons at their disposal, censorship, defamation, threats, imprisonment, torture and death" to thwart women's demands for equality (2019: Loc. 292). Perhaps in no other Maghrebi country has systematic repression been more documented in literary texts and films than in Morocco. In the first decades of the 2000s, studying *Les années de plomb* (The Years of Lead), which endured roughly from 1963 to 1999 under King Hassan II, has been the most notable focus of Moroccan authors, male and female. In general, in the first twenty years of this century, Morocco has focused on opening up its society (Orlando 2009). King Mohamed VI's democratic reforms have influenced writers and filmmakers' ability to explore almost forty years of repression, torture, and erasure of civil rights under his father. Contemporary female authors of French expression, Bahaa Trabelsi (*Une vie à trois*, 2003), Souad Bahéchar (*Le Concert des cloches*, 2000), and Siham Benchekroun (*Oser vivre!* 2002), among many others living in Morocco, document women's untold stories of poverty and illiteracy as well as torture and abuse at the hands of men and the state (Orlando 2009).

Some of the most remarkable works focusing on the untold stories of Morocco's dark Years of Lead are by former prisoners. Fatna El Bouih's *Une femme nommée Rachid* (2002) revealed for the first time the horrors women prisoners endured during the reign of Hassan II. El Bouih was thrown in jail for five years for having taken part in the "Mèknes Group" which was part of the larger "23 of March Movement," a Marxist-leftist organization seeking to establish democratic reform in Morocco in the early 1970s. Her political activism was never officially recognized until the publication of her testimony in the early 2000s following the enthronization of Mohamed VI. In the late 1990s, she began for the first time to tell her story of rape and torture. Despite the shame associated with talking about rape, El Bouih's testimony offers an eyewitness account of the Years of Lead from a woman's perspective. The work was hailed in Morocco in the early 2000s for its frankness and as one of the first female accounts that sought to contradict the norms and conventions of a very traditional society in which woman's speech was quasi unheard and speaking of female rape and torture considered taboo (Slyomovics 2005: 133). El Bouih's "je" (I), thus, makes a bold statement about claiming a place in the untold history of women's abuse during Hassan II's reign. With respect to the political climate of the 1970s, El Bouih states that to be a woman dedicated to activism meant "to be a man." She remarks that her torturers and jailors at Kenitra prison only had one goal: to strip her of her femininity: "The gave me a number: 'Now you're named Rachid . . . don't move, don't speak, only if you hear your name. Rachid'" (16). El Bouih notes in her testimony that this "was the beginning of her depersonalization" and her "negation of . . . femininity." In order for her torturers to dehumanize her, she was "made into a man they called Rachid" (16).

El Bouih's testimony also reveals the fear her male torturers had of their women prisoners. Feminine power, although only perceived as potential and never actual, is subtly alluded to throughout her text. This power, Cixous explains, is from "outside," representing a force that for men is viewed as "un déploiement de forces" (a deployment of power) that is threatening for what it can upturn, causing a destabilization of social balance ("un équilibre tremblant") (1975: 41). Echoing Cixous's thesis, El Bouih's prose is powerful:

> When we were brought for interrogation . . . the guard was reinforced. . . . When they put me in and we took off, those men revolted because of this grotesque mobilization for us, or really, because of me alone, since for them I was only a woman. . . . I hesitated between laughing at the comic situation and cursing it because of its machismo that dictated that I was unimportant because of my sex, and not because of my thoughts, my choices and my limits as a human being. (116–17)[6]

[6] My translation.

El Bouih's words find resonance in Cixous's writing and her explanation of the theoretical power of women's pens to unmask what has never been said publicly before: "Such is feminine power" which "takes up syntax, breaking this well-known string... which serves to assure men" of their strength and phallocratic domination (Cixous 1975: 48).

Moroccan women filmmakers of the 2000s—Laïla Marrakchi (*Marock* 2005, *Rock the Casbah* (2013)), Yasmine Kassari (*L'enfant endormi*), Yto Barrada (*Faux départ* 2015) and Narjiss Nejjar (*Les yeux secs*, 2002, *Wake Up Morocco*, 2006, and *L'amante du Rif*, 2011)—have continued the work of pioneering Farida Benlyazid (*Door to the Sky*, 1989) and Farida Bourquia (*Deux femmes sur la route* 2007) who have been making films since the early 1980s. Since Benlyazid made *Door to the Sky* (*Bab al-sama' maftooh*), Marrakchi, Kassari, Nejjar, Barrada and others continue to probe the sociocultural and political constructs in contemporary Moroccan society that have kept women disenfranchised.

In 2004, Yasmine Kassari completed her first feature-length film, *L'enfant endormi*, which, although based on a fictional narrative, resonates in the reality of clandestine immigration stories about Moroccans crossing the slim sea between Morocco and Spain. The film focuses on Halima and her friend, Zeineb. Both women's husbands have left for Spain, illegally crossing the Mediterranean in order to find work in Europe. Most of the men have left, leaving their women behind to fend for themselves in a bleak, desolate landscape where crops have ceased to grow due to climate change and governmental mismanagement of the land. Kassari's film reminds audiences that women's oppression, although patriarchally defined, is also rooted in oppressive traditions, poverty, and illiteracy. In a country where 80 percent of rural women are still illiterate in any language, Kassari's film casts a critical eye on the millennial persisting disparities in the country which still influence the outcomes of women's survival.

Halima's husband does eventually come home, only to beat her for his suspicions that she has committed adultery with Amziane, a local farmer who refused to go to Europe. She decides to return to her family instead of continuing a life of domestic abuse. Zeineb stays in the village to take care of her aging family. On her wedding night, before her husband Hassan leaves for Europe, she becomes pregnant. Now husbandless, she and her mother-in-law decide to "put the child to sleep" with a talisman obtained from a holy man in the village, Touarit. This ancient, pre-Islamic belief is practiced in the Maghreb and other parts of Africa. The custom circumvents biological science in order to make pregnancies legitimate for up to four or five years. In order to keep family honor intact, save face if a woman becomes widowed or pregnant out of wedlock, or if the woman needs an heir in the case of an absent husband, she may invoke the power of "the sleeping child." This allows her to put the "child to sleep" until the appropriate time comes to wake it up. When Zeineb tells her husband in

a letter (written by Amziane) that she is pregnant but has decided to "put to sleep their child" because she refuses to raise it on her own, enclosing also a picture she has had taken in the village, Hassan becomes cold and unforgiving. Realizing that she can expect nothing from a husband who has become so unfamiliar, the young woman tears up the talisman and throws it into the river, "washing away" her potential child and motherhood. This rupture with the myth of the sleeping child symbolically marks a certain agency, although limited, over her body and her destiny.

Showing their faces on camera, normally taboo in this traditional society, Halima and Zeineb "make their meaning." Their rebellious action demonstrates that even though they are illiterate, they will not be cowed into accepting their fate of poverty and oppression. No longer feeling subjugated and silenced by their husbands, they now assert (to a certain point) a feminine agency they have never known before. This newfound agency ultimately changes the dynamics of the village and, in some regards, the dynamic of power between the women and their husbands.

Kassari's and El Bouih's works reflect Françoise Vergès's call to women to "fight against all forms of oppression" in order to make readers and audiences aware that "justice for women" is also "justice for all" in a society such as Morocco's which is emerging from a dark past into a more democratic present (2019: Loc. 356). As both these works demonstrate, women in Morocco are defined more than men by the sociocultural and political realms in which they must operate. Justice for all in civil society is, thus, tied primarily to equality.

Tunisia: The Dupery of "State Feminism"

In general, male authors have dominated Tunisia's literary scene in French. Despite a robust feminist movement and legislation focusing on equality in education and all public sectors hammered out by Tunisia's first president, Habib Bourguiba, in the decades following independence, Tunisian feminism was co-opted by what feminist historian Sophie Bessis calls "State feminism" (1999: 94). Immediately following independence in 1956, Bourguiba granted women the most advanced civil rights in the Arab world (such as the right to abortion and the banning of polygamy). "In the years following independence, women obtain the right to work, to move around, to open bank accounts and to create businesses without the authorization of their husbands" (Bessis 1999: 94). Contraception, widely available, also deterred women from having multiple children. The UNFT's (L'union des femmes de Tunisie) work for women's rights was integrated into the state's official discourse which, according to Bessis, made the country attractive to the West, particularly Europe, for doing business in the post-independence era (Bessis 1999: 95).

Despite forward thinking feminist causes supported by the government, women's rights have slowly eroded since the late 1970s. With the coup d'état of Zine el-Abidine Ben Ali in 1987 and his subsequent twenty-five-year oppressive rule, women lost significant political ground. Since the Arab Spring in 2011 for which Tunisia was ground zero, the rise in conservative Islamic politics in the country has complicated women's advancement, as noted by journalist and feminist Fawzia Zouari. When women lose political ground, she notes, their bodies are the first to be covered by headscarves and heavy clothing. Harassed in public space, women give up, defeated by patriarchal oppression: "I am shocked by this hasty move by women to sell their freedom for a faith that they display more than they practice, just so that they can exist in public space . . . why must we pay the fines of submission in order to have access to public space?" (Fourreau 2018: 18).

The shifting sociocultural and political tides in Tunisia and how women are affected by them are the subject of women's writing and filmmaking. Although fewer in number than their Maghrebi sisters in Morocco and Algeria, Tunisia's postcolonial, literary history has been marked with high-profile feminist pens. Perhaps the most famous is Gisèle Halimi (1927–2020), a feminist-activist and lawyer for women's rights. Postcolonial women, contributing to Tunisian literary production today, include Azza Filali (*Chronique d'un décalage*, 2005), Dora Latiri (*Un amour de tn*, 2013), and Fawzia Zouari (*Valentine d'Arabie; la nièce oubliée de Lamartine*, 2020, *La deuxième épouse*, 2006).

Of the most recent generation of authors, Wafa Ghorbel's (b. 1975) debut novel *Le Jasmin noir* (2016) captures a contemporary Tunisia that offers women little in the way of emancipation from the patriarchal status quo. Professional singer as well as a university professor, Ghorbel's novel weaves the autobiographical with commentary on the sociopolitical and cultural tensions of present-day Tunisia post the 2011 Arab Spring. Ghorbel's novel is epistolary comprised of three letters to men in her life who either have abused or disappointed her. Like Ghorbel, the unnamed protagonist is a young university professor who has just finished her doctorate in Paris. She is now seeking an academic position in France, as she reflects on exile, the pain she has suffered in the past (we learn later in the novel that she was raped), and the difficulties of negotiating between living a "Western" life and the traditions her family back in Tunisia want to foist on her. "As a rule in my country . . . a girl doesn't leave the family lap until she joins her spouse's family. Despite the progressive Tunisian laws regarding women, compared to the rest of the Islamo-Arab world, tradition often has the upper hand and makes you, voluntarily or not, dependent and hobbled" (12). Most important is Ghorbel's exploration of the feminine body in the body politic of modern-day Tunisia where, as her protagonist remarks, "*I grew up in a society where no one wants a woman who is in charge of her own body. I followed the*

herd for fear of being outcast" (19).[7] Confronted by the memories of the past (rape; one of the letters is to her rapist), her present failing marriage with a Frenchman, and the future she must determine for herself despite her overbearing Tunisian family, Ghorbel writes a novel that is a testament to the "the signals, forces, interdictions and conditioning" placed on the Maghrebi feminine body since independence (Boutouba 2012: 148).

Tunisian women filmmakers, although not as numerous as Moroccan and Algerian, have led the way in seeking to visualize the post-independent feminine body "as dynamic" so as to "reposition it at the heart of public space" (Boutouba 148). In *Les silences du palais* (1994), pioneering filmmaker Moufida Tlatli was the first filmmaker to explore on screen the silences of women's corporeal and psychological pain and suffering in Tunisia due to tradition and politics. Although set in the 1950s at the time of independence struggles, in the 1990s the film resonated with contemporary women who saw themselves as victims of the "mechanisms of power that seek to maintain [them] in places of non-representation" (Boutouba 149). The film focuses on the stories of Khedija and her daughter, Alia. Both have grown up in one of the last harems of the Beys of Tunisia. The film explores the physical and political power over women and their bodies as they are confined in the space of the harem as well as the larger structure of traditional Tunisian life and French colonialism. Khedija, a concubine, is repeatedly raped by the Beys. Alia is the fruit of this violence. Where her mother is trapped and finally dies in the prison of abuse, Alia breaks free (like her newly independent country), establishing her own agency as a singer and performer. Although the film ends on a somewhat hopeful note, Tlatli also leaves her audiences with the lingering impression that the feminine body in Tunisia is "forever a site of suffering," impeded by patriarchal sociopolitical and cultural forces (Hadj-Moussa 2014).

Younger Raja Amari's 2002 film *Satin Rouge* presents a different context for widowed Lilia who, contrary to Tlati's women confined behind the gates of a palace, embarks on a path of self-discovery in the working-class milieus of Tunis. Freed of her husband and the constraints of marriage, she ventures out one night to a cabaret where she discovers that her own aptitude as a dancer is prized. In the illicit space of the cabaret, she is free of the sociocultural constraints placed on her in public space. In the cabaret space of non-conformity, Lilia's "image is no longer represented by the rigidity of motherhood" as depicted at the beginning of the film (Boutouba 2012: 153). However, much like Ghorbel, Amari suggests that Tunisian women can only be entirely free in body and spirit when they are in spaces that are forbidden or suspicious, outside the national body politic.

[7]Author's italics.

Ghorbel's and Amari's texts demonstrate that women's physical and psychological autonomy is precarious in a society that is still rooted in tradition and expectations in which women are mandated socioculturally and politically to play specific roles. As Bessis notes, women in Tunisia have been constantly marked by an "assumed modernity" that is evoked in political discourse, yet in reality, is too "radical" for the society in which they live (Bessis 1999: 104). Reminding us of this reality, Ghorbel's anonymous narrator remarks, "Here, I'm trying to learn to be free, be a woman, be myself—construct my own story" (91).

Conclusion

Over forty years after Algerian-born Hélène Cixous published her famous "Le Rire de la Méduse," women in the Maghreb are still seeking to rectify "the enormity of repression that has kept them in check," relegating them to positions of inferiority in society (Cixous 39). Their collective works in film and literature demonstrate the importance of revealing "the future of women in their sense [of being] and their history" (Cixous 39). Maghrebi female pens and cameras insert women's silenced voices into the visual and textual past and present of their countries. The tools of their craft are Cixous's "antilogos weapons," used to instruct audiences and readers about the challenges and struggles of women's everyday lives.

References

Bensmaïa, R. (2003), *Experimental Nations or the Invention of the Maghreb*, Princeton: Princeton University Press.
Bessis, S. (1999), "Le féminisme institutionnel en Tunisie," *Femmes du Maghreb 9*: 93–105.
Bey, M. (2005), *Surtout ne te retourne pas: roman*, Alger: Barzakh.
Boutouba, J. (2012), "Femmes d'images et image de femmes : Parcours féminins et culture visuelle au Maghreb," *Nouvelles Études Francophones* 27 (1) Spring: 145–262.
Cixous, H. (1975), "Le rire de la Méduse," *L'Arc*, 39–54.
El Bouih, F. (2002), *Une femme nommée Rachid*, Casablanca: Le Fennec.
Fourreau, E. (2018), "Fawzia Zouari: Entretien," *Nectart #8* (October): 12–23.
Ghorbel, W. (2020), *Black Jasmin*, trans. Peter Thompson. *Le Jasmin noir* (2016), Tunis: La Maison Tunisienne du Livre.
Hadj-Moussa, R. (2014), "The Past's Suffering and the Body's Suffering: Algerian Cinema and the Challenge of Experience," in R. Hadj-Moussa (ed.), *Suffering, Art and Aesthetics*, 151–75, New York: Palgrave Macmillan.
Kristeva, J. (1979), "Le temps des femmes," *34/44: Cahiers de recherche de sciences des textes et documents 5* (Winter): 5–19.

Le Bris, M. and J. Rouaud (2007), *Pour une littérature-monde*, Paris: Gallimard.
Orlando, V. (1999), *Nomadic Voices of Exile: Feminine Identity in Francophone Literature of the Maghreb*, Athens: Ohio University Press.
Orlando, V. (2009), *Francophone Voices of the 'New' Morocco in Film and Print: (Re)presenting a Society in Transition*, New York: Palgrave Macmillan.
Slyomovics, S. (2005), *The Performance of Human Rights in Morocco*, Philadelphia: Pennsylvania University Press.
Vergès, F. (2019), *Un Féminisme décolonial*, Paris: La Fabrique.

16

Toward a New Theory of Feminist World Literature, in Film

Robin Truth Goodman

Iranian filmmaker Samira Makhmalbaf's 2003 film *At Five in the Afternoon*[1] tells the story of a young woman who aspires to be president of Afghanistan after the 2001 invasion by the United States and its allies and the defeat of the Taliban. Following Fredric Jameson's theory of "singular modernity" and its followers, I argue that the film uses this narrative of "progressive feminism" to build a visual technique of "uneven development," borrowing some of the conventions of "Third Cinema," in particular, its aesthetic experiments with technological failure, partiality, and finitude. The dominant feminist narrative advances by casting its background/context as "backward" or "primitive" and in need of technological fixes. Yet, the dominant project of universal inclusion through "adding on" or technological development is eclipsed by intruding fragmented pictures of social dispossession on the frame. Conceptually centralized even while appearing on its margins, these fragments of history indicate that "feminist progressivism," by its links to militaristic imperialism, causes rather than reverses or solves social and technological breakdown. This technique re-thematizes the camera's relation to the woman-as-image of classic cinema. Recreating the veil as a visual technology that is split with conflicting and refracting temporalities, the film exhibits the male gaze as foundationally disoriented and unevenly distributed, an effect of world historical modernizing technologies that double as machines of destruction. The result is a suggestion of a new feminist subject unassimilated to world systems, constituted through

[1]This film can be accessed on YouTube at https://www.youtube.com/watch?v=16-1OU_AiCQ&t=981s"?

their limits and partialities. With a combination of Iranian and French production and in the Afghani Dari Persian dialect (a version of Farsi), the film shows that, even as early as 2003, the promise of women's progress in Afghanistan was a narrative on which the failures of the imperialist "one world" "democracy" project and the regime were already embedded.

The problem of feminism's universalizing tendencies has been evident since its inception. Yet, as well, the feminist subject was foundationally disturbed by its awareness of the limits of the subject's universalizing pretensions; in its very inception, the feminist subject would be thought outside of itself as its own other. In her statements that ushered in what is now widely recognized as feminism's "Second Wave," Simone de Beauvoir identified the problem that women posed to philosophy as their confinement to particularism: "[I]t is vexing," she famously writes, "to hear a man say: 'You think thus and so because you are a woman' . . . It would be out of the question to reply: 'And you think the contrary because you are a man,' for it is understood that the fact of being a man is no peculiarity" (1953: 15). Assessing freedom as a transcendence of women's embodied localism, Beauvoir develops a concept of Otherness to address women's situation.[2] As Susan Hekman has argued, in the Othering of women's subjectivity, Beauvoir is challenging the entire tradition of Western philosophy by posing "women" as "Other": "What Beauvoir seems to be suggesting . . . is that the question of women does not fit within the parameters of the philosophical positions she has been espousing. What this entails is that the question of woman requires a radically new approach that jettisons previous philosophical methods" (2014: 13). Beauvoir's focus on the Other—the sexual or geographic Other, ethnic, racial, national— Hekman proposes, implies that the philosophical tradition is inadequate to adapting women's situation into its universalist projects of a subject. Here I pose a feminism that is, following Beauvoir, reflecting on Otherness—the inequalities, insecurities, peculiarisms, and precarities posed by modern political universalism when that universalism appears feminist.

In this chapter, I read *At Five in the Afternoon* in light of the challenge to universalism that "woman" introduces politically and philosophically for Beauvoir's critique. *At Five in the Afternoon* is Makhmalbaf's third feature film. In 1998, at the age of 18, she was nominated for a Golden Camera award at the Cannes film festival for her movie *The Apple*, which told of two girls who were locked up in their house by their parents and then released by the interventions of social workers. In 2000, her film *Blackboards* won the Grand Jury Prize at Cannes and was nominated for the Palme d'Or. Taking

[2]She explains this through an analogy with a colonial setting: "In small-town eyes," she elaborates, "all persons not belonging to the village are 'strangers' and suspect: to the native of a country all who inhabit other countries are 'foreigners'" (16), and she cites Claude Lévi-Strauss, who catalogues human sociality based on duality, alienation, and opposition.

place in a mountainous border region, *Blackboards* interweaves two stories about Kurds in the wake of the Iran-Iraq war: a group of migrants tries to return home to die in their village from which a chemical attack had forced them to migrate, and a group of boys survive by smuggling goods across the border on their backs. Her fourth feature film, *Two-Legged Horse* (2008), is about the relationship between two boys who have been orphaned, physically and emotionally crippled by mines and bombs in Afghanistan. The daughter of Mohsen Makhmalbaf, who is often considered the "father" of Iranian neo-realist cinema,[3] and sometimes appearing in his films, Samira Makhmalbaf as director uses techniques that she borrows from the European avant-garde, documentary, and "Third Cinema." These include employing untrained actors who often speak languages that she does not know and whom she meets near the film sites;[4] doing "on location" filming in landscapes that are majestic, daunting, uncommon, and sometimes, as in *Blackboards*, dangerous;[5] montage; splitting sound and image apart as well as breaking perspective; constructing images around visual and narrative contradictions; enhancing color to create painterly patterns and sounds that might be disassociated from the image, or non-diegetic; and adopting "real life" effects, non-glamourous objects, loose narrative construction, some improvised speeches, and camera movements, sometimes "hand held" or askew, that interrupt the stability of an image. *At Five in the Afternoon* can, therefore, be said to be, at least in part, continuing the traditions of "Third Cinema" filmmaking that Julio García Espinosa called "imperfect cinema"—promoting the use of less-than-masterful but accessible equipment that allows for proliferating techniques not recognized as "quality" in elite production—or that Glauber Rocha, in reference to Brazilian *Cinema Nova*, called "An Esthetic of Hunger"—acknowledging technological deprivations as enhancing and even beautifying the image—perhaps otherwise distinguished as ugliness, sadness, or violence.

Taking its title from the refrain in Federico García Lorca's 1935 "Llanto por Ignacio Sánchez Mejías" ("Lament for a Bullfighter"), *At Five in the Afternoon*—also a winner of the Jury Prize at Cannes as well as a nominee

[3]Among many other films, Mohsen Makhmalbaf made the acclaimed, prize-winning 2001 film *Kandahar* about a Canadian woman trying to find her suicidal sister in a Taliban-controlled, pre-9/11 Afghanistan. Similarly to *At Five in the Afternoon*, *Kandahar* is described by Mark Graham as set "in the bleak and public spaces of refugee camps, squalid villages, and barren deserts" (2010: 62). Graham identifies such Western-leaning films about Afghanistan within a tradition of Orientalist discourse (2010: 66). Graham does not include *At Five in the Afternoon* (or any woman directors) in his film archive.
[4]Samira Makhmalbaf's sister Hana Makhmalbaf made the documentary film *Joy of Madness* (2003) that depicts the complex negotiations that Samira engaged in to convince local people in Afghanistan to participate in *At Five in the Afternoon*.
[5]Samira Makhmalbaf's brother Maysam Makhmalbaf made the documentary film *How Samira Made "The Blackboard"* that depicts, among other things, how Samira works as a director to integrate local cultures and landscapes into her filming process.

for the Palme d'Or—adapts the elegiac, tragic poem into a film about a protagonist who fantasizes about being the first female president of Afghanistan. While the poem features the combination of death and desire as universalizing the humanist subject of lamentation, the film adapts this theme to a feminist desire for equality in tension with the death caused by that universalizing project, as the "progressive" subject of feminism demanding inclusive politics through democratizing projects contradicts the death scene of her surrounding visual context. As the main character celebrates the possibility of female political leadership as progress—adopting a liberal narrative that gradually "adds on" excluded cultures and identities in an advancing of universal democratic freedoms, starting with Benazir Bhutto—appearing on the edge of the frame are crowds of refugees, orphans, bombings, the rubble of ruined cities, and extreme dispossession. Additionally, above, below, or to the side of the main narrative action intrude images of military airplanes, helicopters, and UN soldiers, and news of the war and its aftermath filters in with the gossip passed between refugees and migrants in whispers.[6] As Zizek remarked about Alfonso Cuarón's 2007 movie *Children of Men*, "I would say that the true focus of the film is there in the background. . . . If you look at the thing too directly—the oppressive social dimension—you don't see it. You can see it in an oblique way only if it remains in the background" (2007). Makhmalbaf's film similarly splits the screen, distorting and bracketing historical "truth" on the margins with the domination of a universalizing liberal fantasy of inclusion that conflicts with those visuals.

The film indirectly demonstrates how Simone de Beauvoir's critique of the subject as Other foreshadows the critique of "uneven development" that World Literature, according to the Warwick Research Collective (WReC), "registers" (2015: 20) in its "spatio-temporal compression, its juxtaposition of asynchronous orders and levels of historical experience, its barometric indications of invisible forces acting from a distance on the local and familiar" (2015: 17). The film poses a premodern nationalist and paternalistic Islam as the basis for the oppression of women that modernity promises to overcome by its political inclusion of women, but also makes clear, contradictorily, that modern progress on the back of a military invasion in the name of freeing women is the catalyst for the cultural backwardness and social catastrophe

[6]Samira Makhmalbaf is conscious here of looking at the effects of global events like 9/11 in places where the inhabitants might be so marginalized that they are unaware of their relationship to these central global narratives. As Lynn Higgins points out, in Makhmalbaf's appearance in the multi-director film *11 '9 "01—September 11* (2002), a teacher arrives in an Afghani refugee camp and ask the assembled students "if they have heard about the disaster. They haven't" (2005: 31)—the teacher tries to explain the catastrophe by drawing analogies with local calamities but is only met with expressions of incomprehension.

that its mission, supposedly, is to defeat.[7] Foregrounding the contradiction between the universalizing feminist subject and its visualization, *At Five in the Afternoon* constructs a universalizing "one world" image that is built not through progressive assimilations of excluded others but rather through imposing inequalities that look back at the universal from the position of its other.

In *Combined and Uneven Development, Towards a New Theory of World-Literature*, the Warwick Research Collective pushes back against a trend in World Literature theory based in world-systems theory and exemplified by scholars like Pascale Casanova and Franco Moretti. In the perspective of these scholars, literary innovation moves from the center to the periphery where it is localized, and the "raw material" of the "periphery" is absorbed in or "added on" to the "center"'s productive enterprise. Scholars have predominantly explained the center/periphery divergence as either: (1) because all countries are at a different stage in a path toward development and modernity that everyone follows; or (2) there are many different modernities, all developing on their own paths. Within such views, structural inequalities appear as "culture" or autonomous, self-contained, and self-referential cultural enclaves of "difference" or outsidedness to be "added on" rather than as a networked web of interrelationships based in dissonances, antagonisms, and conflict.

The Warwick Research Collective, following Fredric Jameson, proposes that world-literary systems theory needs to consider modernity as riding on a singular integrated but uneven system where areas of high productivity and technological richness are coterminous, coexistent, dependent on, and causational of archaisms, impoverishment, and technological deficiency. As Jameson puts it in *A Singular Modernity*, unequal development "offers the useful perspective of an emergence of technological modernity within a decidedly unmodern landscape" (2002: 144) that can be linked to Marx's idea of primitive accumulation. In primitive accumulation, Jameson says, Marx's scenario tells of capital gradually taking over the autonomous,

[7] The myth that Muslim women need to be saved from their own cultures is a colonialist moral imperative whose critique is long-standing within a tradition of feminist scholarship made notable by Gayatri Spivak. Spivak criticized Western colonial discourses for articulating a figure of a silenced "third-world woman" for justifying its practices on the basis of "white men saving brown women from brown men" (1988: 297). Saba Mahmood has shown how the connection between secularism and modernity is a cliché that bolsters a sense of superiority for secular progress, but in actuality Islamic revivalist movements following the 1979 Iranian Revolution demonstrate "other forms of human flourishing and life worlds" that are not "necessarily inferior to the solutions we have devised" (2005: xi). The myth, perpetuated by the George W. Bush administration among others (particularly Laura Bush), that the US invasion of Afghanistan was for the purpose of saving Afghani women from sharia law has returned as the US troops currently withdraw, even though the US-installed Afghani government's record on women's rights has been hardly exemplary.

privately controlled means of production in the countryside, forcing workers into urban factories, meaning that processes of accumulation happen in the same geographical and historical frame as a dispossession that generates regressions.

The Warwick Research Collective understands that modernity's accumulative excess and growth are part of a simultaneous process of deindustrialization, technological depletion, and primitivization both inside and outside the same geographical milieu and context, as though time travel is occurring without spatial or temporal movement, identified through "a fundamental dissonance in the structure of reality" (2015: 65). The "theory of 'combined and uneven development,'" writes the Collective, "was therefore devised to describe a situation in which capitalist forms and relations exist alongside 'archaic forms of economic life' and pre-existing social and class relations" (2015: 11), inside the same frame. They are here expanding on Fredric Jameson's analysis of modernity as what he calls "incomplete capitalism" (2002: 142) or "uneven development" (2002: 144) where Jameson remarks that history's sense of a developmental gap between the country and the city is actually a displacement of technology's gathering of multiple uneven temporalities in a singular space. For Jameson as for the Collective (and as evinced in *At Five in the Afternoon*), the coexistence of multiple temporalities is characteristic not only of productive sites and technologies but also of artistic practices, language, culture, media, and subjectivities, leading to a crisis in representation: "Culture thus stands as the blurring of the boundaries and the space of passages and movements back and forth, the locus of transmutation and translation from one level or dimension to the other" (2002: 177–8). Within literary practice, the Collective agrees, the unevenness is not just apparent in the content but also in an incongruence and conflict of internal forms, technologies, and types of mediation, including literary ones: "We want to suggest that the novel" [or let's read "the poem" in *At Five in the Afternoon*],

> ... has changed irrevocably within an altered mediascape in which diverse cultural forms, including new and newly calibrated media, compete for representational space and power. The consequence has been that hybrid genres and interactive platforms have retrospectively altered our understanding . . . in light of an expanding communicational economy. (2005: 16–17)

Different levels of technological development coexist within the same media moment, in fact "calibrating" each other. According to this view, what makes World Literature worthy of the name is the contradiction arising in these temporal dislocations and "generic discontinuities" (2005: 82), as the incompatibility between capitalist modes and their "underdeveloped" social environments "dramatize[s] the trauma of modernity" (2005:

81). While *At Five in the Afternoon* privileges images that are distorted through a juxtaposition and integration of multiple historical, generic, and technological frames, it also emphasizes antagonisms between them: between literature and film, for example, or between oral, written, photographic, and filmic modes, as well as between military communication devices and the relaying of messages through the everyday gossip, rumor, and speech of migrants.

Unmentioned by either Jameson or the Collective, women structurally inhabit this temporal divide between precapitalist, pretechnological modes of lived reproductive economies and modernity's technological progress. A case in point is made by French feminist Christine Delphy's influential contributions to the project of historicizing reproductive economies in her ethnographic studies of rural production, *Close to Home* (1970). In these studies, Delphy borrows from Friedrich Engels to counter the common trope that inheritance as a mode of accumulation precedes hegemonic market exchange as the origin of the domination of women and the nuclear family. Whereas conventional historiography generally assumes that agricultural economies were a "prior stage" of development that eventually evolved into more complex cultures of markets and trade, Delphy shows how peasant economies still have various workers who, like women in domesticity, are unpaid because inheritance passes to the progenitor, leaving these others dependent on the sole receiver of the legacy. Reproductive domesticity with its system of "unpaid labor" is, then, the result of market concentration, an apparent "backwardness" that is simultaneous with or resulting from "advancement," and gender difference was belatedly projected onto a social system to create a family structure dependent on the regressions of unpaid labor and instituted by the needs of market exchange. This projection of "backwardness" onto a population is a mode of primitive accumulation through dispossession. "The effect of the dispossession of one group," Delphy explains, "is clear in the agricultural world for instance. Those who do not inherit—women and younger siblings—work unpaid for their husbands and inheriting brothers" (1970: 49). For Delphy, a multi-temporal class structure exists *within* the contemporary family. In a more recent book, *Separate and Dominate*, about September 11 and its aftermath, Delphy returns to Beauvoir to ask if women's inequality therefore challenges the "monopoly control of the universal" (2015: 39).

At Five in the Afternoon similarly understands "woman" as pivoting through multiple contradicting temporalities that compose modernity's global turn. What Delphy recognized as antagonistic temporalities of reproduction, *At Five in the Afternoon* understands as the logic of antagonistic (secular and religious) temporalities in the gaze. The film ties its commentary on the male gaze to its commentary on Western technological and military dominance. The veiled woman forces the camera to disclose its own particularity by showing itself as on the margins. The veil serves to

deflect the gaze so that the dominant narrative of "progress," "inclusion," or "improvement" is looked back at from the position of its other, that is, from the position of technological destruction or inequality. The film frame repeats, visibly, inside the image—in dilapidated architectural structures of post-invasion Kabul, for example, in missing pieces of dry-wall, breaks, textures, shadows, and most prominently, the veil. The veil blocks the camera's view, indicating the absences within its reach, so that the "non-modern" and the "modern" are coterminous.

Throughout the film, the characters and action pass through multiple architectural and other types of frames within the film frame, and the frames, in turn, allow for multiple but simultaneous crossing and eroding viewpoints and regressions. The technique follows in the course of Orson Wells's revisions of classical Soviet montage: in original montage (as for Sergei Eisenstein), an image may contradict the previous image through editorial splicing, shock, and clashes of class conflict between frames, but in *Citizen Kane*, the foreground image of the parents negotiating the child's fate is broken in the very center by a window lighting the child Kane receding in the center as he plays in the snow. In *At Five in the Afternoon*, instead of contradiction, montage mixes different times together to produce an aesthetics of simultaneity. The film frame slices through the image to divide the scene temporally, with regression and progression both products of this technological cut. The veil breaks in to split the scene, and the gaze, from within.

The veil has been regularly charged with complicated cultural significance, struggle, and conflict.[8] *At Five in the Afternoon* foregrounds this aspect of the veil to comment on the geopolitics of film culture, technology, liberalism,

[8]See, for example, Lila Abu-Lughod (2002) and Joan Scott (2007) for post-9/11 analyses of the way the veil has acquired overdetermined meanings in its symbolic existence between Muslim cultures and its others. Abu-Lughod notes, "Liberals sometimes confess their surprise that even though Afghanistan has been liberated from the Taliban, women do not seem to be throwing off their burqas" (2002: 785). Her polemic asks how the veil has become a symbol in the West for the unfreedom of women elsewhere and a justification for imperialism and war. Joan Scott asks, "Why has the veil been singled out as an icon of the intolerable difference of Muslims? How has insistence on the political significance of the veil obscured other anxieties and concerns of those obsessed with it? How has the veil become a way of addressing broad issues of ethnicity and integration in France and in Western Europe more generally?" (2007: 5). See also Judith Butler, who writes: "I attended a conference in which I heard a talk about the important cultural meanings of the burka, the way in which it signifies belonging-ness to a community and religion, a family, an extended history of kin relations, an exercise of modesty and pride, a protection against shame, and operates as well as a veil behind which, and through which, feminine agency can and does work. The fear of the speaker was that the destruction of the burka, as if it were a sign of repression, backwardness or, indeed, a resistance to cultural modernity itself, would result in a significant decimation of Islamic culture and the extension of US cultural assumptions about how sexuality and agency ought to be organized and represented" (2004: 142).

feminism, and the gaze. By foregrounding the veil as a film technique, *At Five in the Afternoon* reimagines the conventions of film images and the politics of the gaze that Laura Mulvey outlined when she put feminism and the cinematic gaze onto the film studies map back in the late 1970s. "The beauty of the woman as object and the screen space coalesce," explains Mulvey about the classical cinematic gaze's fetishization of the image. Her "body, stylized and fragmented by close-ups, is the content of the film and the direct recipient of the spectator's look" (1997: 439). The viewer identifies with the camera's male gaze onto the fetishized woman-as-image as the source of narrative pleasure.

Showcasing the veil as it blocks the gaze, the film reflects on this woman-as-image that feminist film theory following Mulvey has criticized in popular film traditions. Makhmalbaf paints a complex interplay of veiling and unveiling, both inviting and diverting the look at different points simultaneously. The first identifying shot of the protagonist Noqreh is constructed around veiling and unveiling. We see her in a blue burka, carrying jugs of water, framed and dwarfed by the surrounding stone. In the next shot, Noqreh, now outside the building, turns back while two uncovered women walk by. The unveiled women divide the space between Noqreh and her father behind her into different historical paths: the unveiled women anticipate Noqreh's (and Afghanistan's) future, the father reflecting her past. Her father, in the shadows of the building on the other side of the unveiled women's diagonal, averts his eyes by leaning his face on the wall, reasserting the culture of the veil in reaction to modernity's gaze slicing through the shot's center.[9] When the father looks away from the unveiled women, he admits a strange, uncomfortable complicity between religious paternalism and feminist film theory as both resist the eroticization of women induced by the gaze, emphasizing how different cultures are simultaneously creating different—even opposing—meanings for the technologies. The gaze that has been feminism's nemesis simultaneously appears as its ally in its pretensions to unveil women for Western-style emancipation and progress.

The veil has been used in film previously to express resistance against imperialism through resistance to the male gaze and its technologies. As Negar Mottahedeh has shown, the post-revolutionary Iranian regime directly opposed this Western use of the gaze to eroticize women. "[F]or Khomeini," Mottahedeh elaborates, through this gaze "women's bodies marked the site

[9]Makhmalbaf tells Geoffrey Macnab of *The Guardian* about her first trip to Afghanistan after the invasion: "The 23-year-old Iranian film-maker had just arrived at her hotel when she caught the gaze of an old man. 'When he saw my face, he turned back to the wall and closed his eyes,' she recalls. She wasn't wearing a burka. The old man, a strict fundamentalist, could not even countenance the idea of looking directly at her face. 'I felt real sympathy for him. How is he going to live now? He really believed what the Taliban believed'" (2003).

of contamination" (2008: 1) of Western values into Iranian culture, and thus also was evidence of the Shah's beholdenness to foreign powers. According to Mottahedeh, the revolution's conflict with Iran's overthrown royalty and its international allies would play out, in part, over how women were depicted in film. Referencing the sacred invisibility of the martyred imam with its purified community of believers, the veil in particular blocked the viewing habits of the gaze, says Mottahedeh: "the post-Revolutionary camera looks awry in a gesture of purification" and so can "produce a different relation to time and space in film beyond the commodified image" (157) of Hollywood. *At Five in the Afternoon* takes this critique farther. For the film, the role of the veil in signaling toward a premodern patriarchal or indigenous culture combines with its role in emphasizing a limit to modernity's universalizing impulse carried on the back of military power, a view of modernity from those it positions as outside, "backward," technologically deficient, and Other. The gaze, even bolstered by advanced surveillance systems and aerial precision, is checked by the view from outside. The camera's omniscient views and vast landscapes are cut short and turned back by the falling walls, ruins, and crumbling architecture that it connects, as film device, to the veil. Through the veil, Makhmalbaf builds an aesthetics based in modernity's—and imperialism's—finitude.

At Five in the Afternoon foregrounds the male gaze's compatibilities with destructive technologies that visualize cultures—like they visualize women—as objects and to imagine them as "backward." The gaze that objectified women in the image now can be said to be constituted by the coalition's expansion as it objectifies other cultures. Yet, by turning away, the father's gaze makes "some discontinuous or surcharged reading of the respective historical moment unavoidable" (1986: 311), as Jameson describes the filmic gesture in the essay "On Magic Realism in Film." Jameson is interested here in a legacy of "Third Cinema" whose practitioners invoked "an esthetic of hunger" or an "imperfect cinema," where technological depletion is a reaction to modernity's technological abundance, not its prior stage, a method of making visible how "progress" coincides with anti-progress. The camera eye, as Jameson describes such cinema, "is constitutively dependent on a type of . . . disjunction [that] is structurally present," "a content which betrays the overlap or the coexistence of precapitalist with nascent capitalist or technological features" that are "still locked in conflict" (1986: 311). There is a connection between this technological poverty and the veil, as the veil is likewise a limit to totalizing fetishizations, blocking the gaze. In *At Five in the Afternoon*, the veiled woman forces the technologies of the gaze to be seen from the perspective of their own limitations.

This analysis, then, poses the veil as a film device, a marker of an absence through which modernity sees itself in-relation, a very different viewpoint from the (few) usual feminist approaches to "Third Cinema," where women

represent positive difference and interiority untouched by (and, therefore, before) cultural imperialism. Ella Shohat, for example, insists that "Third Cinema" positions women as expressing the particularities of the anti-colonialist nation-state against "First World Eurocentric feminism" (52), refusing the "universalizing of 'womanhood'" or a "facile discourse of global sisterhood," in favor of "a 'location,' arguing for specific forms of resistance" (2003: 52). *At Five in the Afternoon*, rather, depicts the woman as the carrier of the universalizing and, indeed, homogenizing politics of feminism *even as* she disrupts the universalizing tendencies of the gaze.

The veil allows for a visualization of the camera playing tricks with temporality. Not only the veil, but the film uses substitutes for the veil: ruins, architecture, lighting patterns, objects, shadows, colors, rows of walking people, and even clothing to double the frame, angling perspectives from the camera's eye through the view from the other back toward the camera's eye. The characters can exist on one side of a temporal-cultural framing, walk through a framing device like an arch or a pile of rubble, and then into another, with different color schemes, dress codes, and rules of conduct. An example of this occurs when the veiled Noqreh arrives at the mosque soon after the opening sequence only to then, on the other side of the frame, become a schoolgirl. The camera stands on one side of a door-like opening with a thick black edge and Noqreh in light, approaching. Passing through this doorway, Noqreh walks toward the camera and through its lens; the camera pivots in the dark to another door-like square where it stops and stills, and we see, from behind, Noqreh walking away through an iris-like border, toward a different light on the school for girls. The shot suggests two sides to the camera, a dark passage in the middle like a film cut (or veil) seeming to separate modernity from its dark outside or "primitive" imbalance from where it is viewed.

Substituting for a film cut, the passage through different architectural spaces divides the street from the mosque, and then divides the mosque from the school. Blocks and breaks in the shot refer back to the camera's positioning at intersections between modernity's narratives of progress on the one hand and, on the other, its appearance as the premodern. Noqreh joins a group of women kneeling in prayer, and, all in full-covering blue burkas like hers, reciting sharia rules for concealing their beauty. Leaving, she passes through yet another doorway where she lifts her veil and dons a pair of white high-heeled shoes. A man passing by turns to the wall to avert his gaze (repeating the gesture of the father from the prior scene)—as though she passed through the dark frame into modernity, now unveiled. Her gesture of unveiling is what makes her prior veiling, along with the man who hides the gaze, seem temporally distinct or "backward." Noqreh then is in school, her face framed by a white head-covering in a sea of women's faces also framed in white headscarfs. The conversation in school is about

professional careers: their willingness to become doctors, say, or politicians. Women, inasmuch as they are situated as embodied defenses of the local culture, are also situated as embodied defiant modernizing warriors, using the disguise of local culture as a temporal gage for modernity's aspirations and advances.

Like Makhmalbaf, Noqreh, then, uses overlapping frames to historicize women multiply *within the frame*. Needing portraits for her presidential campaign, Noqreh sits for a photograph. Ducking behind a camera lens drape-covering that resembles a veil, the cameraman shoots Noqreh in a series of still portraits: sitting, standing, frowning, serious, upside-down as though in a *camera obscura*, and lastly veiled,[10] which is the shot the cameraman likes the best. "How many women in Europe and American have become president?" the biker-migrant/potential love-interest who accompanies her on the photo-errand asks. Later, the biker-migrant hangs many of the photographs on the pillars of the bombed-out, abandoned palace where Noqreh is temporarily lodging with her father, sister, baby niece, and horse. The towering pillars dwarf and surround the photographs. The series of portraits on the series of pillars hang in sequence, where each still shot—on its own pillar—cancels the one that came before, looking back at it as though the pieces of the majestic biblical architecture fall between images in a filmstrip.

The modern film frame is thus shown to be an extension of an ancient temple wall coming to be replaced by that wall. The dwarfing of the still-frames series by the pillars marginalizes film technologies in their sweeping historical context. Like the veil, then, the architecture turns modernity's gaze back on itself, invoking its limits and smallness. Additionally, the film makes explicit modernity's elision between the ruins, film technologies, and military technologies. Noqreh's family has to move from the ruins where they live because she invited refugees from Pakistan, crowding her own family out of the space and making it unlivable. The refugees have no place else to go, so the family relocates to a downed US-issued military plane, cracked in the middle, half serving the father for prayer, while a clothesline hangs off the other side. The circle of the plane's interior frames the father's ablutions inside a burned-out metallic circle on the one side and the women's domestic chores

[10]Mark Graham writes, "What emerges from the shadowy folds of the *chadari* to stare back at us then is not simply Afghanistan but Afghanistan *as* Islam, as an independent and resistant force" (2010: 3–4). I would say, however, that Samira Makhmalbaf presents resistance as substantially more complicated, with many of its narratives of independence and autonomy linked to contested and displaced liberalism. Indeed, *At Five in the Afternoon* seems to create a hard division between the sacred and the secular, with the veil between them. The religiosity of the imam, Noqreh's father, is shown as regressive and helpless while technology, including the camera, is on the side of secular modernity.

on the other, each as though inside an iris of early cinema. Replicating the kinetic motion of a handheld camera, both circular pinholes rock and shake when the refugees on the outside start playing on the wings, climbing up the side, hanging decorations, and setting up residence on the top. The camera eye thus stands as a shaky border inside the globalizing military-technological wreckage.

The ruins of the military plane are the visual counterpart to the destruction of modernity's ideologies, including progressive feminism. The triumphalism of the coalition's ousting of the Taliban to free women from family controls—allowing them to choose careers, to engage politically, and to not fall victim to the regime's abuses and inflicted deprivations—falls short before tragedies like Noqreh's friend Mina's and her sister-in-law Leylomah's. Mina is Noqreh's schoolmate who articulates the justification for a woman to be president, blaming the regime in Kabul for the rocket that killed her family and for the whipping she received at the killer's hands, but then she falls victim to a coalition bomb at a barbecue stand, her cracked glasses skidding on the dirt road as synecdoche. As the women leaving school approach the stand, the camera cuts, so we only see the explosion from behind, with the women's faces again hidden and their subjectivities, literally, erased. The cracked glasses are feminism's visual counterpart to the camera whose vision is also split. The series of framed photos from Noqreh's campaign, hung on broken pieces of an archaic palace, are followed by a series of similar photos of Mina hanging on the mosque wall, as though Mina's face, now dead and mourned, finishes the sequence begun by Noqreh's campaign photos signifying universal inclusion. Rather than "getting over" the despotisms of the past in the promise of equal access, and rather than "proving" its success by engaging difference and inviting the excluded through its frame, feminism in *At Five in the Afternoon*, like technology, looks back at itself from the cracks and absences splitting its visual field, from the position of its other.

At Five in the Afternoon constitutes history not by the triumphal global pretensions of the American war machinery, then, but rather by focusing on the words and images of migrants who appear on the edge of the frame as gaps and absences in progress. In response to Noqreh's questions about the president of Pakistan, a migrant confesses, "I don't like politics. I'm after real life," or, another: "No, I don't know anything. I was a beggar in Pakistan. My son was killed," or "My unfortunate mother had four sons. One was killed in a Russian assault, one in a civil war, and one by the Taliban." As Zizek continues about *Children of Men*, this is "the best diagnosis of the ideological despair of late capitalism. . . . The true infertility is the very lack of meaningful historical experience . . . the loss of this substance of meaning" (2007). This could refer to Noqreh's sister-in-law Leylomah who spotlights the central theme of the film from its margins. As Noqreh launches her campaign to be the first female president

of Afghanistan, Leylomah (like Penelope)[11] awaits her husband Akhtar's return from Pakistan where he went to fight. After she finally learns from the gossip of migrants that he was killed by a mine, her baby dies of hunger, her milk drying up, and she buries the child on a stretch of empty desert on the edges of the Taliban stronghold of Kandahar. Leylomah's constant lament for her lost husband and dying child—her worry about insufficient food and water with her husband being gone (her lament seems to be mostly about despairing over the material means of survival, not romantic love) and the loss of social bonds due to the constant uprootedness of post-invasion migrant life—is the main tie-in the film expresses to the lament of the bullfighter in Lorca's poem to which the title alludes. Makhmalbaf is not forthcoming about her choice to include and to emphasize Lorca's poem aside from liking it.[12] Still, the biker-migrant writes the poem on the back of Noqreh's campaign photo. The centrality of the image is set askew by the words of lamentation sketched on its back. The poem displaces the celebration of imperialist democracy by calibrating it alongside the everyday suffering that imperialist democracy buries on its edges. The sound now non-diegetic and from nowhere in the image, the words of the poem float on voice-over as the now-bereft family, on a sandscape between Kabul and Kandahar, walks away from the camera, away from the child's grave and toward the Taliban stronghold.

In *Sex and the Failed Absolute*, Zizek indirectly embellishes on the split in the screen that he noticed in *Children of Men*, that is, the split— the antagonism or tension—between the foreground of the romantic, salvational plotline and the substance of history: the social dimension or apocalypse obliquely remaining in the background. Here, Zizek revises the Kantian epistemological block between the subject and its world, based in the subject's finitude, inside Hegelian "contradictions and antinomies [that] are the innermost feature of things themselves" (2019: 85): "for a thing to be," notes Zizek, "it can come to exist only against the background of its

[11]Makhmalbaf has commented on her citations of *The Odyssey* as not only a reference to origins but also as a displacement of Western culture by viewing it from the exterior. See, for example, *How Samira Made "The Blackboard."* Maysam Makhmalbaf, Makhmalbaf Productions, 2000.

[12]The poem is given attention at the end of the film: the biker-migrant love-interest gives Noqreh a copy handwritten on the back of one of her campaign photos after she admits that she cannot prepare her campaign speech because she is uncomfortable speaking in public. He then tells her that many presidents rehearse their speeches in front of cows and sheep first, and this is how he reads his poems as well, as—she adds—poetry is close to nature, and the speaker in the poem likes cows and sheep. As the camera pulls away at the end of the film, the poem is read in the voice-over as Noqreh, Leylomah, and Noqreh's father trek out on the desert having lost what remained, unsheltered, their donkey having died and their wagon burnt to warm the feverish child. Not only does the poem here bridge between nature and culture, between public and private, between woman and man, but also literature takes on a material form, almost like film, as written but lived markings on the back of a photograph.

impossibility" (2019: 85). *At Five in the Afternoon* creates a visual logic for the contradictions of late capitalism and shows those contradictions as they appear against the background of a feminist world. On the one hand, the central plot is about the universalizing feminist promise of equality, equal access, and equal representation, even though that central plot gets skewed against antagonistic images of deprivation due to a global expansion of militarized accumulation. The militarization depicted in the film carries with it the promising narrative of a feminist future even while it also makes that future of equality impossible. In fact, it virtually turns such feminist promise inside-out by emphasizing the lament that, from the other sides of its frame, looks back from the position of its historical despair.

In August 2021, the United States and its allies withdrew from Afghanistan after twenty years of what had become known as "America's Forever War." Images of US citizens and those who had helped them flashed across television screens around the globe as those fleeing tried to board US military planes taking off from the Kabul Airport, some dying as they clung to the rising aircraft or stowed-away. Right away, as the Taliban reconquered the country and entered Kabul with little resistance, the plight of Afghani women under the Taliban became the symbolic narrative of the military failure, as pundits, referencing prewar reports on the abuse of women, noted the reversals in girls' schooling, women's university matriculations, women's employment, and women's appearance in public spaces, and marchers for women's rights were beaten with batons. After the withdrawal, sanctions on Afghanistan and holds on foreign bank accounts worsened the situation more, especially for women, with hospitals running out of medicines and food shortages everywhere. Even with media reports testifying that women may be let back into school but cannot attend the same schools nor board the same transport as men, food insecurity is taking over, the country seeming on the brink of collapse. In 2002, in the aftermath of the initial invasion, Lila Abu-Lughod criticized Laura Bush's November 17, 2001, radio address for collapsing the distinction between the Taliban and the terrorists, thereby making the US military action seem as though its purpose was saving the women (2002: 784).[13] Anyone who has studied Southeast Asia and its colonial history, Abu-Lughod goes on, knows that "the use of the woman question in colonial policies . . . was used to justify

[13]Judith Butler also remarks, "That this foreclosure of alterity takes place in the name of 'feminism' is surely something to worry about. The sudden feminist conversion on the part of the Bush administration, which retroactively transformed the liberation of women into a rationale for its military actions against Afghanistan, is a sign of the extent to which feminism, as a trope, is deployed in the service of restoring the presumption of First World impermeability. . . . Feminism itself becomes, under these circumstances, unequivocally identified with the imposition of values on cultural contexts willfully unknown. It would surely be a mistake to gauge the progress of feminism by its success as a colonial project" (2004: 41).

rule" (2002: 784). Indeed, *At Five in the Afternoon*, a year later, revealed the lie that the TV cameras finally broached only after the regime's fall: militarism used feminism as a veil for the impoverishment and dispossession of a region while infractions against women and their rights were allowed to continue under the shadows of the widespread corruption in the US-backed regime in Kabul and US alliances with pre-Taliban warlords in the countryside,[14] and so any projected changes could not grow roots. *At Five in the Afternoon*, then, demands a different feminism, a feminism that looks back from the world to bear witness to the finitude of imperialist policies that dress themselves up as the universal of liberation.

References

Abu-Lughod, L. (2002), "Do Muslim Women Really Need Saving? Anthropological Reflections on Cultural Relativism and Its Others," *American Anthropologist* 104 (3): 783–90.

Beauvoir, S. de (1953), *The Second Sex*, trans. and ed. H. M. Parshley, London: Jonathan Cape.

Butler, J. (2004), *Precarious Life: The Powers of Mourning and Violence*, London and New York: Verso.

Delphy, C. (2015), *Separate and Dominate: Feminism and Racism After the War on Terror*, trans. D. Broder, London and New York: Verso.

Delphy, C. (2016), *Close to Home: A Materialist Analysis of Women's Oppression*, ed. and trans. D. Leonard, London and New York: Verso.

Espinosa, J. G. (1979), "For an Imperfect Cinema," trans. Julianne Burton, *Jump Cut* 20: 24–6.

Gopal, A. (September 13, 2021), "The Other Afghan Women," *The New Yorker*. Available online: https://www.newyorker.com/magazine/2021/09/13/the-other-afghan-women (accessed September 22, 2021).

Graham, M. (2010), *Afghanistan in the Cinema*, Urbana, Chicago, and Spingfield: University of Illinois Press.

Hekman, S. (2014), *The Feminine Subject*, Cambridge and Malden: Polity.

Higgins, L. A. (2005), "Documentary in an Age of Terror," *South Central Review* 22 (2): 20–38.

Jameson, F. (1986), "On Magic Realism in Film," *Critical Inquiry* 12 (2): 301–25.

Jameson, F. (2002), *A Singular Modernity: Essay on the Ontology of the Present*, London and New York: Verso.

Macnab, G. (May 19, 2003), "A Woman's Place," *The Guardian*. Available online: https://www.theguardian.com/film/2003/may/19/cannes2003.cannesfilmfestival (accessed September 19, 2020).

[14]See, for example, Anand Gopal's magnificent piece in *The New Yorker*: "The Other Afghan Women" (2021): "*In the countryside, the endless killing of civilians turned women against the occupiers who claimed to be helping them.*"

Mahmood, S. (2005), *Politics of Piety: The Islamic Revival and the Feminist Subject*, Princeton and Oxford: Princeton University Press.

Makhmalbaf, S., dir. (2003), *At Five in the Afternoon*, prod. Back Films, Makhmalbaf Productions, Wild Bunch.

Mottahedeh, N. (2008), *Displaced Allegories: Post-Revolutionary Iranian Cinema*, Durham and London: Duke University Press.

Mulvey, L. (1997), "Visual Pleasure and Narrative Cinema," in R. Warhol and D. P. Herndl (eds.), *Feminisms: An Anthology of Literary Theory and Criticism*, 432–42, New Brunswick: Rutgers University Press.

Rocha, G. (1997), "An Esthetic of Hunger (1965)," in M. Martin (ed.), *New Latin American Cinema Vol. 1*, 59–61, Detroit: Wayne State University Press.

Scott, J. W. (2007), *The Politics of the Veil*, Princeton and Oxford: Princeton University Press.

Shohat, E. (2003), "Post-Third-Worldist Culture: Gender, Nation, and the Cinema," in A. R. Guneratne and W. Dissanayake (eds.), *Rethinking Third Cinema*, 51–78, New York and London: Routledge.

Spivak, G. C. (1988), "Can the Subaltern Speak?" in C. Nelson and L. Grossberg (eds.), *Marxism and the Interpretation of Culture*, 271–313, Urbana-Champaign: University of Illinois Press.

Warwick Research Collective (WReC). (2015), *Combined and Uneven Development: Towards a New Theory of World-Literature*, Liverpool: Liverpool University Press .

Zizek, S. (2007), "Zizek on Children of Men," *Youtube.com*. Available online: https://www.youtube.com/watch?v=pbgrwNP_gYE (accessed September 24, 2020).

Zizek, S. (2019), *Sex and the Failed Absolute*, New York and London: Bloomsbury.

17

Passivity and Nomadism in the Literature of Luisa Valenzuela

Sofia Iaffa

> The nomad distributes himself in a smooth space; he occupies, inhabits, holds that space; that is his territorial principle. It is therefore false to define the nomad by movement. Toynbee is profoundly right to suggest that the nomad is on the contrary *he who does not move.*
> —GILLES DELEUZE AND FÉLIX GUATTARI 2013: 444

> All that I can say is that this "coming" to language is . . . a practice of the greatest passivity. At once a vocation and a technique. This mode of passivity is our way—really an active way——of getting to know things by letting ourselves be known by them.
> —HÉLÈNE CIXOUS 1991: 57

This chapter deals with the passive female characters in Argentinian author Luisa Valenzuela's prose and aims to understand their passivity not only as subjugation but as certain forms of resistance. These passive literary characters will be studied through the lens of the concept of the nomad, a common notion in the field of World Literature. There, nomadism is often associated with mobility, displacement, and border crossings, something which I argue is problematical. The nomadic also entails important aspects

of stasis and passivity and is thus in need of a revision, making way for new, feminist applications of it in the realm of World Literature.

Valenzuela (1938–present) is an acclaimed "post-Boom" novelist and short story writer whose career for a long time coincided with periods of social unrest and military dictatorship in Argentina, notably the last dictatorship between 1976 and 1983, also called the Dirty War. Due to the nature of her writing (which undermines political, social, and sexual myths and taboos) and her explicit critique of the military regime, Valenzuela had to flee her home country to the United States in 1979, where she stayed for ten years. Works like *Como en la Guerra* (*As in War*) (1977), *Cambio de armas* (*Other Weapons*) (1982), *Cola de Lagartija* (*The Lizard's Tail*) (1983), and *Realidad nacional desde la cama* (*National Reality from Bed*) (1990) combine an examination of patriarchal forms of power and gender relationships with a strong critique of dictatorship and of political and sexual violence. Interestingly, this critique is often carried out through absurd and dream-like stories in which the female protagonists are highly passive, immobile, imprisoned, and distressed about crossing borders. These female protagonists refuse, negate, avoid, are silent, and wait (often for their male partners, or just for something to happen) and have erotic relationships with violent and evasive men.

The topic of passivity appears already in Valenzuela's first novel *Hay que sonreír* (*Clara*) from 1966, in which the prostitute Clara passes from man to man. As Linda Craig notes in her study of the novel: "The lack of control or autonomy which is the consequence ... of Clara's passive resignation ... is actually the major theme of the novel" (2005: 110), and Clara's "major characteristics are silence and passivity" (2005: 111). Similar passive female figures reappear in Valenzuela's later narratives, such as *El gato eficáz* (*The Efficient Cat*) (1972), *Realidad nacional desde la cama*, and the short story collections *Cambio de armas* (*Other Weapons*) and *Simetrías* (*Symmetries*) (1993). In this, Valenzuela's prose can be compared to that of other South American and Caribbean women writers, such as Maria Luisa Bombal, Clarice Lispector, and Jean Rhys, who in their texts also emphasize more or less passive female figures. Molly Hite observes, for instance, that the main characters in Jean Rhys's novels are often characterized as passive and masochistic and deposited "in the foreground of narratives that chronicle only their incapacity to control their own lives" (1989: 24).

In the case of Valenzuela, many scholars have interpreted the passivity of her female protagonists in terms of subjugation, and as something essentially negative that must at any cost be overcome in order for them to be truly emancipated (and for the text to become truly feminist) (Martínez 1994; Muñoz 1992). But the passive figure in Valenzuela's works is not merely a simple representation of female subordination in a patriarchal world—there is more to it. In fact, Valenzuela's literary works challenge traditional

notions of the feminine by deconstructing and complicating the binary active-passive. This happens, for example, in the two texts that I will center on in this chapter, the short story "Other Weapons" and the novel *National Reality from Bed*.[1] These narratives can be read as direct responses to and dramatizations of the context of the last dictatorship in Argentina, with its war between the dictatorial military regime and the various political and religious resistance and guerilla groups (often constituted by young people and students, but also by intellectuals and artists as well as other opponents to the regime). In "Other Weapons," the female protagonist is held imprisoned in an apartment by a man who is her husband and lover, but also a torturer and military agent. In *National Reality*, the female protagonist has returned to Argentina from exile after the end of dictatorship and decides to install herself in a bed in a rented bungalow, in which she stays throughout the novel. These two protagonists suffer torture, rape, and verbal aggressions, to which they respond with uncanny passivity, immobility, and amnesia. But, as I will show, this passivity does not only make them into victims, but there is also a certain kind of resistance evoked in the figure of the passive woman, a resistance I would like to call nomadic.

On a first level, the passivity and immobility of Valenzuela's characters seem to dissolve and complicate any coherent subjectivity in the texts. Gilles Deleuze and Félix Guattari's nomadology can help shed light on this, since their version of nomadism entails a radical erasure of the subject as well as emphasizes that there is something in the nomadic that has to do with abstaining from action and "staying put." In fact, as they remark in the quote above, nomadism (and the mode of resistance it entails) should be understood in terms of *immobility*. At the same time, however, the passivity of the female characters in Valenzuela is one of the very literary techniques that makes (a feminist) subjectivity readable at all in the texts. Rosi Braidotti's theory of nomadism is, I argue, more apt for discussing this second form of passive resistance that appears in Valenzuela's narratives, since she gives more attention than Deleuze and Guattari to what the nomadic might mean for women and for the gendered aspects of resistance. Before I discuss these things in more detail, however, I will make a brief critique of how nomadism usually is understood in the field of World Literature.

[1] The citations in this text from "Other Weapons" are taken from the English translation of the original "Cambio de armas" (1982). The citations from *National Reality from Bed* (1990) are instead taken directly from the Spanish original and are translated by me. For the sake of readability, however, I will refer to this novel by the English title, *National Reality from Bed* (also translated by me), abbreviated *National Reality*.

A Brief Critique of the Uses of Nomadism

Deleuze and Guattari's concept of the nomad has been worked on and debated in various fields and from a wide range of perspectives. In this chapter, I will not delve into an exhaustive description or critique of the concept and all its possible applications, but instead briefly discuss how it has been used in World Literature as well as investigate how it can contribute to studying the passive female characters in Valenzuela's literature in particular.

In the field of World Literature, the idea of the nomad is seldom connected to passivity or immobility but is rather used as a synonym for travel, homelessness, and border crossings and is associated with the itinerant, exiled, multilingual, and/or cosmopolitan lifestyles of different writers and their aesthetics. The association of nomadism with movement and displacement has made it especially popular in studies of exile and migrant literatures (see Averis 2014; Harrington 2013; Jeremiah 2012; Kaminsky 1999; Olsson 2011). The concept of the nomad is also central to some strands of feminist theory, especially after having been picked up and contested by influential thinkers such as Luce Irigaray and Braidotti, for whom it is a key aspect in their respective discussions about *écriture féminine* and feminist agency. The nomad is also associated with ideas about the dissolution of essential identities and is set up as a challenge to traditional Western (binary and logocentric) thinking, while it has also been subject to critique for being itself a vehicle for those very Western colonial and patriarchal forms of thinking (Ghambou 2001; Kaplan 1996).

In fact, the term *nomadic* is used in so many different ways that its meaning and function stand out as vague and imprecise. In the field of World Literature in particular, the nomadic can denote everything from questions of (personal) identity and positionality/biography (the scholar's position, the literary writers' lifestyles, etc.) to more formal questions such as the displacement of the characters within the narratives or the style/genre/structure of the texts themselves (fragmented, multilingual, etc.). For example, Kate Averis uses the term *nomadism* in her study of exiled women writers to designate the authors' "personal experiences of displacement" (2014: 39) and their discursive elaboration of (exile) identity. Averis even identifies the authors' very consciousness as nomadic, a consciousness that originates in their displacement and exile: "the texts that constitute the object of analysis here are read in terms of their author's nomadic consciousness, which stems from their experience of exile" (2014: 38).

The vagueness in the parlance on nomadism in the field of World Literature might be a consequence of what Emily Apter coined "border-speak" in her book *Against World Literature* (2013). Apter warns against the loose parlance of "borderlessness" and "translatability," ideas that, according to

her, have become overvalued and ripped from actual geopolitical conditions in some strands of the World Literature discipline:

> Border-speak spilled into the parlance of literary studies as actual national borders were increasingly weaponized and surveilled post-9/11 yet rendered fungible by the economic instruments and institutions of global finance capital. In the world of super-states, "borderlessness" became an operator, sometimes yoked theoretically to Deleuzian / Guattarian "spaces of flow" (often strangely detourned from nomadology to become the perfect watchword for information and currency trading). (Apter 2013: 103)

As Apter underlines, such overuse of catchwords like "spaces of flow" or "borderlessness" is a worrisome deviation from Deleuze and Guattari's nomadology because it tends to idealize border crossings, flux, and movement. As I argue in this text, Deleuze and Guattari's theory on the nomad, in fact, also includes important discussions on immobility and stasis, something which is often overlooked in the applications of nomadology in the field of World Literature.

Another reason for the vague use of the term *nomadism* is the conflation of Deleuze and Guattari's theory on nomadism with Braidotti's—two notions on the nomad that are in fact quite different in a number of ways. For Deleuze and Guattari, literary nomadism does not primarily refer to authors' consciousness and experiences of exile and displacement but appears in and through the very stylistic and aesthetic techniques of the texts and as a process that dissolves, rather than institutes, subjects, and identities. For Braidotti, as mentioned above, nomadism is more connected to embodied experience and to her feminist project of formulating feminist subjectivities. But even though the nomadic has different functions and purposes for Deleuze and Guattari and Braidotti, they share the conviction that the nomadic is *resistance*. In the following, I will discuss the phenomenon of passivity as resistance in Valenzuela's narratives and how Deleuze and Guattari's and Braidotti's notions of nomadism, in their different ways, can contribute in this endeavor.

The Immobility of the Nomad

The short stories in Valenzuela's collection *Other Weapons* are populated by female protagonists who continuously face and are fascinated by borders and thresholds of different sorts (doors, windows, exits, etc.) but respond to them in a cautious and motionless way. Valenzuela describes Laura, the protagonist of the short story "Other Weapons," as follows:

It's exasperating, for example, to confront the one called door and try to figure out what to do. A locked door, yes, but there are the keys, on the ledge, within her reach, and the lock's easy to open, her fascination with the beyond, which she can't make up her mind to face. . . . She, so-called Laura, is on this side of the door, with its so-called locks and its so-called key begging her to cross the threshold. But she can't; not yet. Facing the door, she thinks about it and realizes she can't, although no one appears to care much. (Valenzuela 1985: 106)

Likewise, the female protagonist in *National Reality*—called simply *la Señora*—rests in bed throughout the whole text, while other characters move in and out of her bedroom. La Señora shares many of Laura's traits: she is reluctant to move, remember, talk: "Who really wants to move after having moved around so much in the world?" (Valenzuela 1990: 8, my translation). Valenzuela herself mentioned in an interview that, with this novel, she wanted to "deconstruct the myth that passivity is not active" (Lagos 1996: 43). Valenzuela's literary and feminist mission with these texts and characters can in this sense be compared to Judith Butler, Zeynep Gambetti, and Leticia Sabsay's reformulation of resistance in the book *Vulnerability in Resistance* (2016), in which they criticize "Dominant conceptions of vulnerability and of action" (2016: 1) which "presuppose (and support) the idea that paternalism is the site of agency, and vulnerability, understood only as victimization and passivity, invariably the site of inaction" (ibid.). What they propose instead is calling "into question . . . that vulnerability and resistance are mutually oppositional" (ibid.).

"Other Weapons" and *National Reality* underscore the passivity of its respective protagonist by repeatedly making her observe and negate the environment around her: the telephone with which she could call her friends, for example, is easily accessible to la Señora, and the door and keys in front of Laura are "begging her to cross the threshold" (Valenzuela 1985: 106)—yet neither woman moves to use them. Laura's and la Señora's passivity are also underlined by their speech. For example, and not unlike Herman Melville's character Bartleby in *Bartleby, the Scrivener* (1853), the most frequent phrases Laura utters are "no," "I don't want to," and "I don't know." According to Deleuze, Bartleby is one of those literary characters who "prefer . . . no will at all, a nothingness of the will rather than a will to nothingness. . . . They can only survive by becoming stone, by denying the will and sanctifying themselves in this suspension" (1997: 80). This nothingness of the will that Bartleby and Valenzuela's characters express can be seen as literary "lines of flight," in Deleuze's vocabulary.

Deleuze and Guattari's notion of the nomad—which is connected to that of "lines of flight" and to a cluster of other similar concepts and terms such as *rhizomes* and *deterritorialization*—can be helpful in approaching this strange female passivity in Valenzuela. Ian Buchanan indicates that the

term *nomad* in Deleuze and Guattari's philosophy does not originate in an idealized or romantic image of actual nomadic peoples—it is rather a strictly philosophical notion stemming from their interpretation of "Kant's claim that the outside of philosophy is a wasteland fit only for nomads" (Buchanan 2010: "nomadology"). In Deleuze and Guattari's view, the nomadic entails a certain tendency toward a collapse of structures, which, as Buchanan notes, "can be found to some degree in all phenomena" (ibid.). The nomadic is also put in close relation to the term *deterritorialization*, which in Deleuze and Guattari's writings more generally indicates the destruction of forms, ideas, and norms.

In the plateau "1440: Nomadology: the War Machine" in *A Thousand Plateaus* (1987), Deleuze and Guattari create a theory of spaces that is crucial to their understanding of the nomadic and in which their views on movement and immobility can be discerned. In this text, they write about "striated" space and "smooth" (also called "nomadic") space and their different characteristics. Striated, sedentary space has a form, making up a territory with distinct boundaries, while smooth space can be compared to the ocean or the desert; it has no clear boundaries and is defined by what in the science of physics are called "intensive" properties, like pressure, color, and temperature (Deleuze and Guattari 2013: 558). As physics distinguishes between two types of movement (speed and velocity), Deleuze and Guattari suggest that movement in striated space develops as *velocity* (it has direction, "from A to B") while movement in smooth/nomadic space is best defined as *speed* (pure movement without direction) (2013: 559). The exact borders between striated and smooth space (and their inhabitants) are however never fixed as they co-create and negotiate each other's existence. In this theory of spaces, the nomad is the abstraction of someone or something (it can be anything from human beings to plants, animal species, or minerals) that inhabits and adapts to smooth space and its intensive properties. With their description of nomadic/smooth space, it becomes clear that for Deleuze and Guattari, the nomad is not a subject, nor a representation of an identity, but entails instead the deterritorializing force par excellence; it lives on deterritorializing the earth, as it does not reterritorialize on it afterward (like the migrant), or upon something else in sedentary and mediated ways (like the State) (2013: 444).

For my reading of Valenzuela, what is also important to gather in Deleuze and Guattari's nomadology and theory of striated and smooth spaces is that immobility is not posed as the opposite of movement but as a certain kind of movement and resistance in itself. According to Eleanor Kaufman, Deleuze's writings on the nomad (and on cinema) especially reveal "Deleuze as a philosopher of immobility no less than of movement, indeed of the non-oppositional relation of these two terms" (2001, Sec. 22). As I described above, Deleuze and Guattari emphasize that nomadic movement cannot be defined in terms of a linear trajectory, as in striated space, because:

"Whereas the migrant leaves behind a milieu that has become amorphous and hostile, the nomad is one who does not depart, does not want to depart ... who invents nomadism as a response to this challenge. Of course, the nomad moves, but while seated. ... The nomad knows how to wait, he has infinite patience" (Deleuze and Guattari 2013: 444). One of the examples Deleuze and Guattari use to explain this kind of immobile movement—and the nomadic resistance enabled by it—is guerilla warfare: "guerilla warfare, minority warfare, revolutionary and popular war are in conformity with the essence" (2013: 492) of the nomad. If state-sanctioned war and violence are territorializing and impose their methods on a territory, the nomadic methods of guerilla warfare are to *follow* the territory and its materiality; using, adapting to, and merging with and into the surrounding smooth space in order to resist and fight back (camouflage being one such method) (Deleuze and Guattari 2013: 485). In this view, a central aspect of nomadic resistance involves the tactics of abstaining from acting and moving in certain circumstances and of adapting to the surrounding (smooth) space. The passive female figures in Valenzuela's texts produce this kind of guerilla/nomadic mode of resistance. The male characters in the narratives often embody the dictatorial side with its paramilitary groups and strategies of persecution, torture, and rape, while many of the female protagonists inscribe the (feminist) resistance and their methods. For instance, one of the side characters in "Other Weapons," trying to make Laura remember her past, says: "when there were the guerillas up North. You're from Tucumán, aren't you? How can you not remember?" (Valenzuela 1985: 119). Hence, the text hints that Laura was once a guerilla fighter and inserts a reference to the battle of Tucumán—the first large-scale military operation in the Argentinian Dirty War in which the regime attempted to crush the Guevarist guerilla group the People's Revolutionary Army (Lewis 2002).

The nomadic guerilla fighter must, according to Deleuze and Guattari, sometimes stand absolutely still and merge with the surroundings through camouflage in order to hide and avoid being discovered; it is an adaptation to smooth space and its intensive properties. In Valenzuela's narratives, this kind of nomadic resistance is expressed as a subject-erasing process, a movement toward becoming-object. For example, in "Other Weapons," Laura understands that the keys at her disposal on the shelf in the apartment where she is kept imprisoned are placed there as a trap, and thus her immobility and refusal to use them are not an expression of a simple feminine subjugation or naive inability to act, but rather indicate a conscious tactic of avoiding and waiting to act, so as not to be fooled. In one of the torture scenes, she also obsessively touches a drop of dried paint on the wall, to the point that she merges with it. She defends herself from the violence around her through becoming a part of the décor, withdrawing from her position as a subject. In *National Reality*, la Señora withdraws in her own manner: "she installed herself ... in this country club in search of refuge, so that

she could observe things slowly" (Valenzuela 1990: 8, my translation). Her immobile refuge in the bed challenges and dissolves her subjectivity in the text, since it enables the other characters to (ab)use her as they please. It is also the various side characters who come in and out of la Señora's room who make the story move forward, rather than the protagonist herself. These forms of passivity and immobility in Valenzuela's narratives can be seen as deterritorializing lines of flight; and these, according to Deleuze, are precisely what constitute resistance in literary texts. As he underlined in a conversation with Claire Parnet: "to flee is not to renounce action: nothing is more active than a flight" (2006: 27). In this way, the passivity and immobility of the female protagonists in Valenzuela's narratives can be read not only as allegories of women's role in patriarchy and dictatorship but also as resistance to these very institutions in a nomadic sense, as Kaufman clarifies regarding Deleuze's view on the immobility of the nomad: it is "at once a withdrawal and a force of resistance" (2001: Sec. 22).

Passivity as Feminist Nomadism

Deleuze and Guattari's nomadology has proven useful in discerning how the passive and immobile figures in "Other Weapons" and *National Reality* exert a kind of nomadic resistance with a primarily destabilizing and deterritorializing function in the texts. However, these protagonists also convey another, slightly different, kind of passivity and nomadic resistance, which enables a construction (not dissolution) of subject positions and underscores the feminist aesthetics of Valenzuela. It is here that Braidotti, with her feminist critique and innovation of Deleuze and Guattari's concept of the nomad, becomes useful.

Although Braidotti largely draws on Deleuze, the focus on embodiment and subjectivity is one important point where her approach to the nomadic differs from that of Deleuze and Guattari. Braidotti's purpose when discussing the nomadic is to develop a feminist theory of difference, focusing on the particular questions of gender and subjectivity, as she writes in the introduction to *Nomadic Subjects* (1994):

> The nomad is my own figuration of a situated, postmodern, culturally differentiated understanding of the subject in general and of the feminist subject in particular. . . . The nomadic subject is a myth, that is to say a political fiction, that allows me to think through and move across established categories and levels of experience: blurring boundaries without burning bridges. (Braidotti 1994: 4)

Braidotti thus makes the nomadic into a figuration—or a "political fiction," as she calls it—in her writing, similar to Luce Irigaray's thought images

drawn from female sexuality and morphology and Donna Haraway's figuration of the cyborg. According to Braidotti, these kinds of figurations provide ways out of phallogocentric and reactionary modes of thought (1994: 3).

In this theory of subjectivity and feminist agency, the nomad illustrates a specific notion of sexual difference and gender. In line with both Deleuze and Irigaray, Braidotti regards the relationship between the sexes as *asymmetrical* and positively different, and thus adheres to a feminism of sexual (positive) difference rather than of equality. Nomadism is her choice of figuration in articulating and rendering these differences productive—differences between men and women, between women, and within one and the same woman. As Braidotti explains regarding Irigaray's notion on gender: "Woman as the other remains in excess of or outside the phallocentric framework that conflates the masculine with the (false) universalist position. The relationship between subject and other, therefore, is not one of reversibility; on the contrary, the two poles of the opposition exist in an asymmetrical relationship" (1994: 160). A similar notion of the asymmetrical relationship between the sexes can be discerned in Valenzuela's literary aesthetics, conveyed especially in the relationship between the female and male characters in the narratives. As Craig notes, Valenzuela's short stories and novels are often concentrated around a heterosexual couple, in which every one of the "male protagonists . . . seems to assume effortlessly an unquestioning identification with the patriarchal role" (2005: 113) while the female character, as in the case of the protagonist in the novel *Clara*, "allows herself to be almost completely taken over by this powerful patriarchal discourse, when it is so patently not in her interest" (ibid.). With Laura and la Señora, however, Valenzuela goes a step further.

At the beginning of "Other Weapons" and *National Reality*, the male partners of Laura and la Señora enjoy and abuse their power over these passive and immobile female characters, but during the course of the stories, they become increasingly anxious about this passivity. Ultimately, they end up desperate and helpless in the face of the women's stubborn inactivity, unresponsiveness, and refusals. In the final pages of "Other Weapons," when Laura more forcefully refuses to remember how she ended up in the house, the man who is holding her imprisoned yells:

- What is this about not wanting to know? Since when does Madam make decisions in this house? . . .
- Nothing can be perfect if you stay out there, on the other side of things, if you refuse to know. I saved your life, do you know that? I know it doesn't look that way, but I saved your life. . . . So listen to me, and maybe you'll pop out of your sweet little dream. (Valenzuela 1985: 132–4)

Through sarcastically suggesting that he "saved" her life, Laura's torturer thus tries to push her out of her passivity and amnesia, but she keeps avoiding the truth he wants to force on her. This kind of culmination in the story, depicting a dance between a frustrated male character and a refusing and passive female protagonist, also appears in *National Reality*. Toward the end of the novel, the character Alfredi (who is a coronel but also la Señora's doctor and lover), persuades her to stand up and leave the bed where she has been lying the whole time, as she holds back and hesitates:

> Alfredi turns discretely toward la Señora who is lying in the bed and extends his hand.
>
> - We will dance now ...
> - We will dance, he insists in a versatile manner. The Lady takes his hand, just like that, but she tries to push him toward the bed.
> - No, standing up, he says.
> - No, not vertically yet, she supplicates.
> - Yes, vertically. With your forehead held high.
> - I need some more time.
> - The time is now.
> - Wait. I want to understand. I'm frightened.
>
> (Valenzuela 1990: 103, my translation)

These passages show that Laura and la Señora's passivity is different from that of earlier female figures in Valenzuela's narratives, for example, the protagonist Clara in her first novel. According to Craig, by the end of the story, Clara has "totally accepted her lack of autonomy. She is no longer making any effort to question the contradictory discourses which surround her.... She has become a fragmented entity, now ... totally subsumed within patriarchal discourse" (Craig 2005: 127). This is also how most earlier critics have generally characterized the female protagonists in Valenzuela's works (Martínez 1994; Muñoz 1992). But in the passages from the culminations and endings of "Other Weapons" and *National Reality* cited above, Laura and la Señora instead begin to appear as autonomous subjects in the texts. While they are still exceptionally passive, like Clara, their passivity is, so to speak, not only a tragic sign of their total subjugation and their place in patriarchy, as it is for Clara; it goes instead to such extreme levels that it starts working *against* the very representatives of patriarchy and disrupts its logic. Both "Other Weapons" and *National Reality* are written in an ironic and distanced narrative voice that somewhat parodies the protagonists' passive behaviors. In this parodic setting, Laura and la Señora's excessive passivity becomes a threat to the male characters, an illustration of the

asymmetrical relationship between the sexes and a textual means that make them not only objects obeying the rules and norms of their oppressors, but also legible as subjects. As Laura says in her typical negating mode when her captor tries to force her to wake up from her passivity and amnesia: "'No, no' she starts up again, shaking her head. *Not as equals,* not with that gun" (Valenzuela 1985: 133, my emphasis).

In relation to this subject-forming aspect of Laura and la Señora's passivity, Braidotti comes in as especially useful: her philosophical theories highlight, to a greater extent than Deleuze and Guattari's, the *territorializing* potential of the nomadic. Ultimately, this has its roots in Braidotti's feminist critique of Deleuze's notion of gender, in which she underlines that the feminine cannot in fact be deconstructed or deterritorialized unless it has first been defined and reclaimed (by women). She writes that, according to Deleuze, "Women . . . can be revolutionary subjects only to the extent that they develop a consciousness that is not specifically feminine, dissolving 'woman' into the forces that structure her. The ultimate aim [for Deleuze] is to achieve not a sex-specific identity but rather the dissolution of identity into an impersonal, multiple, machinelike subject" (Braidotti 1994: 116, my clarification). Braidotti is unconvinced by this call for the dissolution of sexed identities through the neutralization of gender dichotomies, claiming instead that "one cannot deconstruct a subjectivity one has never controlled. Self-determination is the first step of any program of deconstruction" (1994: 117). In this project of reclaiming the feminine, the nomad is Braidotti's guiding metaphor for the tracing of an alternative subjectivity that avoids phallogocentric notions and instead accounts for the experiences and transformations of real-life women.

Lisa Folkmarson Käll has suggested that Braidotti's feminist theory affirms a certain kind of essentialism, albeit without reducing it to determinism: "on the one hand Braidotti does want to affirm a binary framework of sexual difference and sexual identity based on the specificity of sexed embodiment, and on the other hand she wants to move away from an essentialism which entails fixed masculine and feminine essences" (2006: 200). It has proven important to note in my reading that this more essentialist conception of the nomad is absent in Deleuze and Guattari. This difference between Deleuze and Guattari and Braidotti's approaches to essentialism is arguably connected to what was discussed above; that while Deleuze and Guattari's nomadology put the subject under radical erasure, Braidotti's nomadic theory recaptures the subject, yet changes it for the purposes of feminism and real-life women.

Conclusion

In this text, I have suggested that the passivity of the female characters in "Other Weapons" and *National Reality* can be read as a form of nomadic

resistance—and not only, as earlier studies of Valenzuela have claimed, as the ultimate representation of female subjugation in patriarchy (Craig 2005; Martínez 1994; Muñoz 1992). My analysis has shown that this nomadic resistance appears in the texts in two coexisting ways. Some of Laura's and la Señora's passive aspects—such as their immobility and guerilla-like ability to camouflage and wait to act—can be read with Deleuze and Guattari's take on nomadism as a mainly deterritorializing force that collapses structures and dissolves their positions as subjects in the texts. Other passive characteristics of Laura and la Señora—such as their (parodic) refusals of the male characters' requests at the end of the stories that they wake up from their passivity—have more to do with nomadism and feminist agency in Braidotti's sense. When it comes to Deleuze and Guattari, I have suggested that their concept of the nomad is especially fruitful in studying the immobility of these characters in Valenzuela, and that it enables one to problematize and move away from a simplistic view on nomadism as automatically connected to movement and displacement. Braidotti's approach to nomadism has proven useful in discerning the territorializing aspects of nomadic resistance: how female protagonists in the texts are not only dissolved as subjects by their passive ways, but also embodied and given a voice of their own. Making these distinctions between different forms of and approaches to nomadism, I argue, can prevent the vague uses nomadism in the field of World Literature and a conflation of Deleuze and Guattari's nomadology with Braidotti's nomadic theory, while also deepening and nuancing the knowledge about passive female figures in Valenzuela's literary and feminist responses to Argentina's last dictatorship.

References

Apter, E. (2013), *Against World Literature: On the Politics of Untranslatability*, New York: Verso.
Averis, K. (2014), *Exile and Nomadism in French and Hispanic Women's Writing*, London: Legenda.
Braidotti, R. (1994), *Nomadic Subjects: Embodiment and Sexual Difference in Contemporary Feminist Theory*, New York: Columbia University Press.
Buchanan, I. (2010), "Nomadology," in *A Dictionary of Critical Theory*, Oxford University Press. Available online: https://www-oxfordreference-com.ezp.sub.su.se/view/10.1093/acref/9780199532919.001.0001/acref-9780199532919-e-483.
Butler, J., Z. Gambetti, and L. Sabsay, eds. (2016), *Vulnerability in Resistance*, Durham: Duke University Press.
Cixous, H. (1991), *"Coming to Writing" and Other Essays*, ed. D. Jenson, trans. S. Cornell, D. Jenson, A. Liddle, and S. Sellers, Cambridge: Harvard University Press.
Craig, L. (2005), *Juan Carlos Onetti, Manuel Puig and Luisa Valenzuela: Marginality and Gender*, Suffolk: Boydell & Brewer.

Deleuze, G. (1997), *Essays Critical and Clinical*, trans. D. W. Smith and M. A. Greco, Minneapolis: University of Minnesota Press.
Deleuze, G. and C. Parnet (2006), *Dialogues II*, trans. H. Tomlinson and B. Habberjam, New York: Continuum.
Deleuze, G. and F. Guattari (2013), *A Thousand Plateaus*, trans. B. Massumi, London/New York: Bloomsbury Academic.
Folkmarson Käll, L. (2006), "Sexual Difference as Nomadic Strategy," *Nordic Journal of Women's Studies* 14 (3): 195–206.
Ghambou, M. (2001), "A Critique of Post/Colonial Nomadism," *Journal X* 6 (1): Article 5. Available online: https://egrove.olemiss.edu/jx/vol6/iss1/5.
Harrington, K. N. (2013), *Writing the Nomadic Experience in Contemporary Francophone Literature*, Lanham: Lexington Books.
Hite, M. (1989), *The Other Side of the Story: Structures and Strategies of Contemporary Feminist Narratives*, Ithaca: Cornell University Press.
Jeremiah, E. (2012), *Nomadic ethics in Contemporary Women's Writing in German*, Rochester: Camden House.
Kaminsky, A. (1999), *After Exile: Writing the Latin American Diaspora*, Minneapolis: University of Minnesota Press.
Kaplan, C. (1996), *Questions of Travel: Postmodern Discourse of Displacement*, Durham: Duke University Press.
Kaufman, E. (2001), "Deleuze, Klossowski, Cinema, Immobility: A Response to Stephen Arnott," *Film-Philosophy* 5 (32): no page. Available online: https://www-euppublishing-com.ezp.sub.su.se/doi/full/10.3366/film.2001.0033.
Lagos, M. I. (1996), "Entrevista a Luisa Valenzuela," in G. Díaz and M. I. Lagos (eds.), *La palabra en vilo: Narrativa de Luisa Valenzuela*, 27–52, Santiago de Chile: Editorial Cuarto Propio.
Lewis, P. H. (2002), *Guerillas and generals: The Dirty War in Argentina*, Westport: Praeger.
Martínez, N. Z. (1994), *El silencio que habla: aproximación de la obra de Luisa Valenzuela*, Buenos Aires: Ediciones Corregidor.
Muñoz, W. O. (1992), *El personaje femenino en la narrativa de escritoras hispanoamericanas*, Madrid: Editorial Pliegos.
Olsson, A. (2011), *Ordens asyl: inledning till den moderna exillitteraturen*, Stockholm: Bonnier.
Valenzuela, L. (1985), *Other Weapons*, trans. D. Bonner, Hanover: Ediciones del Norte/Persea Books.
Valenzuela, L. (1990), *Realidad nacional desde la cama*, Buenos Aires: Grupo Editorial Latinoamericano S.R.L.

CONTRIBUTORS

Sarah Afzal received her PhD in English literature in 2021 from Florida State University, USA, where she taught undergraduate courses in literature and composition. Her research interests focus on feminist theory, film and adaptation studies, and the literature and scholarship of partition. Her work has appeared in *The Bloomsbury Handbook of 21st-Century Feminist Theory* (2019), *South Central Review*, and the *Trust for History, Art, and Architecture of Pakistan* journal.

Mieke Bal is committed to interdisciplinary approaches to cultural artifacts and their potential effects. She focuses on gender, migratory culture, psychoanalysis, and the critique of capitalism. Her forty-five books include a trilogy on political art: *Endless Andness, Thinking in Film, Of What One Cannot Speak*. *Emma & Edvard Looking Sideways* demonstrates her integrated approach to academic, artistic, and curatorial work. She (co-)made documentaries on migratory culture, and "theoretical fictions." A LONG HISTORY OF MADNESS argues for a more humane treatment of psychosis, and was exhibited in a "site-responsive" version, SAYING IT, in the Freud Museum in London. MADAME B was combined with paintings by Edvard Munch in the Munch Museum in Oslo (2017). REASONABLE DOUBT explores the social aspects of thinking (2016). She exhibits a sixteen-channel video work Don Quixote: tristes figuras. Her essay film, IT'S ABOUT TIME! REFLECTIONS ON URGENCY was produced in Poland (2020). www.miekebal.org.

Jessica Berman is Professor of English; Gender, Women's + Sexuality Studies; and Language, Literature and Culture at the University of Maryland Baltimore County, USA, where she also directs the Dresher Center for the Humanities. She is the director of the Dresher Center's Inclusion Imperative Programs, funded by a major grant from the Andrew W. Mellon Foundation. She is the author of *Modernist Fiction, Cosmopolitanism and the Politics of Community* (2001) and *Modernist Commitments: Ethics, Politics and Transnational Modernism* (2011), editor of *A Companion to Virginia Woolf* (2016) and a reprint edition of *Purdah and Polygamy* by Iqbalunnisa Hussain (2018). Berman was a coeditor of Futures, the ACLA's Report on

the State of the Discipline (2017) and coedits the Modernist Latitudes book series at Columbia University Press. Her current project investigates global radio in relation to transnational modernism.

Debra A. Castillo is Stephen H. Weiss Presidential Fellow, Emerson Hinchliff Professor of Hispanic Studies, and Professor of Comparative Literature at Cornell University, USA, where she directs the Migration Studies minor. She is past president of the international Latin American Studies Association. She specializes in contemporary narrative and performance from the Spanish-speaking world (including the United States), gender studies, comparative border studies, and cultural theory. Her most recent books include *South of the Future: Speculative Biotechnologies and Care Markets in South Asia and Latin America* (with Anindita Banerjee, 2020) and *The Scholar as Human* (with Anna Sims Bartel, 2021).

Laura Doyle is Professor of English at the University of Massachusetts-Amherst, USA, and co-convener of the World Studies Interdisciplinary Project (http://wsipworldstudies.wordpress.com/). Her latest book, *Inter-imperiality: Vying Empires, Gendered Labor, and the Literary Arts of Alliance* (2020), was awarded the Immanuel Wallerstein Prize by the American Sociological Association, and her earlier books include *Bordering on the Body: The Racial Matrix of Modern Fiction and Culture* (awarded the Perkins Prize, 1994) and *Freedom's Empire: Race and the Rise of the Novel in Atlantic Modernity, 1640–1940* (2008). She has also published two edited collections: *Bodies of Resistance: New Phenomenologies of Politics, Agency, and Culture* (2001) and *Geomodernisms: Race, Modernism, Modernity* (with Laura Winkiel, 2005). She has received a Leverhulme Research Professorship (UK); a Rockefeller Fellowship in Intercultural Scholarship (Princeton); and two Fellowships from the American Council of Learned Societies. Doyle is currently coediting a collection on decolonial Global Studies with Simon Gikandi (Princeton) and economist Mwangi wa Gĩthĩnji (UMass-Amherst).

Debjani Ganguly is Professor of English and Director of the Institute of the Humanities and Global Cultures at the University of Virginia, USA. She is the author of *This Thing Called the World: The Contemporary Novel as Global Form* (2016) and *Caste, Colonialism and Counter-Modernity* (2005). She is the editor of the two-volume *The Cambridge History of World Literature* (2021), and also the series editor (with Francesca Orsini) of the CUP book series *Cambridge Studies in World Literature and Culture*. She is currently working on a book entitled *Catastrophic Modes and Planetary Realism* that explores the constellation of life forms in contemporary novels across four iconic contemporary scenarios of catastrophe: drone warfare, viral pandemics, nuclear accidents, and climate change. The book traces the ways

in which biological, technogenic, and geological understandings of human beings relate to notions of political belonging, social justice, and human flourishing. She is a Fellow of the Royal Asiatic Society of Great Britain and Ireland, and advisory board member of the Harvard Institute for World Literature, the Academy of Global Humanities and Critical Theory (Bologna), and the Interdisciplinary Center for Global South Studies (Tübingen).

Keya Ganguly is Professor in the Department of Cultural Studies and Comparative Literature at the University of Minnesota, USA. She is the author of *States of Exception: Everyday Life and Postcolonial Identity* (2001) and *Cinema, Emergence, and the Films of Satyajit Ray* (2010). Her essays have appeared in *Cultural Studies*, *History of the Present*, *New Formations*, *Race and Class*, and *South Atlantic Quarterly*. Her teaching interests are in the critical theory of the Frankfurt School, Marxism, film and visual studies, postcolonial critique, and the sociology of culture. She is currently writing a book on the revolutionary Indian thinker, Aurobindo Ghose, entitled *Political Metaphysics*.

Robin Truth Goodman is a professor of English at Florida State University, USA. Her published works include *Understanding Adorno, Understanding Modernism* (edited collection, Bloomsbury, 2020); *The Bloomsbury Handbook of 21st Century Feminist Theory* (edited collection, 2019); *Promissory Notes: On the Literary Conditions of Debt* (2018); *Gender for the Warfare State: Literature of Women in Combat* (2016); *Literature and the Development of Feminist Theory* (edited collection, 2015); *Gender Work: Feminism After Neoliberalism* (2013); *Feminist Theory in Pursuit of the Public: Women and the "Re-Privatization" of Labor* (2010); *Policing Narratives and the State of Terror* (2009); *World, Class, Women: Global Literature, Education, and Feminism* (2004); *Strange Love, or How We Learn to Stop Worrying and Love the Market* (co-written with Kenneth J. Saltman, 2002); and *Infertilities: Exploring Fictions of Barren Bodies* (2001). She has recently completed a monograph for Bloomsbury called *Gender Commodity: Marketing Feminist Identities and the Promise of Security*, with publication expected in 2022.

Sofia Iaffa is a PhD student in Comparative Literature at Stockholm University, Sweden. In her PhD thesis, she investigates the relations between exile and forms of passivity and immobility in the Hispanic writers Luisa Valenzuela, Gloria Gervitz, and Cristina Peri Rossi. She has also translated and introduced Hispanic literature to a Swedish audience, see, for instance: "Prologue" in *Mullvadarna* (2008) by Félix Bruzzone (translated by Linnea Rutström, 2021). She obtained her master of arts with the thesis "'My Insides Were Like a House': A Study of Body and Space in Mercè Rodoreda's La Plaça del Diamant," MA (2016).

Caren Irr is Professor of English at Brandeis University. She is the editor of *Life in Plastic: Artistic Responses to Petromodernity* (Minnesota 2022) and *Adorno's Minima Moralia: Fascism, Work, and Ecology* (2022), as well as three monographs on the political novel.

Valérie K. Orlando is Professor of French & Francophone Literatures at the University of Maryland, College Park, USA. She is the recipient of the Fulbright-Tocqueville Distinguished Chair Award (Université de Lyon-Lumière II, Lyon, France, fall 2019) and was Research Fellow at the Collegium de Lyon (L'institut d'études avancées de l'université de Lyon, spring 2020). She is the author of six books, the most recent of which include *The Algerian New Novel: The Poetics of a Modern Nation, 1950–1979* (2017), *New African Cinema* (2017), and *Screening Morocco: Contemporary Film in a Changing Society* (2011). She has published with Cécile Accilien *Teaching Haiti: Strategies for Creating New Narratives* (2021). She publishes articles in French and English on a wide variety of subjects in the areas of Literary Studies, Women's Studies, African Cinema, and French and Francophone Studies, specifically focusing on Africa and the Caribbean. Since 2004, she has worked as Series Editor for *After the Empire: The Francophone World and Postcolonial France* with Lexington Books.

Marie Ostby is Assistant Professor of English and Global Islamic Studies at Connecticut College, USA. Her research focuses on modern and contemporary Iranian literature and its global circulation. Her current book project, *The Global Genres of Modern Iran: Flexible Forms and Cross-Cultural Exchange from Travelogues to Twitter*, uses the interwoven modern histories of Persian and Euro-American literature, art, and film to explore how transnational literary exchange under politically fraught circumstances is often mirrored in the crossing of genre boundaries.

Katharina N. Piechocki is Assistant Professor in the Department of French, Hispanic, and Italian Studies at the University of British Columbia, Vancouver, Canada. She specializes in early modern French and Romance literatures, in particular theater and opera, gender studies, cartography, and translation studies. The cofounder and cochair of the Cartography Seminar at Harvard's Mahindra Humanities Center, Katharina is the author of *Cartographic Humanism: The Making of Early Modern Europe* (2019) and the coeditor of a special double issue on "Early Modern Clouds" (*Romance Quarterly*, 2021). She is currently completing her next book titled "Hercules: The Rise of the Opera Libretto" as a fellow at the Villa I Tatti, the Harvard University Center for Italian Renaissance Studies (2021–22).

Nicole Simek is Cushing Eells Professor of Philosophy and Literature and Professor of French and Interdisciplinary Studies at Whitman College,

USA. Her publications include *Hunger and Irony in the French Caribbean: Literature, Theory, and Public Life* (2016) and *Eating Well, Reading Well: Maryse Condé and the Ethics of Interpretation* (2008). She is the translator of Maryse Condé's *The Belle Créole* (2020) and coeditor, with Christian Moraru and Bertrand Westphal, of *Francophone Literature as World Literature* (Bloomsbury, 2020).

Hortense J. Spillers is the Gertrude Conaway Vanderbilt Chair in English, Emerita, and Professor of English, Emerita, at Vanderbilt University, USA. Her collection of essays, *Black, White and in Color: Essays on American Literature and Culture*, juxtaposes inquiries in feminist studies, minority discourse, and psychoanalytic theory, as well as American and African American literatures. Her essays have appeared in a number of journals, most recently in *Small Axe* and *boundary 2*. She is at work on two big projects—the idea of Black culture and the life and status of women under revolutionary conditions in emergent Haiti, the modern French state, and the early United States.

Karen Thornber is Harry Tuchman Levin Professor in Literature and Professor of East Asian Languages and Civilizations at Harvard University, USA. She is author of four major scholarly monographs: *Gender Justice and Contemporary Asian Literatures*; *Global Healing: Literature, Advocacy, Care*; *Ecoambiguity: Environmental Crises and East Asian Literatures*; and *Empire of Texts in Motion: Chinese, Japanese, Korean, and Taiwanese Transculturations of Japanese Literature*. Thornber's fourth single-authored monograph, *Gender Justice and Contemporary Asian Literatures*, is under preliminary contract with the Modern Languages Association Publication Program. In addition, Thornber has published more than eighty academic articles and chapters in a range of fields (e.g., medical humanities, health humanities, environmental humanities, diaspora, imperialism, transculturation, translation, indigeneity, gender, inequality, and injustice), is editor or coeditor of several volumes, and is an award-winning translator of Japanese literature.

Lisa Ryoko Wakamiya is Associate Professor of Slavic and Courtesy Associate Professor of English at Florida State University, USA. She is the author of *Locating Exiled Writers in Contemporary Russian Literature* and coeditor of *A Late Soviet and Post-Soviet Reader* (with Mark Lipovetsky) and *ReFocus: The Films of Alexander Sokurov* (with Sergey Toymentsev). Her publications include studies of transnational literary migration, gender, post-Soviet literature and film, and retranslation. Her current book project examines writer-collectors and the intersections between narrative and material culture.

INDEX

23 of March Movement 246
"1312" (song) 71
"1440: Nomadology: the War Machine" (Deleuze and Guattari) 276

Abbasid Empire 168, 173
abortion 248
absolutism 84, 95
Abu-Lughod, Lila 260 n.8, 267
academic struggle 148
Achaemenid Empire 171
Achebe, Chinua 180, 181 n.3
actant 61, 68
Adichie, Chimamanda Ngozi 190
Adorno, Theodor W. 112, 159, 160
Adulthood Rites (Butler) 65
Advertencia Lírica 78
Aeschylus 159
aesthetics 72, 102, 120, 127, 130, 138, 139, 262
Affective Geographies of Transformation, Exploration and Adventure: Rethinking Frontiers (Hayley and Waterton) 86
affirmative culture 109
Afghanistan 253, 254, 267
Africa 13, 87–9, 95
African American oral tradition 118, 119
African(s) 181
 Diaspora 86, 180, 190
 enslaved 28
Afrofuturism 66
"Against the Queen of Naples" (poem) 126
Against World Literature (Apter) 273
agency 3, 13, 17, 61, 62, 83, 217, 235, 248, 273, 279, 282

agential realism 62, 64
agricultural reforms 235
Aidoo, Ama Ata 191
À la recherche du temps perdu (Proust) 199
Algeria 241–5
Algerian civil war (1990s) 242–5
Algerian earthquake (2003) 244
Algérie, la vie quand même (Algeria, Life All the Same, 1998) 245
alienation 184–6, 190, 218
aliens 62, 63
allegorical maps 88, 92, 94, 95
allegorization 91, 94–6
"Allegory of America" (Stradanus) 92
All Over Creation (Ozeki) 195, 196
"Alma Mestiza" (album) 80
Amari, Raja 240, 250, 251
America 90–5. *See also* United States
Americanah (Adichie) 190
American demonization 38
America's Forever War 267
Amhad, Aijaz 73
anachronism 72, 147
andarun (women's quarters) 26, 29–32, 38
And the World Changed: Contemporary Stories by Pakistani Women (Shamsie) 140
Anglo-American civilization 50
Anglophone 133
animal(s) 32, 33, 39, 47, 61, 202. *See also* nonhuman
 kingdom 32, 37
 and plants 26
anthropocentric cognition 62
anthropology 24, 118, 119

anthropomorphism 62
anti-capitalist forms 230, 232, 235
anti-colonial politics 210
anti-feminicide activism 76
anti-imperialism 134
anti-Muslim sentiment 229
antiquity 5, 23, 83, 84, 88, 125, 126, 158
Anzsatzpunkt 102
aporia 11–13, 109
Apple, The (1998) 254
Apter, Emily 10, 273, 274
Arab Spring (2011) 241, 249
Ardis, Ann 136
Arendt, Hannah 4, 6, 7, 13–15, 59
Argentina 271, 272, 282
Arjomand, Said Amir 172
Armah, Kofi Kwei 180
Armah, Kwei 181 n.3
Armstrong, Amanda 230
Arruzza, Cinzia 229
Artaxerxes 171
Arthur C. Clarke award 66
Asia 87–9, 92, 95
At Five in the Afternoon (2003) 253–68
Atluri, Tara 227
Atwood, Margaret 42–5
Auerbach, Erich 1, 102
Austin, Arthur Everett "Chick" 124
authorial intention 148, 149
authoritarianism 42, 43, 50, 51, 53
authoritarian regimes 42, 78
automatic writing 148
autopoiesis 59, 60, 234
Averis, Kate 273

Bab al-sama' maftooh (*Door to the Sky*,1989) 247
Bābees 36
Babism 26, 36
Bachir-Chouikh, Yamina 245
bacterial life forms 60
Bahá'í faith 36
Bahéchar, Souad 245
Bakhtiari tribe 30
Bakhtin, Mikhail 102, 103
Bandung Internationalism 58

Barad, Karen 59, 62, 64
Barakat! (Enough!, 2006) 245
barbarism 35
Bardhan, Kalpana 104
Bardic Nationalism (Trumpener) 165
Barnes, Djuna 136
Barrada, Yto 247
Barthes, Roland 104
Bartleby, the Scrivener (Melville) 275
Basu, Lopamudra 112
Batalla, Guillermo Bonfil 79
Batallones femeninos 76, 77
Bateson, Gregory 8
Baudrillard, Jean 118
Beautiful Ones Are Not Yet Born, The (Armah) 181 n.3
Beauvoir, Simone de 2, 254, 256, 259
Beckford, William 124
Before She Sleeps (Shah) 43, 44
Belk, Russell 118
Bell, Gertrude 32
Ben Ali, Zine el-Abidine 249
Benchekroun, Siham 245
Benefactor, The (Sontag) 127
Bengali 101–4, 107–9, 111
Benjamin, Walter 105, 124
Benlyazid, Farida 247
Bennett, Jane 59, 61
Bensmaïa, Reda 243
Berman, Jessica 144
Bessis, Sophie 248, 251
Bey, Maïssa 240, 243–4
Bezanson, Kate 223
bhakti 166
Bhutto, Benazir 256
Bible 87, 88
Bildungsroman 183
biographical information and documents 147
biopolitics 209, 219
Birth of Territory, The (Elden) 96
Black analytic 214
Black Arts movement 181 n.3
Blackboards (2000) 254–5
"Black Body Politics: Social Hierarchies and Violence" (Daley) 86
Black feminism 215

Black liberatory movement 58
Black Lives Matter 148
Black men 184
Black Power movement 181
Bloom, Jonathan 168
Blue Marble (1972) 59
Boas, Franz 118, 119, 122
Bodies That Matter (Butler) 86
body image 80
body politic 95
Bombal, Maria Luisa 271
book collections 122
border crossings 274
borderlessness 274
Borderline (1930) 136
border-speak 273, 274
El Bouih, Fatna 246–8
Bourguiba, Habib 248
Bourquia, Farida 247
Bradley, Milton 2
Braidotti, Rosi 26, 33, 35, 273, 274, 278, 279, 281, 282
Braude, Benjamin 87
break dancing 75
Britain 27, 32
British
 colonialism 222, 226
 Empire 24
 travelogues 28
Brown, Wendy 8
Buchanan, Ian 275, 276
Buddhist manuscripts 168
Buechley, Evan R. 234
Buisseret, David 84
Burgess, Anthony 42
Bush, Laura 267
Butler, Judith 6, 16, 86, 214, 267 n.13, 275
Butler, Octavia 49, 50, 56, 58, 59, 61–5
Butler, Samuel 165

Cambio de armas (*Other Weapons*, Valenzuela) 271, 272, 274–5, 277–82
Cambridge University Press 137
Cannes film festival 254, 255
capital-accruing economies 166–9

capitalism 4, 101, 105, 107, 109, 112, 150–2, 160, 222, 224–5, 230, 234, 235
captivity narratives 27
Cárdenas, Cuaútemoc 78
careless indifference 32
Caribbean 119, 138, 181
Caribbean Artists Movement (CAM) 181 n.3
cartographies 73, 84–6, 88–91, 94
Casanova, Pascale 1, 110, 257
Cassandra (painting) 158–60, 162
Castillo, Debra A. 1
Cayetano, Caye 76
cellular evolution 60
Cervantes, Miguel de 154, 156, 162
Césaire, Aimé 181
Chakravorty, Dipesh 131
Cham 87, 88
Chamayou, Grégoire 7
Changes (Aidoo) 191
Changing India (Hussain) 140
Chapela, Bojórquez 75
Charlie Hebdo 210, 213, 214
Chatterjee, Partha 2
Chatwin, Bruce 124
Cheah, Pheng 211
"Checklist of Pre-Twentieth-Century Women in Cartography" (Hudson and Ritzlin) 85
Children of Men (2007) 256, 265, 266
Children of Men (James) 49
China 167
Christian fundaments 216
Chronique d'un décalage (Filali) 249
chronology 147–50
Cinema Nova 255
circumcision 51
Citizen Kane (1941) 260
civic imagery 95
civil rights 245, 248
Civil Rights movement 3, 181
Cixous, Hélène 239, 240, 246, 247, 251, 270
class 102, 112–14, 176, 228
 position 225
 privilege 34

relations 225
structures 229, 259
struggle 224
climate
 catastrophe 58, 66
 change 58, 203, 204, 206
Close to Home (Delphy) 259
Coddington, Kate 84
Cohen, Arthur A. 124
Cola de Lagartija (The Lizard's Tail, Valenzuela) 271
"The Collectors" (Sontag) 127
Collu, Gabrielle 113
colonial European discourse 242
colonialism 8, 13, 15, 57, 182, 215
coloniality 26, 86
colonization 16
Combined and Uneven Development, Towards a New Theory of World-Literature 257
commodification 18, 108, 233
Como en la Guerra (As in War, Valenzuela) 271
Comparative Literature Department 73
Condé, Maryse 181, 209–11, 218
Conka, Karol 76
Conley, Tom 84
consciousness 26, 57, 62, 77, 106, 108, 139, 187, 206, 274, 281
 historical 105, 112
 nomadic 35, 273
 subaltern 113
continental thinking 84, 85
continents 83, 84, 86, 96
contraception 248
Cook, Diane 51–3
Core of the Sun, The (Sinisalo) 47–8
Cornell University 71
Cosmographiae Disciplinae Compendium (Postel) 88
Cosmographiae Introductio (Waldseemüller) 91
cosmopolitanism 1, 2, 57
countermemory 35
Covid-19 235
Cowper, William 37
Craig, Linda 271, 279, 280

Crenshaw, Kimberlé 133
Criminal Tribes Act (1871) 226
Critical Race Theory 86
cross-culture
 communication 34
 interactions 31
 representation 24
"Cuando una mujer avanza" (Sedillo) 71, 78
Cuarón, Alfonso 256
Cultural Capital: The Problem of Literary Canon Formation (Guillory) 135
culture
 coloniality 73
 differences 42, 57
 exchange 57, 77
 forms 74
 geography 45
 materials 73
 practices 119
 production 72, 241, 242
cumbia 75
curatorship 126
Currah, Paisley 142
"The Cyborg Manifesto" (Haraway) 59
cyborgs 65–9, 279
Cyrus the Younger 171

Daiichi Nuclear Power Plant 202
Daley, Patricia 86
Damrosch, David 1, 2
Dance, Daryl Cumber 121
Dangarembga, Tsitsi 180–2, 184, 189, 190
Davalos, Carlos 77
Davis, Henry 120
Davoine, Françoise 152, 154
Dawn (Butler) 63–5
death drive 218, 219
Deckard, Sharae 228
decolonial feminism 177, 241
decolonization 180, 183, 184, 187
De Grazia, Victoria 135
Deleuze, Gilles 270, 272–8, 281, 282
Delphy, Christine 259

democracy 1, 7, 8, 8 n.6, 10, 13–16 , 47, 107, 110, 266
democratic reform 246
demodystopianism 50
demography 41, 42, 46
demotic form 108, 109
dénominateur symbolique 241
Derrida, Jacques 153
de Souza, Eunice 140
despotism 35
deterritorialization 275, 276, 278, 281, 282
Deux femmes sur la route (2007) 247
Devi, Mahasweta 101–4, 106–14
"Dhowli" (Devi) 101–10
dialectical effects 167
dialogics 103
Di Chiro, Giovanna 233
diffractive reading 62
Dinerstein, Ana Cecilia 230
Dirty War (1976–83) 271, 277
distributive agency 62
DJ 75
Djahnine, Habiba 245
Djahnine, Nabila 245
Djebar, Assia 240–3
domestic abuse 247
domestic labor 225, 227
domestic space 139
Domingo, Andreu 41
Donne, John 89–91
Donnell, Alison 138
Don Quijote (Cervantes) 154–6
"Don't Trust a Man When He's in His Liquor" (Hurston) 121
double bind 8, 10–12
"Douloti the Bountiful" (Devi) 110
Doyle, Laura 134, 136, 138
"Do You Hear Me?" 159
"The Dream Life of Political Violence: Georges Sorel, Emma Goldman, and the Modern Imagination" (Redding) 135
Duzer, Chet van 88
dystopia 42, 46, 47, 52–4

early modernity 87, 88, 155
Early Modern period 85

Earth 59
earthbound 59–62
Earthrise (1968) 59
earth systems science (ESS) 58
Eastern Europe 27
ecocritical world literature scholarship 195
ecocriticism 195
ecofeminism 195, 202
ecofeminist literary criticism 195
ecological crises 233–5
economic growth 223
economic models 234
economic systems 233–5
ecosystems 233–5
Eisenstein, Sergei 260
Elden, Stuart 96
El gato eficáz (*The Efficient Cat*, Valenzuela) 271
Elliott, T. S. 136
elusive postcolonial 182
elyat 31, 32, 34
embodiment 142, 143, 278, 281
Emecheta, Buchi 180
Emery, Mary Lou 134, 138
emotional capitalism 149–53
Enchi Fumiko-san 201
endosymbiotic theory of evolution 60, 61, 63
Engels, Friedrich 1, 259
English language 184, 185, 188
English translation 73
Enlightenment 8–10
environmental challenges 195, 206
environmental crises 41, 43, 54, 195, 197, 206
environmentalisms 195
environmental justice 195, 196
environmental problems 42
en vogue 88
Erdrich, Louise 50
Espinosa, Julio García 255
essentialism 137, 281
"Este cuerpo es mío" (this body is mine, song) 80
"An Esthetic of Hunger" (Rocha) 255
estrangement/defamiliarization 32, 102, 104

ethicopolitical 11
ethnography 24, 25
Etymologiae (Isidore of Seville) 87
Euro-American
 aesthetic practices 130
 traditions 134
Eurocentrism 73
Euro-Iranian travelogues 26
Europa 87, 95
Europa regina 95
Europe 87–9, 92, 94, 95
European
 avant-garde 255
 modernism/modernity 139, 215
extra-terrestrial worlds 58–9

Fachinger, Petra 196
False Dawn (Wharton) 123
Fanon, Frantz 186
Farrokhzād, Forugh 26
fat shaming 80
Faux départ (2015) 247
Febres, Mayra Santos 71
Federici, Silvia 225
female. See also woman/women
 allegories 84, 87–9, 92–5
 inquiry 24
 self-sufficiency 47
 sociality 26
feminicide 74, 80
feminine power 246, 247
femininity 1–2, 89, 95
Feminism and Geography: The Limits of Geographical Knowledge (Rose) 85
feminist agency 279
feminist approaches 114, 211, 262
feminist craft 164
feminist criticism 112, 133, 134
feminist demodystopias 41, 42
 city and nomad 43–6
 fetishistic displacements 46–8
 individualisms 50–4
 literacy and liberation 48–50
feminist discourse 42
feminist film theory 261
feminist geographers 84, 86
feminist issues 147

feminist liberatory movement 58
feminist literary recovery 130–1, 134–44
feminist materialisms 59–62
Feminist Modernist Studies 137, 144
feminist nomadism 26, 33, 38, 278–81
feminist progressivism 253
feminist rappers 76
feminist scholarship 130–3, 136, 138, 143
feminist science studies 56, 61
feminist speculative genres and modes
 Butler's fiction 56–9
 feminist materialisms 59–62
 human-alien encounters 62–5
 swarming cyborgs 66–9
feminist subject 253, 254, 257
feminist theory 78, 117, 273, 278, 281
feminized selfhood 61, 65
Femmes d'Alger dans leurs appartements (Djebar) 242
Ferguson, Susan 225
Fernald, Anne 135, 136
fertility crisis 46, 49, 50
fetishistic obsessions 46
Fifteenth Amendment, of US Constitution 184
Filali, Azza 249
first-wave feminist perception 30
First World 75, 77
first-world feminism 74
Flaubert, Gustave 149–53, 162
Fleur des Histoires (Mansel) 87
Flint, Kate 133
focalization 153, 159, 160
folktales 119
forest 51, 105, 107, 197, 203, 204
Forget English! (Mufti) 73
Fortunati, Leopoldina 227
fossil fuel 203
Foucault, Michel 35
Fowler, Edward 200
France 214, 217
freedom 26, 31, 36
freedom of speech 35
free indirect discourse 104, 107

free sex 227
French colonialism 216
French feminist movements 239
French World Literature 240
fresco 31, 32, 35
Freud, Sigmund 150, 151, 218
Friedman, Susan Stanford 133–6, 138
Fukushima prefecture 202, 203
Funk, Audry 72, 79–81
Future Home of the Living God (Erdrich) 50

Giffney, Noreen 61
Gaia theory 59
Gamaker, Michelle Williams 150
Gambetti, Zeynep 275
García Lorca, Federico 255, 266
garden 34
Garrity, Jane 137
Gather the Daughters (Melamed) 43–5
gaze 30, 31, 62, 260
 cinematic 261
 female 124
 imperial 27, 32
 male 39, 89, 253, 259, 261, 262
Gee, Maggie 46–7, 49
gender 26, 29, 34, 38, 85, 87, 91, 113, 121, 132, 135–7, 143, 182, 211, 214, 220, 278, 279
 analysis 137, 141
 bias 74, 113, 131
 diversity 142
 dynamics 106, 130
 embodiment 142, 143
 equality 47, 214, 241
 expression 138
 identity 138, 142 n.15, 143, 227
 justice 195, 196
 relations 183, 184, 271
 violence 74, 77
Gender, Place and Culture: A Journal of Feminist Geography 86
"Gender, Race, and Narrative at the End of Empire" 136
"Gender and Geography II: Bridging the Gap-Feminist, Queer, and the geographical Imaginary" (Wright) 86
gendered body 89
gendered seclusion 30
gendered structure 209
gendered theories 117
"Gendered Transnationalism in 'The New Modernist Studies'" (Winkiel) 138
"the Gender of Modernity" 136
genealogies 88, 117, 127, 133
genetic engineering 63, 64
gene trading 63, 64
genocide 58
genre(s) 17, 26, 27, 33, 38, 39, 45, 46, 48–50
 of framed tales 170, 173
 multiple speech 103
Geography (Ptolemy) 84, 89, 91
geography and feminism 84–7
Geomodernisms (Doyle and Winkiel) 138
geopolitics 57, 170, 176, 224, 229, 260, 274
Geschlecht 111
Ghorbel, Wafa 249, 251
Gilbert and George 124
Glimpses of Life and Manners in Persia (Sheil) 23, 26, 29, 37
global capitalism 74, 75
global feminism 11
globalization 25, 41, 42, 59
Global North 71, 74, 132, 228, 233
Global South 41, 74, 75, 131, 202, 228, 233
global terrorism 209–11
global warming 46, 203
Goethe, Johann Wolfgang von 1, 74, 124
Goldman, Emma 200
Goodman, Robin Truth 41, 223
Gore Capitalism (Valencia) 73, 74
Grady, Constance 42
graffiti writing 75
Graham, Mark 264 n.10
Gramsci, Antonio 11, 181–2 n.5
"Great Game" 27
Great Garbage Patches 203
Green, Barbara 137

Greene, Thomas 90, 91
Guatemala 80
Guattari, Félix 270, 272–8, 281, 282
Guenther, Lisa 213
guerilla warfare 277
Guillory, John 135
Gulf States 119
Gulistan (Saadi) 37
Gutenberg, Johannes 88
Gyasi, Yaa 191
gynocritics 130, 132, 133, 137

Habitual Criminals Act (1869) 226
Hadj-Moussa, Ratiba 245
Halimi, Gisèle 240, 249
Hamilton, Emma 125, 126
Hamilton, William 124–6
Handmaid's Tale, The
 (Atwood) 42, 43
Haraway, Donna 58–60, 63, 65, 234, 279
harem 31, 250
Harlem Renaissance 133
Harrison, Harry 42
Harun al-Rashid 171, 173
Hassan II (King) 245, 246
Hawthorne, Nathaniel 43–4
Hayley, Saul 86
Hay que sonreír (Clara)
 (Valenzuela) 271, 279
Hazar Afsan 165, 173
H. D. 133, 136
Head, Bessie 180
Hebe, Sara 76
Hegel, Georg Wilhelm Friedrich 107
Heidegger, Martin 117
Hekman, Susan 254
Hemenway, Robert E. 119
Herbert, Thomas 25
Hesse, Barnor 213
heteroglossia 102, 103
heterosexuality 110
Hijra community 142, 142 n.15, 225–9
Hildegard von Bingen 50
Hill, Kate 117
Hindu Nationalist Party 223
hip-hop 71, 72, 75–81

Hird, Myra J. 61
historicity of form 111
Hite, Molly 271
Hollywood 262
Holmqvist, Ninni 47, 49
Holocaust 15
Homer 159
homophobia 80
homosexuality 110
hoodoo practices 119
hooks, bell 119, 133
Hoonaard, Will C. Van Den 85
Hormizd 171
Horowitz, Maryanne Cline 95
House of Mirth, The
 (Liming) 122, 123
How Fascism Ruled Women: Italy, 1922-1945 (De Grazia) 135
Hudson, Alice 85
Human Condition, The (Arendt) 59
humanity 47, 56, 65, 111, 118, 211, 214–19, 233
human-nonhuman relations 58, 61, 62
human(s) 62, 65
 agency 61, 83
 cognition 62
 exceptionalism 60, 67, 69
 habitability 59
 rights 58, 79
 supremacy 63
 world 57
Humm, Maggie 132
Hurston, Zora Neale 118–21
Hussain, Iqbalunnisa 131, 138, 140, 143

Ice People, The (Gee) 46
illiteracy 245, 247, 248
immanent critique 102, 111
immigrants 6, 11, 143, 202
immigration 247
immobility 272, 274–8, 282
imparfait 149
imperfect cinema 255, 262
imperialism 11, 134, 261, 262
implied author 148
incomplete capitalism 258

India 110, 139, 140, 143, 168, 222, 223, 226, 227, 229–30, 235
Indiana, Rita 76
individuality 61, 65, 67
individuation 184
Innaurato, Albert 124
In Search of Lost Time (Proust) 201
In Search of Vanished Blood (2012) 158–9
insoumis 240, 242
institutional libraries 122
interdependency 59
inter-imperial economy 166, 176, 177
inter-imperiality 164, 165, 167, 168, 170, 172, 173, 176
Inter-imperiality: Vying Empires, Gendered Labor, and the Literary Arts of Alliance (Doyle) 164, 166, 176
inter-imperial positionality 167
intermediality 155, 156
international feminism 26
internet 77, 80, 203
intersectional criticism 106, 113
intersectionality 133, 134, 138, 176
intertemporality 156
intertextuality 26, 37, 38
In the Dust of This Planet (Thacker) 58
"Introduction to the Speeches of Maréchal Pétain" (Stein) 135
Iran 24, 26–8, 30, 32, 37–9, 262. See also Persia
Irigaray, Luce 86, 273, 278, 279
Iris Center 137
Isidore of Seville 87
Islam 139, 214, 217, 256
Islamicate states 168, 172, 173
Islamic politics 249

Jaggi, Maya 211
James, P. D. 49
Jameson, Fredric 2, 111, 253, 257–9, 262
Jantar Mantar 230, 231
Japan 168
Japhet 87, 88
Jean-Philippe, Clarissa 210
Jet Propulsion Laboratory, NASA 56
Jezero Crater 56
Johnson, Adrian 219
Jordan, Hillary 43, 44
Joyce, James 171
Jungle Crow (*Corvus japonensis*) 204–6

Kabul 260, 265–8
Kadlec, David 135
Kajjars 28
Käll, Lisa Folkmarson 281
Kanno Sugako 200
Kant, Immanuel 13, 102, 276
Kariba dam 66
Kashmir 229–32
Kassari, Yasmina 240, 247, 248
Kaufman, Eleanor 276, 278
Kaul, Suvir 140
Kawabata Yasunari 201
The Keepers 72
Kentridge, William 160
Kenyatta, Jomo 181
Kincaid, Jamaica 135
kinship 222, 224, 230, 233–5
Kirkley, Laura 3
Klein, Naomi 235
Knight, Richard Payne 124
knowledge-making 122
knowledge production 116, 121
Krishnaswamy, Revathi 166
Kristeva, Julia 241
Krudas Cubensi collective 76
Kuijsten, Anton 41

Laachir, Karima 166
labor 85, 86, 165, 222
 relations 226, 228, 229
 unions 223
La décennie noire (the civil war, 1989–2005) 241
La deuxième épouse (Zouari) 249
Lahore Literary festival (2013) 140
Laity, Cassandra 135
L'amante du Rif (2011) 247
Lamos, Colleen 135
L'amour, la fantasia (Djebar) 242

Lane, Rebeca (Rebeca Eunice Vargas Tamayac) 72, 79–81
"language of usefulness" 123
La nouba des femmes de Mont Chenoua (1978) 240
La soif (Mischief, Djebar) 243
Lastesis collective 71, 72
Latin America 56, 71, 72, 74–6
Latin American feminisms 78
Latin American Studies Association 71, 76
Latiri, Dora 249
Latour, Bruno 61
Lazarus, Neil 112
Le Blanc de l'Algérie (1996) 243
Le Concert des cloches (Bahéchar) 245
l'écriture féminine 239, 240, 273
Lee, Vernon 133
le féminine 240
Left-front government 106
Le Jasmin noir (Ghorbel) 249–50
L'enfant endormi (2006) 240–1, 247–8
Lenin, Vladimir Ilyich 101, 105, 107
Leninism 106, 107
Lentin, Alana 210, 213, 214
"Le rire de la méduse" (The Laugh of the Medusa, Cixous) 239, 251
Les années de plomb (The Years of Lead, 1963–99) 241, 245, 246
Les années noires (Black Decade, 1992 to 2005) 243
lesbian feminism 78
lesbophobia 80
Les silences du palais (1994) 250
Lessing, Doris 133
Les yeux secs (2002) 247
Le temps retrouvé (Proust) 199–200
Lettre à ma soeur (Letter to My Sister, 2008) 245
Lewis, Mark Edward 167
Lewis, Wyndham 135
liberal individualism 49
liberation 48, 52, 268
Liber chronicarum (Schedel) 87–8
life forms 59, 61, 63, 65
life sciences 58

Liming, Sheila 122, 124
Lionnet, Françoise 3, 4
Lirika, Mare Advertencia 71, 72, 76–9, 81
Lispector, Clarice 271
literacy 48, 50, 54, 167
literary aesthetics 279
literary forms 111, 164, 170, 176
literary mediation 176
literate institutions 166–9
literature 118
 Arabic and Persian 170, 173
 Indian 139
 sexual-intersectional matrix 164
 and video 155–6
"A Literature of Their Own" (Showalter) 132
"Literatures in English" 73
Living My Life (Goldman) 200
"Llanto por Ignacio Sánchez Mejías" ("Lament for a Bullfighter," poem) 255
Los Cojolites 78
Lovelock, James 59
Loy, Mina 136
"Lucha por respirar" (Fight to breathe, song) 79
Lukács, Georg 107
Lyon, Janet 136

Maa, Chhoti 76
MacCleod, Dianne Sachko 117
MacDonald, Gail 135
macho cultures 75
McNamara, Brendan 33
Madame Bovary (Flaubert) 149, 150, 152–3
Madame B (2011–13) 150, 153
Maddress, Avril 86
Maghreb 239, 241, 242, 251
magical realism 66
Mahmoody, Betty 38
Majumder, Auritro 111–13
Make Room! Make Room (Harrison) 42
Makhmalbaf, Mohsen 255, 255 n.3
Makhmalbaf, Samira 253–6, 256 n.6, 261, 264, 266

Malani, Nalini 158, 162
Mandela, Nelson 181, 182
"Manifesto against police violence" 71
"Man in Liquor" (Parsons) 122
Mansel, Jean 87
Mao, Doug 136, 137
mapmaking 84, 85
mappamundi 87
Mappings: Feminism and the Cultural Geographies of Encounter after Mappings (Friedman) 138
Mapplethorpe, Robert 124, 127
maps 91
Map Worlds: A History of Women in Cartography (Hoonaard) 85
maquis (rebel fighter cells) 243
Marcus, Jane 133
Marcuse, Herbert 109
marginalization 3, 4, 16, 103, 107
Margulis, Lynn 59–61, 63, 64
Marinetti, F. T. 135
Marock (2005) 247
Marrakchi, Laïla 247
marriage 122
Mars 56
Marson, Una 138
Marxian approach 225
Marxism 4, 101, 106, 225
Marxist and Marxian school 225, 231
Marxist feminism 225
Marx, Karl 1, 17, 150, 151, 153, 257
Marzagora, Sara 166
masculine coloniality 26
masculinism *vs.* feminism 155
masculinist family ideology 181
masculinity 26, 33, 37, 69, 85, 117, 140, 141, 184
Mason, Charlotte Osgood 118, 119
Massey, Doreen 85–6
material culture 122
materiality 122
matriarchy 46
Mbembe, Achille 8 n.7, 16, 189
MC 75
media and print studies 136, 137
Mèknes Group 246

Melamed, Jennie 43–5, 49
Melman, Billie 29
Melville, Herman 275
memoir/life writing 24, 27, 33, 38
men's collecting/as collectors 121–2
"Merchant and His Wife" 175
"The Merchant and the Demon" 176
merengue 76
Mernissi, Fatima 240
Merteuil, Morgane 227
metaphoricity 91
metaphors 65, 90, 91, 120
métier 111
#MeToo 148, 156, 158, 162
México profundo (Batalla) 79
Midnight's Children (Rushdie) 171
migration 3, 34, 46, 86
Milani, Farzaneh 27, 36
militarism 268
militaristic imperialism 253
military dictatorship 271, 272, 278, 282
mimetic form 105, 112
minimalism 104
Ministry of Utmost Happiness, The (Roy) 222–35
Miss Bolivia 76
Mitchell, Katharyne 84
mitochondria 60
mitosis 60, 60 n.1, 64
Miyazawa Kenji 201
"Modern and Contemporary Women Poets" 136
modernism 131–4, 137–40, 143
Modernism/Modernity 134, 135, 137
Modernist Archives Publishing Project 137
modernist literary practices 131, 132
modernist studies 130–2, 134–8, 140, 143, 144
Modernist Studies Association (MSA) 134–6
modernity 130, 138–41, 257–9, 261–5
Modi government 235
Mohamed VI (King) 245, 246
"The Monophobic Response" (Butler) 62

montage 260
Moore, Lisa Jean 142
Moore, Marianne 135
Moretti, Franco 1, 41, 74, 257
Morgan, Katie Stack 56
Morier, James 37
Morocco 241, 245–8
Moschus 87
Moss, Pamela 86
Mottahedeh, Negar 261, 262
Muensterberger, Werner 118
Mufti, Aamir 4, 5, 73
Mujeres trabajando 76, 77
Mukherjee, Bharati 135
Mules and Men (1935) 118–21
multilingualism 26, 37
Mulvey, Laura 261
"mundus novus" (New World) 85, 91, 92
Münster, Sebastian 94
museum studies 126
Music Business Worldwide 72
Mwampa, Flora 180
My Year of Meats (Ozeki) 195–6

Nakjavani, Bahiyyih 33
Nakury 72, 79
naming 83, 88, 91–2, 94–5
narcocorrido 75
narrative fiction 72
narratives as collections 116, 117, 119
Naru, Akua 72
NASA (National Aeronautics and Space Administration) 56
Naser al-Din Shah 26
nationalism 2, 49, 110
Natsume Sōseki 201
Nazim al-Murk 172
Négritude Movement 181
"Negro Folk-Lore in South Carolina" (Davis) 120
NEH (National Endowment of the Humanities) 137
Nejjar, Narjiss 247
Nelson, Horatio 125
NeoEocene 197, 204
neo-hostage narratives 27

neoliberal forms 222–4
neoliberal globalization 229
neoliberalism 5, 7, 14, 18, 223, 224, 226–8, 233, 235
neoliberalization 228
neoliberal reforms 235
neologisms 83, 88, 92
Nervous Conditions (Dangarembga) 180, 182–9
Newman, Jane O. 12
new materialism 61
"The New Modernist Studies" (Mao and Walkowitz) 136
New Wilderness, The (Cook) 51–3
New World 89
New Year's Day (Wharton) 123
New York Times 71, 127
NGOs (Non-governmental Organization) 2, 78, 226–8
Nickels, Joel 224, 230–2, 235
Nielson Music data (2019) 72
Nigeria 190
Nkoloso, Edward 66
Nkrumah, Kwame 181
Noah, sons of 87–9
nomad 270, 273–8, 282
nomadic consciousness 35
nomadic cultures 30 n.10, 34
Nomadic Subjects (Braidotti) 278
nomadic women 26, 30
nomadism 35, 270, 272–4, 277, 279, 282
nomadology 272, 274, 276, 281, 282
noncapitalist practices 226, 230–4
nonhuman 202, 204. *See also* animal(s)
 animals 206
 companionship 33
 life 26, 58
 symbolism 31
 world 61, 62
noninstitutional spaces 224
non-state networks and archives 231–3
non-state spaces 224, 225, 230–3
non-Western others 111
"Notes on Camp" (Sontag) 125

Not Without My Daughter
 (Mahmoody) 38
nuclear fallout 203, 206
Nulle part dans la maison de mon père
 (Nowhere in My Father's House,
 Djebar) 243
Nyerere, Julius 181

Oaxaca 72, 77, 78
objectification 31, 190
Occidentalism 72
Odyssey (poem) 165
oikoumene 84, 87–9, 92
Okorafor, Nnedi 51, 53
Old Drift, The (Serpell) 59, 66–9
Old New York (Wharton) 123
"On Magic Realism in Film"
 (Jameson) 262
oppression 34, 35, 57, 81, 102, 113,
 152, 202, 248
oral storytelling 15, 53
oral testimonies 243
oral traditions 53, 120, 121, 167
Oran, langue morte (1997) 243
Orientalism 4, 5, 27, 29, 37, 39
Origins of Totalitarianism, The
 (Arendt) 13
Orlando Project 137
Orsini, Francesca 166
Ortelius, Abraham 92, 94–6
Oser vivre! (Benchekroun) 245
Otherness/Othering 32, 112, 254
Ovid 87
Ozeki, Ruth 195–7, 201–3, 206

Pakistan 139, 223
Panchatantra 165, 173
paper-making technologies 167
Parable of the Sower (Butler) 49–50
Paris attacks (2015) 209–10
Parnet, Claire 278
Parsons, Elsie Clews 122
passivity 270–2, 275, 278–81
pastoral life 34
patriarchy 45, 278, 280, 282
 societies 44, 45, 239
 structures 240
 thinking 156

p'Bitek, Okot 180, 181 n.3
Pechriggl, Alice 89, 91, 95
Peeren, Esther 153
people of color 202
People's Revolutionary Army 277
peripheral literature 111, 112
Peroz 171
Perrot, Michelle 89
Perseverance Rover 56
Persia 23–32, 24 n.2, 34–38. *See
 also* Iran
Persian
 culture 34
 poetry 37
personifications 84, 87, 88, 92
Peters, Jeffrey 88, 92
phallocentrism 132, 279
Phillips, Adam 126
Pimentel, Eleonora Fonseca 125, 126
Pitts, Frederick Harry 230
planetary crisis 61
*Planetary Modernisms: Provocations
 on Modernity Across Time*
 (Friedman) 138
planetary scholarship 131
PMLA 136, 137
police brutality 148
political activism 156, 246
political biography 182
political economies 165, 172, 177
political fiction 278
political freedom 106
political philosophies 170
political schisms 222
political violence 148
pollution 206
polygamy 139, 141, 248
Porter, Andrew 124
postcolonial/postcoloniality 183,
 191, 240
 African 189
 critique 181
 fragmented identity 242
 societies 241
 studies 131, 134, 137
Postel, Guillaume 88
posthuman
 reversal 64

universe 64
world 62
postmodern tradition 181
Postone, Moishe 102, 104
poverty 245, 247, 248
precarity 6–8, 11, 13
Preciado, Paul Beatriz 74
pre-posterous history 148, 149
printing press 88
print-making technologies 167
prison/prison narratives 27, 38, 44, 250
productive labor 222–4
productive structure 223
progressive feminism 253, 265
proprietary biotechnology 235
prostitution 105, 112, 227. See also sex work
Proust, Marcel 199–201
provincializing Europe 131
psychoanalysis 117, 118
psychological stress 242–5
Ptolemy 84, 88, 89, 91
Public Enemy MC Chuck D 75
purdah 31, 139, 143
Purdah: An Anthology (de Souza) 140
Purdah and Polygamy (Hussain) 131, 138–40, 142, 142 n.15, 143
Pussy Riot 71, 72

Qajars 28
quantum mechanics 62
"Queer Theory" 136
queer woman 74, 75
"¡Que mujer!" (What a woman, 2010) 77

race 46, 111, 114, 135, 176, 211, 214, 220
 panic discourse 42
 relations 184
Rachida (2002) 245
racial conflict 184
racial discrimination 189
racial identity 210
racial indifference 218
racialization 86

racialized communities 218
racialized structure 209
racial justice 196
racial observations 28
racial purity 28
racism 29, 214
racist caricature 214
racist practices 214
radicalism 101
radicalization 209, 210, 213, 215, 217, 218
Rainey, Lawrence 134, 135
rap 71, 72, 75, 76, 78
rape 51, 80
Realidad nacional desde la cama (National Reality from Bed, Valenzuela) 271, 272, 275, 277–82
Redding, Arthur 135
Reflections on the Way to the Gallows (Kanno Sugako) 200
reforestation 204
Refuse the Hour (2012) 160
régimen live 75
relationality 59
relational networks 116–18
relational ontologies 61
religious freedom 35
religious violence 229
reproduction 42–6, 48, 51–4
reproductive domesticity 259
reproductive economies 259
reproductive labor 223, 224, 227
resistance 225, 230–1
retrieval 3
revolutionary ideology 242
rhizomes 275
Rhys, Jean 138, 271
Ritzlin, Mary M. 85
Rivera, Rabia 76, 79
Robbins, Bruce 135
Rocha, Glauber 255
Rock the Casbah (2013) 247
Roffman, Karin 122
romanticism 149
Room of One's Own, A (Woolf) 133
Rose, Gillian 85

Roy, Arundhati 222, 224, 228, 232, 235, 236
Rushdie, Salman 171
Russia 27

Sabsay, Leticia 275
Sackville-West, Vita 26, 30, 32, 34
Sahraoui, Djamila 245
Said, Edward 1
Saisselin, Rémy 121
Salinas de Gortari, Carlos 78
same-sex desire 133
Sánchez Prado, Ignacio 72–4, 76
Sanctuary (Wharton) 122
Sapphic modernism 133, 136
Sarker, Sonita 134, 137, 138, 140
Sassanid Empire 168, 170, 171, 173
Satin Rouge (2002) 240, 250
scar 212–13
Scarlet Letter, The (Hawthorne) 43
Schedel, Hartmann 87, 88
scholasticism 169
Schwartz-Bart, Simone 181
science fiction 56, 58, 66
Scott, Joan 260 n.8
screen-imagery (*imaginaire-écran*) 89, 95
second-wave feminism 180, 254
secularism 9, 214
secular republicanism/*laïcité* 213, 214, 216
Sedillo, Simon 71, 77, 78
Segato, Rita 74
Şekercioğlu, Çağan H. 234
Seljuq Empire 172
Sem 87, 88
Sembene, Ousmane 180
Senghor, Léopold Sédar 181
Separate and Dominate (Delphy) 259
Serpell, Namwalli 59, 65, 66, 69
Seshagiri, Urmila 134
Sex and the Failed Absolute (Zizek) 266
sexual crisis 169, 170
sexual difference 110, 239, 279, 281
sexual enslavement 105
sexual identity 142, 143, 281

sexuality 110, 111, 114, 135, 136, 165, 172, 182, 239
sexualization 31
sexual labor 105, 108
sexual luring 151, 152
sexual violence 45, 51, 271
sex work 107, 222, 227, 228. *See also* prostitution
Shah, Bina 43, 44, 49
Shaheesevens 31
Shakespeare, William 165
Shamsie, Muneeza 140
Shapiro, Stephen 228
Sheil, Justin 24, 27, 28
Sheil, Lady Mary 23–38
Shih, Shu-mei 3, 4, 166
Shiva, Vandana 235
Shohat, Ella 263
Shona language 184, 187
Showalter, Elaine 130, 132, 133
"Show Me the Zulu Proust" (Amhad) 73
Simetrías (Symmetries, Valenzuela) 271
singular modernity 253
Singular Modernity, A (Jameson) 257
Sinisalo, Johana 47–9
Siskind, Mariano 41
sisterhood networks 76
slavery 29, 182
slave trade 37
Snaith, Anna 138
social class 30
social conflicts 102
social democracy 47
social exclusion 46
social inequality 106
social justice 72, 74, 79, 80
social media 24, 74, 75
social realism 34, 35
social reproduction 222, 224–5, 227–33, 235
Society for the Study of American Women Writers (SSAWW) Recovery Hub 137
soft colonialism 75
solidarity 174–6

Somos Guerreras collective 72, 79, 80
Song of Lawino (p'Bitek) 181 n.3
son jarocho 78
Sontag, Susan 118, 124–7
Sorabjee, Cornelia 138
South African apartheid 182
South Asia 224, 226
Southern Illinois University 137
Soyinka, Wole 180, 181 n.3
Spatial Divisions of Labour (Massey) 86
speculative fiction 56–8, 66
Spillers, Hortense J. 213
Spivak, Gayatri Chakravorty 7–15, 110, 111, 113, 117, 131, 133, 134, 136, 210, 218, 257 n.7
Stammers, Tom 121
Standing, Guy 6 n.2
standpoint 102, 104, 131, 138
state bureaucracy 168
state capitalism 225
state feminism 248–54
statelessness 8, 13, 14, 16
Staying with the Trouble (Haraway) 60
Stein, Elliot 124
Stein, Gertrude 124, 135
stereotypes 39
 ethnic 24
 gender 78
 Orientalist 31
Stradanus (Jan van der Straet) 89, 92, 94
Stravinsky, Igor 135
street performances 75
striated and smooth spaces 276
struggle for independence 242, 245
Stryker, Susan 142
subaltern 10, 106, 107, 111, 112, 189
subjectivity 272, 278, 279, 281
sub-Saharan Continent 180, 190, 192
Sugako, Kanno 199
Surtout ne te retourne pas (Above All, Don't Look Back, Bey) 240, 243–4
surveillance 174–6

swarming 66–9
Swarnakumari Devi 138
symbiogenesis 63, 67
sympoiesis 60, 61, 69, 234

Tahirih Qorratol'Ayn 26, 36
Tale for the Time Being, A (Ozeki) 195–206
"The Tale of the Ox and the Donkey" 174–5
Taliban 265–7
Tamil ecopoetics 166
Tang dynasty 168
Tangled Hair (Midaregami, poem) 201
techno-animist realm 64, 68
technological development 66, 253, 258, 259
temporality 42, 148, 160, 182, 213, 263
Tepco 203
"Te pertenece" (It belongs to you, song) 80
terrestrial life 59
territorialized resistance 230
territories 83, 86, 88–91, 94–6
terrorist attack 210
Testaments, The (Atwood) 43
Thacker, Eugene 58
Theatrum orbis terrarum (Ortelius) 92
Things Fall Apart and *Man of the People* (Achebe) 181 n.3
Third Cinema 253, 255, 262, 263
Third World 75
This Mournable Body (Dangarembga) 182, 190
This Sex Which Is Not One (Irigaray) 86
Thousand and One Nights, The 164, 165, 167–76
Thousand Plateaus, A (Deleuze and Guattari) 276
Thunberg, Greta 158
Tijoux, Ana 76
Time 71
Tlatli, Moufida 250
"To His Mistress Going to Bed" (poem) 89–90

Tolonnikova, Nadya 71
toponyms 83, 84, 87–9, 91, 92
torture 43, 245–6, 272, 277
Toure, Sekou 181
Trabelsi, Bahaa 245
transactional sex 104
transcendental criticism 102
Transcendent Kingdom (Gyasi) 191
transfeminism 74, 75
transgender
 identity 141
 theory 142
translation 73, 91, 103, 104, 108, 110, 165, 168–70, 174–6
translation projects 167, 168
transnational modernism 137–44
transnational scholarship 138, 141, 143
transnational theory 131, 132
transnational turn 136, 138
trans theory 74
travelogue genre 24, 26
travelogues 23–6, 29, 31–5, 37, 38
Travels in Persia (Herbert) 25
tribal people 106, 107
Triple Disaster (2011) 196, 197, 202
Trumpener, Katie 165
Tucumán, battle of 277
Tunisia 241, 248–51
Tunisian feminism 248
turntabling 75
Twelve Days in Persia (Sackville-West) 30
Two-Legged Horse (2008) 255

UCLA (University of California at Los Angeles) 124, 127
Ulysses (Joyce) 171
Umayyad Empire 168
Un amour de tn (Latiri) 249
Une femme nommée Rachid (El Bouih) 246
uneven development 253, 256, 258
Une vie à trois (Trabelsi) 245
Un Féminisme décolonial (Vergès) 241, 245
UNFT (L'union des femmes de Tunisie) 248

Unit, The (Holmqvist) 47
United States 180, 181, 181 n.3, 184, 190, 267, 268. *See also* America
universalism 12, 254
university/higher education 73, 80
unsubmissiveness 240, 242
"Un violador en tu camino" (A rapist in your path, 2019) 71
utopia 45, 53

Vajpayee, Atal Bihari 229
Valencia, Sayak 73, 74
Valentine d'Arabie; la nièce oubliée de Lamartine (Zouari) 249
Valenzuela, Luisa 270–80, 282
Van Dusen, Wanda 135
Van Hallberg, Robert 134, 135
veil 89, 253, 259–64, 268
veiling 31
Vergès, François 241, 245, 248
vernacular dialect 102, 103
vernacular literatures 110
Vespucci, Amerigo 89, 91, 92, 94
vibrant matter 61
video installation 155–6
Villegas, Linda 72, 78
Vindication of the Rights of Women (Wollstonecraft) 3
vis formandi 89
visual arts 84, 87
vital materialism 62
vizier families 172–3
Volcano Lover, The (Sontag) 124–7
Vonnegut, Kurt 42
Vulnerability in Resistance (Butler, Gambetti and Sabsay) 275

Wagstaff, Sam 124
Waiting for Godot (Sontag) 126, 127
Wake Up Morocco (2006) 247
Waldseemüller, Martin 91, 92
Walker, Kathy Le Mons 223
Walkowitz, Rebecca 136, 137
walls 31, 35, 43, 45, 262
Wanting Seed, The (Burgess) 42
Warhol, Andy 124
Warwick Research Collective (WReC) 256–9

Waterton, Emma 86
Wa Thiong'o, Ngugi 180
Weeks, Kathi 225
Weheliye, Alexander 214
Weinstein, Harvey 158
"Welcome to the Monkey House" (Vonnegut) 42
Well of Loneliness, The (Radclyff Hall) 142
Wells, H. G. 42, 48
Wells, Orson 260
Weltliteratur 41
Wenzel, Jennifer 107, 109, 113
"We shall overcome" (song) 72
Western
 imperialism 41, 87
 literary forms 72
 philosophy 74, 254
 subjectivity 111
Wharton, Edith 118, 122–4
When She Woke (Jordan) 43
When the Sleeper Wakes (Wells) 42
white analytic 210, 213, 214
White hegemony 87, 95
whiteness 214, 219
white supremacy 24, 46
Whittle, Stephen 142
Who Fears Death (Okorafor) 51–2
"Why the Cat Eats First" (Hurston) 120
widowhood 102
Williams, Raymond 109
Winkiel, Laura 134, 136, 138
Wintle, Michael 89
Wolf, Christa 159, 160, 162
Wolfson, Mitchell 124
Wollstonecraft, Mary 3
woman-as-image 253, 261
woman/women. *See also* female
 Afghani 267
 African American 63
 African writers 180, 191
 Algerian 242–5
 as anti-suicide bomb 154–6
 authors 240
 beauty 28
 Black 184
 bodies 89–92, 94, 95, 261
 British 29, 32, 39
 collecting/collections 116–19, 121–7
 of color 214, 215
 as continents 88–91, 94
 education 51
 European 29
 exploitation 105, 107, 109
 filmmakers 244, 247, 250
 histories and literatures 197, 201
 Iranian 27
 labor 101, 102, 105, 176
 Maghrebi 240, 242, 251
 Muslim 131, 143, 257 n.7
 as objects 262
 oppression 202, 256
 Persian 29–32, 34
 rights 71, 248–9, 268
 storytelling 165, 169–74
 travelers 26, 29
 tribal 102
 Tunisian 250, 251
 visual representations 87, 89, 95
 of viziers families 172
 voices of 242, 244
 writer-collectors 116–18, 126, 127
 writers recovery 131–4
Women's March 86
Women's Voices: Selections from Nineteenth and Early Twentieth Century Indian Writing in English (de Souza) 140
Wondrous and Tragic Life of Ivan and Ivana, The (Condé) 209, 211–13, 215–20
Woolf, Virginia 2–3, 7, 9, 132, 133, 135, 136, 165
Words Like the Wind (Kaze no gotoki kotoba, Enchi Fumiko-san) 201
world-for-us 58
worlding 59, 60, 116, 117, 121, 165, 166
world-in-itself 58
worldliness 5, 127
world literary systems 257
World Literature 56, 57, 59, 69, 72, 73, 75, 76, 81, 102, 147, 162,

165, 166, 211, 224, 235, 236, 258, 273, 274
 criticism 1
 theory 74, 257
 as worlding project 165, 166
world-making 15, 58, 59, 62, 69, 127, 224, 229
world systems theory 257
World War I 13, 14
world-without-us 58
Wright, Melissa 86
Writing and Authority in Early China (Lewis) 167
Wynter, Sylvia 214

Xenogenesis trilogy (Butler) 59, 62–5

Yeğenoğlu, Magda 29
Yema (2012) 245
Yosano Akiko-san 201
"You Don't Hear Me" 159
"Y tú ¿qué esperas?" (song) 79

Zaman, Arif 140
Zambian history 66
zero-degree writing 104
Zimbabwe 184
Zizek, Slavoj 219, 256, 265, 266
Zouari, Fawzia 249

www.ingramcontent.com/pod-product-compliance
Lightning Source LLC
Chambersburg PA
CBHW070749020526
44115CB00032B/1588